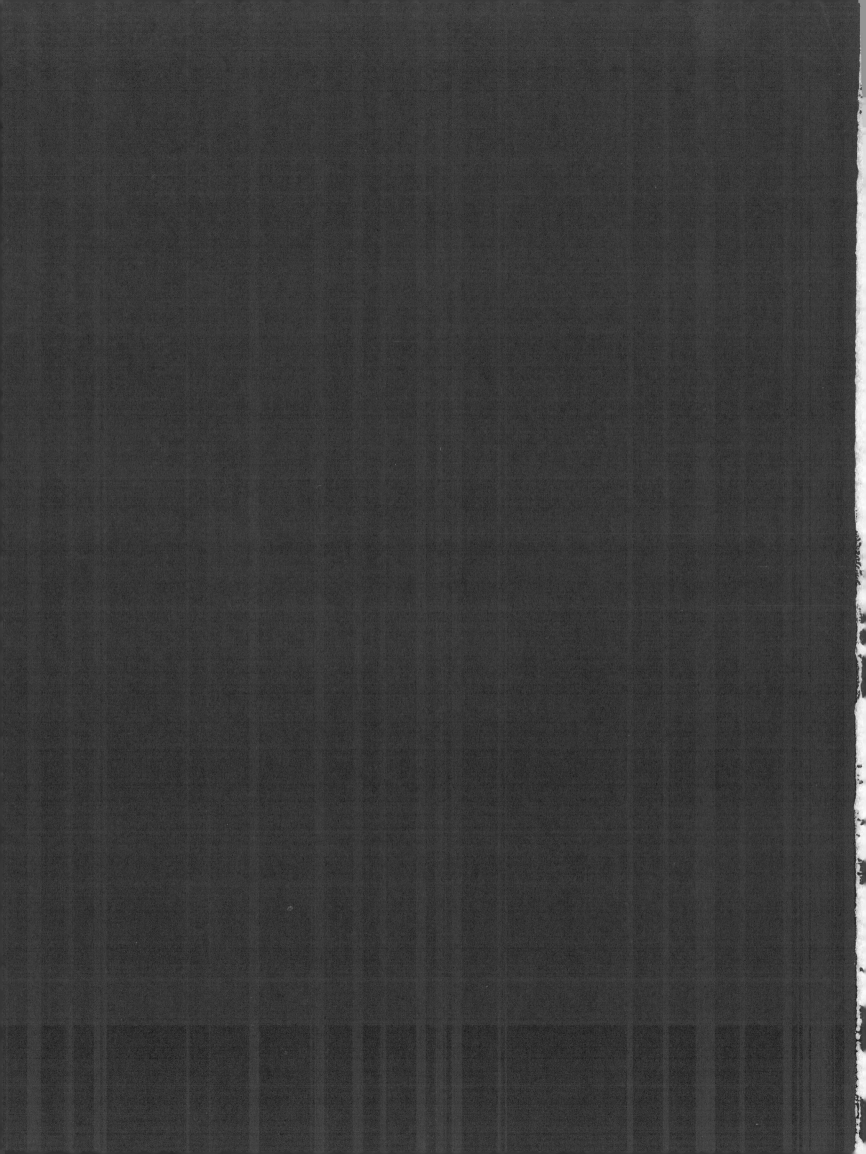

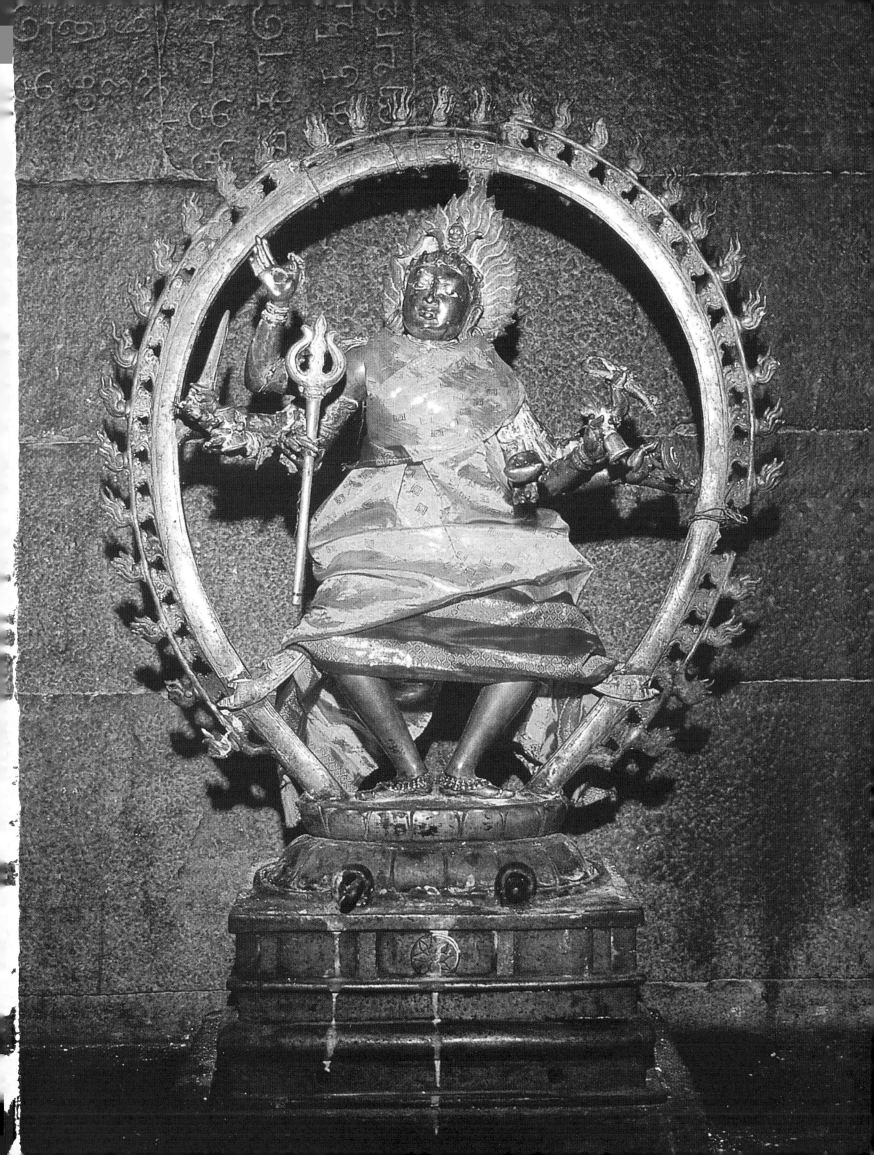

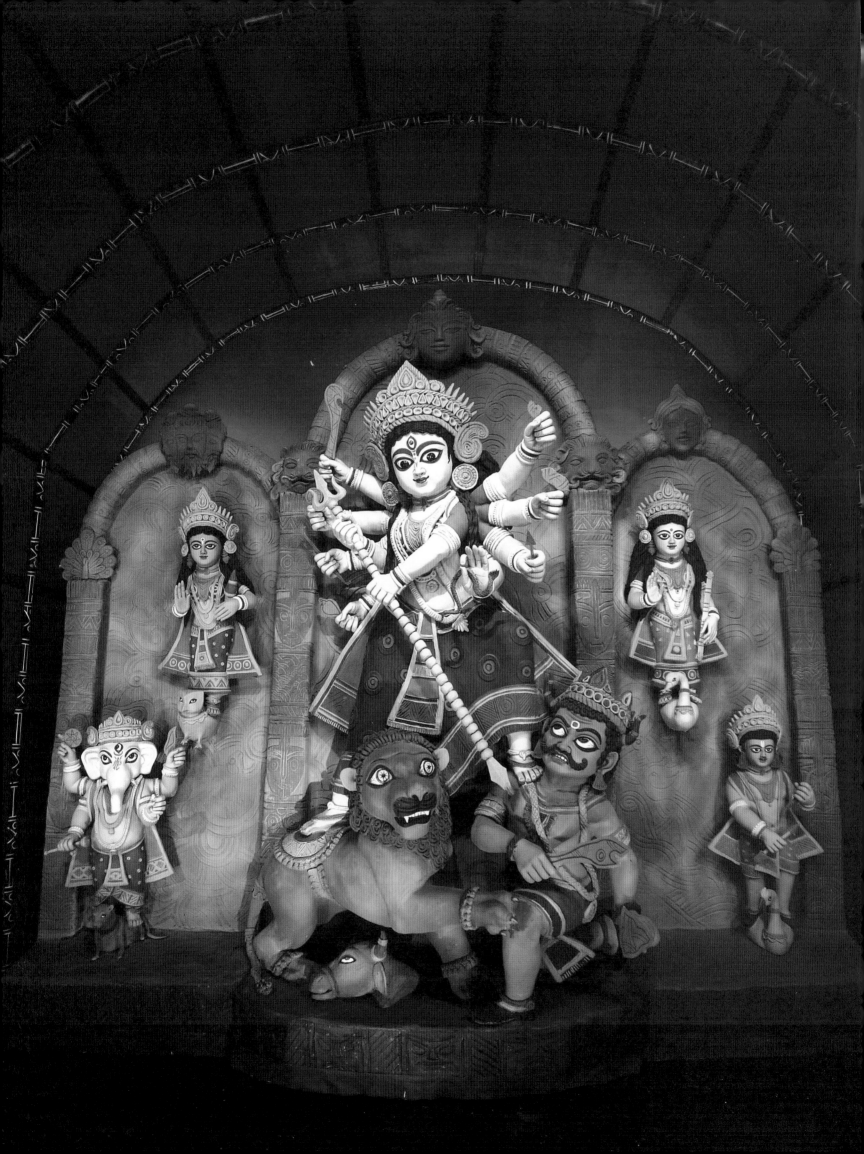

GODDESS DURGA

The Power and The Glory

edited by
Pratapaditya Pal

Marg publications

The publication of this book has been
made possible with a major donation from
A.J. Speelman, London

Marg's quarterly publications receive support from
the Sir Dorabji Tata Trust – Endowment Fund

Acknowledgements
Art India Mumbai for permission to reproduce the
essay by Tapati Guha-Thakurta from the issue on the
Festival Aesthetic, 9(3), 2004.
Christine Knoke at Norton Simon Museum,
Pasadena for help with photographs.

Vol. 61 No 2
December 2009
Price: Rs 2500.00 / US$ 68.00
ISBN 13: 978-81-85026-93-0
Library of Congress Catalog Card Number: 2009-341504

Marg is a registered trademark of Marg Publications
© Marg Publications, 2009
All rights reserved

Published by Radhika Sabavala for Marg Publications
on behalf of the National Centre for the Performing Arts
at NCPA Marg, Nariman Point, Mumbai 400 021.
Processed at Marg, Mumbai 400 001.
Printed at Thomson Press (India) Ltd., Navi Mumbai 400 708.

Captions to preliminary pages:
Page 1: See page 146.
Page 2: Ultadanga Yubak Brinda's Puja pandal, Kolkata.
Photograph: Satyaki Ghosh.
Page 3: See page 161.
Pages 4–5: Puja pandal of Badamtala Aashar Sangha, Kolkata.
Photograph: Satyaki Ghosh.
Pages 6–7: New Alipore's Suruchi Sangha Puja pandal, Kolkata.
Photograph: Satyaki Ghosh.

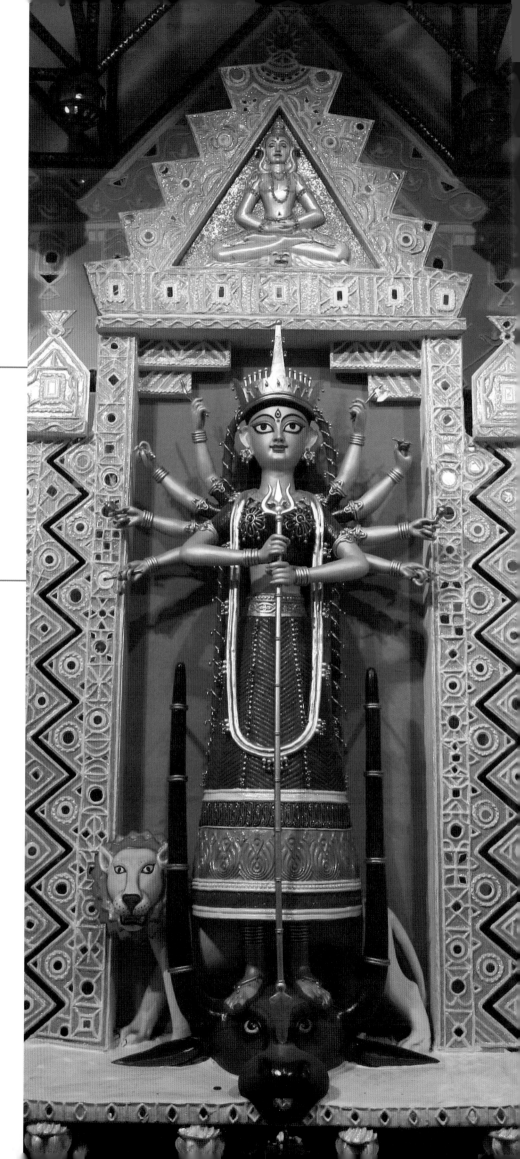

CONTENTS

8 **Introduction**
Pratapaditya Pal

22 **The Defeat of the Gods and the Victory of the Goddess:**
The Divine Feminine in Indic Spirituality
Gerald James Larson

38 **Vessels for the Goddess: Unfired-Clay Images of Durga in Bengal**
Susan S. Bean

54 **From Spectacle to Art:**
The Changing Aesthetics of Durga Puja in Contemporary Kolkata
Tapati Guha-Thakurta

82 **Durga in Kashmir**
Pratapaditya Pal

96 **Dasai:**
The Celebration of the Goddess Durga in Kathmandu Valley, Nepal
Anne Vergati

106 **Dance of Conception and Baby Shower:**
Tracing a Latent Aspect of Durga Puja in the Light of
the Cult of Kumara
Gautama V. Vajracharya

130 **Constant Companion, Autonomous Spirit:**
Two Facets of the Feminine in Tamil Tradition
Rajeshwari Ghose

152 **The Muchilottu Bhagavathi Cult in Kerala**
Pepita Seth

164 **The Fifty-one Shakta Pithas**
Pratapaditya Pal

188 **The Hinglaj Shrine, Baluchistan**
Ibrahim Shah

198 **Index**

200 **Contributors**

Introduction

Pratapaditya Pal

O Queen of the universe, you protect the universe. As the self of the universe, you support the universe. You are the (goddess) worthy to be adored by the Lord of the universe. Those who bow in devotion to you themselves become the refuge of the universe.[1]

1

Ever since I can remember I have been familiar with Durga, who, along with Kali, is the most popular deity of the Bengali Hindus. During the '40s of the last century Durga was worshipped every autumn in our home in Calcutta (now Kolkata), in a polished brass waterpot. On Shashthi, the sixth day of the lunar fortnight in the month of Ashwin (September–October), the family priest would ceremoniously consecrate the pot by filling it with water from the holy river Ganga (known as the Hooghly as it flows past the city to the Bay of Bengal), and inserting a twig with mango leaves (snapped from the tree behind our house) into the neck, then place a green coconut, which was covered with a thin, gauzy towel of the native kind, on its aperture. On the front of the pot he would paint an abstract stick figure with vermilion and so the terrestrial form was ready for the goddess to be invoked. Then with offerings of food and flowers, appropriate rituals and mantras, she would be worshipped for four days until the tenth (Dashami or Dassera), and the family would gather around the priest for the final blessings known as *shanti* or peace.

It was many years later that I learnt from the *Devipurana*, an ancient text recounting the myths, images, rituals, etc. of the Devi, a generic designation for goddess, that besides an icon she could be invoked in a waterpot, a book, a weapon such as the sword, and various other material forms.[2] In 1950 my parents began to commission annually a complete tableau of polychromed clay that is typically Bengali (figure 2, see also pp. 2, 4–7, and articles by Bean and Guha-Thakurta) and this tradition continued for the next 25 years. The four most vivid memories of Durga Puja of my childhood were the new clothes we were given, the relentless feasting for four days, the daily excursions to the various neighbourhoods to view the elaborate images and their settings in public assemblies (known as *barawari puja*), and the noisy bacchanalian processions on the tenth evening (or even the eleventh and twelfth nights). I also recall two other exciting elements of the annual festival which is like Christmas for Bengali Hindus, though much more joyously raucous and passionate in its public expression. These are the eager anticipation of the release of new literary anthologies known as *sharadiya* (autumn annuals) published by the leading newspapers and magazines, and of new records of popular songs, both Rabindrasangit or Tagore's songs, and others characterized as "modern" (see Guha-Thakurta).

While the autumnal worship and festival of Durga is a pan-Indian observance, its distinctive carnivalesque character and the centrality of the goddess's presence among the Bengali Hindu communities cannot be denied. Durga's characterization in Sanskrit texts is as a warrior goddess indulging in blood and gore. In Bengali homes, however, she is welcomed every autumn as a beloved daughter coming for her brief annual visit with her children but without Shiva, the husband.[3] Her *barwari* worship, however, has become an excuse for levity, revelry, and collective catharsis.

In her essay, enhanced by her own photographs, the American scholar of Bengali culture Susan Bean has given us a meticulous narrative of the history of the Puja and the seasonal construction of the traditional unfired clay tableaus of Durga and her entourage, which she appositely characterizes as "vessels for the goddess". Tapati Guha-Thakurta, a daughter of Bengal and resident of Kolkata, on the other hand, speaks about the same clay "vessels" and their

1

(opposite)
Bhagavathi shrine in the Guruvayur Temple, Kerala.
Photograph: Pepita Seth.

elaborate temporary habitats but in their contemporary forms. Hers is a fascinating discussion of the transformation of the festival into a spectacle towards the end of the 20th century in a political environment dominated by Marxist philosophy. The only comparable architectural productions are the Hollywood extravaganzas of the famed director Cecil B. DeMille.

2

I left India in 1962 and returned home during Puja only on a couple of occasions. In the late '50s, however, I was once in Nepal where I witnessed the tradition of sacrificing 108 buffalo calves before the royal temple of Taleju in Kathmandu but was surprised that there was no custom of creating clay tableaus of Durga complete with her brood of four children as was the case with the Bengali

festival. Both the mode and significance of the worship of Durga in the Kathmandu Valley are quite different, as demonstrated in this volume by two articles, by Gautama Vajracharya and Anne Vergati. While Vergati provides an anthropological perspective in her analytical account of the festival of Dasai (as it is called in Nepal), Vajracharya offers new insights and interpretations of discretely Newari rituals and beliefs that reveal forgotten traditions in India.

Indeed, while the entire subcontinent was once the realm of Durga, as is clear from the

2
Durga Puja in the Pal home in Madhyamgram near Kolkata in the 1980s. Photograph: Pratapaditya Pal.

3
Bhadrakali, Mamallapuram, Tamil Nadu, 13th–14th century. Stone sculpture. Photograph: Pratapaditya Pal.

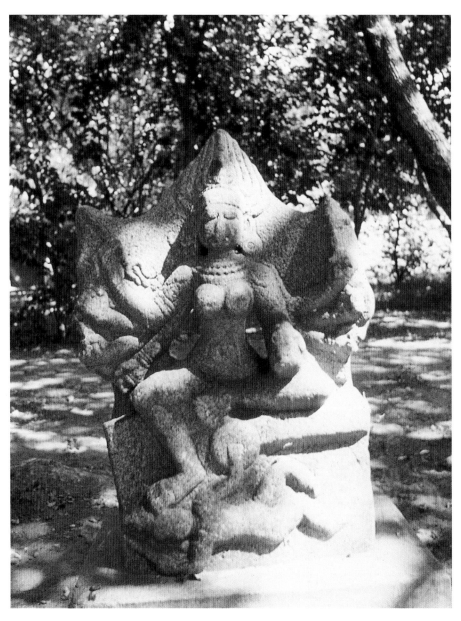

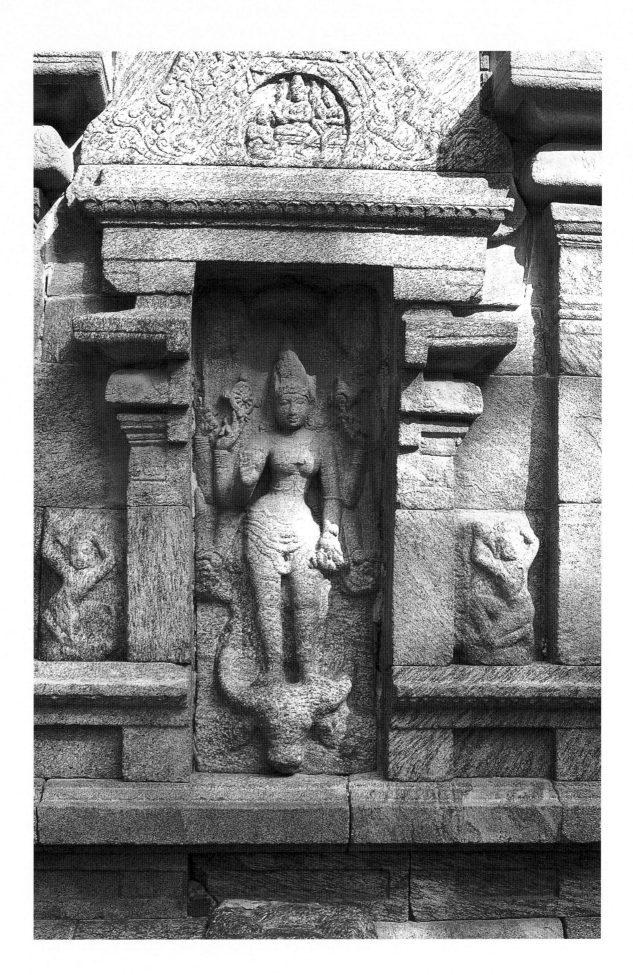

4
Durga, Nagaswami Temple,
Manampadi, Tamil Nadu,
9th century. Photograph:
Pratapaditya Pal.

concept of Shakta Pithas (and from the diverse articles in this volume), the forms and the rituals differ from region to region, reflecting the vast social, religious, cultural, and aesthetic diversity of the Hindu communities. Notwithstanding such differences, the volume begins with the unifying and overarching essay by the eminent Samkhya Yoga scholar Gerald Larson on the divine feminine in Indic spirituality. Apart from providing a brief outline of the cultural history of Devi, he presents a succinct analysis of the *Devimahatmya*, a 5th–6th-century text of fundamental importance for her worship, and offers a refreshingly novel discourse on the modes of apprehending or experiencing the divine feminine from an aesthetic perspective.

While Rajeshwari Ghose, a noted Indian art historian and a Tamil brahmin, recounts with personal experience the unique nature and meaning of the annual festival, known across the subcontinent as Navaratri (literally Nine Nights since it lasts for nine nights from the first to the tenth day of the lunar fortnight), in the Tamil Smarta context, Pepita Seth, a scholar/photographer of English origin who has long settled in India and for many years in Kerala, studying and photographing the region's temple life, tackles with remarkable brevity the complex and ancient Malayali tradition of Theyyam, probably a survival of an ancient empowering and transformative ritual associated with Shamanism. The focus of her article is the Muchilottu Bhagavathi, a generic expression for the goddess in the region.

In Tamil Nadu, unlike the Bengali tableau, Durga is often depicted alone and uncombative. Addressed as Bhadrakali or the auspicious Kali, she is shown either as a beautiful woman standing on the head of a buffalo (figure 4) or as a more militant figure destroying the titan while seated[4] (figure 3). In the first image type she invariably holds the wheel and the conchshell with her upper hands (she either has four or eight arms, while the Bengali Durga in clay images is always Dashabhuja or ten-armed). The Tamil image clearly emphasizes her close association with Vishnu or Narayana, as is the case in the

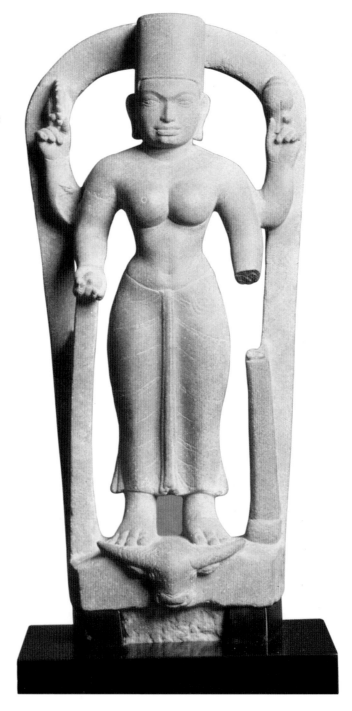

Devimahatmya, by far the most important religious text for the worship of Durga, its daily recitation being obligatory during Durga Puja. The most well known and beautiful eulogy in the text is known as *Narayanistuti*, or the exaltation of Narayani (the feminine of Narayana).[5] In the meditative invocation (*dhyana*) with which one always makes the offerings of flowers (*anjali*) she is as well addressed as Narayani in the expression *narayani namastute* (salutation to Narayani). It may be noted that in Southeast Asia too she always holds the wheel and the conch in her two upper hands, and in early Cambodia particularly her form closely resembles that of the Pallava images (figure 5).

3

Indian mythology associates Durga with two mountain ranges, the Himalayas stretched across the north like a crown and the Vindhyas in central India which form a girdle around the hip. While she is known as Vindhyavasini or the dweller of the Vindhyas, it is as the daughter of the Himalayas that she is most famous. One of her most popular names is Parvati, literally meaning one whose father is the mountain (*parvata*), in this instance, referring to the Himalayas. In the ancient world the mountain- or cave-dwelling goddess was a universal concept stretching from the Himalayas to Greece in the West. The classical goddess Cybele, or even the older Nana of West Asia, are the best known examples beyond India.[6] One of the finest examples of a representation of Cybele was found in Bactria, the ancient Indo-Greek kingdom in present-day Afghanistan whose political influence extended down to Punjab and Sindh (figure 6). Here we see the imperious goddess riding a chariot pulled by

a pair of lions atop a mountainous terrain. Not only does this splendid object have an early date, earlier than any lion-riding Durga discovered on the subcontinent, but only in Kashmir, which probably formed part of the Indo-Greek kingdom, do we encounter the form of a chariot-riding Durga, as I have discussed here in my article on Durga in Kashmir. The best known stone image to have survived from ancient Kashmir is the superb late-8th-century example at Dengapura[7] (figure 7). Together with the two essays on her cult in Nepal, the article on Kashmiri Durga provides interesting discourses on the cult of the goddess in her mountain abode.

It may not be inappropriate to mention here that Durga images have been found in a Buddhist context in Afghanistan, or ancient Gandhara, and in the distant Tibetan plateau beyond the Himalayas.[8] For that matter her enormous influence on all three Indic religions is also evident from the prevalence of her cult among the Jains of Rajasthan where she is worshipped as Sachiyamata or Sachika (figure 8). While Durga is not directly venerated by the Buddhists, except for the Gandhara example found in her shrine in a monastery, in later Vajrayana Buddhism she seems to have had a profound and pervasive influence, both conceptually and formally. For instance, Parnashavari, an important Vajrayana deity, is also the name of Durga. The name means literally Shavari (woman of the Shavara tribe) who is clad in *parna* (leaves); the bacchanalian rite associated with Durga is called *savarotsava* or the festival of the Shavaras. Among the protective Pancharaksha goddesses are such forms as Mahasahasrapramardani or Mahapratyangira whose relationship with Mahishasuramardini has been discussed at length by Dipak Bhattacharya; there is even

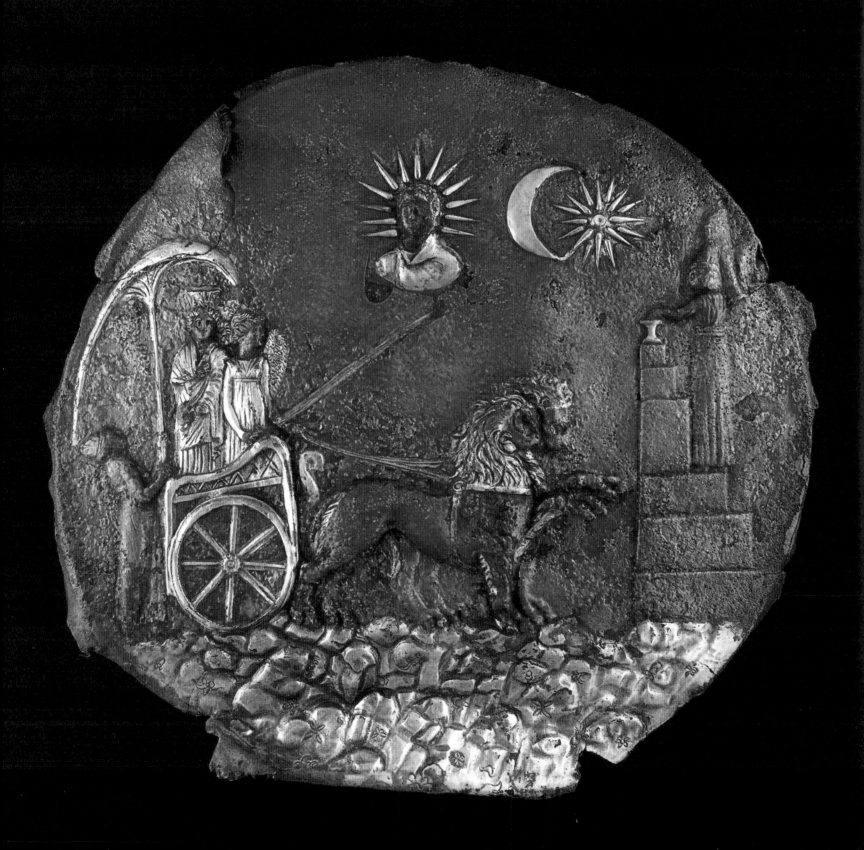

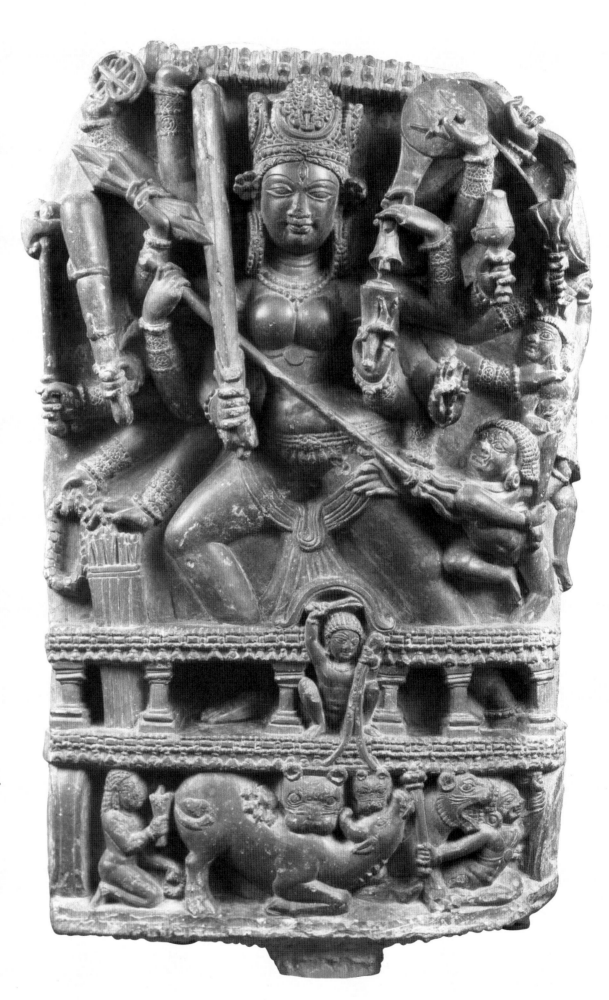

6

(opposite)
Bactrian plate depicting Cybele,
3rd century BCE. Gilded silver.
Reproduced from *Afghanistan:
Hidden Treasures from the
National Museum, Kabul.*

7

Durga Battling Mahishasura,
Kashmir, c. 800. Stone; 68.6
x 43.2 cm. Present location
unknown.

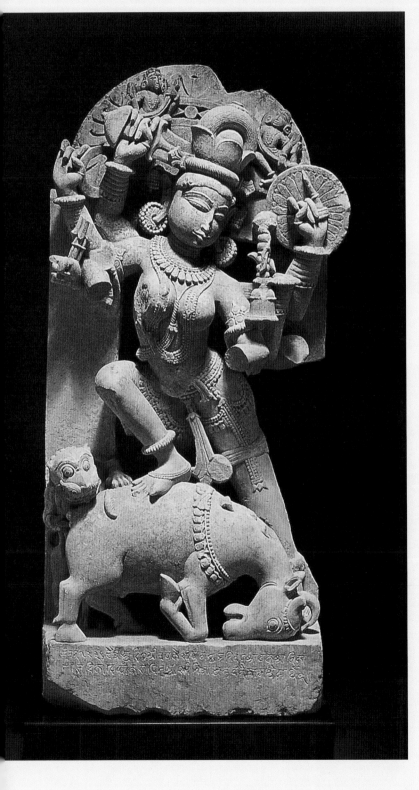

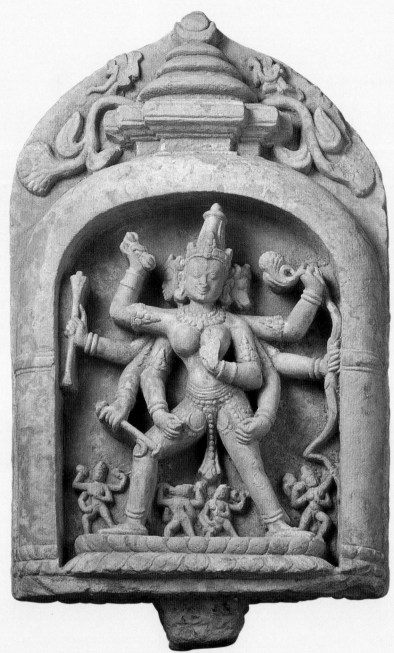

8
Durga as Sachika, Rajasthan,
1179 CE. Sandstone; 83.8 cm.
The Star Collection,
San Francisco.

9
(above)
Marichi, Bangladesh, 10th
century. Sandstone; 36.9 cm. Los
Angeles County Museum of Art,
Gift of Tom and Nancy Juda.
Photograph: Pratapaditya Pal.

a form of Tara known as Durgottarini Tara.[9] Tara is, of course, a synonym of Kali and both are conceptually related and are hierophanies of Durga. Incidentally, the name Durga is often explained as one who saves the devotee from all *durgati* or misfortune. Indeed, militancy, visually expressed by the *alidha* posture in their iconographic forms, as may be seen in an image of Marichi the Buddhist goddess of light (figure 9), is a characteristic that both Durga and many of the female deities of Vajrayana Buddhism share.

This kind of stridency and violence, however, are generally absent in the forms of deities – male or female – among the Jains, whose obsession with peace is legendary. Therefore, the adoption of Durga as Sachika or Sachiyamata is all the more surprising. The cult of Sachiyamata is confined to the Jodhpur region of Rajasthan and it is likely that she was an ancient and extremely powerful local goddess who appealed to the martial instinct of the Rajputs and was assimilated with Durga. Indeed, all Rajput princes worship their weapons on Vijaya Dashami (the Victorious Tenth day) of the festival, as I had the privilege to observe at the Jaipur court in 1976.

4

This tradition of identifying local goddesses with Durga/Bhadrakali or Chandi is pervasive all over the subcontinent, from Kashmir in the north to Kerala in the south and from the Arabian seacoast to Kamakhya in modern Asom (formerly Assam). In most of these shrines the goddess resides in a natural stone but is given specific Sanskrit names and mythologies. For instance, in the northwest she is known by such local names as Bhedadevi or Sharika in Kashmir,

as Mariamma or Meenakshi in the south, as Tulaja or Kamakhya in the east. The capital of both Punjab and Haryana states in India is known as Chandigarh or the fort of Chandi, a very popular epithet of the goddess in Bengal, where literally there are thousands of local shrines dedicated to Chandi (the terrible or angry one).[10] Among the Bengalis Chandi is a popular expression to describe any woman who is prone to anger. It should be noted that Chandika or Chandi occur in the *Devimahatmya*. As a matter of fact, in both Bengal and Odisha (Orissa), the recitational or assembly hall (*mandapa*) attached to a shrine is often referred to as the *chandimandapa*. One wonders if this had any influence on the application of the word in Java to generally designate a shrine, as in Chandi Borobudur.

In the south the word Bhagavathi has the same general denotation and is commonly applied to the goddess's shrine. How pervasive her presence is in the south is evident from the fact that ensconced in the famous temple of Guruvayurappan, a form of Vishnu, is a shrine of Bhagavathi (figure 1). As Pepita Seth has written in her recent study of this popular temple,

> The Malayali's unquenchable devotion to the Goddess has enabled Her to maintain Her position in Guruvayur, keeping the aura of Her presence running through the temple like a thread, the string on which Guruvayurappan's pearls are strung. Though She now faces west, towards Guruvayurappan, Her name, the Edathariyathukavil Bhagavathi – the Goddess who "moved to the left" – reminds everyone that She gave Her original sanctum to the Lord....

No one knows how Guruvayurappan's idol actually came to be installed or how smooth the changing of the deities really was, but one fact is obvious: before Guruvayurappan became the lord of Guruvayur, a Goddess was enshrined in what is now His temple. As has been repeatedly stated, no evidence exists that might offer up any clues about Her original shrine. All we know is that the area was then sparsely inhabited, surrounded by water and full of trees. Yet, though this is in sharp contrast with today's temple, due to the devotion She continues to command, it is not difficult to imagine the men and women who first sought Her blessings.[11]

This is of course not an isolated instance but time and again, from prehistoric times, as discussed brilliantly many years ago by D.D. Kosambi, ancient shrines have been usurped and revalorized to serve new divinities.[12] Prehistoric archaeology has yielded plenty of material evidence to conclude that among the inhabitants of the subcontinent popular piety was directed to goddesses rather than gods (figure 10). Subsequently, as is clear from Vedic literature (2nd millennium BCE), patriarchal ideas began dominating the religious landscape and the male deities came to predominate. Very likely in reaction to this kind of usurpation, tantric theologians emphasized the concept of Shakti and some speculated that the Purusha was only a passive observer, while Prakriti was the active agent, as in the Samkhya system of Indic philosophy, attributed to the sage Kapila.[13] It is noteworthy that the development of the concept and iconography of Durga as the destroyer of the Buffalo titan coincides with that of the Classical Samkhya beginning in the 1st century of the Common Era, and the composition of the *Devimahatmya* with that of the *Samkhya-karika* of Isvarakrishna, which was translated into Chinese between 557 and 569 CE. The *Devimahatmya* is replete with Samkhya ideas and terminologies. In a highly eulogistic passage in the first chapter Brahma exclaims: "You are the primordial cause of everything (Prakriti) bringing into force the three qualities (*gunatraya*)."[14] Elsewhere (chapter 4, verse 7), she is extolled unambiguously with Samkhya overtones:

> You are the origin of all the worlds.
> Though you are possessed of the
> three gunas, you are not known to
> have any of their attendant defects
> (like passion).... You are verily
> the supreme primordial Prakriti
> untransformed.[15]

5

The verse quoted as the epigraph to this Introduction makes it clear that the

10
Bevy of Beauties, Pakistan, Mehergarh, Quetta Culture, c. 2500 BCE. Terracotta. Private collection. Photograph: Pratapaditya Pal.

Devimahatmya was composed not merely as a eulogy of a particular goddess but of a super deity with unambiguous cosmic import. It was also one of the earliest attempts to universalize her concept by assimilating diverse local and regional goddesses into one mega divinity. This is evident from the different myths of her encounters with different *asura*s or titans, among which the duel with Mahishasura gained pre-eminence and became the most popular with theologians and artists; the other was Chamunda/Kali. Moreover, in the 11th chapter (verses 40–53) the process of assimilation is clearly indicated in the explanations she herself offers for her various epithets such as Raktadanta (Red-toothed), Shatakshi (Hundred-eyed), Shakambhari (filled with vegetables), Durgadevi (slayer of the titan Durgama – third such explanation for the name Durga in the text).

The regional significance of these names is explicitly stated when she declares that she will assume a wrathful form in the Himalayas to destroy the monsters and protect the sages and will become famous as Bhimadevi.[16] Bhimadevi was one of the most famous Devi shrines in the northwest and was noted by the 7th-century Chinese pilgrim Xuanzang. A shrine of Bhimadevi also existed in the vale of Kashmir a mile and a half on the Dal Lake beyond Thid or Theda of Kalhana (12th century).[17] It may also be emphasized that the *Nilamatapurana* identifies several local goddesses and rivers with Durga (see Pal, Durga in Kashmir). A classic instance of assimilation is mentioned by Stein, the translator of Kalhana's *Rajatarangini*, when he writes about Sureshvari, another ancient shrine of the goddess in the Valley. "It was sacred to Durga-Sureśvari, who is still worshipped on a high crag rising from the mountain range

of the east of Iśābār village. The seat of the goddess is on a rugged rock, some 3,000 feet above the village, offering no possible room for any building."[18]

Not only does this demonstrate the numinous nature of the original shrines of the goddess, but the example of Sureshvari is also a microscopic episode in the much larger macrocosmic myth of Sati and the creation of the concept of Shakta Pithas or seats of Shakti or Energy that spread from Baluchistan in the north to Kerala in the south and from the western seas to Asom. Quintessentially, the myth was woven as a net to pull together the disparate and myriad shrines of the goddess spread across the subcontinent and to revalorize them during the rise of Tantrism, which itself is an accommodative religious system to the glory of the divine feminine.

The myth is simple. Sati was the first wife of Shiva and was the daughter of Daksha Prajapati, the bastion of orthodox Brahmanism. Since Shiva's origins were dubious, he was excluded by Daksha during a sacrifice. Sati was so insulted by this slight of her husband by her father that she took her own life. A distraught Shiva not only ravaged the sacrificial ceremony, but with his wife's corpse began roaming the world like a madman, as we see in a beautiful and rare Pahari painting (figure 11). Predictably Vishnu comes to the rescue and chops up Sati's body and scatters the pieces all over the subcontinent. The conventional number of pieces is said to be 51 and a shrine springs up at each site. Known as *pitha* or seat of the goddess, these 51 shrines are particularly revered by devotees, but the expression is applied loosely to countless shrines of the deity, such as the famous Tarapitha in West Bengal. The *pitha* concept is also significant

in yogic praxis and is shared by all three religions, though the Buddhists were more ardent in adopting the idea than the Jains.[19]

Because the subject of *pitha*s, both as power spots for yogis as well as pilgrimage centres for lay devotees, has generally been neglected in anthologies and books about the goddess, we have included two essays here. The longer of the two (Pal) explains the significance of the number 51 which clearly relates to the Sanskrit syllabary and the *nyasa* rite or the process whereby the worshipper's body is symbolically purified to become the suitable residence of the deity and hence to gain immortality. Significantly the Sanskrit expression for the alphabet is *akshara* (that which does not decay) which forms the basic building blocks of speech and hence knowledge. As is well known the goddess is the very personification of knowledge, Vac or Vak.

In the second essay Ibrahim Shah, a Pakistani scholar, has given us a firsthand description with fresh and previously unpublished photographs of his travels to the relatively obscure *pitha* of the goddess in Baluchistan known as Hinglaj. Its situation deep in the desert and the extremely difficult journey have contributed to its mystique and mystery for ages, and hence it is less well known than the more familiar power spots. Hinglaj is one of the oldest Shakta Pithas in the subcontinent whose presiding deity is known as both Hinglajmata (the mother of Hinglaj), and Nana. The latter was already famous across Asia for millennia after she was adopted by the imperial Kushan dynasty as their tutelary deity (Pal, Durga in Kashmir). She is also known as Nanibibi to Muslims. Though the shrine is in Baluchistan today, the pilgrimage begins in Karachi as Hinglaj was also the *pitha* of Sindhi Hindus.

Thus, while the concept of Nana/Durga can be traced back to at least the Kushan period, if not earlier, that of Vac or Vak is as old as the Vedas. Both spatially and temporally the sacred realm and history of Goddess Durga are not only truly ancient, but the tenacity of the tradition down to the present makes her by far the oldest and most resilient spiritual force in the history of mankind. While she may have lost some ground in parts of the subcontinent where Islamic states have been formed in the latter half of the 20th century and is no longer as popular as she once was in Southeast Asia, her realm is expanding west to Europe and North America, wherever there is a diasporic Hindu community. In three of her South Asian strongholds – West Bengal, Kerala, and more recently Nepal – communism has come to prevail but has not succeeded in diminishing the ardour of her devotees' devotion.

A final benediction in the words of the *Saundaryalahari* (The Waves of Beauty) attributed to the philosopher Adi Shankaracharya (c. 8th century):

11
Disconsolate Shiva Carrying Sati's Body on His Trident, Himachal Pradesh, c. 1800. Opaque watercolour and gold on paper; 29.21 x 40.64 cm. Los Angeles County Museum of Art, 79.1, Purchased with funds provided by Dorothy and Richard Sherwood, Mr Carl Holmes, William Randolph Hearst Collection, and Mr Rexford Stead. Photograph © 2009 Museum Associates/ LACMA.

Unless Shiva is united with Shakti he
cannot create.

Without this energy he cannot even
stir.

How can I without any merit praise
and salute,

One who is venerated by Brahma,
Vishnu, and Shiva?[20]

NOTES

1 Swami Jagadiswarananda, *Devi Māhātmya* (Sri
Ramakrishna Math, Madras 1953), p. 145, ch. 22,
v. 38. For the text, translation, and interpretations of
Devimāhātmya see Thomas B. Coburn, *Encountering
the Goddess: A Translation of the* Devi-Mahatmya *and
a Study of its Interpretation* (State University of New
York Press, 1991). For other discursive studies see
Phyllis Granoff, "Mahiṣāsuramardini: An Analysis of the
Myths", in *East and West* (n. s.) 29, 1979, pp. 139–
51; Shingo Einoo, "The Autumn Goddess Festival:
Described in the Purāṇas", in Masakazu Tanaka and
Musashi Tachikawa, eds., *Living with Śakti*, Senri
Ethnologica Studies no. 50, National Museum of
Ethnology, Osaka 1999; and Yuko Yokochi, "The
Warrior Goddess in the *Devimāhātmya*", in Tanaka
and Tachikawa, pp. 71–113. Perhaps unmatched for
its erudition and analytical brilliance is Sashibhushan
Dasgupta, *Bhārater Sakti-sādhanā o śakta sāhitya* (The
Sakti Worship and Sakta Literature of India), (Calcutta:
Sahitya Samsad B.S. 1367 [1960 CE]).
2 R.C. Hazra, *Studies in the Purana Records on Hindu
Rites and Customs*, Dacca 1942, 2nd edn. (Motilal
Banarsidass, Delhi 1975), Vol. 2, pp. 92–93. See also
Pratapaditya Pal, *Durga: Avenging Goddess, Nurturing
Mother* (Norton Simon Museum, Pasadena 2005).
3 Jawhar Sircar, "The Domestication of the
Warrior Goddess, Durga: An Attempted 'Rationalist'
Deconstruction", in Jashodhara Bagchi, ed., *Women's
Education and Politics of Gender* (Bethune College,
Kolkata 2004).
4 It should be added that in Pallava art she is
sometimes portrayed as a multi-armed woman standing
triumphantly holding a bow over her contorted lion,
or, as in the well known tableau in Mamallapuram,
engaged in a vigorous battle with the colossal buffalo-
headed titan. This may well be the most dynamic and
dramatic battle scene in all of ancient Indian plastic art.
5 The famous *Nārāyaṇistūti* occurs in ch. 11, vv.
8–23.
6 For the concept and other representations of
Cybele in classical art see Maarten J. Vermaseren, *Cybele
and Atis: The Myth and the Cult* (Thames and Hudson,
London 1977), and for Nana, B.N. Mukherjee, *Nana

on Lion (The Asiatic Society, Calcutta 1969).
7 Unfortunately the temple at Dengapura was
abandoned in the mid-1990s with the exodus of the
Hindu Pandit community from Kashmir and the image
too disappeared. Its present whereabouts are unknown.
8 For the remnants of the Devi shrine in the
Buddhist monastery in Afghanistan, see Maurizio
Taddei, "The Mahisamardini Image from Tapa Sardar,
Ghazni, Afghanistan", in Norman Hammond, ed.,
South Asian Archaeology (Noyes Press, Park Ridge, NJ
1973), pp. 203–13. For metal images of Durga in
the Potala Collection in Lhasa: Ulrich von Schroeder,
Buddhist Sculptures in Tibet, Vol. 1, India and Nepal
(Visual Dharma Publications, Hong Kong, 2001), Vol.
I, Pls. 64A–C. Both images are made of brass and may
have been made in Himachal Pradesh. Both reflect
a mixture of Kashmiri and Pratihara influences. The
face and hair of both are painted in typically Tibetan
manner, the face in cold gold and the hair in orange,
which classifies her as an angry goddess.
9 See D.C. Bhattacharya, *Studies in Buddhist
Iconography* (Manohar, Delhi 1978), pp. 13–18, 26, 71–
77, and Benoytosh Bhattacharya, *The Indian Buddhist
Iconography*, 2nd edn. (Firma K.L. Mukhopadhyay,
Calcutta 1958), p. 307.
10 Sibendu Manna, *Bānglār Lokamātā Devi Chaṇḍī*
(Bengal's Folk Mother Goddess Chandi), (Navadvip
Puratattva Parishad, Navadvip, WB 2007). See also
Dasgupta, pp. 50–62.
11 Pepita Seth, *Heaven on Earth* (Niyogi Books, New
Delhi 2009), pp. 206–07.
12 D.D. Kosambi, *Myth and Reality: Studies in the
Formation of Indian Culture* (Popular Prakashan, Bombay
1962). Particularly relevant is Kosambi's brilliant
interpretation of the connection between the cult of
Mhasoba in Maharashtra and Mahishasura, which seems
to have escaped most writers on the subject.
13 For an overview of the history and essence of
Samkhya philosophy, see Gerald J. Larson, *Classical
Samkhya*, 2nd edn. (Motilal Banarsidass, Delhi 2001).
14 Swami Jagadiswarananda, p. 18, *prakritistavam cha
sarvasya gunatrayavibhāvin*.
15 Ibid., p. 54.
16 *Devimāhātmya* 11, 50–53. Does the specific
mention and location of this shrine indicate that
the text, or at least this passage, was composed by a
brahmin from the northwest, perhaps Kashmir?
17 M.A. Stein, *Kalhana's Rājataranginī*, 2 vols., reprint
(Motilal Banarsidass, Delhi 1979), Vol. 2, p. 454.
18 Ibid., Vol. 2, p. 455.
19 While much has been written about the *pitha*
concept in Hindu literature and context, very little has
been done with extensive references to the *pitha*s in
Buddhist literature.
20 Sri Sankaracharya, *Saundaryalaharī* (Harvard
University Press, Cambridge, Mass. 1958).

The Defeat of the Gods and the Victory of the Goddess
The Divine Feminine in Indic Spirituality

Gerald James Larson

INTRODUCTION

Let me begin by attempting to evoke a certain sensibility for my presentation: first, with a bit of humour; then, with two more serious comments. A man said to his wife one day, "I don't know how you can be so stupid and so beautiful all at the same time." The wife responded, "Allow me to explain it to you, darling. God made me beautiful so you would be attracted to me; God made me stupid so I would be attracted to you."

In a more serious vein, an unnamed woman is quoted as follows:

You can tell the story of your life to men, and they're interested or amused, but sooner or later they try to fit you into their preconceived ideas.... Well, that's not for me anymore. Sometimes I get frightened at the thought that I'm retreating, closing myself off, trying to live life alone as a woman, and I know I can't make it that way, but it's a temptation.... It's not that I don't need men, I do, but I've never met a woman who behaved as badly towards men as men behave towards women every day, without even noticing it or caring much...until men have learned to be open, to stop trying to control situations as if control were all that mattered, we'll always be divided and have to live like strangers.[1]

The French feminist thinker, Luce Irigaray, has commented that women are often relegated to oblivion.[2] They have simply been forgotten, and, in some cases, not even allowed to exist. In this regard, I have often pondered the startling demographic statistic that in India there are 930 women for every 1,000 men. Gender differentiation is approximately equal over time, so this ratio is rather striking. When put in terms of the total population of contemporary India with just over a billion people, the statistic means that some 70 million women have simply disappeared. It is not that they have been forgotten. It is, rather, that they have never been allowed to exist. Luce Irigaray argues that women must demand to be remembered and taken seriously, indeed, that they have a unique subjectivity profoundly different from men. Says Irigaray:

Sexual difference means that man and woman do not belong to one and the same subjectivity, that subjectivity itself is neither neutral nor universal.... Between man and woman a strangeness must subsist which corresponds to the fact that they dwell in different worlds.

We have to discover a new way of differing as human by entering into communication as two different subjectivities. This necessitates that man [gives up an exclusively male path] and that woman works out her own differentiation...from being only a mother or a lover for man, from becoming like man. Such a differentiation on the part of woman herself is the most important step towards achieving a new stage in our becoming human.[3]

Irigaray comments further in her book, *An Ethics of Sexual Difference*, "Sexual difference is one of the major philosophical issues, if not the issue, of our age. According to Heidegger, each age has one issue to think through, and one only. Sexual difference is probably the issue in our time which could be our 'salvation' if we thought it through."[4]

As I looked over the visual evidence in India, it occurred to me that a careful and critical appreciation of the divine feminine in the religious sensibility of South Asia could possibly become one interesting starting-point for addressing this issue of sexual differentiation. As Feuerbach suggested long ago, religious belief-systems or, if you will, theology, is often a reflection of anthropology. In other words, we project on to the sacred our own self-understanding. Hence, the divine feminine in South Asia, I am inclined to argue, may well prove to be an important chapter in human self-understanding.

In order to develop my argument, my presentation will have two parts. In Part I, I offer a brief excursus into the cultural history of the goddess in South Asia, since it has not always been the case that goddess cults have been salient in the religious traditions of South Asia. Then, in Part II, I discuss what I would like to call three sensibilities regarding our apprehension or experience of the divine feminine in South Asia.

I. A BRIEF EXCURSUS INTO THE CULTURAL HISTORY OF THE GODDESS IN SOUTH ASIA

No other major world civilization has maintained continuous traditions of the divine feminine as has the culture and civilization of South Asia. Athena, Aphrodite, Persephone, Demeter, Ishtar, Isis, and hosts of other feminine portrayals of the sacred have long passed into

1
(opposite)
Yakshi/Tree Goddess and an Amorous Couple, from a railing pillar, Bharhut, Madhya Pradesh, c. 100 BCE. Sandstone; 147.3 cm. The Norton Simon Foundation, Pasadena, F.1972.11.1.S.

oblivion, apart from museums, archives, or the scholar's study. Only in India and South Asia have traditions of the Great Goddess and/or the medley of goddess cults been maintained up through the present time as living historical traditions. As mentioned earlier this has not always been the case. The notion of the divine feminine initially was at best a minor tradition. In the sacred literature and ritual of the Indo-Aryan Brahmanical tradition (as set forth in the Vedas, from the 2nd millennium of the Common Era), there are occasional references to various goddesses (Indrani, Sarasvati, and so forth). There are also references to an inherent power (*shakti*) of the gods – which is somehow distinct from their masculine identity. (The very term "shakti" derives from the term "Shaci", one of the names of Indra's wife.) Also there are various feminine substantives, including Vac ("Speech"), Ratri ("Night"), Aditi ("Non-restraint"), Ushas ("Dawn"), and Prithivi ("Earth"), and so forth, but it is difficult to know if such forms played an important role beyond that of being feminine nouns. Some of these may have been goddesses, but we don't really know. Generally speaking, the notion of a goddess or the motif of the feminine as sacred is not an especially important component. The situation is similar in the early Buddhist and Jain traditions of the 6th through the 3rd centuries BCE. To be sure, there probably were local village traditions or folk traditions which stressed fertility rituals and which centred on the worship of local deities (*grama-devata*s) and vegetation figures such as the "tree-spirits" (*yakshi*s, figure 1).

Such local traditions may well have pre-dated the Indo-Aryan Brahmanical tradition and may go back even before the older Indus Civilization of the 3rd and 2nd millennia BCE. There may well have been archaic matriarchal goddess traditions in South Asia analogous with the Stone Age "Venuses" of the Mediterranean and ancient West Asian region that stretch back to time immemorial. In any case, however, in the early Brahmanical, Buddhist, and Jain traditions of the 1st millennium BCE, these older and parochial traditions of fertility religion, though undoubtedly present, exercised little influence either on the level of religious ideas or religious practice among the elites, or on mainstream traditions.

The situation begins to change with the rise into prominence of theistic and devotional (*bhakti*) spirituality, however, in the epic literature (the *Mahabharata* and the *Ramayana*, from the 3rd century BCE into the early centuries CE). Also, there are the more popular mythological texts, the numerous *purana*s, from the 3rd century CE onwards, and the famous "Song of the Lord" or *Bhagavadgita,* a beloved devotional text in the *Mahabharata*. To some extent these popular texts reflect a reaction against the elitist spirituality and excessive asceticism of the older periods. To some extent they reflect the emergence of towns, a rising merchant class, a money economy, and a more sophisticated technology. And to some extent they represent an attempt to assimilate and synthesize a variety of local devotional traditions into the developing mainstream or "Great Tradition" of what we now conventionally call South Asian spirituality. In these popular religious texts one begins to read about the consorts of the major Hindu gods, namely, Shri or Lakshmi (the consort of Vishnu); Uma, Parvati, or Devi (the consort of Shiva); and the female

companions of the various manifestations or "incarnations" (avatars) of Vishnu. There are the milkmaids (*gopis*) and, somewhat later, the cult of Radha, around Krishna, and the obedient Sita, the wife of Rama. The goddess or female companion in art and mythology is symbolically portrayed as the creative energy (*shakti*) of her consort. She is also the nurturing mother, the passionate wife, the preserver of the holy family, and the mediator between god and his devotees. She is at one and the same time passively submitting to the god and yet also seducing or enticing him away from his extreme austerities (especially in the mythology of Shiva and Parvati).

But it is primarily in a text entitled "The Majesty of the Goddess" (*Devimahatmya*), deriving approximately from about the 5th–6th century CE and included as a portion of a larger Sanskrit work, the *Markandeyapurana*, that the goddess emerges in her own right. She emerges not only as the divine feminine but as a figure more powerful than the gods themselves – or, to refer to the title of my presentation, the text wherein one finds "The Defeat of the Gods and the Victory of the Goddess". The *Devimahatmya* is a kind of locus classicus for the symbolism of the Great Goddess in Indic culture. The Sanskrit text is widely known and used not only among

2
Recumbent Narayana with Brahma Threatened by Madhu and Kaitabha, from a *Devimahatmya* series, Pahari painting, Guler, c. 1810. Pigments on paper. Private collection.

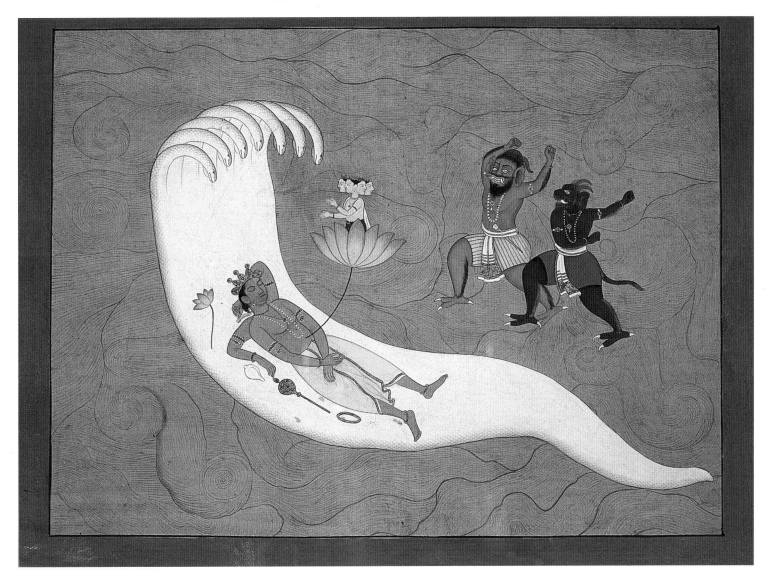

Shakta groups (namely, those devotional groups who worship Devi as the most exalted manifestation of the divine or the ultimate) but among Vaishnavas, Shaivas, and other devotional groups as well. The text sets forth three episodes of the emergence of the goddess, each episode sequentially inflating her nature and importance.

(1) In the first episode, the goddess is the sleep-state of Vishnu (*yoga-nidra*) while he sleeps in the cosmic ocean before the world appears (figure 2). Two demons, Madhu and Kaitabha, emerging from Vishnu's ear-wax, threaten to destroy the cosmos, but Brahma implores the goddess to come forth so that Vishnu might be awakened. She emerges from Vishnu's eyes, mouth, nose, arms, heart, and chest. The emergence of the goddess from Vishnu coincides with Vishnu's awakening from his deep sleep, or perhaps better, her emergence *is* Vishnu's awakening! In other words, Vishnu is now able to enter into combat against Madhu and Kaitabha and to destroy them.

(2) In the second episode, the male gods are all vanquished by the demonic *asura*s and their vicious leader, Mahishasura, the buffalo-demon. Vishnu and Shiva become enraged (figure 3), and a fierce rage pours forth from their bodies and from the bodies of the other male gods. The fierce rage is really the inherent powerful "effulgence" (*tejas*) of the gods, and

3
Devi in Combat with Mahishasura, from the same *Devimahatmya* series as figure 2.

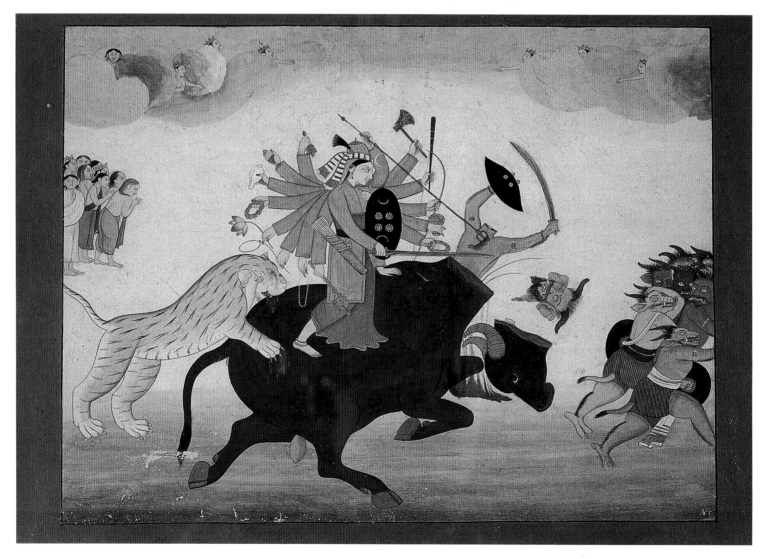

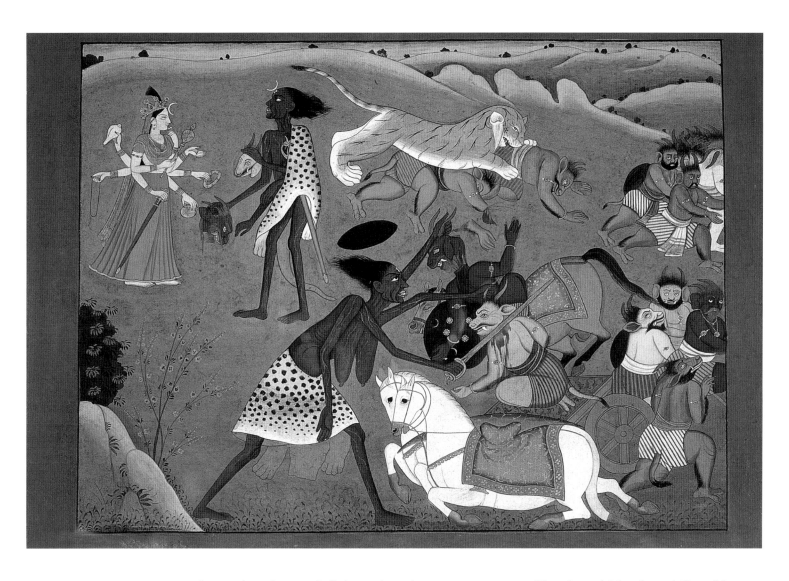

4

Durga Empowering Kali/
Chamunda, from the same
Devimahatmya series as figure 2.

the combined *tejas* of all the gods coalesces into a "peak of excessive effulgence" (*ativa tejasah kutah*) taking the form of a woman (*nari*) that pervades the entire world (*lokatraya*). This woman is Durga or Chandika (the "terrible"); her mount is a lion; and her voice a terrible roar (*ghora-nada*). She becomes intoxicated with power and flushed red in anger, and finally crushes the neck of Mahisha, the *asura*, under her foot. Hence, her name: "the slayer of the buffalo-demon" (Mahishasura-mardini).

(**3**) In many ways, however, **it is the third episode** in the *Devimahatmya* that represents the apotheosis of the Great Goddess (figure 4). In this narrative, the male gods are vanquished once again by the demonic asuras, Chanda and Munda and Shumbha and Nishumbha. This time, however, instead of emerging from within the male gods, Devi or Durga emerges instead from the skin (the *kosha*) of Parvati, the goddess of the mountain and the consort of Shiva, hence, the epithet "Kaushiki" or "coming from the skin or *kosha* of Parvati, the mountain goddess". Moreover, it is in this third episode that when the battle against the powerful *asura*s becomes especially vicious, Durga or Devi generates in her rage the powerful goddess, Kali, from her forehead. Kali with her lolling tongue of dripping blood, necklace of severed heads, and girdle of cut-off hands is able, with Durga, finally, to conquer the evil ones.

In the great battle, the demons proliferate inasmuch as each drop of blood from the demon, Raktabija, generates yet another demon. Kali, however, licks up all the drops. The *Devimahatmya* clearly represents a conflation of numerous older local traditions of village goddesses but, much more than that, it also probably reflects the emergence of the Great Goddess into the mainstream of the "Great Tradition" of Indian-Asian spirituality. Somewhat later, around the 10th or 11th century, two additional texts also become prominent, the *Devibhagavatapurana* and the lovely Shakta poem, the *Saundaryalahari* (the "Waves of Beauty"). Thereafter the Great Goddess becomes a dominant force in the spiritual life of South Asia, and in Hindu, Buddhist, and Jain traditions (but especially in Shakta and Tantric environments). The Great Goddess as consort, cosmic energy, primordial mother, and world-destroyer enjoys a secure and important place in Indian Asian culture and spirituality, a place that continues to be important even in modern South Asia.

II. THREE SENSIBILITIES IN APPREHENDING OR EXPERIENCING THE DIVINE FEMININE

Much more could, and perhaps should, be said regarding the complex cultural history of the Great Goddess, but let me move now, instead, to a more interpretive level of discourse. What intrigues me about the visual evidence is the manner in which we apprehend or experience the divine feminine. Quite apart from the history of the goddess in this or that historical period, or this or that region in India, I find myself wanting to understand what might be called the experiential payoff of the divine feminine.

Put somewhat differently, why should I be interested in the Great Goddess? What can I learn about the Great Goddess from artistic expressions of the divine feminine? In this regard, as I mentioned at the outset, I find myself intrigued by at least three sensibilities or, if you will, three distinct ways of apprehending or experiencing what is happening in art. First, I am fascinated by the **religious sensibility**; second, I am fascinated by the **aesthetic sensibility**; and third, I am fascinated by the **gender sensibility**. Let me say something about each of these.

(1) The Religious Sensibility

Jewish and Islamic religious sensibilities have simply repressed the importance of the divine feminine for human self-understanding of the sacred, and Christian sensibility has only permitted a limited role for the sacrality of womanhood in the traditions of the Blessed Virgin Mary as Mother of the Church. Only in South Asia, in Hindu and to a lesser extent in Buddhist and Jain traditions, has the divine feminine been salient in the long sufferings of Sita, the sexual longings of Radha, the courage and audacity of Durga, the bloodthirsty impulsiveness of Kali, the rich blessings of Lakshmi, or the quiet dignity of Prajnaparamita, the goddess of the Perfection of Wisdom. Indeed, in the ancient Indic philosophies of Samkhya and Yoga, the entire realm of material existence, the fullness of our embodiment as living beings in the massive expanse of the universe in which we find ourselves, is referred to with the feminine noun, Prakriti, "primordial materiality", or, the divine feminine! Primordial materiality or Prakriti becomes the prototype for the Great

5
Maha Kalee, Great Kali (interior
view of Kalighat Temple), by
B.D. Grant, 1852. Colours on
paper; 36.2 x 28.1 cm.
Pal Family Collection.

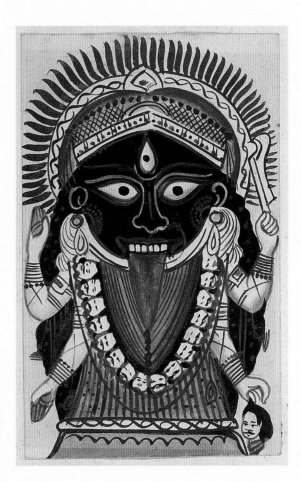

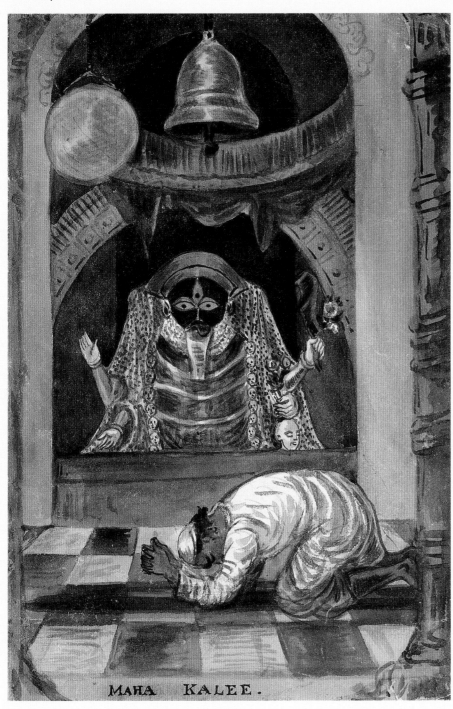

MAHA KALEE.

6
Kali, from a group of ten
known as Mahavidya, Calcutta,
late 19th century. Colours on
paper; 14 x 8.9 cm. Pal Family
Collection.

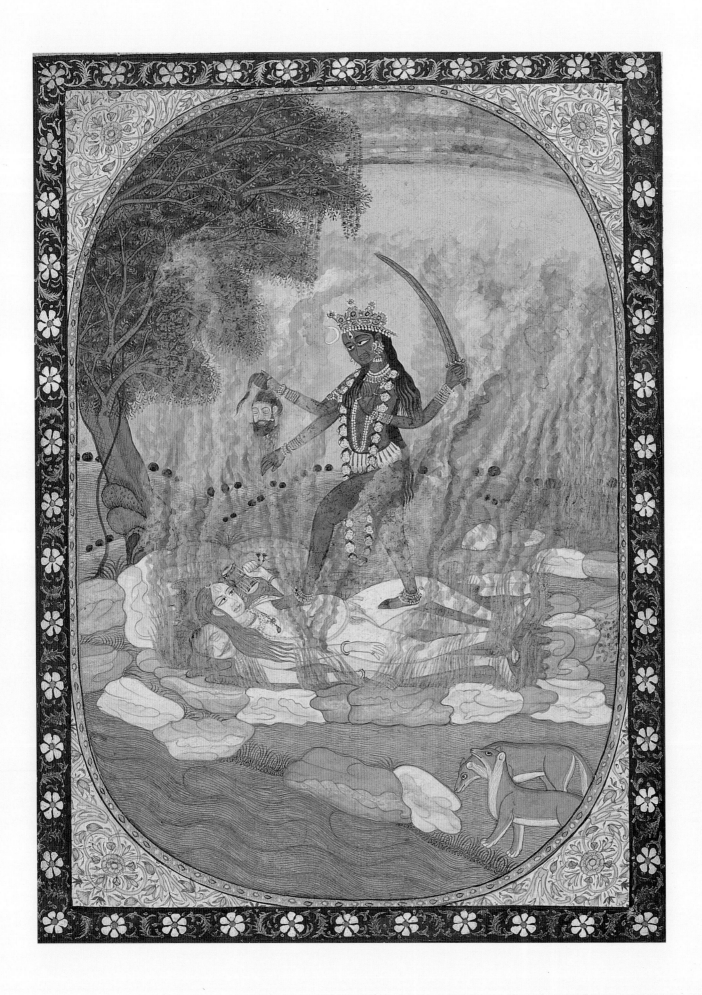

7

(opposite)
Kali, Pahari painting, Kangra,
Himachal Pradesh, c. 1800.
Opaque watercolour on paper;
27 x 21.3 cm. Norton Simon
Museum, Pasadena, Gift of
Ramesh and Urmil Kapoor,
P.2004.07.1.

8

Kali, Calcutta, 1883. Colour
lithograph; 30.5 x 24.1 cm.
Published by Calcutta Art
Studio Co. Pal Family
Collection.

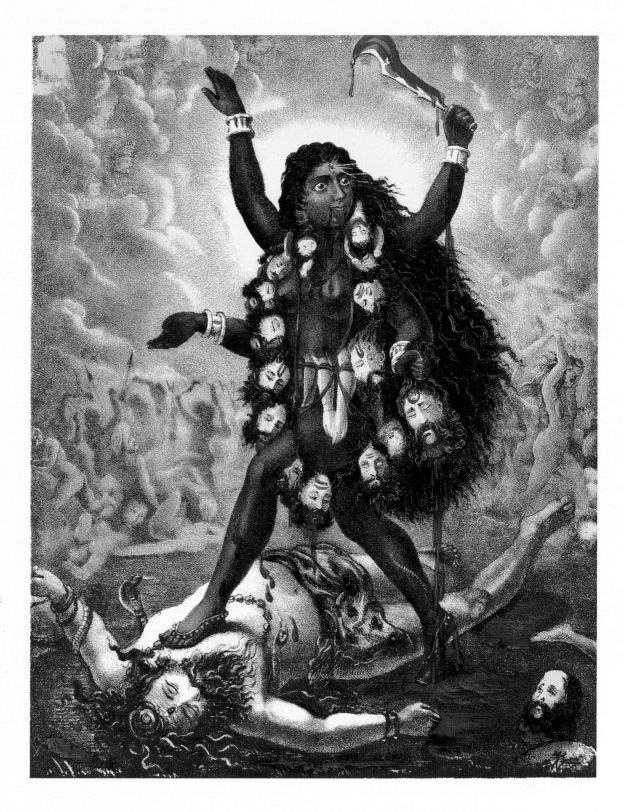

Goddess (Mahadevi) as Durga or Ambika. The Great Goddess or Mahadevi encompasses the realm of wisdom and thought as the constituent process of *sattva*, the translucent splendour of truth itself, or Mahasarasvati. She encompasses the realm of energy and action as the constituent process of *rajas*, the brilliant red of passion, or Mahalakshmi. And she encompasses the realm of gross matter as the constituent process of *tamas*, the black or dark-blue of finite, earthly embodiment, or Mahakali. The Great Goddess is material existence and our material embodiment. Hence, She is the loving mother from whom we all come forth. She sustains us in moments of crisis and anxiety. Most of all, She helps us to understand that as embodied beings we will one day die. Durga and Kali in

Indic religious sensibility, it seems to me, are the Great Goddesses of what Victor Turner called the "liminal" times in existence, those dangerous boundary situations when everyday conventional life becomes problematic. Whether it be the pain and uncertainty of the birth-process itself, or disturbing moments of anxiety and/or violent conflict, or the deeply threatening passage from life to death, millions of devout believers go for refuge to Durga and Kali.

(2) The Aesthetic Sensibility

Aesthetic sensibility (*rasasvada*) in South Asian thought is close to religious sensibility (*brahmasvada*), but they are not identical. In Indic thought, the aesthetic has to do primarily with "tasting" or "relishing" (*rasa*),

9
Shiva, Vishnu, and Brahma Adoring Kali, Pahari painting, Basohli, Himachal Pradesh, c. 1740. Opaque watercolour, gold, silver, and ink on paper; 19.7 x 29.2 cm. Los Angeles County Museum of Art, Purchased with funds provided by Dorothy and Richard Sherwood and Indian Art Special Purpose Fund, M.80.101. Photograph © 2005 Museum Associates/LACMA.

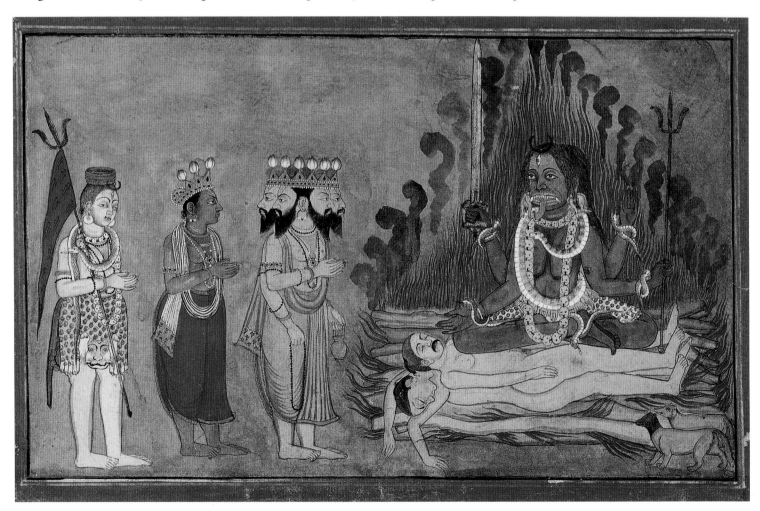

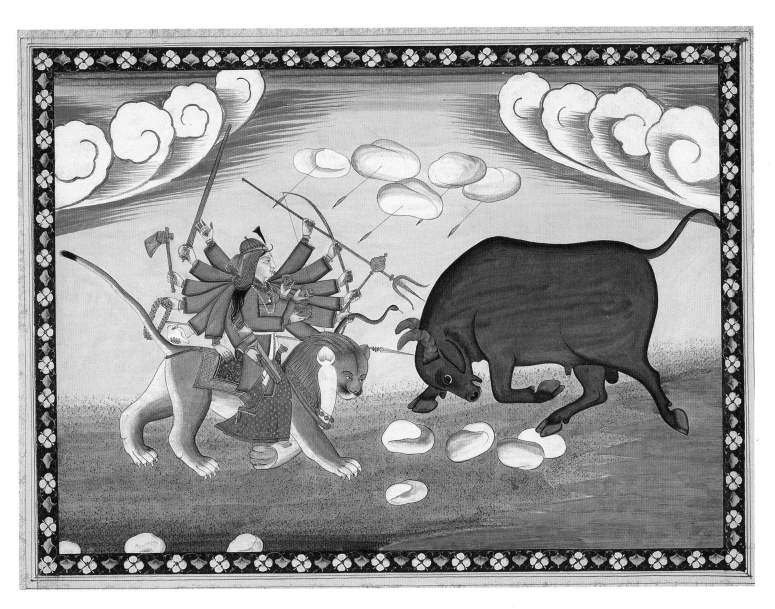

10

Durga Engages the Buffalo
Titan, illustration from
a *Devimahatmya*, Guler
workshop, Himachal Pradesh,
c. 1825. Opaque watercolour
on paper; 25.1 x 33 cm.
Norton Simon Museum,
Pasadena, Gift of Ramesh and
Urmil Kapoor, P.2004.07.5.

and aesthetic tasting is related to certain fundamental emotions. These emotions include delight or love (*rati*), energy (*utsaha*), repugnance (*jugupsa*), anger (*krodha*), laughter (*hasya*), fear (*bhaya*), sorrow or grief (*shoka*), wonder (*vismaya*), and sometimes a ninth emotion, detachment (*nirveda*). The aesthetic experience, however, is not the literal emotion but, rather, its generalizable or universalizable likeness. If it were only literal, we would hardly be inclined to attend the theatre, or an art exhibition, or a concert. According to Anandavardhana and Abhinavagupta, perhaps the two greatest aestheticians in

Indian literature and philosophy, working in the 10th and 11th centuries in Kashmir, the aesthetic "tasting" or "relishing" lifts us out of the literal, enabling us to appreciate the emotional sensibility in a general and shared or communal context. There is, then, a general *rasa* or tasting for each literal emotion, and that "tasting" or "relishing" (sometimes called *vyanjana*, or more often, *dhvani* or "resonance") is a kind of "after-taste", a generalized, blissful experiencing lifted out of the literal. For the literal emotion of love, there is the generalized *rasa* of erotic arousal or physical intimacy (*shringara*).

For the literal emotion of energy, there is the generalized *rasa* of the heroic or noble (*vira*). For the literal emotion of repugnance, there is the generalized *rasa* of disgust or repulsion (*bibhatsa*). For the literal emotion of fear, there is the generalized *rasa* of terror (*bhayanaka*). So also there are equivalent "tastings" for anger, laughter, sorrow, wonder, and detachment. Aesthetic sensibility in Indic thought requires that one be something of a connoisseur (*sahridaya*) to appreciate and experience the "tasting" or "relishing". Moreover, the aesthetic experience is especially intense in a corporate context – the audience of a drama, a group listening to poetry or music, a group encountering an image in a temple.

In the context of this discussion, I have selected four pairs of images, as follows:

– Mahakali, Kalighat, by B.D. Grant, 1852; Kali, Kalighat style, late 19th century (figures 5 and 6).

 *Rasa*s: **astonishment** (*adbhuta*), **terror** (*bhayanaka*), **pity** (*karuna*).

– Kali, Kangra, c. 1800; Kali, colour lithograph, Calcutta, 1883 (figures 7 and 8).

 *Rasa*s: **anger** (*raudra*), **terror** (*bhayanaka*), **astonishment** (*adbhuta*), **horrific** (*bibhatsa*).

– Shiva, Vishnu, Brahma, and Kali, Basohli, c. 1740; Mahishasuramardini, Guler, c. 1825 (figures 9 and 10).

 *Rasa*s: **astonishment** (*adbhuta*), **heroic power** (*vira*).

– Mother and Child, Rajasthan, 6th century; Shiva and Parvati, Rajasthan/Madhya Pradesh, 11th century (figures 11 and 12).

 *Rasa*s: **erotic arousal, physical intimacy** (*shringara*), **pity** (*karuna*).

What would be the "tasting" or "relishing" arising from these?

I would suggest that the fourth pair evoke the rather conventional emotion of **delight** or **love** (*rati*), and the corresponding "tasting" would be, in my view, the erotic *rasa*, or, one might say, the *rasa* of physical intimacy.

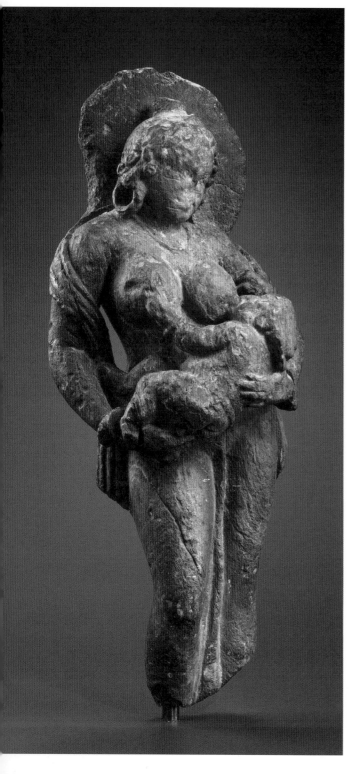

11
Mother and Child, Thanesar, Rajasthan, 6th century. Stone; 57 cm. Pritzker Collection, New York. Photograph: Hughes Dubois.

12
(opposite)
Shiva and Parvati, Rajasthan or Madhya Pradesh, 11th century. Beige sandstone; 78.7 cm. The Norton Simon Foundation, Pasadena, F.1978.23.S.

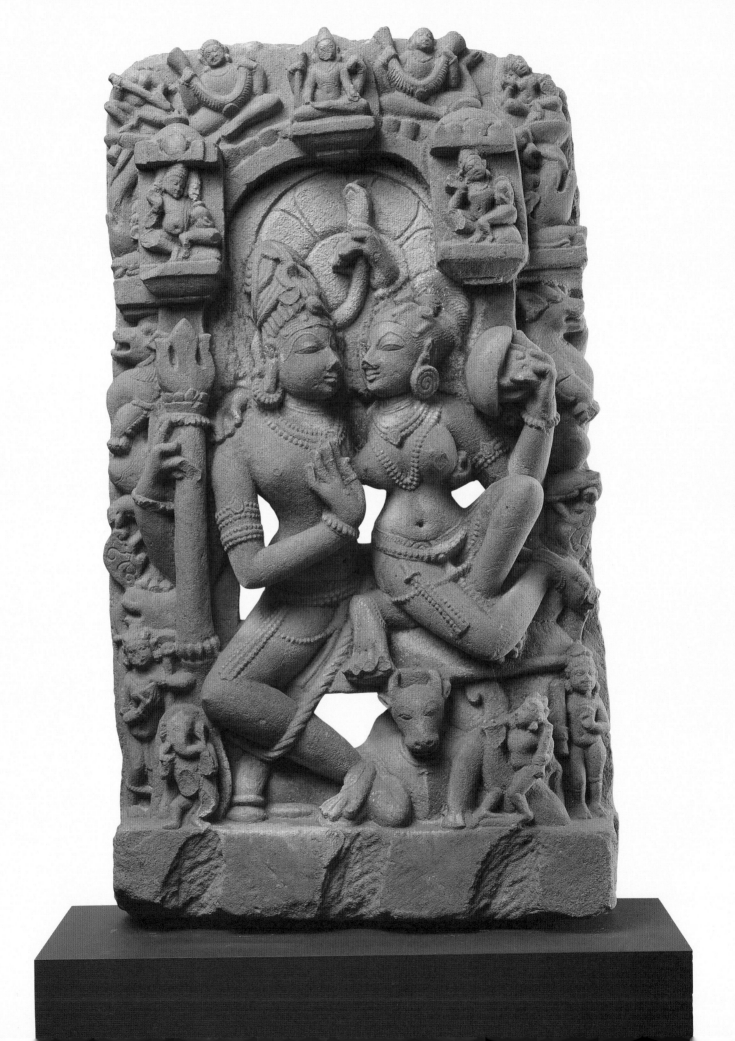

But what of the other three pairs?

The basic emotions, it seems to me, are **energy** (*utsaha*), **repugnance** (*jugupsa*), **anger** (*krodha*), **fear** (*bhaya*), and **wonder** (*vismaya*) – and the related "tasting" would be the **heroic or noble** (*vira*), **the horrific** (*bibhatsa*), **anger** (*raudra*), **terror** (*bhayanaka*), and **astonishment** (*adbhuta*).

(3) The Gender Sensibility

Turning, finally, to what I am calling the gender sensibility, I have in mind what, of course, is obvious but often overlooked, namely, that all of these images of the divine feminine are for the most part products of the male imagination. The images of the divine feminine, in other words, are the projections of the manner in which men – priests, poets, dramatists, artisans, pandits – have portrayed the sacrality of the feminine. And in regard to the specific representations of Devi or Durga and Kali, there is evident a profoundly paradoxical and deeply ambivalent attitude towards the Mother. Pratapaditya Pal touches on this ambivalence when he comments as follows about Kali in a recent publication, "Although her appearance is that of an avenging goddess, to the Bengali, Kali is essentially a protective and nurturing mother."[5] I am inclined to generalize a bit further. Not only the Bengali, but all men and all women have the task of working through their relationships to the Mother, and it is almost always a complex and highly conflicted task, wherein what appears to be the case on one level is profoundly different on another level. According to Girindrasekhar Bose, Sudhir Kakar, Ashis Nandy, and Gananath Obeyesekere, the mother–son relationship is quite different from the mother–daughter relationship. More than that, although there are important parallels, the mother–son and the mother–daughter conflicts in an Indian family are not at all the same as in a European or American family.

This is not the occasion to get into an elaborate discussion of gender differences in mother–son and mother–daughter interactions whether in contemporary Indian culture or contemporary American culture. My only intent here is to raise the issue of gender sensibility as one important perspective for appreciating and experiencing the divine feminine in art. Let me illustrate what I mean by referring to a wonderful myth about the Mother, widely known in India (especially south India) and in Sri Lanka. The myth concerns the Great Goddess and her two sons, Skanda and Ganesh. Here it is in the words of Gananath Obeyesekere:

> A mango was floating down the stream and Uma (Parvati) [Devi] the mother said that whoever rides around the universe first will get the mango. Skanda [Kartikeya] impulsively got on his golden peacock and went around the universe. But Ganesha, who rode the rat, had more wisdom. He thought: "What could my mother have meant by this?" He then circumambulated his mother, worshipped her and said, "I have gone around my universe." Since Ganesha was right his mother gave him the mango. Skanda was furious when he arrived and demanded the mango. But before he could get it Ganesha bit the mango and broke one of his tusks.[6]

Sudhir Kakar then comments about the myth:

Here Skanda and Ganesha are personifications of the two opposing wishes of the older child [or, in other words, the young boy at the time of puberty]. He is torn between a powerful push for independent and autonomous functioning, and an equally strong pull towards surrender and re-immersion in the enveloping maternal fusion from which he has just emerged. Giving in to the pull of individuation and independence, Skanda becomes liable to one kind of punishment – exile from the mother's bountiful presence, and one kind of reward – the promise of functioning as an adult, virile man. Going back to the mother – and I would view Ganesha's eating of the mango as a return to feeding at the breast, especially since we know that in Tamil Nadu, the analogy between a mango and the breast is a matter of common awareness – [Ganesha] has the broken tusk, the loss of potential masculinity, as a consequence. Remaining an infant, Ganesha's reward, on the other hand, will be never to know the pangs of separation from the mother, never to feel the despair of her absence.[7]

CONCLUSION

Whether one agrees with Kakar's interpretation or Obeyesekere's is not really important for what I am suggesting here. My point is simply that in addition to the obvious religious sensibility and aesthetic sensibility of works of art depicting the goddess, we would be wise to be aware of what Durga and Kali tell us about our gender identities and our gender differentiation. Fortunately, we live in a time when women are, more and more, participants in conversations about religion, aesthetics, and gender differentiation, and we can look forward with great anticipation to finding fresh dimensions of meaning and innovative ways of encountering the image of the Great Goddess as these conversations unfold.

In these troubled times around the globe, let me close with a verse from the *Devimahatmya*:

O Devi, who removes the pains
 of those who come for refuge, be
 pleased.
Be pleased and gracious, O Mother
 of the entire world,
Be pleased and gracious, O Sovereign
 of the world,
Protect the world, for You are the
 Lord, O Devi, of everything that
 is![8]

NOTES
1 Michael Korda, *Male Chauvinism* (Random House, New York 1973), p. 30.
2 Luce Irigaray, ed., *Key Writings* (Continuum, New York 2004), pp. 26–27, 70ff.
3 Ibid., p. xii.
4 As cited in Mary Beth Mader and Kelly Oliver, "French Feminism", in R.C. Solomon and D. Sherman, eds., *The Blackwell Guide to Continental Philosophy* (Blackwell Publishing Ltd., Oxford 2003), p. 316.
5 Pratapaditya Pal, *Durga, Avenging Goddess, Nurturing Mother* (Norton Simon Museum, Pasadena 2006), p. 36.
6 As quoted by Sudhir Kakar in his book, *Intimate Relations* (Viking, New Delhi 1996), p. 116, from Gananath Obeyesekere, *The Cult of Patini* (University of Chicago Press, Chicago 1984), p. 471.
7 Kakar, 1996, pp. 116–17.
8 *Devimahatmya*, Third Episode, 11th Chapter, Verse 3, in S. Shankarnarayanan, ed., *Glory to the Divine Mother (Devimahatmyam)* (Dipti Publications, Pondicherry 1973), p. 249.

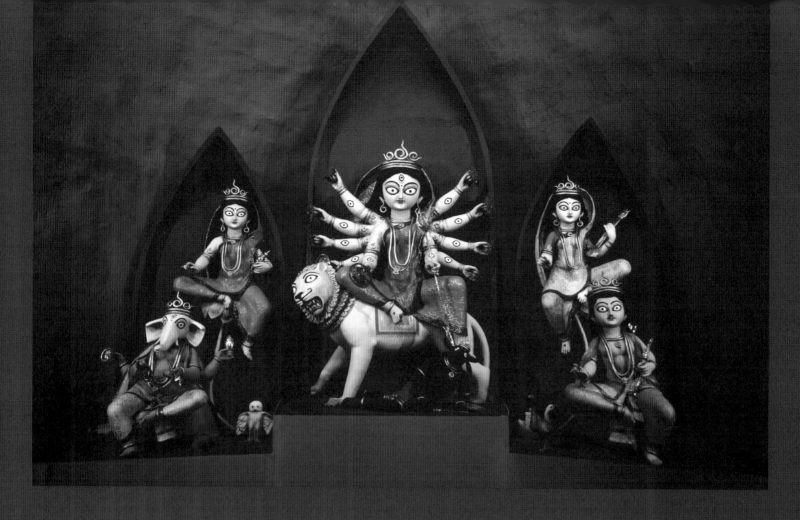

Vessels for the Goddess
Unfired-Clay Images of Durga in Bengal

Susan S. Bean

Every autumn Goddess Durga leaves her husband Shiva's abode on Mount Kailash
and travels with her four children to her natal home in Bengal. Their visit is celebrated as
Durga Puja, the region's most splendid festival, a two-week extravaganza of religion, art, and
commerce. The deities are welcomed into thousands of elaborately dressed and ornamented
images (*pratima*) sculpted of unfired clay (figure 1). At the centre Durga stands in triumph over
Mahishasura, the buffalo-demon. To her left are Sarasvati and Kartik; to her right, Lakshmi and
Ganesh. Only in Bengal is Durga's arrival treated as a homecoming, and only in Bengal are the
great goddesses Sarasvati and Lakshmi presented, along with Kartik and Ganesh, as her children.

Throughout the region images are installed in private homes, apartment blocks, office
complexes, and public spaces. Because it takes substantial resources to purchase an image
and perform the necessary rituals, home pujas are held only by families of means, some even
funded by dedicated trusts and often celebrated in old family homes with special enclosures
for the image (*thakur dalan*, figure 2). Some contemporary apartment blocks simulate these
private pujas, appointing a committee to organize the event for the residents. For these family
and semi-private pujas the clay images of Durga are usually conservative in style, the makers
following traditional models in emphasizing the gorgeousness of decoration and the power of
the goddess's gaze.

Kolkata is the epicentre of Durga Puja, with splendid displays to be seen throughout the city. Neighbourhoods and clubs commission monumental images and place them in temporary structures erected on roadways and in parks (figure 3). For these public pujas, the styles of the images of the goddess and her children range from traditional to trendy, from folkloric to Bollywood. The fanciful shelters (*pandals*) built to house them imitate everything from sacred waterpots (*ghatas*) to the Ellora caves or the US Capitol. The organizers hire priests and provide all the paraphernalia necessary for the rituals. The *pandals* also accommodate performances of music and dance. In the evenings the streets are filled with "*pandal* hoppers" moving about the city to enjoy the Puja sights and take darshan (reverential viewing) of the images. In the city and across the region families and friends gather; gifts are exchanged; people buy new clothes; special foods are served; periodicals release Puja annuals featuring art and literature. On the final day, the celebrants bid farewell to the goddess and her children as they depart for Kailash, and the images, now just empty vessels, are taken in procession and immersed in a river or pond – returning to the earth from which they were formed.

During the festivities Durga reigns supreme. In her triumph over the buffalo-demon she annihilates the forces of evil whatever their form. She is the omnipotent protector and the universal mother. Her festival takes place in autumn, commemorating the puja performed by Rama, the greatest king ever known, to secure her blessing before going into battle against the mighty Ravana. In Bengal's clay *pratima*s Durga's pre-eminence is emphatically expressed by her size and commanding position at the centre of the composition. In her maternal role she encompasses Lakshmi and Sarasvati; together they represent Mahakali, Mahalakshmi, and Mahasarasvati, the three great forms of the Goddess contained in the key text, *Devimahatmya*. Through their combined presence, Durga, Lakshmi, and Sarasvati also evoke their consorts, the three supreme deities Shiva, Vishnu, and Brahma, all portrayed in the arch-shaped painting (*chalachitra*), placed above the clay images. Lakshmi, Sarasvati, Ganesh, and Kartik, as children of the goddess, represent humanity: Lakshmi, presiding over wealth, the vaishyas; Ganesh standing for labour, the shudras; Sarasvati, patron of art, culture, and education, the brahmins; and the valorous Kartik, the kshatriyas. The presence of these deities also alludes to the four desired ends of human existence – *dharma* (virtue) embodied in Ganesh; *artha* (wealth) in Lakshmi; *kama* (desire) in Kartik; learning, the path to enlightenment, in Sarasvati – with Durga, representing *moksha* (final release), presiding over all. Bengal's Durga *pratima* encompasses the realms of gods, demons, and humans, conveying the awesome power of the goddess and encouraging all to seek her blessing.[1]

CLAY

More than any other part of the subcontinent Bengal is a region of clay where stone and wood are scarce, but clay is abundant. In this vast deltaic region of intensively cultivated, richly fertile alluvial soils, clay is dug from riverbanks and rice paddies, cleaned, and mixed with sand, chaff, jute fibre, or dung to the required consistency. Clay is moulded into bricks; formed on a potter's wheel; altered with anvil and paddle into useful shapes for cooking, eating, and storing foods; and modelled by hand into figural forms. For millennia the earth of Bengal has provided

1
(opposite)
A non-traditional Durga
pratima in Kasba Bosepukur
Sitala Mandir, Kolkata, 2007.
Photograph: Satyaki Ghosh.

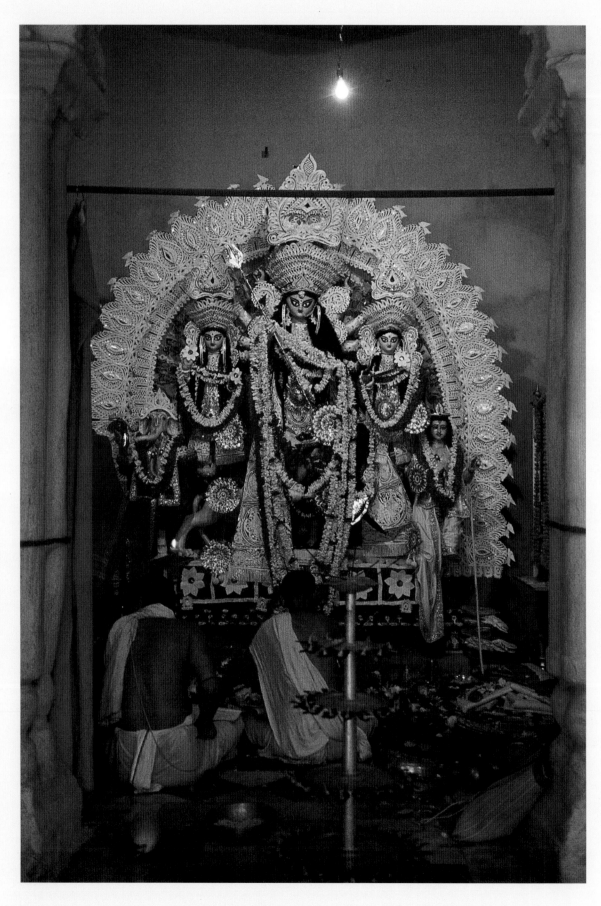

2
Durga image for the *thakur dalan* of the Akrur Dutta house in north Kolkata, 1998.

3
(opposite)
Pathurighata Pacher Palli *pandal*, north Kolkata, 2007.
Photograph: Satyaki Ghosh.

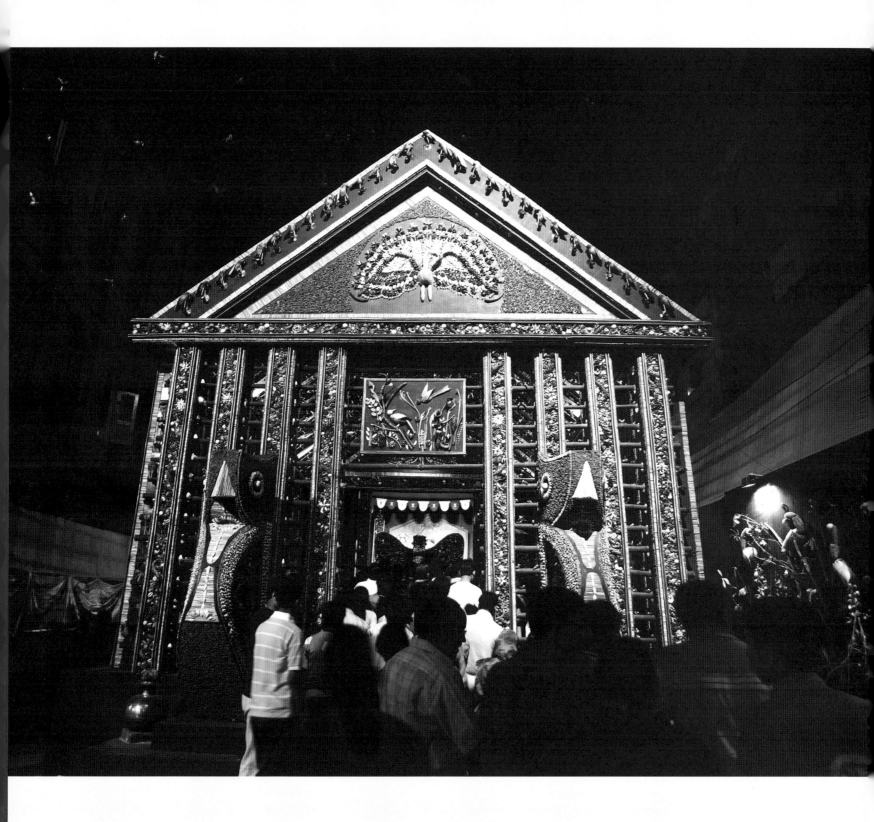

the material for vessels, votive offerings, images of deities, and buildings. The region is renowned for three genres in clay: magnificent carved-brick temples built during the 17th to 19th centuries, votive terracotta animals made in Bankura district, and unfired-clay images made for Durga Puja and other festivals of the annual cycle.[2]

Clay, chiefly in the form of low-fired earthenware, or terracotta, is ubiquitous in the subcontinent. Even in the 21st century, India is home to more working potters than any nation on earth.[3] Before plastic, aluminium, and stainless steel became readily available, terracotta, typically unglazed, was the most widely used material for cooking and storage vessels. Terracotta vessels are ephemeral: low-fired clay breaks easily, and, because it is porous, becomes defiled so that cups and bowls once used must be discarded. Being made of readily available, inexpensive materials, what must be thrown away is easily replaced, creating a perennial demand for potters. Terracotta vessels are also esteemed; their porosity keeps drinking water cool even in summer, and contributes to the special flavour and texture of delicacies like Bengal's famous sweet yogurt, *mishti doi*.

Clay, both unfired and terracotta, is also the principal material across the subcontinent for votive images. Potters in many locales model anthropomorphic and animal figures as offerings. They also serve as priests, carrying out rituals to restore health or bring a good harvest. In Bengal women from potter families make votive images in unfired clay and terracotta for sale in the bazaar (figure 4). Women of other communities also make unfired-clay images for their own families, especially of the goddesses Shashthi and Shitala.

Unfired clay with the life-sustaining combination of earth and water intact is the proper substance for images of Durga and her four children, as well as for other temporary images made in Bengal throughout the annual cycle.[4] The *Devimahatmya* identifies Durga with the Earth, as Mother. She is also Shakambhari, the goddess of plants. The ritual of the nine plants, *navapatrika*, performed as part of Durga Puja, portrays Durga's identity with vegetation and fertility. She is yellow, the colour of ripened grain, and her festival occurs

4
A potter with moulded, low-fired, and painted images of Shiva made by her and her husband. Nadia district, 1992.

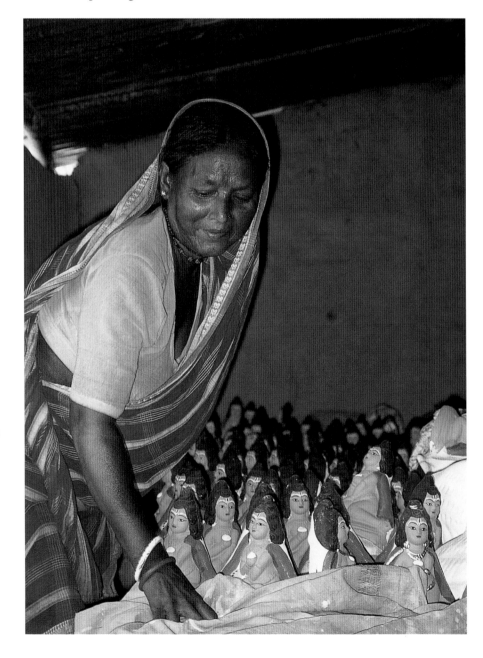

at harvest time.[5] In her union with Shiva, Durga/Parvati brings forth energy and life to form the universe. It is fitting that images of this life-giving goddess are composed of life-sustaining matter. Clay (*mati*) is earth itself, the most humble and most powerful of substances. Firing removes water and transforms clay into a utilitarian material that can contain liquids, but no longer has the means to support life. The distinctions between unfired clay and terracotta, both technical and conceptual, are fundamental.

Unfired clay has been of ritual importance in the Indian subcontinent for at least 2,000 years as a principal medium for the creation of religious images for both Hindu and Buddhist practice.[6] K.M. Varma, citing archaeological evidence of unfired-clay sculpture from the 1st to the 8th centuries CE in the Indo-Afghan region and Kashmir, proposed that the art of unbaked-clay sculpture spread with Buddhism across Asia.[7] Extant images date from the 7th century at Todaiji in Nara, Japan, the 8th century at Fo Guang Temple at Mt Wutai in China, and the 11th century at the Tabo Assembly Hall in the Spiti Valley, India.

The earliest references to unfired-clay images are found in south Indian Agama texts including the 8th-century *Vimanarchanakalpa*, the *Kashyapashilpa* "treatise of arts" assigned to the 12th century, the 16th-century *Kashyapajnanakanda,* and the 16th–17th-century *Samurtarchanadhikarana.* These texts prescribe four materials for the substance of principal images in a temple: stone, wood, bronze, and unfired clay. According to Varma's analysis the process of constructing images described in these texts is fundamentally the same as that followed in modern Bengal, linking current practice to a 2,000-year-old art of unfired-clay sculpture.[8]

CREATING UNFIRED-CLAY SCULPTURE

The technique of clay sculpture has been developed to exploit the plastic qualities of the clays and give maximum strength and solidity to large figures that are composed of fragile, friable, dried earth. Every sculptor evolves his own approach to the medium based on his particular training and experience. The process of making the images described below follows the practice of Nemai Chandra Paul, an accomplished senior artist based in Shashthitala, Krishnanagar, who specializes in a classical, conservative form of the Durga *pratima*. The description also draws on information provided by the sculptor Syamapada Hajra to Varma for his study of the genre.[9]

The sculptor begins with a framework of bamboo and wood *(kathama)*. Sometimes frames are retrieved after immersion and reused; otherwise they are newly made. For the classic version of the Durga image known as *ek-chala* (under one roof-arch), five vertical supports rise from a platform. These supports are arranged so their tops describe an arch. The centre support for Durga is the tallest, below to either side are supports for her daughters, Lakshmi and Sarasvati, and on the ends are the shortest bamboos that will hold her sons Ganesh and Kartik, both seated. Other vertical supports are added according to the maker's conception for a particular image. At key places on these supports pegs are fixed where the torsos are attached. The arch described by the figures is repeated above them by the *chalachitra*, installed when the figures are complete, which depicts Durga's consort Shiva and other deities including Brahma and Vishnu, the consorts of Sarasvati and Lakshmi. The *kathama* is not only the

structural underpinning for the image, but its ritual foundation as well. The platform at its base provides the altar for puja offerings. The success of the image as a whole depends upon the strength, stability, and proportions of the *kathama*. Before the maker proceeds to work on the images, he does puja to the foundation *(pata puja)*.

The sculptor starts by making straw cores *(mer)* for the figures and attaching these to the supports. He uses rice straw, usually from the recent harvest. An assistant often prepares the straw, sorting out the stalks, about a metre in length, into piles. The sculptor begins at the bottom centre of the composition with Durga's lion and the demon Mahisha. He bundles straw to the appropriate bulk, binds it tightly with jute string, and attaches it to the wooden supports. When the cores of the lion and demon are in place, he sets to work on Durga, first forming and placing her legs (figure 5). Her left knee is bent sharply into the position it takes on the neck of the demon Mahisha, and her right leg is strongly extended, planted firmly on the back of the lion. After her legs are in place, the sculptor shapes and compacts her torso, securing it to the supports and joining it to the straw extensions of the legs. For each figure the legs are first formed and placed, then the torso created, and finally the arms attached. The vertical supports extend beyond the shoulders, where the heads will be attached.

Syamapada Hajra explains that the bottom of the torso is the central point on a figure, the head and neck should comprise one quarter of the upper part of the body, and the legs be slightly longer from knee to heel than from knee to hip.[10] Nemai measures two hand-spans from heel to bottom of knee and keeps a vertical line from the big toe to the inside of the knee.

When the central composition of Mahishasuramardini, Durga slaying the buffalo-demon, is in place, the sculptor arranges the rest of the figures in relation to it. He begins at the base on either side of Durga, positioning Kartik astride his peacock and Ganesh seated with one leg drawn up and one pendant. The composition is completed with Lakshmi and Sarasvati who are mirror images of each other, with their legs crossed and arms bent to hold their attributes. In the finished

5
Nemai Chandra Paul preparing the straw core for Durga's legs. Peabody Essex Museum, 1995.

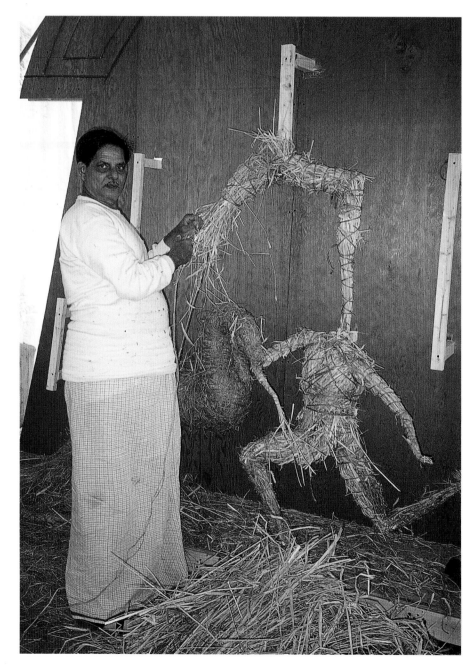

image Lakshmi will hold a lotus, and Sarasvati her vina. According to Nemai Chandra Paul, the size and placement of the figures relates in interconnected triangles to the arch described above them where the *chalachitra* is placed. These straw forms (*mer*) provide the essential structure of the image and, masterfully executed, convey a sense of wholeness and possess a formal elegance that belies the crude material of which it is made.

Clay is purchased from suppliers, dried and pulverized, cleaned of stones and other foreign matter, mixed with water and kneaded until smooth. The first clay applied to the figures, known as *etel mati* (sticky clay) or *kala mati* (black clay), is sticky and very plastic. It is blended with water and rice chaff to a very soft consistency, spread over the *mer*, and worked into the straw to further compact the cores (figure 6). The chaff in the clay allows air to circulate for more even drying, reducing cracking and crumbling. After the clay has dried and cracks are filled, a second firmer mixture, made with less water, is applied in patties of clay worked by the sculptor to form the outer contours of the bodies. When this preliminary surface is complete the maker goes over it with a serrated wooden stick, preparing it for the addition of the second layer of clay.

After the application of the first layer of clay, the sculptor attaches the heads to the vertical supports which have been prepared with clay shaped into elongated cones. Apart from Ganesh, whose head must be modelled on the figure itself because of its complex shape, the others are formed either by pressing clay into a mould the sculptor has made for repeated use, or modelled by hand to suit the particular dimensions and character of an image. The heads are composed of fine, sandy clay, *bele mati*, which holds crisp detail, and reinforced with sticky clay and chaff (figure 7). The maker applies liquid slip *(gola)* to the neck opening of the head and works it into place using a plumb line of jute string with a ball of clay attached to adjust the position of the face. Sticks protrude through the top of the head to accommodate the crown. The opening at the top is partially filled with clay and straw, allowing space for air to pass for even drying and for the clay to shrink.

The second layer of clay, *bele mati*, is usually collected from riverbanks and beds. It too must be cleaned and then kneaded with water until very smooth. The maker applies it in thick patties which he works together, forming surface details. When the clay becomes more firm, he refines the surface by smoothing it with a wooden tool dipped in water. (Such deceptively simple tools are often so prized that they are passed from one generation to the next.) Cracks that appear during drying are filled with a mixture of *bele mati* and cow dung. At this stage the fingers and toes are formed and attached (figure 8). The maker, or his assistant, prepares a mixture of sticky clay, *etel mati,* mixed with chopped jute fibre for added strength and plasticity. Each finger and toe is prepared individually from sets of clay balls sized appropriately, first for Ganesh and Kartik, then Sarasvati and Lakshmi, and finally Durga, whose feet are the largest. Each ball is elongated, the finger or toe is pressed into its correct shape, and smoothed with a stick. The same stick is pressed into the soft clay to form the nail and knuckle. When the toes for a foot are completed, the maker brushes slip where they are joined and works thin oblongs of clay above and below each set of toes to make the top and ball of the foot. He blunts and

6
Nemai Chandra Paul applying
the first layer of clay to the
figure of Lakshmi. Peabody
Essex Museum, 1995.

7
Lakshmi's head moulded of
fine, sandy clay, being attached.
Peabody Essex Museum, 1995.

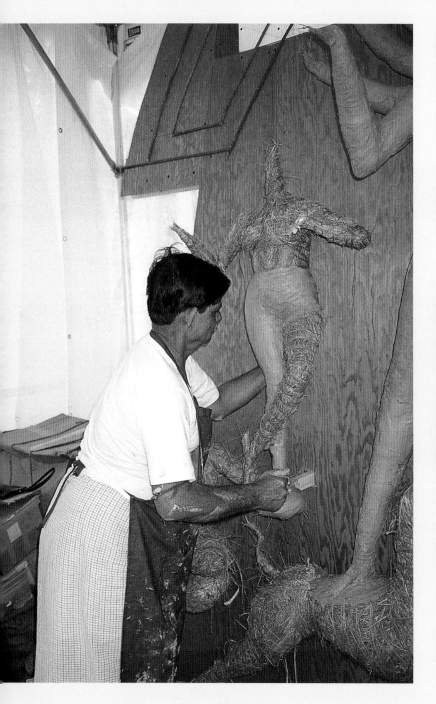

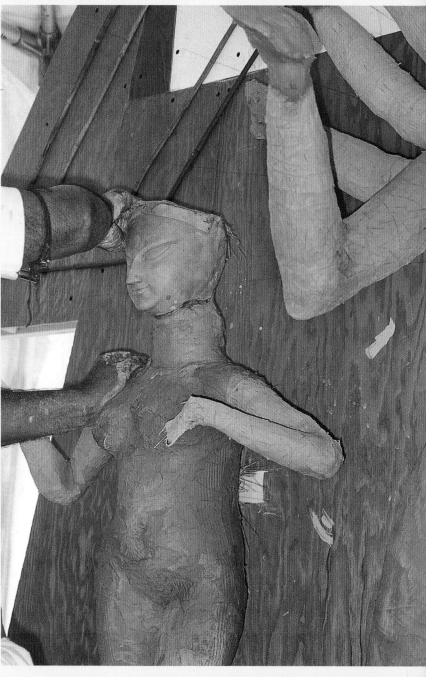

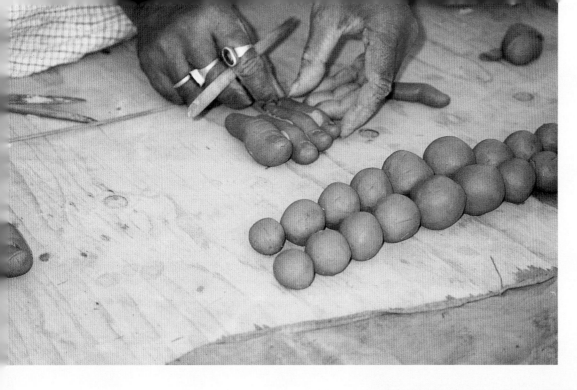

8
Forming toes. Peabody Essex
Museum, 1995.

9
Trimming the applied cloth
strips. Peabody Essex Museum,
1995.

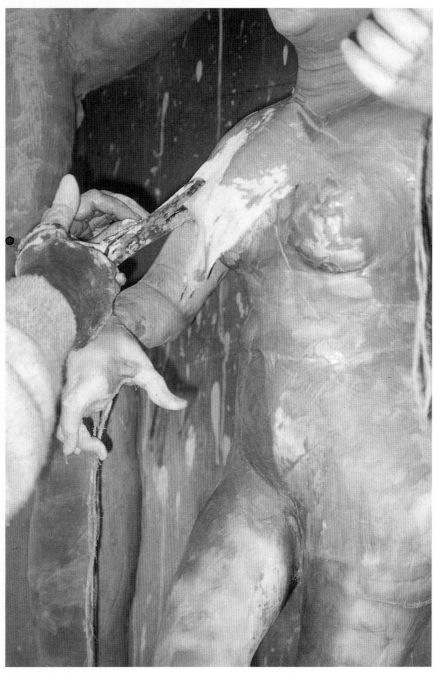

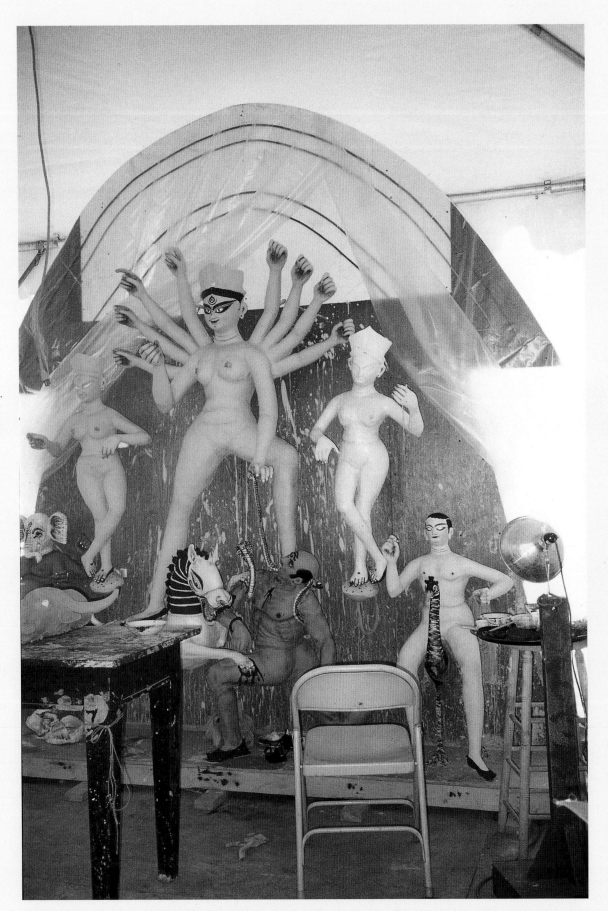

10
The figures partially painted.
Peabody Essex Museum, 1995.

11
(opposite)
Nemai Chandra Paul dressing
Sarasvati. Peabody Essex
Museum, 1995.

straightens the end with a knife and slits it so that it can be joined to the back part of the foot on the figure. Hands are made and attached in the same way, then lightly bandaged with strips of cotton to keep them in place until firm and dry. The peacock's toes are made from small soft coils squeezed in the hand in a way that leaves finger impressions simulating the shape of a bird's claws.

When the figure is completely dry, it is sanded smooth. Next the maker, or his assistant, prepares liquid clay and tears fine white cotton dhoti cloth into strips. The cloth strips are dipped in the clay slip and smoothed onto the surface of the figures, working in the frayed edges so no line is visible. The cloth secures the figures firmly, preventing the dried clay from crumbling (figure 9). Some ornaments, made from clay pressed into moulds, are applied to the finished images. Other features, like the lion's mane, are built of coils made by hand. When the addition of clay ornaments is complete, a special white clay (*khari mati*) from Suri in Birbhum district is mixed with water into a fine slip; two coats are applied to the figures, forming a base for the colours.

Makers purchase factory-produced pigments from the market. Shops in Kumartuli and Krishnanagar have the best selections. Most pigments are mixed with white-clay slip and tamarind-glue binder. Some colours, including red and blue, are not water-soluble. Red, for example, is mixed directly with tamarind glue binder and blue with sugar. Each figure is painted its proper colour: yellow for Durga and Lakshmi, light yellow for Kartik, green for Mahisha, pink for Ganesh, and white for Sarasvati (figure 10). The bodies are given two coats; a third is applied to the faces. Powdered pigment is applied with a brush or cloth-covered finger to shade and volumize creases, joints, and muscles. The colours are sealed first with a coating of arrowroot cooked in water, which prevents bleeding, and then given a coat of glistening copal varnish. The white figures – Sarasvati, Durga's lion, and Ganesh's face – are dusted with mica powder mixed in water and glazed with tamarind glue to augment the sparkle and shine.

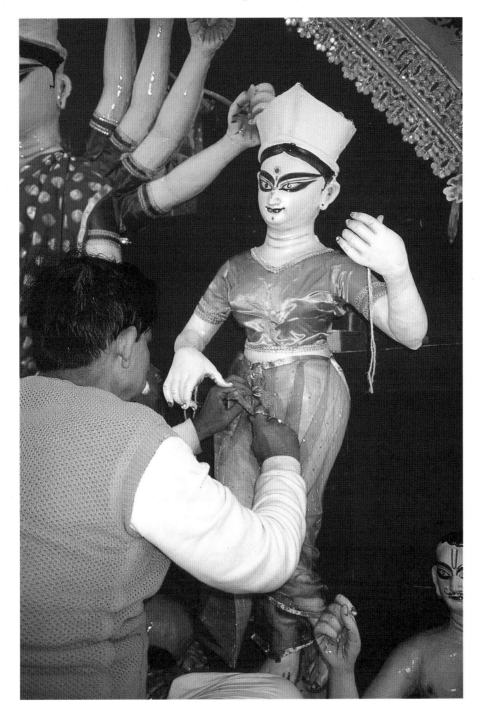

When the clay sculptures are complete, the sculptor erects a cloth barrier and, in privacy, paints the pupils of Durga's eyes – signalling that the image is ready to receive the goddess. After this ceremony, the figures are dressed using specially prepared cloth that is draped, glued, and tacked into place (figure 11). The maker finishes the images, adorning them with an abundance of pith (*shola*) and shiny metallic paper (*daker shaj*) ornaments purchased in the bazaar. The result is an eye-dazzling composition whose central figure, Durga, captivates viewers with her penetrating gaze and sweet, delicate, maternal smile.

UNFIRED-CLAY SCULPTURE IN BENGAL

In Bengal, though unfired-clay images for worship have probably been in use for at least a millennium, only in the 17th century did they become important in the annual round of festivals. Bhabananda, founder of the Nadia dynasty, and Laxmikanta of Barisha, whose family transferred rights to the East India Company for the area that became Calcutta, are both remembered for holding lavish Durga Pujas centred on the worship of clay images. The practice spread to other small kingdoms in the region including Gaur, Rajmahal, and Murshidabad.[11]

A century later Maharaja Krishnachandra Roy of Nadia (r. 1728–83) made Durga Puja featuring elaborate unfired-clay images the centre of the annual cycle, and sponsored grand pujas with clay images for other goddesses. Maharaja Krishnachandra expected his subjects to participate in the rituals, and zamindars in his dominion were instructed to sponsor pujas. The Maharaja even offered financial help to those who needed it to do the puja properly. Maharaja Krishnachandra's

lasting impact on the celebration of Durga Puja in the larger context of changing power relations in Bengal is evident in a commentary published decades after his death: "It is due to this (his puja) that the rich are no longer afraid to flaunt their wealth before the British rulers and are increasingly spending more."[12]

Maharaja Krishnachandra's regard for clay sculpture led him to be a keen patron of the art. He recognized sculptors' achievements, their technical skills, and the distinctiveness of their conceptions. He attracted the best sculptors to Krishnanagar, where they may also have been drawn by the excellent plastic qualities of the local clay. Sculptors were encouraged to create elaborate religious images of the highest quality and also to make innovative sculptures displaying creative and technical virtuosity, commissioned for Puja entertainment. For example, Kalachaudi Pal, a famous sculptor of the last quarter of the 18th century, achieved renown for two novel figures: a horse made up of 32 other animals and an elephant composed of five women.[13]

In Calcutta, grand Durga Puja celebrations became the preserve of men who had made their fortunes in the new colonial regime. Gobindaram Mitra of Kumartuli and Nabakrishna Deb of Shobabazar led the way with their pujas. Gobindaram Mitra (1720–56), the "black zamindar" enlisted by the East India Company to administer Calcutta, held lavish pujas in his Kumartuli home where the goddess was seated on a silver throne with her sons. Her daughters, Lakshmi and Sarasvati, were placed beside her and at the close of the puja carried in their own decorated palanquins to the river for immersion. In 1757 Nabakrishna Deb added a *thakur dalan* to his house for a special Durga Puja to celebrate the victory of the East

India Company over Nawab Siraj-ud-Daulah at Plassey. The Deb house also engaged the best singers and musicians to perform, and on occasion, performers who entertained by imitating the manners of foreigners.[14]

Through the 18th century, Durga Puja was mainly a family affair, simple for families of modest means; grand, semi-public celebrations with entertainment and feasting organized by wealthy and powerful families. The proper balance between religious observance and carnival was already a subject of controversy, and has remained a recurring concern ever since. Even in 1823 commentators complained about its carnival character: "Durga Puja in Calcutta is better described as a festival of chandeliers, lamps, poets, nautch girls, or even of the wife's ornaments and clothes."[15]

As the popularity of Durga Puja and other festivals featuring clay images grew, Calcutta, the principal city of British India, became as important a centre for clay sculpture as Krishnanagar. The potters' quarter in Calcutta at Kumartuli, was at first an outpost of Krishnanagar where sculptors worked during the festival seasons. Even after potters had settled there, they continued to bring their clay the 65-odd kilometres down river from Krishnanagar which, even now, is an important source. Later, sculptors from other towns in Bengal moved to Calcutta in response to the ever-increasing requirement for puja images.

Towards the end of the 18th century the festival's prominence and popularity gave rise to a new kind of puja that soon spread throughout the region. A group, originally of 12 brahmins, collaborated to organize and manage the event. In this way devotees of more modest means, without access to the grand pujas of the wealthy families, could participate in an elaborate worship of Durga and other deities. Such pujas presented new challenges and opportunities for sculptors who had to work with a changing roster of patrons with different notions of how the image should look to honour the goddess and attract worshippers and supporters.

By the middle of the 19th century such community pujas evolved into neighbourhood association or club events managed by groups of young men who solicited support from households in their locale, commissioned images, and organized the rituals and accompanying entertainments. According to a contemporary account, "a party of young men tax each family once a year and dispose of the money thus realized in the 'worship'.... A splendid image is erected in the public place of the town, and music and theatrical performances are held before it."[16] As the celebrations of Durga Puja and festivals for Jagaddhatri, Kali, and Sarasvati multiplied, sponsorship and control of these festivals shifted from the powerful elite to a broader, more diverse public. Variations of taste were accommodated as sculptors responded to demands for relevant, innovative, and even trendy imagery, especially in sculpture for secular display. Deities began to appear in new styles. Sculptors gave Kartik European clothes and the hairdo and moustache of Prince Albert.[17] Other figures in clay were commissioned to represent mythology, celebrities, and current events. Sculptors incorporated Western naturalistic modelling into their repertoires, opening rich possibilities for both religious and secular statuary. In the middle of the 19th century, for example, Rajinder Dutt of the Akrur Dutt family, ordered life-size clay figures for both Durga

Puja and Rash Jatra of characters from Shakespeare's plays and Walter Scott's novels, of leaders of the French Revolution, and of the first American president, George Washington.[18]

A Jagaddhatri Puja described in Kaliprasanna Sinha's mid-19th-century *Hutum Penchar Naksha* featured "equestrian models of Highlanders, images of fairies and of western women bedecked with jewels, varieties of replicas of birds, paper pulp flowers and lotuses", and satirical dioramas of young dandies wearing "trousers and English jackets...lying drunk in ditches...."[19] One display at the Hindu Mela of 1873 includes a preaching Christian missionary with poor peasants listening in rapt attention while an inebriated European with a bottle of wine loiters nearby. Another features a brahmin priest shouting for a watchman as a thief escapes and the watchman only berates the priest. Portrayals took sharp aim at targets of popular satire, from religious hypocrites to haughty nawabs.[20]

Commentators persisted in expressing dismay and concern for the religious sincerity of the puja. T.N. Mukharji, for example, commented that puja imagery seemed "more for amusement than for a religious obligation" and the displays included not only "life-size mythological scenes, [but] scenes from daily life, portrait figures of athletes and other celebrities, caricatures, comical subjects and figures representing any scandal current at the time...."[21] With the growth of the nationalist movement around the turn of the century, patriotic fervour was extended to images of Durga, which were given attributes of Mother India. In the first quarter of the 20th century community-organized pujas with nationalist overtones came to be known as *sarbojanin* "for all the people".[22]

Responding to the shifting context of pujas, Gopeshwara Pal, returning from studying sculpture in Italy in 1935, made a revolutionary Durga Puja image that accelerated the pace of change. He separated the figures of Lakshmi, Kartik, Ganesh, and Sarasvati, taking them out from the arch formation, *ek-chala*, that had been a defining feature of the image. He designed a battle-hungry Durga, her trident raised to pierce the demon, as it was chased by the lion, and he gave Mahishasura rippling muscles. Jagadish Pal, the sculptor working with him, quit, and priests refused to worship the image. Despite the initial resistance, the changes caught on and became a staple composition in a growing repertoire. In Faridpur, for example, during the Second World War, a sculptor modelled a European in military garb as Mahisha with Durga's lion tearing at his abdomen and incorporated a clay likeness of Netaji Subhas Chandra Bose.[23]

The explosion of interest in Durga Puja during the 20th century fuelled a return to Maharaja Krishnachandra's practice of conferring awards, first by the Government of West Bengal, which held competitions in 1975–77, then by a succession of corporations beginning with Asian Paints in 1985. Prizes have been awarded for the best images, best *pandals*, best lighting design, and best overall presentation. From the mid-'90s a new trend for "theme pujas", devised by professional designers, sometimes with commissions to established artists, and supported by exponentially increasing corporate sponsorships of neighbourhood puja *pandals*, became the latest wave of change.[24]

The genre of unfired-clay sculpture has a long history in the subcontinent and in the relatively recent revival in Bengal, from

the 17th century, has developed into one of the most elaborate, refined, and popular arts in contemporary India. This dynamic history should provoke reconsideration of received wisdom about traditional Indian art – that it is fundamentally static in character, that all traditional arts plunged into decline under the onslaught of colonial rule and industrial competition, and that the rare cases of sur-/re-vival were the results of outsiders' interventions. The clay sculpture of Bengal is certainly not a singular exception, an art that had a renaissance during colonial rule and is now a hotbed of innovation and creativity. The powerful meta-narratives of the deleterious impacts of colonialism and industrialization, and the lack of agency attributed to artists/artisans, have obscured actual patterns of development and transformation along the vast and varied terrain of art production in India.

NOTES

1 See T. Richard Blurton, *Bengali Myths* (The British Museum Press, London 2006); Dulal Chaudhuri, *Goddess Durga: The Great Mother* (Mrimol, Calcutta 1984), especially p. 36; Pratapaditya Pal, *Durga: Avenging Goddess, Nurturing Mother* (Norton Simon Museum, Pasadena 2005); Gaurinath Sastri, "The Worship of the Clay Image of Durga", in *J.N. Banerjea Volume: A Collection of Articles by His Friends and Pupils* (Calcutta University, Calcutta 1960).

2 Jane Perryman, *Traditional Pottery of India* (A&C Black, London 2000), p. 9.

3 Gurusaday Dutt, *Folk Arts and Crafts of Bengal* (Seagull, Calcutta 1990), p. 88.

4 However, in recent years, the increased emphasis on novelty and artistic expression and the practical requirements of puja images that are sent abroad have motivated artists to explore a variety of media.

5 Dulal Chaudhuri, *Goddess Durga: The Great Mother* (Mrimol, Calcutta 1984), pp. 13, 14.

6 See Christian Luczanits, *Buddhist Sculpture in Clay* (Serindia, Chicago 2004); K.M. Varma, *The Indian Technique of Clay Modelling* (Motilal Banarsidass, New Delhi 1970).

7 Luczanits 2004; Varma 1970, pp. 188–91, and 234–36.

8 Varma, pp. 2–5, 245.

9 Ibid., pp. 203ff.

10 Ibid., p. 203.

11 Sudeshna Banerjee, *Durga Puja: Yesterday, Today and Tomorrow* (Rupa, New Delhi 2004), p. 32; Jaya Chaliha and Bunny Gupta, "Durga Puja in Calcutta", in Sukanta Chaudhuri, ed., *Calcutta: The Living City*, 2 vols. (Oxford University Press, Calcutta 1990), Vol. 2, pp. 331–36.

12 Banerjee 2004, p. 34 cited in *Samachar Darpan*, October 17, 1829, and William Ward, *Literature, and Mythology of the Hindoos,* 3 vols. (London 1822), Vol. 3, pp. 156–57.

13 Sudhir Chakravarti, *Krsnanagarer Mrtsilpa O Mrtsilpi Samaj* (P. Bagchi, Calcutta 1985), appendix 1, interview in 1924, with then leading exponent of the genre Jadunath Pal.

14 Banerjee 2004, pp. 33–41.

15 Ibid., p. 41, quoting Bhabanicharan Bandopadyay, 1823, cited in Shibshankar Bharati, "*Sekaler Saradotsab*", *Bartaman,* October 13, 2002.

16 Joguth Chunder Gangooly, *Life and Religion of the Hindoos* (Crosby, Nichols, Lee, Boston 1860), pp. 177–78.

17 Sumanta Banerjee, *The Parlor and the Streets* (Seagull Books, Calcutta 1989), p. 129.

18 Letters from Rajinder Dutt to Charles Eliot Norton: Norton Papers, Houghton Library, Harvard University; Sara Norton and M.A. DeWolfe Howe, eds., *Letters of Charles Eliot Norton* (Houghton Mifflin, Boston 1913), p. 50.

19 Pradip Sinha, *Calcutta in Urban History* (Firma KLM, Calcutta 1978), p. 129.

20 Banerjee 1989, pp. 124, 130.

21 T.N. Mukharji, *Art Manufactures of India,* (Navrang, New Delhi 1974 [1888]), p. 62.

22 Banerjee 2004, pp. 48–51; see also Jyotirmoyee Sarma, "Puja Associations in West Bengal", *Journal of Asian Studies* 28(3), 1969, pp. 579–94.

23 See Tapati Guha-Thakurta, "From Spectacle to 'Art'", in *Art India* 9(3), 2004, pp. 34–56, reproduced as the following chapter in this book.

24 Ibid.

ACKNOWLEDGEMENTS

The master sculptor Nemai Chandra Paul of Shashthitala, Krishnanagar, and Ruby Palchoudhuri, Honorary Secretary of the Crafts Council of West Bengal have been unstintingly generous with their support and willingness to share their knowledge.

All photographs are by Susan S. Bean, except for figures 1 and 3.

From Spectacle to Art
The Changing Aesthetics of Durga Puja
in Contemporary Kolkata

Tapati Guha-Thakurta

For decades now, it has come to stand as the festival of the Bengalis, most particularly of the city of Kolkata – the biggest, most publicized, and the most extravagant event in the city's calendar, around which all commercial activity and public life revolves for months in advance. The Puja has over time become the occasion for a flood of new releases – from literary annuals and miscellanies to music cassettes, CDs, and films; from garment fashions to new city maps and a spate of advertisements, all of which build themselves around this central event of the "homecoming" of the goddess. And, of course, at the heart of these new productions, each year, is a novel repertoire of images of Durga and her entourage and of *pandal* structures that temporarily crop up throughout the Kolkata streets to house these. The focus of my study is on this last rapidly changing category of productions – of new genres of images and *pandal*s – with the argument that it is this visual dimension which has become the most important marker of the transformed face of today's festival phenomenon in Kolkata. As my title suggests, one of the main trends I wish to track is how what was once predominantly glitter, extravaganza, and mega-spectacle is today clamouring to be conferred an identity as one of the city's most unique public "art" events. This new "artistic" identity, as we will see, is one that has been struggling to assert itself, both within the body of the urban spectacle and within the structure of the religious and ritual event.

The Puja is celebrated every year during the month of Ashvin (September–October), over a prescribed period of five main days and nights, in a period known as the Debipaksha that is inaugurated by Mahalaya and ends on the tenth day with Bijoya Dashami: a day that marks the end of the Puja and the immersion of the idols. The goddess is worshipped during this period in Bengal in her martial role as Mahishasuramardini, symbolizing the victory of good over evil – her worship in this guise during this season is specially associated with the legend of "Akal Bodhan" in the *Ramayana* when, on the eve of his battle with Ravana, Rama invoked and received the blessings of the Devi in this martial form. The image of Durga astride her lion, striking down the buffalo-demon with her trident, curiously coexists in Bengal with her image as mother and daughter – especially as a married daughter who is welcomed to her parental home every year as she arrives with her four children, Ganesh, Kartik, Lakshmi, and Sarasvati in tow, and who is given a tearful farewell on Bijoya Dashami when she returns with her children to the Himalayan abode of her ascetic husband Shiva. There exists a rich body of devotional literature and songs in Bengal that has long celebrated this season as that of the daughter's "homecoming", and has produced a resonating ambience of emotion and affect around the image of the goddess and this festival of her worship. While the first lavish family Durga Puja in the city has been traced back to the beginnings of the 17th century (to the house of the Sabarna Roychowdhurys of Barisha in Behala), its passage from exclusive households to the open streets, from zamindari patronage to community sponsorship, is recognized to be largely a late-19th- and early-20th-century phenomenon, when in select areas the community or the *sarbojanin* (meaning belonging to everyone) Puja also became an important platform for nationalist gatherings.

Rather than lay out a history of the Puja in the city, my study is concerned with the contemporaneity of the event as it has come to be configured in today's Kolkata. It is through such a contemporary lens that we can see "tradition" being continually mobilized, reinvented, and innovatively packaged to make this festival one of the most attractive selling points of the megapolis, locally, nationally, and globally. While my prime focus has been on the category of the community or *sarbojanin* Puja (in its many new incarnations), what has also been of interest are the strategic recreations and reclaimings of the "lost world" of the family or the neighbourhood (*para*) Puja, both in the old zamindari mansions (which now elaborately play out their past Puja traditions as a major tourist attraction) or within the city's burgeoning crop of apartment blocks (where the building's Puja serves as the chief occasion for producing new boundaries of exclusion and cohesion for the residential community). The Durga Puja serves as a powerful mirror of the changing sociology of neighbourhoods and of collective public life in today's Kolkata. And within this broader frame, with my concerns concentrated primarily on the many new varieties of image and *pandal* productions, I see these festivities as also representing the vivacious face of a new urban popular aesthetic.

1

(opposite)
The College Square Puja by night, with the *pandal* designed in the form of a glittering golden barge, 2002.

TRAVELS IN HYPER-REALITY

During that one brief week of the Durga Puja, the familiar city finds itself transformed into an ephemeral fantasy land – a land of make-believe temples, mosques, churches, palaces, fortresses, archaeological ruins, sometimes even of glittering barges on a river (figure 1). Over the

years, we have seen the palaces of Rajasthan, the ruins of Nalanda, or the temples of Khajuraho or Thanjavur reconstructed on the city streets with the same panache as the neo-classical facade of the now-demolished Senate Hall of Calcutta University (figure 2). A few years ago, we even saw a remake of the massive capsized *Titanic* in a *pandal* at Salt Lake that became the greatest crowd-puller of that season: a Puja that has made its mark every season with newer and newer architectural remakes, one of the latest of these being a copy of the fictional Harry Potter castle at Hogwarts, which by getting embroiled in a copyright controversy, gained even greater publicity for itself. With each passing Durga Puja, the transformations get more spectacular, the simulations more novel, the concepts often more and more outrageous. As has long been lamented, the tableaus, lights, and decorations seem to have entirely taken over the festival, pushing its religious or ritual dimensions to a distinctly second place.

The Puja has, over several years now, become a new kind of ritual site, a site for visiting and touring, much like a museum, exhibition, or theme-park, where viewing and wonderment seem to entirely supplant worship. Yet the spectacle, one could argue, produces its own sacral aura: one that is inseparable from the ambience of the Puja that it encodes and encapsulates. If Guy Debord wrote his now classic tract (*The Society of the Spectacle*, trans. by Donald Nicholson-Smith, Zone, New York 1995) in a spirit of denouncement, with "the deliberate intention of doing harm to spectacular society", I think there is immense scope here for extracting and rethinking the notion of the "spectacle" – not as a "specious form of the sacred", nor as we have been told, as "the concrete manufacture of alienation" in modern mass society, but rather as a space of intense engagement and interaction, as one suffused with meaning for the communities of creators and viewers who make and inhabit them, involving both

2
The Park Circus Maidan Puja by night, featuring the now demolished Senate Hall of Calcutta University, 2002.

in new practices of artistic production and spectatorship.

The Kolkata of the Durga Puja, as has been observed by Pradip Bose in an important article, "The Heterotopias of Calcutta's Durga Puja" (trans. from the Bengali article of 1997 by Manas Ray, in Amit Chaudhuri, ed., *Memory's Gold: Writings on Calcutta*, Penguin, New Delhi 2008) lends itself powerfully to Foucault's notion of a "heterotopia": a space both real and utterly unreal, where everyday places are transformed beyond recognition, where time and history indiscriminately collapse, where excesses are the order of the day, and where a single location can be home to a melange of multiple emplacements that are incompatible in themselves. So, it is all too possible in the course of a tour through south Kolkata (as was the case during the season of 2002) to step from an Assyrian palace of Mesopotamia to the Sanchi stupa in Garia, from the Dilwara temple of Mount Abu in Jodhpur Park to the Victorian Gothic structure of the Calcutta High Court on Anwar Shah Road (figure 3), or to suddenly move away from all these imposing edifices into paddy fields, village huts, and the famous

3
Remake of the Calcutta High Court in a park on Prince Anwar Shah Road, in south Kolkata, 2002.

Pather Panchali train scene. It is equally routine to encounter chandeliers, marble walls, and carpeted floors and staircases inside *pandals* simulating an old temple or a mosque. Neither for the viewers nor for the creators is there any great burden of authenticity. The copy stands in its own right, a replica to be accepted with all its local accretions and glosses. The Pujas offer "heterotopias" of a particular order, a curious mix of the many types identified by Foucault. The closest parallels are possibly with the theatre – for, as on the stage, everything here is no more than a simulation of real places and structures, illusions created out of bamboo scaffolding, cloth, thermocol, or plaster – or with the fairground, in its markedly transitory, chronic existence, where the "eternity of accumulating time" is experienced by fair-goers across stalls, booths, and performances as a passing event.

It is this fleeting ephemeral character which is most distinctive of the Durga Puja tableaus of Kolkata. It is the knowledge that the spectacle will disappear in no time – since ritual demands that every Durga icon, however beautiful the ensemble, must be immersed at the end of the Puja, just as police regulations ensure that every *pandal* structure, however expensive and grand, comes down within a stipulated time – that makes for the specially frenetic forms of mass participation and spectatorship in the event. Over the past years, we have also seen how the announcement of prizes for *pandals* by Ashtami (the third main day of the Puja) creates its own dynamics of mass movements across the city, making for all-time high congregations and queues around the award-winning *pandals*, especially on the last two nights of the event. Even in a city notorious for its crowd and congestion,

the sheer scale of the movement of people across the length and breadth of the city on these festival evenings and nights surpasses all records. In striking contrast to the chaos of everyday life, what is also remarkable is the control and self-regulated nature of this flow of mass spectators as it moves from one viewing complex to another. All of Kolkata becomes one gigantic heterotopic fairground or exhibitionary complex – where the city sprouts a new festival map for touring, where the rituals of what has been termed "*pandal* hopping" involve relentless walking, merrymaking, eating, and grouping with friends and family.

This identity of Durga Puja as a secularized festival and the city's most spectacular mass public event is now commonplace. Over many years now, the focus shifted from the idols inside to the grandeur and extravaganza of *pandal* structures and lights, with the traditional *ek-chala* (single-frame) ensemble of the goddess giving way to new more "filmic" renditions of Durga, Lakshmi, Sarasvati, and the Asura – the last in particular taking on a range of popular villainous appearances. While the big Puja organizations vied with each other to construct larger and newer types of *pandals*, the lighting (the key attraction of certain mega-Pujas like College Square, Sreebhumi, or Jodhpur Park) specialized in capturing the most contemporary events of that year, ranging from the very local, to the national and the global. It thus became routine to expect to see, every Puja, in crude lighted sequences events ranging from the mauling of a drunk man by a tiger inside the Calcutta Zoo, to the assassinations of Rajiv Gandhi or Phoolan Devi, the parallel deification of Princess Diana and Mother Teresa in the year

of their death (1997), or the destruction of the twin towers of the World Trade Centre in 2001. What is equally well-known is the phenomenon of awards and the resulting spirit of commercialization and competition that have over the years become dominant features of the city's contemporary Durga Puja scenario. Since the 1980s, the growing involvement of the corporate sector and the institution of a large range of prizes for the best, biggest, and most artistic Puja (beginning with the Asian Paints "Sharad Shamman", which still remains one of the most prestigious of all the Puja awards), have created a new trend of what is now widely referred to as the "award-centric" Puja. This category of endeavour now rides high with almost every neighbourhood and Puja organization inviting newer and newer claimants. Once decried by most Puja authorities, contests and prizes are today clearly accepted as the central platform for the mobilizations of funds, fame, and publicity – as something integral to today's new commercial, corporate identity of the festival, also providing, it can be argued, a chief boost to the new "artistic" profile of the phenomenon as is now widely acknowledged. The age of sponsors and wards and the age of the "art" Pujas stand one and indivisible.

FROM "GIMMICK" TO "ART"

It would be obvious to all close observers of today's Durga Puja in the city that the event now demands a new order of aesthetic scrutiny and analysis – that there is an immense need to move beyond its generalized image as commercial public kitsch, and to reinfuse into the phenomenon certain critical notions of "quality", "taste", and "creativity" as differential attributes which are now actively claimed by new groups of

organizers, producers, and publics. What this involves, above all, is a breaking apart of the notion of the spectacle as a unitary, undifferentiated mass, something typically faceless and standardized. In the case of the Pujas, it becomes critical to underline the way new ethnic tastes and artistic trends have been furrowing this social and cultural space of festivity, creating new divisions and hierarchies, bringing into the fray novel types of producers and alternative notions of public art, searching out a more discerning viewership. At the centre of these transformations is a spreading wave of a new genre of what can be loosely termed "art/designer" Pujas – a wave that has been on the rise over the past three–four years in particular, where what is at stake, I would argue, is a radical redefinition of the very notions of "art", "artist", and mass spectatorship.

In Kolkata, this category of the "art" Puja is not in itself new, and has a specific lineage. Since 1975, it has been associated primarily with a club in Bakulbagan in Bhowanipur (one of the old aristocratic, upper-middle-class neighbourhoods of the city), which made its name by commissioning the city's well-known artists to design the central Durga ensemble. In marked distinction from the ostentation and excesses of the other Pujas around it, the *pandal*s at Bakulbagan were always simple and functional – the emphasis was entirely on the artistry of the icon, created over time by a number of established artists from the city. From this select occurrence, the "art" Puja came to later manifest itself as a cognitively different and proliferating trend – one that has mushroomed across different localities of the city, challenging the established centres of fame and popularity, marking out its own distinctive identities, laying out its own select

map and route for the discerning viewer. Many of the creative personnel involved refer to such Pujas as "theme" projects (similar to the idea of "theme-parks"), where the Puja in its entirety – the *pandal*, the image, the lights, the colours, the ornamentation, and even the music – is conceived of and laid out with an integrated theme by an art designer and his team. The tableau takes on here the form of a tightly-designed set, often no less of a hybrid melange of histories, styles, and objects but presented nonetheless as a single concept.

I focus in this essay on a small selection of such special "theme" Pujas from the festive season of 2002, in different localities stretching from the deep south to the centre and north of the city. Let me state here some of the key issues I wish to highlight through these case-studies. First, I would like to focus attention on what emerges as a complex and rapidly expanding new space of popular artistic production and consumption in the city. What we encounter is a highly layered world of new kinds of artists, designers, and set-producers, ranging from the successful art-college-trained professional, the local intellectual, the amateur, and the school-teacher to an emergent group who stand ambivalently strung between identities of "artist" and "artisan". These types are all entering this new field of Durga Puja designing side by side (sometimes in collaboration, more often in competition) with the established circuits of the hereditary idol-makers of Kumartuli and the suburban firms of *pandal*-decorators. Here is a city whose contemporary art scene cannot be described as anything but provincial and mediocre, where there are few professional outlets in art, design, or the audio-visual media. This is where the transforming nature

of Kolkata's Durga Puja seems to have opened out a new avenue for creative expression, earning, and acclaim for many of the city's art-students, artists, or film and television set-designers, even as it has confronted the traditional Kumartuli idol-making trade with new aesthetic choices and new spectres of competition.

The second key issue I wish to draw attention to is an increasing focus within these new Puja themes on the "dying" categories of different endangered rural and folk art forms – whereby the new creed of designers and artists act as the main conduit for drawing in communities of village craftsmen and artisans from across India to work both on and off site on the design and decoration of *pandal*s. It is this fashion of "going rustic" that has come to predominantly shape the new chic-ethnic profile of the city's Durga Puja. The Puja here has become a popular surrogate of the urban crafts mela or emporium, a place where folk arts and crafts are there to be both seen and bought, where craftspersons themselves can be encountered at work, where the middle-class cognoscenti descend on the *pandal* site to mix and blend with the general crowds. Over the years, this rural and folk art wave took on a range of dimensions across Kolkata – in 2002, for instance, we saw entire Pujas focused around particular traditional craft-forms of Bengal such as scroll-paintings, clay circular plates (*sara*s), or intricately carved wooden printing-blocks; or, we could walk through a full crafts bazaar complex displaying 14 mini Durgas each in a different medium – clay, wood, bamboo, jute, *patachitra*, or *kantha* – building up to the main idol encased by a Bengal terracotta temple (figures 4 and 5). The thatched, storeyed structure of the Bengal hut was one of the marked favourites

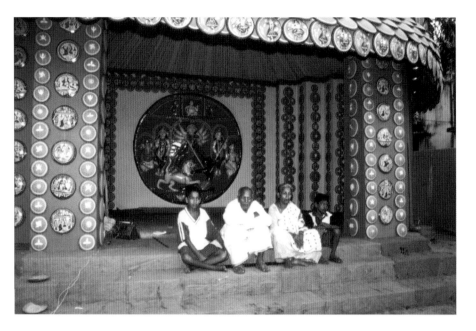

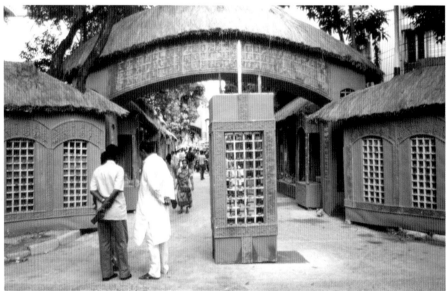

for *pandal* design in 2002 (figure 6) while in another tableau, entire paddy fields and village markets were simulated in the most congested heart of Kolkata.

The third issue I would like to underscore is the way this growing trend of deployment of crafts and folk arts has (among other trends) worked out new fine lines of distinction between "art" and "gimmick", between what an initiated few would recognize as a markedly "artistic" venture, and what the masses would respond to for sheer

4
The *pandal* and image designed with clay circular *sara*s of the Barisha Yubak Brinda Puja, Behala, 2002. Also in the picture are Bengal's oldest surviving *sara*-maker (second from left) and his family from Nadia.

5
The crafts bazaar complex titled "Sonar Bangla", which featured 14 small Durgas, of the Bakulbagan Club Puja at Bhowanipur, 2002.

novelty and sensationalism. This is, of course, an ever-ambiguous and contested line of divide, where we have often broadly the same resource pool of artists/designers operating at both ends of the spectrum, and where the claims of artistry and creativity, we find, surface across all these varied categories of Puja *pandal*s and images. Yet, I would argue, this distinction between "art" and "gimmick" is a trope that is repeatedly brought into play each year by the media, the sponsors, the award-givers, and the publics they create – in marking out different brands of Pujas and new market trends and tastes. Thus, on the one hand, every year, we have certain groups of Puja organizers struggling to outdo each other in terms of sheer novelty (or one could say, sheer absurdity) of the medium they pick for their *pandal* construction and decor – materials ranging from broken

6
The Bengal hut-style *pandal* of the Samajsebi Club on Lake Road, 2002.

bangles, buttons, peacock feathers, and shells to homeopathy medicine bottles, biscuits, earthen tea-cups, broken gramophone records, or sugarcane fibres.

In 2002, the last two materials made the biggest news and made for the two most popular *pandal*s, each standing in strong rivalry with the other at a prominent location on the connecting road to the city's Eastern Metropolitan Bypass, marking out a new locality that then had very recently joined Kolkata's Puja landscape. The biggest success story here has been that of the Bosepukur Shitala Mandir Puja, which has in the past few years shot into increasing limelight for *pandal*s made first of playing-card replicas, then of actual earthen tea-cups, and then, to the greatest publicity, of sugarcane fibres. For the Puja organizers and its main designer, each of these materials chosen have carried a distinct social message about the recyclable and even "art" value of everyday throwaway items – the idea, we were told, was to bring an item like the earthen tea-cup from the roadside stall into the middle-class drawing-room. And, for a locality once shunned by the city's elite upper-middle class and big corporate sponsors, the giant Thums Up bottle now proudly standing atop their *pandal* said it all, as did the record queues of people from all over the city, on whose itinerary the Bosepukur Puja now routinely features. However, at the same time, the "theme" Pujas too have held their separate select ground – and it was in distinct contrast to the gimmicky upstart image of the Bosepukur Puja and its designer, that the "art" Pujas I have picked for discussion below marked out their discrete counter-identity.

The final issue I would like to throw open through these case-studies is the

moot theme of local identity and pride and the ways in which a new sense of locality and neighbourhood gets reinscribed or reinvented in the city in the space of these "art" Pujas. In keeping with earlier times, the Puja is still primarily the enterprise of the *para* club with its senior circle of Puja organizers, *para* subscriptions (while this is an increasingly small percentage of funding vis-a-vis advertisements and corporate sponsorship, its token and symbolic value still remains high in the self-image of the Pujas), and, often, an artist/designer who is resident of the locality. In the new festival map of the city, we see fresh, often non-elite, localities staking out their place and acquiring a new identity, however temporary, through the distinctiveness of their Pujas. But what also need to be addressed are the many simultaneous processes at work in the recession and marginalization of the "local" in the competitive cultural politics of the Pujas. As many small club Pujas have catapulted to new heights of publicity through their "art" and their succession of awards, the local identity of such Pujas has often been little more than nominal. This can be seen in the manner in which artists and designers, having made their mark in their own *para*s, are now up for grabs by Puja organizations in far and distant pockets across the city – or in the ways in which media-publicity and prizes have come to swamp these local Pujas with non-local crowds and viewers who are totally out of tune with space, culture, and topography of the neighbourhood.

THE CASE-STUDIES
A Madhubani Village in Behala

Let us begin our quick tour of the selected "theme" Pujas of 2002 by visiting one

such newly configured neighbourhood that has risen to greater and greater prominence on the "art" Puja map of Kolkata: this is the neighbourhood of Barisha in Behala in the far south of the city (which coincidentally also lays claim to the city's oldest family Puja of the Sabarna Roychowdhurys). That Puja season, the Shrishti Club of Barisha presented us with one of the most complete simulated village sites of the season. Along with Madhubani wall paintings by a group

7a, b
(a) Urmila Devi, the chief artist of the "Madhubani village" created by Amar Sarkar for the Barisha Shrishti Club of Behala, 2002. (b) The re-created huts and painted walls of the "Madhubani village", showing different styles of the pictorial tradition.

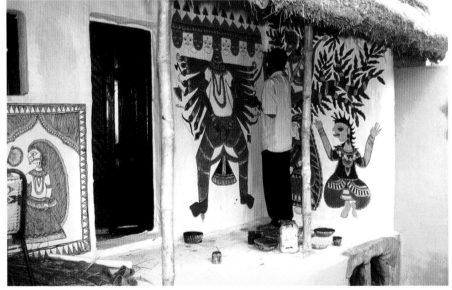

of painters, a whole Madhubani village was grafted on to the site of this *pandal* in what was widely acclaimed as one of the biggest "hits" of that year's Puja. For the organizers of the Puja, the idea was not just to present viewers with a variety of Madhubani paintings (which are familiar, widely-circulating items in Kolkata fairs and emporiums), but to reconstruct the paintings in their authentic setting, and to draw the public into the ambience of a Madhubani village in the midst of the crowds and traffic of Behala. To clinch these effects, a family of painters from the village of Jitawarpur – Urmila Devi, her husband, son, and daughter – were brought in as key personnel to prepare the mud wall facades and execute all the clay relief motifs and wall paintings on site (figures 7a, b).

As with most of these "theme" Pujas, the entire Puja tableaus of the Barisha Shrishti was based on research, fieldwork, and authenticity. We were informed by the chief designer about

the intensity of his surveys in the villages of Madhubani, carried out months before the Puja to search out artists and forms, along with his own library and museum research on the art tradition. We were also introduced to the different caste-based genres of Madhubani art that were carefully assimilated and blended within this Puja site – from the line drawings and coloured paintings that are normally executed by the upper-caste Kayasthas to the Godhna work on the beautiful ceiling canopy, that is the special art of Dalit painters like Urmila Devi and her family. (Godhna work is associated with the earlier practice of tattooing the hands and bodies of Dalit women to protect them against sexual exploitation by British officers and landlords.) At the centre of this village site was the Durga icon, placed under a thatched hut pavilion – an innovative folk-style puppet icon, conceived in close harmony with the Madhubani art around it. This icon was the handiwork of a local art-

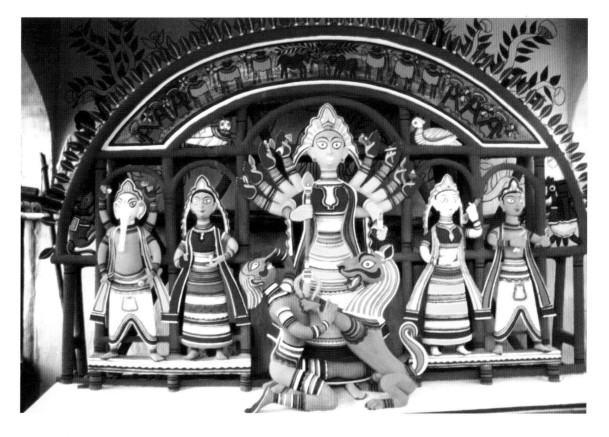

8
The Durga idol made by Bhabatosh Sutar for the "Madhubani village" of the Barisha Shrishti Club, Behala, 2002.

school trained artist who worked on it in tandem with the village painters (figure 8).

The credit for the Barisha Shrishti creation rested with a local designer duo of Amar Sarkar and Bhabatosh Sutar, the former as the key concept person, the latter as the chief artistic executor and maker of the central idol. Both presented themselves as trained professionals, the former a senior art teacher in a Government school, the latter a young art student who had then just graduated from the Government School of Art, Kolkata. What is important to note is the way their kind of initiative has come to signal a wider phenomenon of a regional "art revival" rippling across all of Barisha and its vicinity. Their Puja emerges as but one of many such theme- and craft-oriented Pujas taken on by clubs across the locality, featuring since 1999 various innovative themes such as Durga as a cave deity with relief sculpture, or the Durga pantheon represented as masked Purulia Chhau dancers, placing other local art talents side by side with those of Amar Sarkar and Bhabatosh Sutar. During the Pujas of 2002, it was in and around the Barisha Shrishti Puja that we saw, for instance, the clay *sara* pandal of the Barisha Yubak Brinda, and, right across the road from the Madhubani village, the award-winning *pandal* structure of the Sahajatri Club, featuring wooden printing blocks. The idea, as Amar Sarkar took pains to explain, was to produce in Behala a concentrated cluster of this new genre of artistic Pujas, to rival other clusters of spectacular Pujas in south Kolkata – to pull the crowds away from these centres, to draw (as he said) the attention of "corporate Calcutta" to this socially humbler neighbourhood. The agenda has certainly had its effect, giving Behala its distinctive artistic niche in today's festival map of the city.

But Behala as the centre of a local art revival, we find, has also bred its own share of antagonisms and rivalries (as is only to be anticipated). Let me introduce here a second key local figure – Subodh Ray, one of the main brains and hands behind the area's "art" and "craft" Pujas. He earlier worked with the young Bhabatosh Sutar (a boy he claims as his discovery and protege) for different clubs on some of the area's most novel Pujas (like the cave Durga or the Durga of the Chhau masks), till Bhabatosh left to join Amar Sarkar and the Barisha Shrishti Club. With Subodh Ray, as with Bhabatosh Sutar, we are forced to rethink our middle-class social parameters of an "artist". Bhabatosh, we are told, was a van driver in the mofussils of Behala. The young Bhabatosh's artistic talents, Subodh Ray told us, were "discovered" by him and his wife. He was brought by them to their home in Kolkata and put through the Government Art College. In his own case, Subodh Ray recounted how he had begun to financially support his family from his teens by constructing traditional Durga idols at home and supplying them to the local clubs of south Behala. Although he has an Indian art college degree to his name, he today earns his living as an employee of the Kolkata Municipal Corporation, while etching out since the 1990s a parallel career as a Durga Puja artist and designer. He works today as a team with his wife and another artist, Ramnarayan Ray. His wife, we are told, does the research around the theme; Ramnarayan with his deep knowledge of the scriptures and iconography provides the main fund of ideas on the various forms of Devi; while Subodh Ray specializes in the work of artistic conception and execution. In recent

years, he has emerged as one of the most coveted designers on the Puja market, riding new heights of success and publicity with a spectacular Kerala dance village he designed for New Alipore's Suruchi Sangha Puja in 2003 (figure 9). By this time, his stature in the field of Durga Puja designing was further marked by the fact that the Subodh Ray team was in demand not just in Behala, but was also commissioned to design Pujas in other far-removed neighbourhoods.

9
Durga and her entourage represented in various Kerala dance forms, designed by Subodh Ray for the Kerala dance village he created at the Suruchi Sangha Puja in New Alipore, 2003.

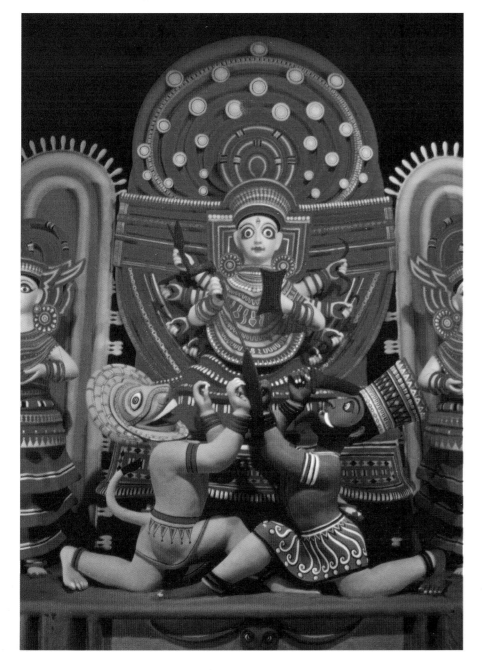

Titumeer's Fort at Dhakuria

Let us now follow this artist out of Behala to a Puja site in the more central south of Kolkata, in the interiors of Dhakuria, another distinctly middle-/lower-middle-class locality, where we encounter a historical tableau he executed, of an altogether different kind and scale. The Babubagan Puja is older than most of the ones at Behala, going back 40 years, with a more established lineage also in the award-winning circuit. Of all its initiatives, however, it was the novelty of the Titumeer theme, alongside the grandeur of its visualization, which made it one of the most visited and talked-about Pujas of that year. To give concrete structure and shape to the bamboo fortress, said to have been constructed by the Muslim millenarian rebel leader of rural Bengal, Titumeer, in 1831, was a feat of imagination (figure 10). We have no historical visual representations of this short-lived fortress, nor any surviving remains, except a mound associated with the structure at Narkelberia in the South 24 Parganas, the site of Titumeer's legendary rebellion that finds only a passing reference in textbooks. The imposing bamboo edifice in the local park at Babubagan symbolized the rural folk hero's gutsy defiance of the might of Bentinck's army, a tribute also to a structure that was felled in a single night by a few cannon shots.

It took an even greater flight of imagination, I would say, to appropriate the figure of Titumeer – a militant *jehadi*, an Islamic puritan and iconoclast by all accounts, the terror of Hindu zamindars and rich peasants – into the space of a Durga Puja *pandal*. Yet, history, it seemed, could easily be turned around to refashion popular memory. For Subodh Ray, the choice of Titumeer was made in a clear-cut present-day stance

10
Titumeer's bamboo fortress re-
created at the Babubagan Club
Puja in Dhakuria, 2002.

11
Clay models of armed peasants
standing sentinel at Titumeer's
fortress at Babubagan,
Dhakuria, 2002.

of anti-communalism. Titumeer became
in this Puja, as he often has in latter-day
nationalist accounts, an archetype of a popular
Muslim anti-British rebel, to be retrieved
and reinstated from our nationalist past. It is
with this introduction to the village Muslim
hero and his heroic resistance that viewers
entered, first, the outer court, and then the
inner ring of the bamboo fortress, where they
saw occasional clay figures of armed peasants
and *lathiyal*s (figure 11), and eventually a
central statue, not of Titumeer, but of a
multi-armed Bharat-Mata (as his curious

surrogate), standing in front of a little well in
which viewers generously dropped coins. And
at night, the entire structure would be lit up
with what looked like village lanterns, and the
music played to the tune of drum beats and
bugle calls of war, to give the place the eerie
ambience of a rural battle-sieged fortress.

In this historical tableau, the central
ensemble of the Durga icon, placed once
again under a thatched hut, came as the
firm reminder that this was, in the end, a
Puja *pandal* (figure 12). It also stood out in
sharp contrast to the "realism" of the clay

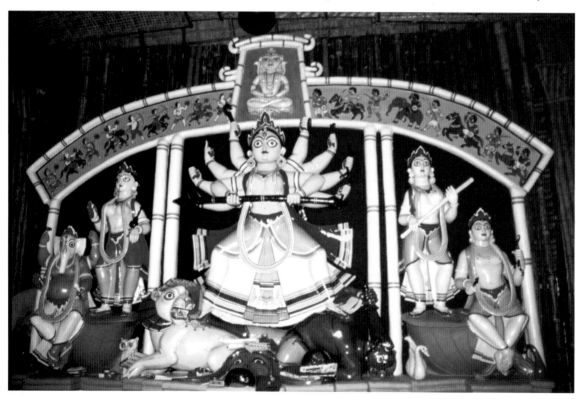

12
Durga in a martial dance
posture, conceived and
executed by Subodh Ray,
within Titumeer's fortress at
Babubagan, Dhakuria, 2002.

figures of the guards and Bharat-Mata, as another unique "artistic" creation. Much of its style and colours not unlike the folk-art icon that graced Barisha's Madhubani village, the Babubagan Durga however (in keeping with the Titumeer theme) exuded a distinctly martial quality, conveyed most forcefully by the dancing posture of the goddess's legs and arms and the horizontal thrust in which the *trishul* (trident) was held. Subodh Ray explained how he had visualized this Durga icon through a *bol* (chant) of a local martial dance form of southern Bengal (the Dhali Nritya *bol* of the Jujur Girja dance of the Raibenshes), that had been first collected and recorded by the ICS officer and folk-art collector, Gurusaday Dutt, in the 1930s. Once again, we see the great premium placed by the artist on research, his deep knowledge of local art forms, as well as the creativity of his own Durga icon. While the bamboo structures and thatching were done by artisans specializing in these crafts under Ray's close supervision, the Durga idol, he emphasizes, was entirely made by him and his artist-friend Ramnarayan Ray. To mark his own difference from his Behala rival, Amar Sarkar, or other set-designers in the field, Subodh Ray underlines his own role as a "hands-on" person, who not only designs but also crafts, models, and paints side-by-side with his artisanal team.

A "Communal Harmony" Pageant at Hindusthan Park

Such comparisons and contrasts bring us to our next selected Puja site at Hindusthan Park, an elite, now largely non-Bengali neighbourhood in the heart of south Kolkata, just off the Gariahat junction – where we encounter now a new more razzmatazz take on the theme of anti-communalism and a

set-design professional of a markedly different brand. In moving from Barisha Shrishti to the Babubagan Club, to the Puja of Hindusthan Park, we have moved to higher and higher budget enterprises – also to new more visible stamps of corporate sponsorship and to a type of impersonalized Puja (as we see in Hindusthan Park) that has only nominally to do with the neighbourhood although it takes its cue from it. In 2002, the Hindusthan Road Puja vied for attention with the other well-known elite Pujas of south Kolkata (those of Maddox Square, Ekdalia Evergreen, Dover Lane, or Lake View Road), competing with the established popularity of these Puja sites and their spectacular *pandal*s and images. Much of this attention, no doubt, had a lot to do with the fact that senior journalists of the biggest Bengali newspaper (*Ananda Bazar Patrika)* were prominent among that year's Puja organizers at Hindusthan Park. And it was in keeping with their interests and tastes that art-director and designer Gautam Basu (whom they commissioned to design their Puja) produced here a specially media-savvy "theme" Puja.

Contemporary political issues have always regularly featured within the space of the Puja *pandal*s – for instance, a Park

13
The "Communal Harmony" tableau, with its blend of temple and mosque architecture, and an image of the Gujarat riot victim at the entrance of the arcade – designed by Gautam Basu, at the Hindusthan Road Puja, off Rashbehari Avenue, 2002.

Circus *pandal* was modelled on the Bamiyan Buddhas, with Durga inside carrying no weapons but only flowers in a gesture of peace. At Hindusthan Park what came to be set up was a free-standing melange of the architectural styles and decor of a temple and a mosque, to highlight at every stage the rich "cross-fertilization of Islamic and Hindu cultures". Unlike other set-designed Pujas in the city this year, where the focus was on the authentic remake of a specific ancient structure like the Dilwara temple of Mount Abu at Jodhpur Park or the ruined Chausath Yogini temple near Bhubaneswar at Lake Temple Road, Gautam Basu planned his ensemble as a deliberate pastiche. So the side walls of a temple were juxtaposed with the arched gateway and dome of a mosque; in the decorated screens leading to the gateway, Hindu *ras-leela* motifs were interspersed with Islamic calligraphic design and lattice-work; even the earth and ochre tones of temple walls were set off by the bright blues and greens used in Persian mosques. To add to the spectacle, there were stained-glass panels on the sides with portraits and sayings of typical secular icons: Kabir, Lalan Fakir, Nazrul, and Gandhi. These blends culminated around the image of Durga, which the designer said was inspired by the style of Mughal miniatures, her sari taking on the patterning of a Persian carpet (figure 14), Kartik and Asura too being garbed in so-called "Muslim attire". The effects, as we can see, were suitably "filmy" and postmodern: a mix of many things, a measure of none in particular. And to foreground the theme of communal violence, the idol at the far end was played off at the entrance by this most famous media photograph of the Gujarat carnage: the face of Qutubuddin Ansari pleading for mercy (figure 13).

The designer of this tableau, Gautam Basu, stands in distinct social contrast to figures like Bhabatosh Sutar or Subodh Ray. A first-ranking graduate of the Government College of Art and Crafts, Kolkata, he made a livelihood in commercial art and design, worked for some years as Creative Designer for Bata, then moved on to work on pavilion

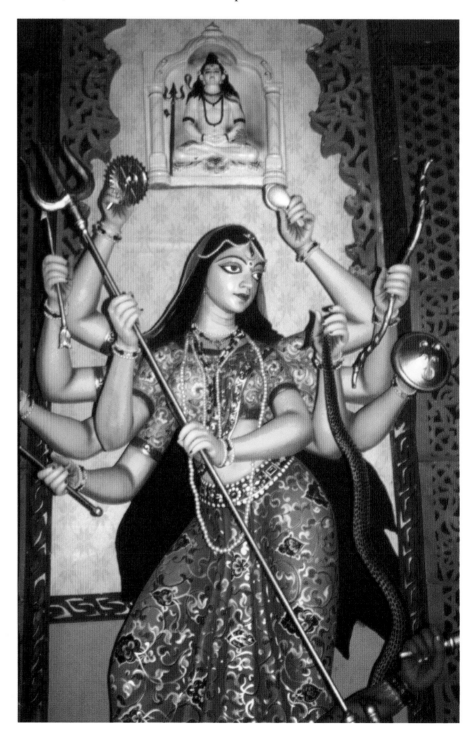

14
The "Mughal miniature-style" Durga, designed by Sunil Pal, for the Hindusthan Park Puja, 2002.

designs for industrial fairs and exhibitions, till he got his first break in set-designing in 1987 in a Mrinal Sen film. After this he worked regularly as the film set-designer of Mrinal Sen and Aparna Sen. Gautam Basu turned to *pandal* designing for the first time in 2002, when Mrinal Sen referred his name to the Bakulbagan Puja organizers (who were in search of a new kind of "art" Puja to commemorate their 75th anniversary). The same year, the *Ananda Bazar Patrika* journalists approached him to take on the Hindusthan Park Puja. Several years of experience in three-dimensional pavilion and set designs made him, like several others in the film and television profession, a choice pick of big Puja organizers in search of "new-look" Pujas.

For the crafts village *pandal* which he designed that same year for Bakulbagan (figure 5), Gautam Basu had to rope in various groups of rural craftsmen; at Hindusthan Park, however, he pressed into service his own trained work team from film and television sets to faithfully execute his scheme from his lay-out drawings. At Bakulbagan, he had left the main idol to be constructed in the traditional mould with gold decorations by one of the biggest names in the current Kumartuli idol-making business, Sanatan Rudra Pal. This combination, in his opinion, did not quite work in the way he had hoped. He pointed out the contrast with the Hindusthan Park enterprise, where another artist Sunil Pal, with a studio also in Kumartuli, produced the Durga in the very form in which Basu had visualized it. It is interesting that while Gautam Basu easily refers to Sunil Pal as a "sculptor" and an artist in his own right, Sanatan Rudra Pal (today, the single most sought-after idol-maker of

Kumartuli) remains, in his eyes, tainted by the demands of mass-production. This is a theme to which I will briefly return, at the end.

A Tantric Tree Shrine at Hatibagan

My final case-study of an "art" Puja of 2002 presents another scenario of sharp contrasts. As one moves from the elite neighbourhood of Hindusthan Park of south Kolkata to a narrow dingy alley of the distinctly down-market lower-middle-class vicinities of Hatibagan in north Kolkata, the difference presents itself most sharply in the changed social picture of the locality. A hub of petty traders and shopkeepers, Hatibagan remains entirely outside the elite professional or residential circuits of the city. Its Puja (organized by the Hatibagan Sarbojanin Durgotsab Samiti), although it dates back to 1935, came into the limelight only recently, as it made its mark on the emerging Durga Puja "art" scene. Distinct from the other "art" Pujas I have considered, Hatibagan's presence has remained unostentatious and low-key. Its appearance on the "theme/art" Puja circuit was entirely propelled by the initiative of a young resident artist named Sanatan Dinda – whose social background places him in a far humbler milieu than the likes of Gautam Basu, more in the company of artists like Bhabatosh Sutar or Subodh Ray. Coming from a poor family resident in Kumartuli, growing up in the midst of the idol-making trade (a background which Sanatan Dinda subtly and quickly glosses over), it was his training in the Government College of Art in Kolkata which made for his transformed self-identity and professional standing as an "artist". With many gallery exhibitions of paintings and sculpture and even so-called "installation art" to his credit, it is his

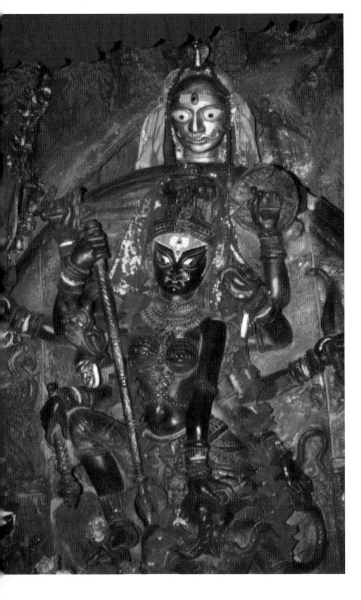

images he created for the Hatibagan Puja during 2000 and 2001 (drawing on his experience of visiting several small tree-shrines throughout Odisha [Orissa]), Sanatan Dinda in 2002 came up with the idea of a Tantric Devi manifesting herself beneath an ancient tree. Central to his tableau was the fabrication of this artificial tree in a narrow Hatibagan alley, and its complete naturalization within its surroundings. A gateway in thatch and bamboo, with embossed images of temple-sculpture-like figurines, and niched wall panels carrying geometric *yantra* motifs, led viewers up the path to the tree-shrine and a relief Durga image on what appeared as a black granite stone-slab. In a deliberate abandonment of bright colours, the artist's intention here was to re-create the effect of the Pala-period black stone images of Bengal and Bihar, and of a *shalagramshila bigraha* (a non-anthropomorphic sacred stone), with silver eyes and a brass Shiva *mukha* crown offsetting the dark stone (figure 15). Cracks on the body of the idol, and the smearing of

15
Durga image, designed by Sanatan Dinda, re-creating the look of a Pala-period black schist sculpture, at Hatibagan, 2002.

16a, b
(a) The colourful *pandal* facade.
(b) Durga as Ganesh-Janani, created by Sanatan Dinda, for the Nalini Sarkar Street Puja at Hatibagan, 2003.

standing as an "artist" that Sanatan Dinda sees as having established his position in the new field of "theme" Pujas, bringing to it a new order of artistic conception, knowledge, and research, specifically on the traditional Tantric iconography of the Devi.

Not unlike many of his art-school-trained co-workers, his discourse on the ideas he conceives and the work he executes is thick with rhetoric, on the one hand, about his artistic genius, and, on the other, about his deep religiosity and spiritual understanding of the cosmic forms of the goddess. Following the success of the special Tantric-style Durga

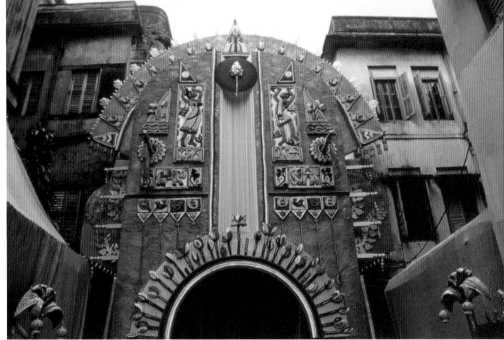

oil, *sindhur*, turmeric, and sandalwood paste were all meant to add to the sense of an old and much-worshipped icon in a shrine.

There is an emphatic blend of the dual prerogatives of "art" and "worship" in Sanatan Dinda's positioning of his Durga Puja creations. His work at Hatibagan, he claims, has always been largely a labour of

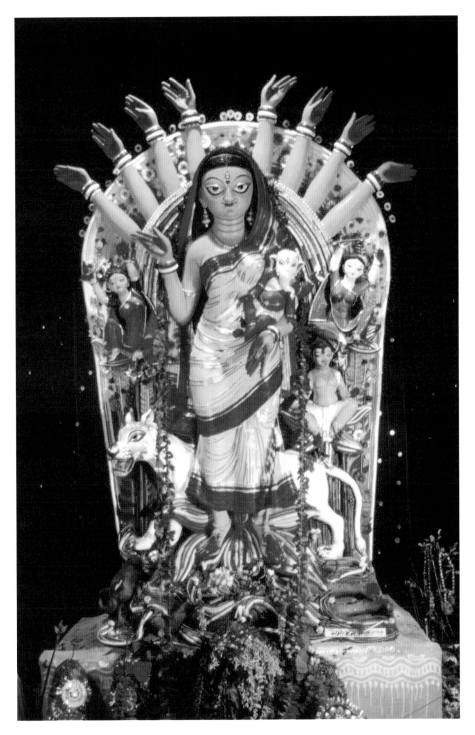

love, driven only by his artistic urges, with little financial support coming either by way of *para* subscriptions from the club or corporate funds. Each year, a large chunk of the funding for his enterprise has come out of his own pocket. Yet, he narrates with pride how, when the Bangkok National Museum wanted to buy the Durga idol from the Puja committee for approximately Rs 1–1.5 lakhs (finally selecting this image out of 40 shortlisted ones), he stubbornly resisted – on the grounds that his Durga Puja image, however artistic, was created to be worshipped and immersed, that he could not allow it to be reduced to a sale item or a prize category. Already in 2002, he said he was working for the Hatibagan Puja despite the fact that the committee still owed him large sums of money from the previous year. With no prizes coming his way that year, and treated roughly by the Puja organizers, Sanatan Dinda decided in 2003 to finally shift his allegiances and design a Puja for a neighbouring club, barely three streets away. Here, he created a colourful folk-style *pandal* with relief images and decorations, and a radiant maternal Durga as Ganesh-Janani, with eight of her ten arms forming an unusual halo around the icon (figures 16a, b). Not to be left behind in the competition, the old club at Hatibagan kept going their newly-found "art" Puja identity, also honing in on the theme of Bengali motherhood in their conception of the *pandal*, buying the services of another professional art-school-trained designer from a different locality, Sushanta Pal, who had been Dinda's junior at the Government College of Art.

COMPETING CLAIMS OF "ARTISTIC" PRODUCTION

Such stories of switched allegiances and rivalries, of free-floating talents and

their outpour of innovative themes and designs, have become typical of the radically transfigured visual culture of Durga Puja in the city. In most cases, what seems to be centrally at stake is the projection of new identities of "art" and "artistic" creation, and a bid for new kinds of discerning viewership and patronage. Bred within and feeding off the ritual event of the Puja, such stakes and claims can today be seen as pushing at the boundaries of earlier traditions. Over the past few years, one rising manifestation of such changed stances can be seen in the search for permanent homes for these Durga Puja creations. If Sanatan Dinda in 2002 expressed his avowed reluctance to allow his Durga idol to be bought as an art object and museumized, the 2003 Puja saw some of his colleagues and rivals in the field clearly bidding for their Durga imagery to find a place in city hotels and theme parks – some even investing in expensive material like teak and fibreglass for the Durga images with the understanding that these were to be bought by a hotel and not be immersed at the end of the Pujas.

Bhabatosh Sutar, who had made the "Madhubani village" Durga in 2002, and who in 2003 took on the sole charge of designing the Barisha Shrishti *pandal* and image in the style of the Bankura terracottas, was determined to preserve what he saw as his unique artistic creation (figure 17). It became one of the most artistically acclaimed productions of the season, not only of Behala but of the city's entire "art" Puja scene. In keeping with the artist's wishes, it was even ensured that the Puja rituals were performed before a small substitute set of idols that were to be immersed, leaving his sculpture (and we may as well give it that designation, now)

intact and untouched by worship. And it was seen as the greatest honour for the artist and the club when this award-winning work was selected by the Delhi Tourism Board to be transported to Delhi and installed in a new Heritage Park on the outskirts of the city. With that deal falling through, Bhabatosh Sutar's terracotta ensemble came to be transported from the by-lanes of Barisha to the sprawling lawns of one of Kolkata's five-star hotels (the ITC Sonar Bangla) on the Bypass. The Durga image then, in select cases, can be seen to be fast transcending its ritual status as a worshipped icon, to be imagined as a pure "work of art" – as a viewable and collectible object. The fact that the West Bengal government or Kolkata's municipal authorities have taken no initiative towards the acquisition, preservation, and display of these artistic creations in a museum or public park in the city is often decried by many in the media and in the Puja profession. The Durga Puja *pandals*, as we see them today, are grappling to negotiate their main new identities – as "theme-parks", as open-air "installation art", as mass spectacle, and as public art exhibitions – where the ephemeral event harbours its own little dreams of permanence, where the "local" makes a conscious bid to woo the national and the cosmopolitan.

Closely tied to this new self-image is the scenario I have described, of a rapid shifting of patrons, artists, and designers among Pujas and localities. The field is rife with stories of intense, cut-throat competition; and of "theme" imitations and piracies. In 2003, we saw, for instance, three Kerala theme-villages coming up in different pockets of the city, all focused on the different dance forms of the state. Among all of these, Subodh Ray

17
Bhabatosh Sutar's terracotta Durga image, created for the Barisha Shrishti Club of Behala, 2003 – now installed on the lawns of the ITC Sonar Bangla hotel in the city.

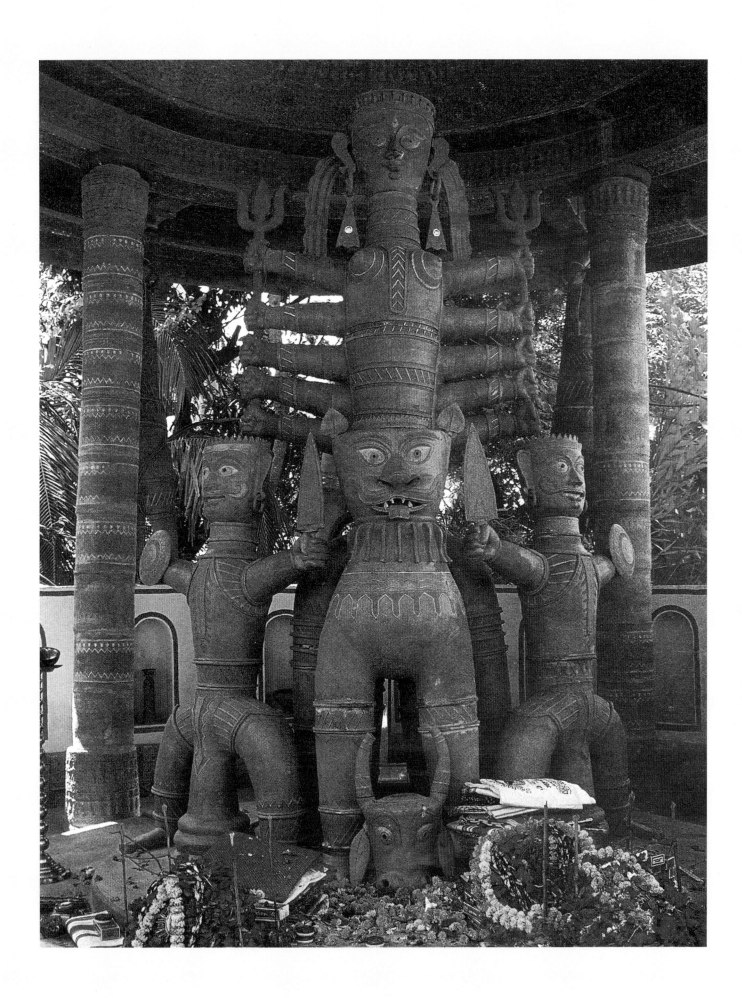

asserted his patent on the "original" idea, offering the most spectacular dance-village and the most "artistic" and "authentic" rendering of the divine group in different dance attires and postures, Ganesh and Kartik in Kathakali, Lakshmi and Sarasvati in Kudiattam, and Durga as Bhadrakali in Theyyam (figure 9). Even a cursory survey of the kinds of creative and design personnel who are today active on Kolkata's Durga Puja scenario reveals a wide and varied stock, stretching from senior established artists who have turned in recent years to the designing of Durga images (and sometimes the entire ensemble around them) to art-school products like Sanatan Dinda or Bhabatosh Sutar who look at their success in the field of "art" Puja designing as the route that may help them gain the stature of artist and access into the mainstream art world. The field also includes now a new category of designer/impresarios, who do not directly work on the images or the *pandals* but are able to mobilize groups of craftspersons from different parts of India to work on their special designed ethnic Pujas, and to smoothly handle commissions across several *pandals* in the city. The best examples of this category of production are those of the art-school-trained Gopal Poddar – in 2003 his work could be seen spread out in different parts of south Kolkata, in village tableaus representing the art of the Odisha *patachitras* at Garia; Pithora paintings and mud and mirror wall decorations from Kutch, both at Selimpur; and Kalighat paintings at Hindusthan Park. In each case, the central idols were commissioned from a city artist, with a Kumartuli background, with the design and clothing of the goddess carefully harmonized with the particular folk art-form that was set out on the surrounding *pandal* enclosure (for

example, figures 18a, b and 19a, b). At its extreme end, this category has begun to even involve a new creed of "event managers" who take on the Durga Puja project as a live five-day-long audio-visual show, staging various tableaus, based for instance on the poems of Rabindranath Tagore or plays by Utpal Dutt.

Last but not least, in the thick of this competition also stand the new transformed and modernized entity of the Kumartuli idol-making firms, represented most powerfully over the past decade by the father and son figures of Mohanbanshi, Sanatan, and Pradip Rudrapal. Rightly referred to as "the first family of Kumartuli", the Rudrapals (together and separately) command the field as the most prestigious "brand-names" in the trade, still controlling the majority of the biggest and most expensive Puja commissions in Kolkata and its vicinity. Migrating from Bikrampur in erstwhile East Bengal in the years after Partition, the family workshop at Kumartuli (Bikrampur Shilpagar) was set up by the elder brother, Rakhal Chandrapal, from which Mohanbanshi later broke away in the early 1980s to form his separate unit with his sons and establish their prime reputation in the trade (figure 20). By 2002–03, the 75-year-old patriarch of the family, Mohanbanshi Rudrapal, restricted himself to working only on small units like the goddess's face, arms, and fingers in his small room at Kumartuli, leaving the mega-images to be assembled in a larger workshop in Telengabagan, which is run by his younger son, Pradip Rudrapal. In a second branching out of their family trade, the elder son, Sanatan Rudrapal, set up in 1997 his rival workshop at Ultadanga to become one of the most coveted Kumartuli idol-makers in the contemporary field. In 2003, he and his team were handling, on an average,

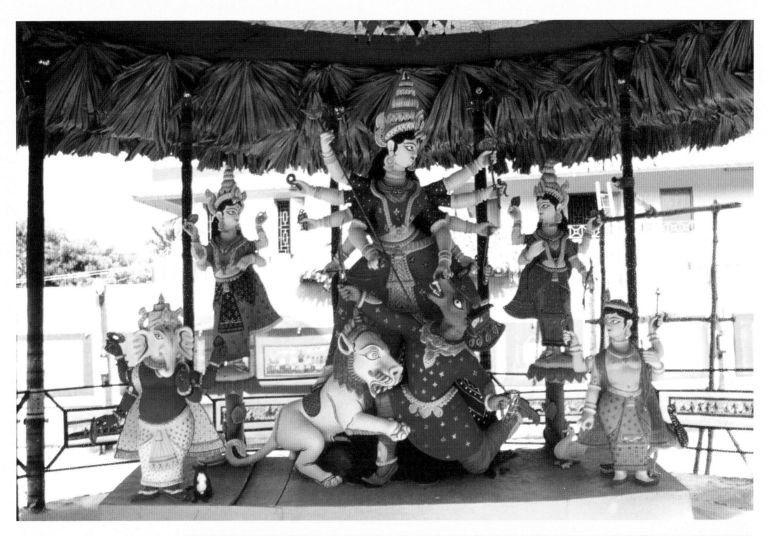

18a, b
One of Gopal Poddar's "folk art" tableaus at the Jatra Shuru Sangha Puja at Garia, 2003 – (a) Durga in an open rotunda, designed in the style of the Odisha *patachitra*s, offset by (b) examples of these Odisha paintings on the surrounding enclosure.

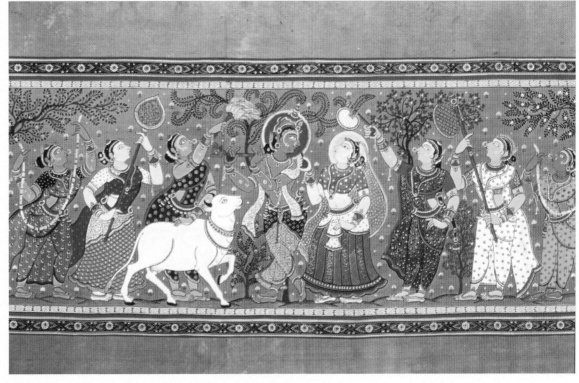

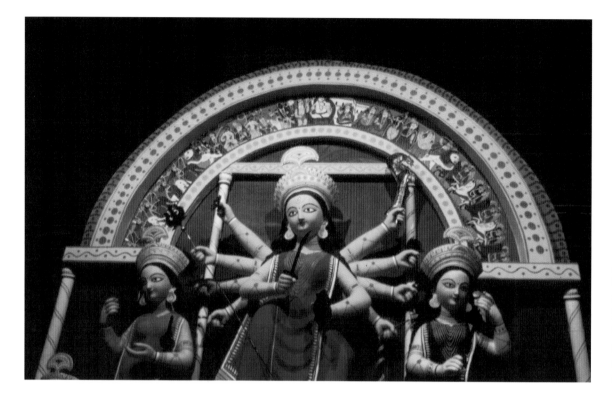

19a, b
Another Puja set designed by
Gopal Poddar, on the theme
of Kalighat paintings, at
Hindusthan Road, 2003 –
(a) the Kalighat *pat*-style Durga
ensemble matched by (b) such
enlarged Kalighat paintings
around the altar.

every season, 60–70 large image orders from
many of the city's biggest Puja organizers
(figure 21). His main internal rival today
is his more savvy younger brother, Pradip,
who, even as he continues under his father's
mantle and trade, draws on his Baroda art
school degree to subtly flaunt a more exalted
identity as an "artist". Showing a greater flair
for folk-style designs and innovations (for
example, figure 22) Pradip Rudrapal is keen to
make his own mark on the "art" Puja circuit
by working in close alliance with some of the
new genre of "theme-makers".

When one takes stock of this entire range
of creative personnel, what we encounter
is a complex and highly variegated field
of production, with marked differences in
stature, ambition, and self-image between
different orders of creative personnel. Even
within the new domain of the "art" Pujas,
there are a series of distinctions that set off
designer from designer, artist from artist,
also artisan from artisan. In conclusion, one

20
Rakhal Chandrapal, elder brother of Mohanbanshi Rudrapal, at work on the face of the goddess at his small workshop in Kumartuli, August 2003.

of the key issues that I wish to throw open for discussion is about the many competing narratives of "art" and the many contending identities of "artist" that have come into play in this sphere of Durga Puja designing and spectatorship. How far this new wave of "theme" Pujas can merit or sustain the status of an art-production remains a hotly debated question among Kolkata's "high art" circles. It is in this context of the continuous laying of boundaries and hierarchies about what is "art" and what is not, that one needs to critically scrutinize the many discourses that converge around this realm of the Durga Puja – discourses on "public art", on the "public" commitment and responsibilities of an artist, on his role in creating new aesthetic tastes and new levels of visual literacy among ordinary people, and on his contribution towards creating a new democratic genre of "installation art" in the city.

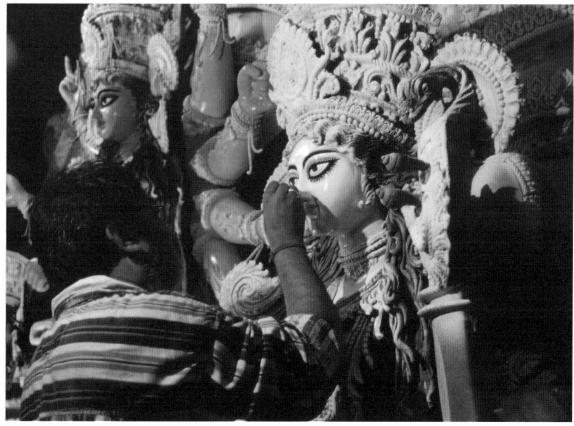

21
Sanatan Rudrapal putting the finishing touches on the eyes of one of his large Durga images, at his workshop at Ultadanga, on the eve of Mahalaya, September 2003.

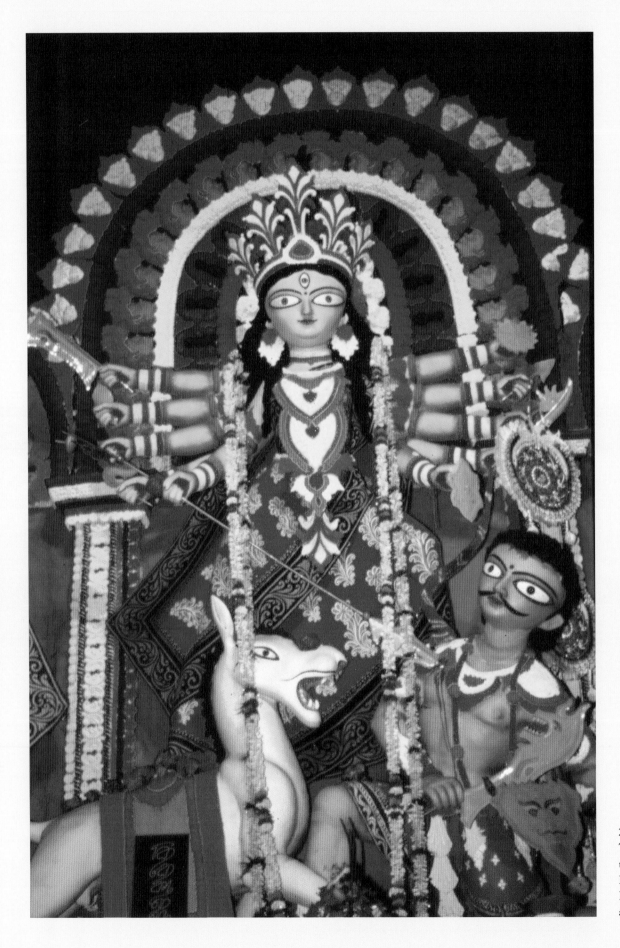

22
The Durga and Mahishasura of
the Vivekananda Sporting Club
Puja, on Simla Street, north
Kolkata, 2002 – an example of
a Pradip Rudrapal creation.

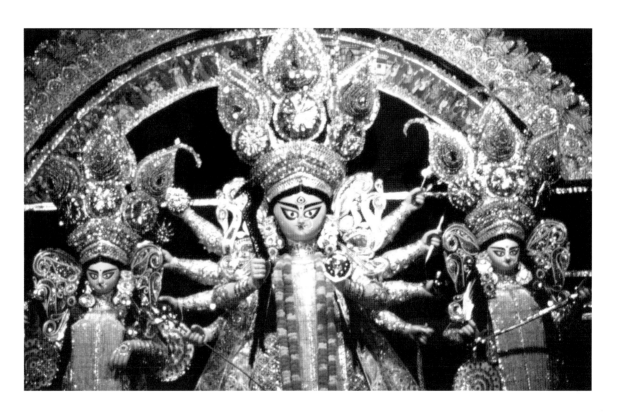

23
The traditional unchanging
daker shaj Durga of the
Baghbazar Sarbojanin Puja,
2002.

There is little doubt that the social and educational capital of many of these new artists and designers sets them apart from the mass-trade and craft of the Kumartuli artisans and the *pandal* contractors, not least of all from the folk artists they employ. This distinction is firmly ingrained in the perception of the Puja organizers and of their targeted public. Yet, what also needs to be underlined is the fragility and ambivalence of the "artistic" aura and identity that they wish to wrest for themselves by their interventions in this space of festivities. Often, this aura turns out to be as momentary or as unstable as their fame and appeal in the market. Here come in the artists' bitter stories of rough-shod treatment and unpaid dues from the Puja organizers, months after the Pujas are through, all the more bitter if no awards came their way. So there are many like Sanatan Dinda or Subodh Ray who are determined not to work for the *para* Puja any more and have made their name by moving out of their locality for bigger and better commissions. Structures and ensembles, mounted with great cost and care, are typically left homeless and forgotten after the hype of the festival. So, even after the success of the Babubagan Puja production, with Titumeer's fortress dismantled, Subodh Ray was left in a huge dilemma about what to do with the expensive mass of bamboo they had invested in, and even considered reconstructing the tableau in Narkelberia as a permanent memorial to this village hero – a scheme for which there were no takers.

Such insecurities and uncertainties become all the more apparent as one moves beyond some select artistic enclaves in Kolkata's contemporary Puja landscape to the surrounding milieu of the more routine orders, supplies, and assembly-line designs that still spill out of the workshops of Kumartuli and the region's long-standing firms of *pandal* decorators and light-makers. There are many who are clearly losing out in this rising wave

of "art" Pujas – as for instance, those who supply the standardized ornaments, headdress, and decor in zari, tinsel, or synthetic fibres for readymade idols at Kumartuli; those *pandal* decorators who specialized in intricate pleated cloth work, which once served as the main medium in *pandal* constructions; or the famous "automatic-lighting" panel designers of Chandanagar, who today face a much shrunken market for their skills and products. And, nowhere does the angst and ambivalence of new "artistic" identities manifest itself more vividly than in the shifting world of the Kumartuli trade, as it struggles to evolve to stay in tune with the transformed designer aesthetics of the "art" Puja circuit.

The Kumartuli we confront today is fast spilling outside its old territorial boundaries to spawn large new workshops for idol-construction elsewhere in the city, as in the case of the rival units of Sanatan and Pradip Rudrapal at Ultadanga and Telengabagan. The nomenclature, one can say, is less to do with the old locality, more to do with the markings of a certain hereditary lineage and skill. That heredity, we find, coexists rather uneasily with other kinds of artistic ambitions and demands, as art school training is becoming a much-coveted label among the younger generation of Kumartuli artisans, sifting from within them a new breed of innovative designers and would-be artists. The Kumartuli identity today can be seen as a fluid and nebulous one: a lineage which many are ready to shelve in their aspirations to be "artists", which some others continue to take pride in, even as they band together to form artists' groups and design "folk art" Pujas in the new "art" Puja sectors of Behala. In many cases, we see the Kumartuli master artists working in close alliance with the "theme" Puja designers,

producing idols to suit their innovative tableaus, but not without a fair share of tensions and dissatisfactions on either side.

The Kumartuli "artist" (a category struggling to be recognized) is armed with his own discourse on artistry and creativity, on tradition and innovation, and on the twin demands on his work of ritual authenticity and aesthetic appeal. Thus, both Sanatan and Pradip Rudrapal labour home the point that their creations are eventually made to be worshipped and that they remain ever-faithful to the divine image of the goddess. The former also marks out clay (the iconographically prescribed medium) as his sole medium for sculpting; he boasts of how the intricate dress and ornamentation of his idols are all produced in clay, and how he sticks to the work of creating Durga images as his forte, steering clear of the new wave of "theme" Pujas. Yet, one can also trace a variety of ethnic stylistic forms and sources that have invaded the studios of both Sanatan Rudrapal and his art-school-trained brother, to cater not only to different kinds of Pujas within the city but also to changing non-resident Bengali tastes in Pujas across India and the globe.

Let me end by comparing two images of Durga, both coming out of the contemporary idol-making trade of Kumartuli – one, a new look colourful "folk-art" icon, carrying the brand name of Pradip Rudrapal; the other, continuing with the unchanging, traditional *ek-chala* image of Durga in resplendent silver tinsel decoration (called *daker shaj*) in one of the city's oldest *sarbojanin* Pujas at Baghbazar, where neither the idol maker or the form of the image has altered for several years (figures 22, 23). If the former carries the mark of the new artistic aspirations of the city's Durga Puja, the latter has remained the most

cherished face of the goddess, never out of fashion, still carrying the greatest emotive and devotional charge of the festival.

In conclusion, let me also offer these Durga Puja festivities of Kolkata as an exemplary object for the new field of study that we broadly term "visual culture". Here is an event that stands at the interstices of certain defined zones of "art", "religion", and urban "popular culture", defying easy categorization under any of these heads, actively corroding the boundaries between these zones. Repeatedly we find that differentiations between the "high" and the "low", like the divide between the "religious" and the "artistic" or the "secular", blur within the body of the event, while other subtle hierarchies and gradations fall into place. While the Durga Puja clearly belongs to the realm of the "popular" and the "public", it also demands a continuous redefinition of the scope of these terms, as it claims for itself newer and newer kinds of aesthetic profiles. What can still be coded as a religious and ritual event has over many years now reinvented itself as a "secular" public festival. There are both clear parallels and contrasts here with the celebration of Ganesh Chaturthi in Maharashtra and its new incarnations at different centres in the south, but the one marked differential that needs emphasizing is the way the festival in Kolkata has resisted and eluded its appropriation by the politics of Hindutva. This "secular" marker is today finding its best new reinforcements and negotiations in the name of "art". If (as is often being voiced today) Durga Puja represents the city at its best, then its new wave of image and *pandal* productions, I would argue, also stands in for all that is the most dynamic and creative in the city's

public visual culture. Spilling into a range of other visual productions, the festival in the city has served to carve out a new sphere of what I will call a "high popular" aesthetic: one which integrally feeds off the expansive worlds of media-publicity, corporate funding, and commercial sponsorship that have all now become an inalienable part of the Puja phenomenon.

NOTE

This article was first published as "From Spectacle to 'Art'" in *Art India* 9(3), 2004, and has undergone only some minor revisions in this version. For a fuller and updated version of this study, based on field research done between 2002–08, see my forthcoming book, tentatively titled, *The Aesthetics of a Public Festival: Durga Puja in Contemporary Calcutta*.

ACKNOWLEDGEMENTS

This essay was written as part of an ongoing research survey on the Durga Puja which I have been conducting since 2002 in collaboration with my colleague, Dr Anjan Ghosh. I would like to thank him and our larger research team from the Centre for Studies in Social Sciences, Kolkata – consisting of Moumi Banerjee, Moumita Sil, Jayani Bonerjee, Kamalika Mukherjee, Sudeepta Ghosh, Abhijit Bhattacharya, and our photographer, Sambuddha Banerjee – for their enthusiastic participation in this project.

All the images are reproduced here by courtesy of the visual archive of the Centre for Studies in Social Sciences, Kolkata. Except for figures 7a, b and 16a, b (taken by the author), all photographs used here are by Sambuddha Banerjee.

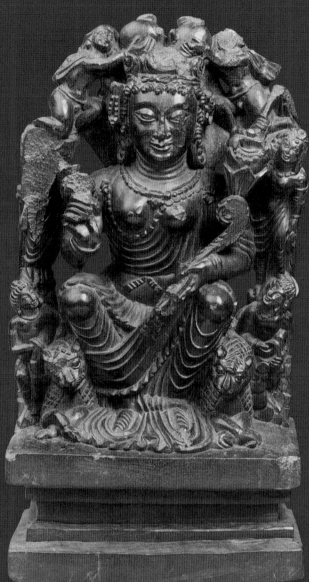

Durga in Kashmir

Pratapaditya Pal

O best amongst the kings, the goddess Umā is the same as Kaśmirā.

Such is the unambiguous declaration of the sage Vaishampayana to King Janamejaya in the Kashmiri text *Nilamatapurana*.[1] In today's troubled Kashmir dominated by Islam and the flight of large numbers of minority Hindus, the worship of Durga has drastically diminished.[2] Once upon a time, however, when Brahmanical Hinduism flourished, the country itself was equated with Goddess Durga. The Kashmir Valley was also famous across the subcontinent as Sharada Pitha, the seat/throne of Sharada, who is equated with Durga, as was its principal river the Vitasta or Jhelum, now polluted beyond description. As the sage Kashyapa asserts in the *Nilamata*, "Assuming the form of a river called Vitasta, oh goddess, the daughter of the mountain, you are not a river but an ascetic lady wife of Sarva, even higher than Sarva."[3] On the riverbank in Srinagar today stands the most popular Islamic religious establishment, the Shah Hamdan Mosque, once the site of one of the most famous temples of the goddess.

1a, b
Lustration of an Enthroned Goddess, probably from Baramula, 5th century. Grey stone; 36 cm. Private collection.

Thus, although Shiva and Vishnu were the principal Hindu deities of pre-Islamic Kashmir and the Valley became famous across India as the bastion of Shaiva religion and philosophy, the popularity of the female deity is unambiguous in the *Nilamata*. The vast body of Kashmiri Tantric texts that originated in Kashmir and spread across the subcontinent also attest to the theological and ritual importance of the goddess. The *Nilamata* can be supplemented by other texts such as the slightly earlier *Vishnudharmottarapurana* (henceforth *VDP*), almost certainly compiled in the region, and the later *Rajatarangini*, the dynastic history of Kashmir written around the mid-12th century by the poet Kalhana. Together with the vast body of Tantric and Agamic as well as Shaiva exegetical literature produced by a galaxy of brilliant gurus and mystics during the 10th and 11th centuries, Kashmir has preserved a formidable body of literary material to form a substantial impression of the concept and worship of the goddess among the Brahmanical/Hindu society of the Valley during the first millennium of the Common Era. Unfortunately, the archaeological evidence is not as rich but what there is will make clear the discrete nature of Durga's form in Kashmir.

1

The early material remains of goddess worship in Kashmir are scant though Kalhana's history does reflect its antiquity. He alludes to the shrines of the mother goddesses who are mentioned in the ancient epic *Mahabharata* and who aid Durga in her struggle against Mahishasura in the *Devimahatmya*.[4] Two fragmentary images have survived from Bijbehara, the ancient Shaiva site known as Vijayakshetra in the *Rajatarangini*,[5] but they are no earlier than the 5th century. In both the goddesses are dressed in classical attire obviously in imitation of neighbouring Gandhara which was the stylistic source for early Kashmiri art when the Valley was part of the Kushan realm (c. 100–300 CE).

The borrowed and syncretic nature of the images in early Kashmir is best exemplified by a well preserved Lakshmi/Anahita/Ardoksho (figures 1a, b). Probably carved in the 5th century, the goddess is clad eclectically in Indo-classical style in sari-cum-himation, chiton, and with shod feet. She sits imperiously in the extended-legs posture (in Sanskrit *bhadrasana* or *pralambapadasana*), usually assumed by mother goddesses in sculptures of the Kushan and Gupta periods (c. 300–600) in Mathura and central India. However, frequently in Kashmir, as in this instance, two lions form her seat, which is a clear borrowal from Nana Anahita of Sassanian iconography. Another foreign feature is, of course, the cornucopia in her left hand seen in earlier images of Buddhist Hariti in Gandhara where the attribute was introduced from the Persian realm further west.[6] The lotus in her right hand is the only attribute this particular goddess shares with the Indian Lakshmi, though in other surviving images, all small (figure 2), she is bathed by two elephants, an

Indian iconographic element. The presence of two male water-dispensing celestials, perhaps cherubs, in figure 1, is an exception and may reflect influence from Buddhist art. Another important feature of both representations is the crescent moon on the back of the head enclosing the lotus, a symbol of the sun; together the sun and the moon emphasize the cosmic nature of the goddess. It should be noted that in the well-known silver bowl from Sogdiana, now in the British Museum, the lion-riding goddess holds the sun and the moon with the two upper hands of her four arms.[7] It should further be recalled that Nana/Ardoksho was an important member of the Kushan imperial religious pantheon and graces their coins.[8] Some of her features – both her cosmic nature and her lion mount – were clearly transferred to Durga/Parvati. The integration of Lakshmi into the great goddess is further reflected in the *Devimahatmya* where one of the three sections is devoted to Mahalakshmi. Moreover, the *Nilamata* identifies her with both Kashmira and Uma.

> O goddess, daughter of the sea [Lakshmi], untouched by dust, pure abode of auspiciousness, it is you who is exalted as Kaśmirā, it is you who is exalted as Umā; it is you who abides in the images of all goddesses.[9]

This popularity and supremacy of Lakshmi in pre-Karkota Kashmir is borne out by the relatively large number of portable lion-riding Lakshmi/Anahita/Ardoksho images in stone that emphasize her cosmic nature unambiguously. They may have been intended for domestic worship or for talismanic purposes in travel or battles.

The importance of Lakshmi and her pre-eminence among the goddesses is further emphasized by the *Pratimalakshana* of the

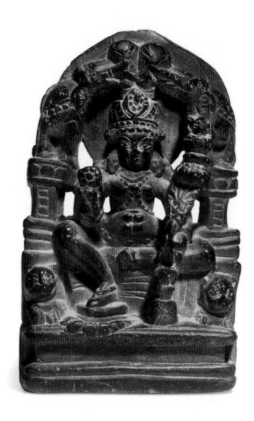

2
Gajalakshmi, Kashmir, 8th century. Schist; 11.3 cm. Pal Family Collection.

VDP, where an entire chapter is devoted to her iconography and the symbolic significance of her emblems.[10] She is described as the wife of Vishnu and the mother of the universe. When she is by herself she is to be seated on a lotus supported on a lion-throne. The flower is also one of her hand attributes. As her seat the flower signifies Vishnu himself while as an emblem it represents wealth. Moreover, a third lotus flower is said to be on her head as we see on the back of one of the two examples illustrated here (figure 1b). The text further describes four attendant goddesses: Rajashri, Svargalakshmi, Brahmilakshmi, and Jayalakshmi. In the tableau (figure 1a) two females, one of whom is missing, are included at Lakshmi's shoulder level, while the two acolytes below appear to be male. Thus, although this textual description is not as assertive as the *Nilamata* in identifying Lakshmi with Uma, it does glorify her

exalted status in calling her the mother of the Universe.

2

What is curious about the iconographic section of the *VDP* is that it does not include the image of Durga as the slayer of the titan Mahisha but it does provide a description of a goddess called Bhadrakali or Auspicious Kali.[11] Compared to the descriptions of other major deities, including Lakshmi, this is rather succinct. It gives merely a physical description and no explanation is provided about the significance of her form or attributes. Considering the generally early date of the text, it is surprising that she is provided with 18 arms when normally most pre-7th-century representations of any form of the goddess do not portray her with more than eight arms, four being the conventional number.[12] However, of greater interest is that the goddess is said to stand in the militant posture (*alidha*) on a chariot drawn by four lions.[13] This mode of conveyance as well as the prescribed attributes are not encountered in any images representing the conventional Kali or Chamunda but are appropriate for Durga, who is equipped in the *Devimahatmya* with weapons by the various gods. Thus, they include the trident, the sword, the shield, the bow and the arrow, and the spear. However, she also holds the rosary, the waterpot of Brahma, fire of Agni, and a staff (*danda*), perhaps of Yama(?). In addition, she is given a black antelope skin, which is generally worn by ascetic brahmins and probably represents her novitiate (*brahmacharini*) form as Gauri when she underwent austere penances to please Shiva. Another curious emblem she holds is the *vedi* or altar which may well be an error for *veda* or a manuscript for she is

also Mahasarasvati as characterized in the *Devimahatmya*, where she is further eulogized as an embodiment of wisdom by Brahma himself.[14] The 17th hand attribute is the vessel of gems (*ratnaghata*), clearly an indicator of wealth and hence Lakshmi, while the final is the gesture of peace (*shantikara* or *abhaya*). Thus, this vast array of emblems announces her cosmic nature, a *vishvarupa* or universal form.

Although nothing is mentioned of her duel with Mahisha in the *VDP*, clearly the goddess is meant to represent Durga who is also invoked as Bhadrakali in her mantra and *dhyana* or invocation.[15] In the typical images of Goddess Durga that have survived in Kashmir we meet her frequently riding a chariot (see figure 3 and Introduction figure 7). That it is a chariot in both the now lost stone and the equally spectacular metal representations is in no doubt as there is a charioteer seated in the front of the balustrade holding the reins as one sees in images of Surya. Interesting as the design and construction of the conveyance are, what is even more fascinating is that along the front is accommodated a scene of a vigorous encounter between at least three lions and the buffalo. Thus clearly the depiction is in keeping with the goddess riding a chariot drawn by four lions as described in the *VDP*.[16]

While this dramatic encounter progresses, the titan has emerged from the neck of the buffalo and has been grabbed by his hair by Durga. In the magnificent sculpture illustrated here his helplessness is made clear as both figures are modelled in the round. His diminutive size, almost that of an adolescent, not only makes her by contrast a colossus and emphasizes her cosmic proportions but portrays him as a comical figure, who swings

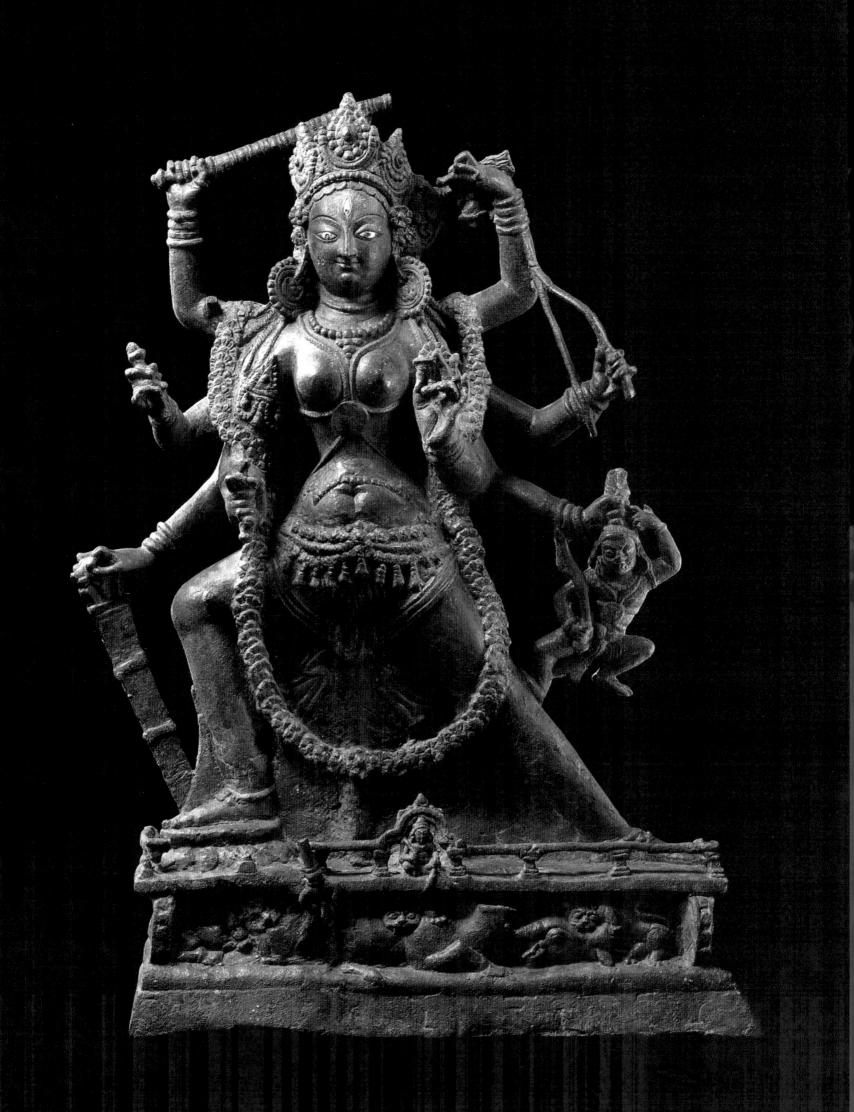

desperately as he appears to slide down her left leg.[17] Like the lion the chariot was likely adopted from classical sources. One immediately thinks of Cybele the nature goddess of the Greeks who is a familiar figure in a wide region from Bactria in today's northern Afghanistan to the Punjab including Kashmir from the invasion of Alexander until the end of the Kushan empire. As has been discussed in the Introduction, Cybele's chariot is drawn by a pair of lions and her abode is the mountain, as is the case with Parvati/Durga (see Introduction figure 6). Undoubtedly to emphasize her importance, theologians in Kashmir made the chariot a quadriga, as we see with Helios/Apollo and Surya in early Indian iconography. Apart from the *VDP*, a chariot is offered to Durga in the later text *Devipurana*, compiled probably about the 9th century.[18] It should be emphasized that the chariot-riding Durga is a discrete feature of Kashmiri

representations seen mostly in stone, and introduced for the first time in this solitary but monumental metal image. Apart from its iconographic distinction, the sculpture is perhaps the most dynamic and aesthetically appealing depiction of the battle in metal that has survived from the subcontinent. Likely it was the focal image of an important shrine of the goddess, as may still be seen in temples in Chamba (Himachal Pradesh).[19] The chariot-riding Durga continues to appear elsewhere in the subcontinent sporadically, as in 17th–18th-century Pahari paintings in contiguous Himalayas,[20] or on 20th-century wall paintings as far south as Ahmedabad in Gujarat (figure 4). It is incredible how an artistic idea that originated in the classical world over two millennia ago, through Bactria (see Introduction figure 6), should survive with such tenacity and creative vigour in modern India.

Returning to the Kashmiri Bhadrakali/

3

(opposite)
Durga (Bhadrakali) Riding a Chariot and Destroying Mahishasura, Kashmir, 8th century. Copper alloy. Private Japanese collection.

4

Wall painting with Durga on Chariot, Ahmedabad, Gujarat, 1966. Photograph: Henri Cartier-Bresson. Reproduced from *Henri Cartier-Bresson in India* (London 1987).

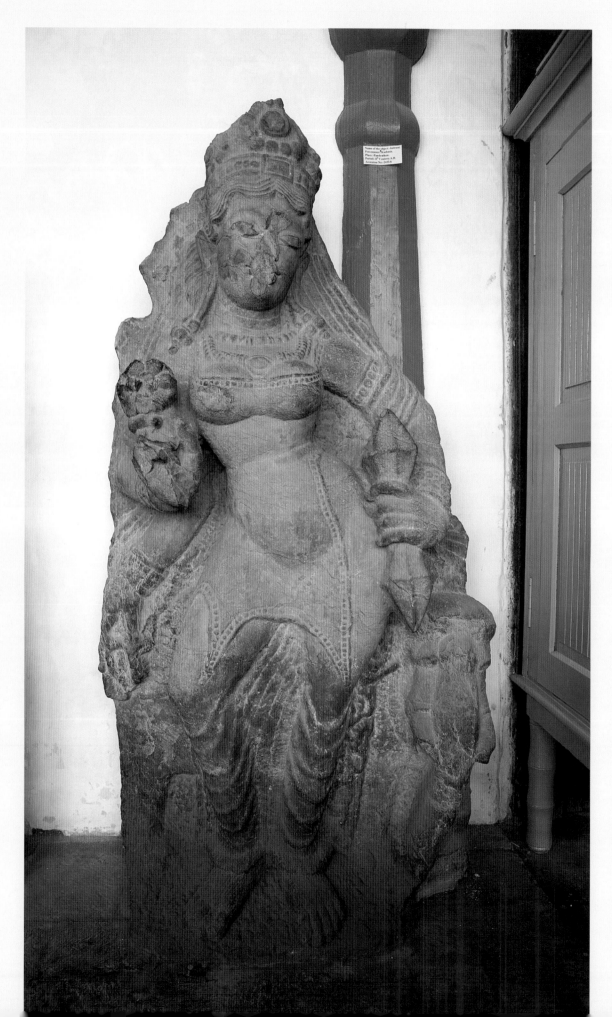

5
Dancing Mother Goddess Indrani, Pandrethan, 7th century. Limestone; 166 cm. Sri Pratap Singh Museum, Srinagar. Photograph: Karoki Lewis.

6a, b
(opposite)
Durga Killing Mahishasura, Kashmir, 6th century. Schist; 14.6 cm. Christian Humann Memorial Fund, Los Angeles County Museum of Art, M.84.180.

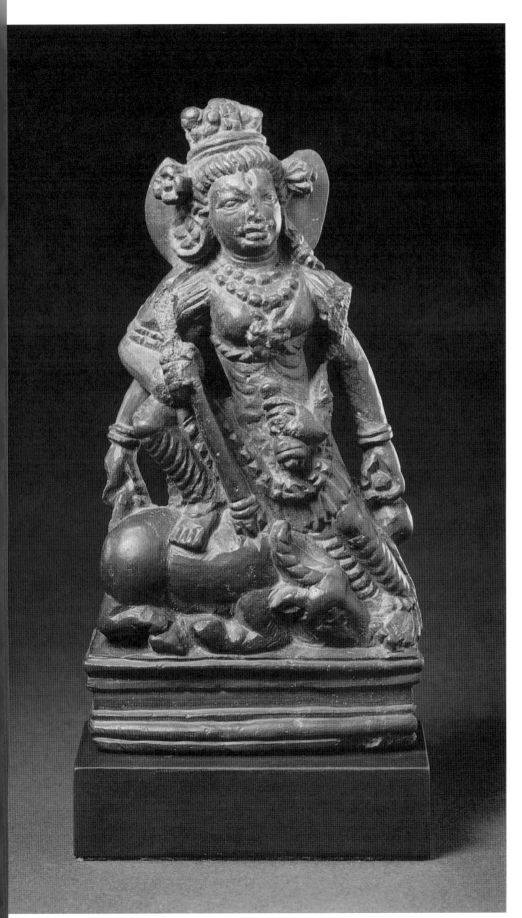

Durga, another noteworthy element is her attire which consists of tightly fitting stitched tunic and himation, though less elaborate than the more obvious classical dress of Lakshmi. Indeed this mode of dress rather than the Indian sari remains a distinctive feature of Durga both as Bhadrakali and as Uma/Parvati throughout the ancient period in the Kashmir valley, as seen in a Shiva-Parvati image of the Utpala period (855–1003), as well as most Kashmiri goddesses, both Hindu and Buddhist (figure 5).

The more familiar, conventional, and pan-Indian form of Durga was also represented in the art of Kashmir and one of the earliest is a small but energized carving in schist (figures 6a, b). I have discussed this spirited representation elsewhere in detail, and suggested a 7th-century date.[21] However, I now believe that an earlier date in the 6th century

is more appropriate. It is clearly a variation of the conventional four-armed Durga of the Gupta period.[22] As in those icons, she pins her animal victim (no human titan) to the ground by her foot, as she plunges the trident deep into his neck. The lion is conspicuously absent and she does not hold the sword and the shield, as do Gupta Durgas; instead, with one hand she grasps the buffalo's tail. The two emblems in her left hands are the bell and the waterpot. She is of course dressed in chiton and himation and additionally, she has the third eye on her forehead. The most noteworthy difference is the crescent moon behind the head, an attribute seen in the early Kashmiri Lakshmi (figure 1b) and, of course, in Nana, as already noted.

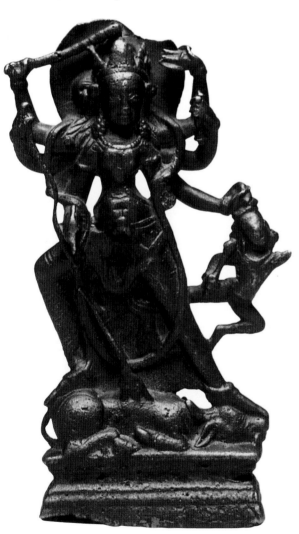

This type of Durga image (figure 6) survives later but with changes in the attire, with a larger number of arms, and without the crescent. A fine bronze example is the small but lively representation in the Alsdorf Collection in Chicago (figure 7). She is a tall, slim, and elegant figure who stands militantly with both feet firmly planted on the outstretched buffalo. No longer does she hold the animal by the tail and we are introduced to a diminutive and boyish anthropomorphic Mahishasura who has emerged from the prone buffalo's severed neck. She now holds him by the hair as he desperately scampers down her leg as if he is running down a mountain slope as in the more elaborate tableau (figure 3). Apart from the trident, a staff, a bell, and the handle of a sword are clearly recognizable. The crescent moon is now replaced by a circular halo and again the lion is absent.

The last representation of the goddess discussed here is probably the most enigmatic (figure 8) and does not show her in battle. She is a robustly modelled figure who stands with a slight swing of her ample right hip on a base with prominent mouldings. She is clad in a tight-fitting tunic with pointed ends and beaded borders, like a *kameez*, over a transparent lower garment with folds between the legs and along the sides. Curiously she is also given a crossbelt (*channavira*)-like ornament that emphasizes her prominent breasts. Additionally, she sports a long floral garland like the *vanamala* of Vishnu. Indeed, this is another discrete iconographical feature of goddesses in Kashmir as seen also in the Mahishasuramardini in the Alsdorf Collection (figure 7). She has a scarf around the shoulders whose flaring ends spread wing-like on either side. While her lower right hand holds the upright sword, her second right

7
(left)
Durga Battling Mahishasura, Kashmir, about 900. Copper alloy; 20.7 cm. The James W. & Marilynn Alsdorf Collection, The Art Institute of Chicago, 217.1997.

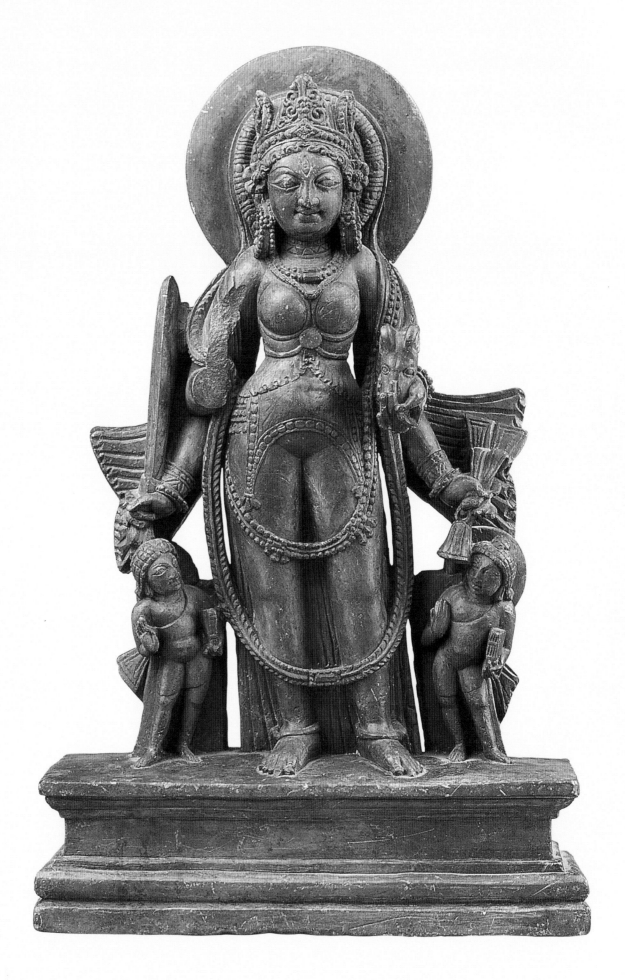

8
Durga/Sharada(?) with Two
Attendant Deities, Kashmir,
about 900. Phyllite; 31.4 cm.
The Metropolitan Museum of
Art, Gift of Mr and Mrs Perry
I. Lewis, 1984, 1984.488.

9
Mould for Durga image,
Kashmir, 10th century.
Terracotta; 18.4 cm. Los
Angeles County Museum of
Art, Gift of Paul Walter and
Marilyn Walter Grounds, L.85.
32.87.

hand is unfortunately damaged. With one of the two left hands she holds a beribboned bell, which seems to be an important attribute of Kashmiri Durgas, but more interesting is the remaining hand attribute (figure 8). It is certainly an animal head and the curled shape of the horns would indicate a ram rather than a buffalo. One wonders if it is the surviving part of a cornucopia which often terminates in a ram's head.[23] No less unusual are the two identical ascetic, dwarfish attendants on either side. Their divinity is in no doubt because of the haloes. As they sway in opposite directions and look at one another they both hold books with their left hands but exhibit different gestures with the right. The one on the goddess's right displays the *jnanamudra* or wisdom gesture, while the other has the palm of the hand turned towards the body which is given to ascetic deities in the northwest from earlier times. The exact meaning of the gesture is not known.[24] If indeed this pair represents gods of wisdom then could this image be identified as Sharada, which is, of course, a synonym of Sarasvati who is assimilated with Durga in the *Devimahatmya*?[25] Besides, Sharada is an appropriate synonym for Durga when she is worshipped in the autumn (*sharat*) which is why it is called *sharadiya puja*. Vasanti is her name when she is worshipped in spring or *vasanta* which is when she was venerated originally in ancient times.

That Sharada is clearly a form of Durga is evinced in the *Sharadamahatmya*, where it is prescribed that she should be offered both meat and alcohol.[26] The temple of Sharada is mentioned in the *Rajatarangini* and Stein has discussed at length its precise location.[27] She is not specifically mentioned in the *Nilamata* but the text does refer to a famous Durga

temple built by the sage Shandilya, which is further elaborated in the *Sharadamahatmya*.[28] Stein also discusses the passage from the *Ain-i-Akbari* of Abul Fazl, the historian of the Mughal emperor Akbar (1558–1605), where he identifies Sharada with Durga. Besides, the *Nilamata* states that in the Durga temple the goddess should be venerated in a book which is very likely the *Chandi* or *Devimahatmya*, the principal text whose reading is obligatory on each day of the ten-day festival. The *Devipurana* as well declares the appropriateness of worshipping Durga in a book, among other objects (see Introduction). One may recall the Buddhist practice of adoring a *Prajnaparamita* manuscript as the embodiment of the goddess Prajnaparamita.

No less interesting than this sophisticated but intriguing stone image of the goddess is a much more modest representation of a terracotta mould (figure 9). The positive impression clearly portrays Durga seated like Gajalakshmi (figure 2) on a lion extended like a stretch limousine. Crowned and with a third eye, she is dressed, however, in the Indian mode. Two of her four arms wield the sword and the trident, but the two attributes in the two other hands are unclear. The one in the left hand is like a pot, thus replacing the cornucopia or rhyton of the earlier forms, though that in the right hand looks similar. In any event, this rather crudely modelled figure may not be an artistic paradigm but it is significant in demonstrating the demand for inexpensive clay images which were perhaps produced at the more important Durga shrines for popular piety, similar to the Buddhist *tsha tsha* or votive tablets.

Finally, this essay on Durga in Kashmir though far from exhaustive can be brought to

a close with a few remarks on the worship of the goddess described in the *Nilamata*.[29] Like the *VDP*, the *Nilamata* too refers to Durga as Bhadrakali and ordains that she should be venerated with incense, garland, clothes, lamps, jewels, eatables, fruits, herbs and roots, meat, and vegetables. Other offerings include leaves of the *bel* tree, sandalwood, *ghi* or clarified butter, and various types of drinks. There should also be dancing and singing at night and oblations are to be offered in the fire and to the brahmins. The inclusion of meat and drinks (alcoholic?) would indicate that the mode of worship was Tantric, though the use of liquor may reflect a general practice of Kashmiri ritual. In fact, Kashmir also had a goddess named Shyama (the dark one), later a popular epithet of Kali in Bengal, who was the presiding deity of vines and was worshipped in the vineyard.[30] The mention of women going to a fruit-tree to worship the goddess may well have survived in the present practice of special rites performed below the *bel* tree during Durga Puja in eastern India. A curious feature of the Kashmiri rite is the offering of balls of food to birds, while in Bengal such offering is made to dogs, the vehicle of Bhairava. It is further stated in the *Nilamata* that in the temple of Durga weapons should be worshipped (as is still done in the royal courts in Rajasthan and elsewhere on Vijaya Dashami, the tenth and final day of the Puja), and artisans should venerate their tools. Thus, the worship of Durga was a fairly comprehensive affair that involved large segments of society and professions with a variety of rites and rituals, many of which survive in different parts of the subcontinent. After the Karkota period in Kashmir her forms and worship as well as her theology under the system known as Krama

became even more complex in the Valley, but that discussion must be postponed for another occasion.[31]

NOTES

1 The language of the text is, of course, Sanskrit but it was composed in the Kashmir Valley probably early in the reign of the Karkota dynasty (c. 626–855). For the text I have used Ved Kumari, *The Nilamata Purana*, 2 vols, 2nd edn. (J&K Academy of Art, Culture and Language, Srinagar and Jammu 1968 and 1973), as it is the most easily available. For corrections, improvements, and extensive discussion of the text see Yasuke Ikari, *A Study of the Nilamata* (Institute for Research in Humanities, Kyoto University, Kyoto 1994).
2 A few Devi shrines still continue to survive in Kashmir, such as Sharika Devi, Khir Bhavani, and Jvala Devi. I am indebted to my Kashmiri brahmin colleague Gayatri Ugra for the following information: "All Kashmiri families 'belong' to one or other of the following three Devis: (a) Sharika Devi – worshipped in the form of a huge vermilion covered rock set on the hillside at Hari Parbat, below Akbar's Fort. This is believed to be a meteorite. The followers are nonvegetarian throughout Navaratri except on Ashtami. Chaitra navami is 'celebrated' with a meat offering to birds, and it should properly include the windpipe, heart, spleen, and liver of goat/sheep. Cooked liver is the 'prasad'. (b) Ragyan Devi – worshipped in the form of a 'kund' or watertank at Khir Bhavani, Tula Mula. These families are vegetarian during Navaratri, but otherwise nonvegetarian. (c) Jvala Devi – worshipped by a small group; have not been able to get correct information on this. (Email communication, January 29, 2009.)
3 Kumari 1973, Vol. 2, p. 80.
4 Sunil Chandra Ray, *Early History and Culture of Kashmir* (Munshiram Manoharlal, New Delhi 1970), p. 184. See M.A. Stein, *Kalhana's Rājatarangini*, 2 vols., reprint (Motilal Banarsidass, Delhi 1979), Vol. 1, pp. 75–80 for King Meghavahana's experience in a temple of Durga/Chandika during his *digvijaya* or world conquest; p. 80 for the foundation of a "circle of mothers" by King Sreshthasena in Pandrethan; see further pp. 107f. for King Ranaditya's mythic experience with Bhramaravasini of the Vindhya mountain who is none other than Vindhyavasini or Durga. How far these accounts and kings are historic remains uncertain but in Kalhana's narrative they are all of the pre-Karkota period.
5 John Siudmak, "The Stylistic Development of the Sculpture of Kashmir", 2 vols., Oxford University, unpublished DPhil dissertation, Vol. 2, figs. 23, 26, and 27.

6 The cornucopia-holding goddess – Fortuna – in the classical pantheon was obviously used as a prototype for several deities during the Kushan period.

7 B.N. Mukherjee, *Nana on Lion* (Asiatic Society, Calcutta 1969), pl. XIV, fig. 47.

8 The importance of Nana in the Kushan pantheon is best exemplified by the Rabatak inscription of Kanishka the Great where the ruler claims to have "obtained the kingship from Nana and from all the gods" which clearly explains the diversity of divine images on Kushan coins. See Nicholas Sims-Williams, "The Bactrian Inscription of Rabatak: A New Reading", *Bulletin of the Asia Institute* (n.s.) 18, pp. 53–68. On the coins of Kanishka I, Nana is portrayed as seated on a lion with a crescent behind his head. See Mukherjee 1969, pl. I, fig. 1.

9 Kumari, 1973, Vol. 2, p. 73.

10 Priyabala Shah, *Visnudharmottara-Purana*, Third Khanda, 2 vols. (Oriental Institute, Baroda 1961), Vol. 2, pp. 154–55; Vol. 1, ch. 82.

11 Shah 1961, Vol. 2, pp. 151–52. In the text Bhadrakali shares a chapter (71) with Kumara. It should be mentioned that in the *Nilamata* too Durga is addressed as Bhadrakali. See Kumari 1973, Vol. 2, p. 207.

12 Yuko Yokochi, "Mahisāsuramardini Myth and Icon: Studies in the Skandapurāna", in *Studies in the History of Indian Thought* (Indo-Shishōshi Kenkyū), (Association for the Study of the History of Indian Thought, Kyoto 1999).

13 *ālidasthānasamsthānā chatuhsimhe rathe sthithā* 118.

14 The invocation for the third part of the text (*uttaracharitam*) is addressed to Mahasarasvati. In chapter one Brahma eulogizes the goddess as *mahavidya, mahamaya, mahamedha,* and *mahasmritih* (p. 77a). "You are the supreme knowledge as well as the great nescience, the great intelligence and great memory."

15 Not only is the presiding deity of the first part of the *Devimahatmya* Mahakali, but in the text she is on several occasions addressed as Bhadrakali.

16 In fact, since the chariot-riding goddess is found only in Kashmir, it further confirms the claim of the Kashmir Valley as a source of the text.

17 In passing it may be mentioned that the boyish and diminutive stature is also a characteristic of the titan in Javanese Durga images.

18 *Kārayedrathadolādi* which means that both a chariot and a swing should be made for the goddess (ch. 22, v. 11). For another stone image of chariot-riding Durga, see Pratapaditya Pal, *The Arts of Kashmir* (The Asia Society, New York and 5 Continents, Milan 2007), fig. 79.

19 M. Postel, A. Neven, and K. Mankodi, *Antiquities of Himachal* (Franco-Indian Pharmaceuticals Pvt Limited, Bombay 1985), figs. 43, 45, 49.

20 W.G. Archer, *Indian Paintings from the Punjab Hills* (Sotheby Parke Bernet, London and New York 1973), Vol. 2.

21 Pratapaditya Pal, *Indian Sculpture*, Vol. 1 (Los Angeles County Museum of Art, Los Angeles and University of California Press, Berkeley 1986), pp. 229–30.

22 See Yokochi 1999 for an extensive discussion of the early Durga images in the subcontinent.

23 See Pratapaditya Pal, *Himalayas: An Aesthetic Adventure* (The Art Institute of Chicago 2003), p. 119, and Pal 2007, p. 85 for discussions of other possibilities.

24 This gesture goes back to the art of the Kushan period in Gandhara and is frequently given in Kashmir to both Hindu and Buddhist deities. It also occurs in the famous metal Brahma found in Sindh (P. Pal, ed., *Sindh: Past Glory, Present Nostalgia* [Marg Publications, Mumbai 2008], p. 58). Some have suggested that it is called *āhuyevarada* or "beckoning-charity".

25 Although Sharada is like the patron-goddess of Kashmir and the country is referred to as Sharada Pitha or the seat of Sharada, no image from the pre-Islamic period has survived that can be definitely identified as the goddess. Unfortunately, I have no copy of the *Sharadamahatmya* accessible to me nor have I come across a contemporary representation such as a poster. See n. 26.

26 The verse is quoted in Kumari 1968, Vol. 1, p. 165, fn. 1.

27 Stein 1979, Vol. 2, pp. 279–89. In his erudite discussion of the shrine Stein quotes the 11th-century Arab scholar al-Biruni's allusion to the wooden image of Sharada, which apparently was also seen by the 15th-century Muslim ruler Zain-ul-Abidin. However, it distintegrated during the king's visit. At the time of Stein's visit the cella was empty and the people worshipped the stone cover of a spring-cavity (*kunda*) as the deity's presence. This is of course a very ancient custom specially with Devi shrines where a numinous stone is venerated.

28 See Stein 1979, pp. 280–81 for the Shandilya legend, also Kumari 1968, Vol. 1, p. 185 and Ikari 1994, p. 411.

29 Kumari 1973, Vol. 2, pp. 207–28.

30 Kumari 1973, Vol. 2, pp. 210–11.

31 For an extensive discussion of Devi with textual sources see Alexis Sanderson, "The Śaiva Exegesis of Kashmir" in Dominic Goodall and Andre Pardoux, eds., *Mélanges tantriques à la mémoire d' Hélène Brunner* (IFI/EFEO, Pondicherry [Collection Indologie 106] 2007), pp. 231–442 and (bibliography) pp. 551–82.

Dasai
The Celebration of the Goddess Durga in Kathmandu Valley, Nepal

Anne Vergati

The royal festival of Dasai is celebrated all over the kingdom of Nepal in the autumn, in the month of Ashvin or Asoj (September–October) according to the lunar calendar. The observation of the festival throughout Nepal contributed to the religious unification of the kingdom and the spread of Hinduism during the 19th and 20th centuries. Dasai is one of the most colourful of the Hindu festivals of Nepal and has acquired national character with the participation of the Buddhists as well. It differs in significant ways from the pan-Indian Navaratri festival and also from the Bengali Durga Puja; moreover, it displays diverse practices and ceremonies of local importance among the major cities of the Kathmandu Valley itself.

In India, the first nine days and nine nights (Navaratri) of the festival are separated by tradition from the tenth day which is called Vijaya Dashami. In Nepal, these two periods of the festival are not considered as separate and the term Dasai, meaning "tenth", designates all ten days of the festival and not just the tenth day. The Newari name of the festival is Mohani (Mvahni), an abbreviated form of the Sanskrit Mahanavami, the ninth day of Durga Puja.[1] To each day corresponds one of the goddesses forming the group known as Navadurga (nine Durgas), whereas the tenth day signifies the victory of the Goddess Durga over the buffalo-demon Mahishasura. This is peculiar to Nepal and Bengal; in the rest of India the tenth day is devoted to Rama and commemorates his victory over the demon Ravana. The Nepalis often refer to the victory of Rama in the context of the tenth day, Vijaya Dashami (*vijaya* meaning victory), but this hero is not present in the rituals they perform. Nevertheless the tenth day is centred around the king and his wars, as was the case with Rajput courts in India, in a way perhaps a transposing of the war conducted by Rama into the local context.

Dasai coincides with the end of the monsoon and the beginning of a new season linked with the abundance of the harvest. In most houses, an area at the centre of a room is selected where a paper image or a statue of Goddess Bhagavati is placed. Barley grains are planted in soil spread on an area of the floor. Each day the priests read the *Devimahatmya,* a text that has the power of redemption. In the three former capitals of the Valley – Patan (figures 2 and 3), Kathmandu, and Bhaktapur – the Dasai celebrations are similar and take place on the same dates. The most important rituals take place in the palaces of the former Malla dynasty (1200–1768, figure 4). Several other royal goddesses play an important role in the ceremonies: Maneshvari, Taleju, Duimaju, Degutale, Kumari, Mahalakshmi, and of course the group of Navadurga.

The goddess Maneshvari, a form of Durga, has been associated with the Lichchhavi dynasty.[2] The descendants of the Malla dynasty still worship the goddess in her temple near Hadigaon. The word Mana is part of the name of the residence of the Lichchhavi dynasty, Managriha, founded perhaps by the 5th-century King Manadeva I. "With the discovery in Hadigaon of the then earliest known inscription of Amsuvarman by Sylvain Lévi at the turn of the century, speculation followed that this might be the site of one if not both palaces, Managriha or Kailasakuta, and that Hadigaon was therefore the capital of the Lichchhavis."[3] The Shivalinga which according to the tradition is from the reign of Manadeva I (464–505 CE) still exists in Hadigaon. It seems that the statue of Goddess Maneshvari from the Royal Palace in Patan is taken out in a procession during the festival of Dasai; for some Newars this goddess is synonymous with the Goddess Taleju.

THE ROYAL GODDESS TALEJU

In the Newar pantheon the only deity constantly linked with royalty is Goddess Taleju, a form of Durga Bhagavati. Her name, which is a carefully kept secret, has come down to us in different variations: Tulaja, Tulasi, Talagu. Among the titles usually accorded to the Devi is Bhavani. She is a Tantric goddess, her image and her cult being secret. Only Hindus who have received the initiation (*diksha*) can see her image.

According to local oral tradition this goddess came from India to Nepal in the 14th century with the prince Harisimha Deva who belonged to the Karnataka dynasty which originated from Ayodhya. He reigned in the Terai, south of the present-day kingdom of Nepal, at Simraongarh, not far from today's Simra. In a battle with Ghiyas-ud din Tughlaq Shah (r. 1320–25), who had invaded the south of Nepal, Harisimha Deva was defeated and had to flee into the mountains. The prince took with him an image of the Goddess Taleju. He died at Tinpata before reaching the Kathmandu Valley but the image of Goddess Taleju made it to the royal town of Bhaktapur (or Bhatgaon) with his followers. King Jayasthiti Malla (r. 1372–95) decided to replace the former Goddess Maneshvari by Goddess Taleju, and she became the tutelary goddess of the Malla dynasty. The king's power or decline, as well as the prosperity of the kingdom, are believed to depend on her.

The first temple to Goddess Taleju was built in Bhaktapur inside the courtyard of the Royal Palace. In the 16th century the Malla rulers once more divided the Valley into three kingdoms. The second temple dedicated to the goddess was built at the northern end of the Royal Palace

1
(opposite)
The living goddess Kumari, Patan.

(Hanuman Dhoka), Kathmandu (figure 5) at the time of Mahendra Malla (r. 1560–74) and the third one in Patan in 1666 by Srinivasa Malla (r. 1661–84). The Malla kings were responsible for the organization of the festival of Dasai. The king was expected to be present and participate in the festival. The swords of the Malla kings are still kept inside the Taleju temples and are taken out by the brahmin priests, the Rajopadhyaya, in processions as part of the festival. The sword symbolizes royal power and represents the king.

After the Gorkha conquest of the three Malla kingdoms in 1768, the new Shah dynasty also adopted Goddess Taleju as their tutelary deity, perhaps to legitimatize their right to the throne. In recent times, the most important celebration of Dasai took place inside the Royal Palace in Kathmandu, until the abolition of the monarchy in 2008.

In the royal town of Bhaktapur (figures 6 and 7), on the seventh day of Dasai, the

2
The Durbar Square in front of the Royal Palace, Patan.

3
View of the temples in front of the Royal Palace with the statue of King Srinivasa Malla, Patan.

statue of Goddess Taleju is taken down to the ground floor of the temple. She is worshipped by the Rajopadhyaya brahmins and several male goats are sacrificed to her.[4] On the same day, when the statue of Taleju is brought down, the sword of the Malla kings is taken out and carried by a brahmin or an astrologer.

In all the three royal temples of Taleju, on the eighth and ninth nights of Dasai a large number of goats and buffaloes are sacrificed inside the temple (figure 8). The goat sacrifices are said to provide strength for Goddess Bhagavati. The only day in the year when an "untouchable" can enter the main courtyard (*mulchok*) of the Taleju temple is the eighth day of Dasai when 21 buffaloes are sacrificed.

Goddess Duimaju (or Do-maju, the Newar name) is an aniconic form of Goddess Taleju and resides in a black stone, in a small

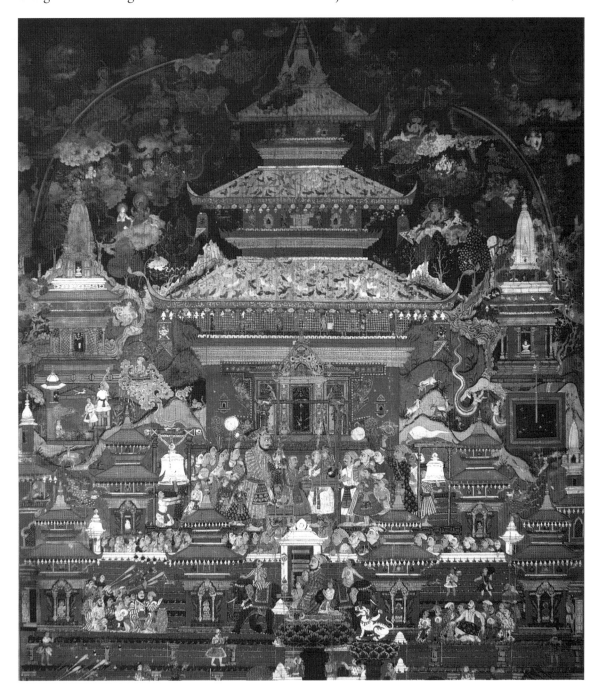

4
Painting depicting King Pratapa Malla in front of the temple of Goddess Taleju, Kathmandu, 1643. He is performing the *tuladana* ceremony for his son Chakravartendra. Collection of College de France, Paris.

5
(opposite)
The royal temple of Goddess
Taleju, Kathmandu.

6
Statue of King Bhupatindra
Malla, 17th century, Durbar
Square, Bhaktapur.

7
Torana of the main entrance to
Taleju temple, Bhaktapur.

sanctuary inside the courtyard of each of the Royal Palaces. The open sanctuary of Goddess Duimaju is considered to be the *pitha* (seat) of Goddess Taleju. In Patan and Bhaktapur, on the ninth day of Dasai, the black stone is taken in procession around the centre of the ancient town. In the evening of the same day, Duimaju and all the other statues of divinities that have been taken in procession have to return to their shrines. Duimaju is said to be the lineage deity of the caste of Maithili invaders and it seems that it helped the king Nanyadeva in 1097 to take possession of the former kingdom of Bhaktapur.[5]

Another manifestation of Goddess Taleju well known in all Newar localities, who is also the focus of worship during Dasai, is the living goddess Kumari (figure 1). She is selected from the Buddhist priest community (*vajracharya*). In Bhaktapur the living goddess is chosen for one year, but in Kathmandu and Patan she reigns for several years. The worship of young girls is highly developed in the three royal towns of the Valley. On the ninth day of Dasai, after the sacrifice of the buffaloes and goats, groups of girls are worshipped in different Newar houses. It is said that the reason for this puja on this day is that the

girls serve as vehicles to bring the goddess inside the house. On the same day the living goddess Kumari is worshipped inside the Taleju temple by the brahmin priests. When the ceremony is over she is brought into the main courtyard where the people who have come in large numbers are waiting for her. It is said that Kumari used to give oracular advice to the Malla kings.

On the tenth day, Vijaya Dashami, processions of an unusual kind are held in different quarters of the old town of Kathmandu. These processions are known as "sword processions", the sword in question being the symbol of the goddess Durga. There are groups of dancers representing the various goddesses. In the streets of Kathmandu, the dancer representing the goddess Bhadrakali would exchange swords with the king of the Shah dynasty, who carried the sword of the previous Malla dynasty. The result of this encounter with the goddess Bhadrakali was to provide the king with divine "power". The fact that Bhadrakali is also called Vaishnavi at Bhaktapur shows her direct links with royalty, for the king was considered a human form of Vishnu.

THE GROUP OF NAVADURGA

Navadurga or the nine goddesses are the most sacred manifestations of Durga and are an important group in the Newar pantheon. Eight of them have the same names as the Ashtamatrika goddesses, which surround the towns, but they are demoniacal aspects. At the centre of the eight goddesses is Tripurasundari. Her temple is situated near the Royal Palace and in Bhaktapur is considered to be the religious centre of the town (figure 9). As is common in Hindu mythology, the same deities can have different aspects. According

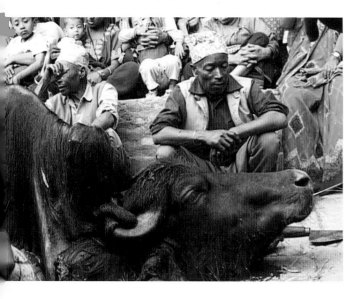

8
Buffalo sacrifice, Patan.

9
Temple of Goddess
Tripurasundari, Bhaktapur.

10
A dancer from the Navadurga
group at Kathmandu.
Photograph: Suzanne Held.

to Sanskrit texts the Navadurga names are
Shailaputri, Brahmacharini, Chandraghanta,
Kushmanda, Skandamata, Katyayani,
Kalaratri, Mahagauri, and Siddhidatri. The
Newars use the names of the Ashtamatrika
for the masks: Brahmayani, Maheshvari,
Kaumari, Vaishnavi, Varahi, Indrayani,
Chamunda, and Mahalakshmi. They are
all represented in the Dasai celebrations by
dancers wearing masks (figure 10). The group
of seven goddesses, Saptamatrika, are also
represented by masked dancers, along with
Bhairava, Ganesh, Seto Bhairava, Sima, and
Duma. These last two are said to be popular
names for lion (*simha*) and tiger (*vyaghrini*).
Some people explain that these two are
a couple, the white-faced Sima being the
male; others will explain that they are two
goddesses. The eighth goddess, Mahalakshmi,
who makes up the Ashtamatrika pantheon,
the goddess linked with kingship, is also
represented by a small mask in silver repousse,

which is hung on the chariot carried by
the dancers during the performance (figure
11). Mahalakshmi is an external form of the
tutelary goddess of the royal dynasty, Taleju.
Shiva is also represented by a small mask with
no eyeholes that is attached to the costume
of the dancer who represents Ganesh and,
during the performances, is hung alongside
the Mahalakshmi mask on the chariot carried
by the dancers. In Bhaktapur, Seto Bhairava
representing the young Shiva is one of the
main characters in the masked dances. He
is a comic figure; throughout the dances
his behaviour is non-conformist, sometimes
obscene.

During the festival of Dasai masked
dancers from the caste of gardeners (*gathu* or
mali) dance in all the three former capitals.
The masks, which are worn by men during
the ritual dances, are made of perishable
materials such as papier mache, wood

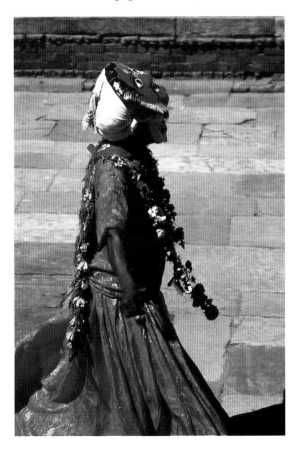

plastered with clay, and linen, and are painted in lively colours as indeed all the statues used to be (figure 12). It is difficult to know how old the ritual dances (*pyakha*) are. They are called "dances of the gods". The Newar word *dyah*, which means god, is applied to images as well as to forces distinct from images but which nevertheless can be brought to reside in them. The dancers must wear appropriate clothes and before starting to dance they have to put a dark mark at the centre of their forehead which is the symbol of Nasadyah, the Newar name for Shiva as Nataraja, the god of dance and music.

There are three different troops of Navadurga dancers in the three former Newar kingdoms: Patan, Kathmandu, Bhaktapur. Their dances have highly esoteric religious aspects. The gods and goddesses represented are Tantric deities: they have demoniacal aspects and are dangerous. According to the oral tradition only a Tantric priest with exceptional skills can control the goddesses. The Navadurga are the only goddesses for whom a pig, an otherwise impure animal, is sacrificed, indicating their demoniacal character.

Peculiar to the Buddhist town of Patan is the masked dance of a second group of dancers, other than the Navadurga. These dancers belong to the high caste of Buddhist priests (*vajracharya*) and former monks (*sakya*). They wear masks of the eight goddesses (Ashtamatrika) who protect the town of Patan. This masked dance is performed throughout the nine days in different parts of the town of Patan, terminating on the last day of the festival.

The masked dances also have political significance since they are linked to the divine power of Nepal's royalty through Goddess

Taleju, located in the royal temple in the palace courtyard. The goddess awakens the dancers' "power" to dance and the "life" of the masks which are consecrated before her. The mantra of Taleju is transmitted to the dancers by a Tantric priest in a secret ceremony before their dance begins.

The French Indologist S. Lévi at the end of the 19th century drew attention to the fact that the *yatra*s (or *jatra*s, processions) prefigure dramatic performances. "The *yatra* processions," he wrote, "contain in germ the notion of the art of drama, to which Tantric beliefs gave new life. Inspired by them, the *yatra* provoked a renewal of Indian theatre in Bengal. In Nepal too they seem to have been transformed, early on, into 'living pictures'."[6]

To conclude, the festival of Dasai in the Kathmandu Valley consists of a succession of processions in which the different forms of

11
The chariot of Navadurga dancers in Bhaktapur.

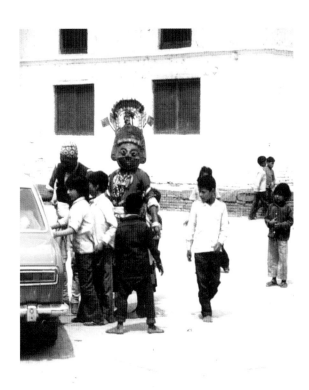

12
A masked dancer during the festival of the goddess in Bhaktapur.

the gods and goddesses of the local pantheon are taken out from the temples and shrines. The statues are wrapped with coloured cloths so it is difficult to view them. There are also processions of masked dancers in the streets of the towns and inside the courtyard of royal palaces; the festival assumes certain aspects of a carnival. Crowds of people drink, fight, and dance in the streets along with corteges of musicians. What is still peculiar to Newar society in the Kathmandu Valley is the *violence*: a great number of animals are sacrificed not only in the courtyard of the royal palace but also in the streets. This aspect of the Dasai festival has been discontinued in all other celebrations of Durga that take place today globally among other Hindu communities.

NOTES

1 This interpretation of the term Mohani is given by Gautama Vajracharya. See also G. Toffin, *Le Palais et le temple La fonction royale dans la vallée du Népal* (Editions du CNRS, Paris 1993), p. 50: *mvahni*

designates also the mark on the forehead of a person during a religious ceremony. The festival has been described in detail for the ancient royal town Bhaktapur by R.L. Levy, *Mesocosm: Hinduism and the Organization of a Traditional Newar City* (University of California Press, Berkeley/Los Angeles 1990), and for the town of Patan by Toffin, op. cit.
2 S. Lévi, *Le Népal: Etude d'un royaume hindou*, 3 vols. (E. Leroux, Paris 1905), Vol. 2, pp. 105-06.
3 M. Slusser, *Nepal Mandala: A Cultural Study of Kathmandu Valley* (Princeton University Press, Princeton, New Jersey 1982), Vol. 1, pp. 114–15.
4 Levy 1990, p. 243.
5 Slusser 1982, Vol. 2, pp. 46, 67.
6 Lévi 1905, Vol. 2, p. 46.

ADDITIONAL REFERENCES

Gutschow, N. "The Astamatrika and Navadurga of Bhaktapur", in *Wild Goddesses in India and Nepal*, ed. A. Michaels (P. Lang, Bern 1996).
Krauskopff, G. and M. Lecomte-Tilouine, *Célébrer le pouvoir: Dasai, une fête royale au Népal* (CNRS Editions, Paris 1996).
Vergati, A. "Le roi et les déesses: la fête de Navaratri et Dasahra au Rajasthan", *Journal Asiatique* 1 (1994), pp. 125–46
Vergati, A. *Gods and Masks of the Kathmandu Valley* (D.K. Printworld, New Delhi 1999).

FIGURE ACKNOWLEDGEMENTS

All photographs are by Anne Vergati, except for figure 10.

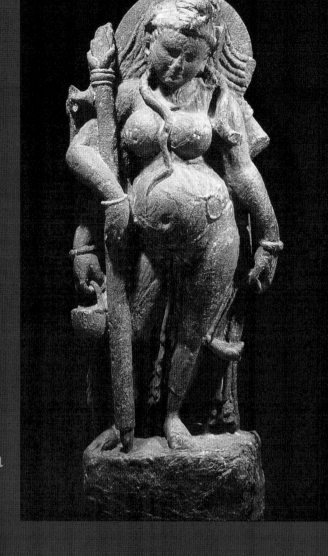

Dance of Conception and Baby Shower

Tracing a Latent Aspect of Durga Puja in the Light of the Cult of Kumara

Gautama V. Vajracharya

BACKGROUND

The Durga Puja festival has at least three different aspects. First, it is a celebration of the autumnal harvest; hence, it was also the time for fights, both offensive and defensive, for protection and plunder of property, mainly the harvest, requiring Durga's blessing. Second, in ancient India the monsoon was a time of intensive study, which came to an end at the time of Durga Puja, thus, explaining Sharada/Sarasvati's association with the festival.[1] The third, almost forgotten aspect, is that this was considered to be the time for the conception of the atmospheric mother goddesses. This aspect can be traced through a study of the age-old monsoon culture of South Asia and its close association with the calendrical cycle of the masked dance of Navadurga, the nine mother goddesses, in Bhaktapur, Kathmandu Valley (see Vergati). Previous scholars are of the opinion that the dance is performed for the protection of the city.[2] Although this interpretation is partially correct, the seasonal association of the dance cycle of the mother goddesses with a peculiar cult of the child god Kumara, and the festival of celestial children descending from heaven, also interrelated with the cult of the child god, indicate that the age-old concept of atmospheric gestation is still discernible in the culture of the Valley.[3] This salient feature is the main focus of our investigation here.

ORIGIN AND DEVELOPMENT OF THE CULT OF MOTHER GODDESSES AND THEIR CHILDREN

Sky father and earth mother is a prevalent Indo-European concept, which continued throughout the cultural history of the Aryans. But already in the *Rigveda* we begin to find the development of a new concept; the sky in this text is not always a father but also a mother. In an earlier essay we have demonstrated that this development was the result of the contact of the Vedic civilization with the pre-existing monsoon culture of South Asia.[4] Because of such contact more than 25 per cent of Vedic literature has not much to do either with the Indo-European or with Indo-Iranian heritage, but directly or indirectly deals with the monsoon culture of South Asia. According to this pre-Vedic culture, besides the earth, the rain clouds – particularly the rapidly expanding multiple clouds of the monsoon, described in Vedic literature as *bahudha* – are viewed as mothers.[5] The exact Vedic word for multiple cloud mothers is *apas*. The cloud mothers conceive in autumn, gestation takes ten lunar months, and a rain child is born at the beginning of the monsoon. In this view, the annual year was divided into two different periods – the rainy season and the period of atmospheric gestation, known in early Vedic literature as *samvatsara*, endowed with an excellent baby. The celebrated frog hymn of the *Rigveda* tells us that at the end of this period (*samvatsare*) frogs start croaking and brahmins start chanting Vedic mantras since their intensive study begins exactly at this time. The rain child is designated in the *Shatapathabrahmana* as *kumara,* baby, who takes birth at the end of gestation (*samvatsare*), exactly when frogs start croaking and even broken branches suddenly become fresh and green (*Atharvaveda* 8.10.18). The significance of the frogs as harbingers of rain and of agrarian prosperity was understood not only by the Vedic people but also by the Newar farmers of the Kathmandu Valley, who still worship the frogs for the fertility of their cultivated land. This is undeniable evidence that some aspects of pre-Vedic monsoon culture have survived even today in the Valley.

The last days of *samvatsara* could be any time around May or June depending upon the expectation and reality of the monsoon's arrival. Thus the end of gestation is not exactly a point of time but a period of time. This is particularly true not only because the arrival of the monsoon is unpredictable but also because the monsoon clouds reach different parts of the Indian subcontinent at different times from late May to early September. The hot and dry summer is transformed into the fertile rainy season. Vedic authors use the word *samvatsare* at the end of *samvatsara* to indicate the phenomenon of rapidly changing seasons.[6]

The clouds are viewed as both mothers and rivers. Their number is seven, which is perhaps based on the Indo-European emphasis on seven. The Vedic Aryans believed that the rain clouds were identical not only with cloud mothers, but also with the seven rivers of north India.[7] Previously they had associated motherhood with the cluster of stars, Pleiades, originally viewed as seven stars including the mother goddess Maia, Greek for mother or nurse.[8] For our study it is important to note that Maia is cognate to the Prakrit word *maya* for mother.[9] The proper name of Buddha Sakyamuni's mother certainly derives from this Prakrit word, not from the Sanskrit *maya,* illusion.

Perhaps, due to the pre-existing association of the stars with motherhood, the Aryans did not see any objection in naming the seven stars after the cloud mothers – Amba, Dula,

Meghayanti, Stanayanti, Abhrayanti, etc. The first word Amba means mother; the last three literally mean raining, thundering, and cloudy, respectively.[10] Clearly this nomenclature is based on the phenomenon of rain. But in the Indian subcontinent, the Pleiades are associated with autumn and this season is not the time for rain. Instead, it is the time when the sky becomes clear.[11] There is, however, a particular reason why the autumnal celestial bodies became associated with the phenomena of clouds and rain. The original Indian name for Pleiades is Krittika, which is derived from the non-Indo-European word for the hide of an animal, particularly that of an elephant, and the animal itself.[12] Apparently, pre-Vedic South Asia visualized an elephant's trunk, tail, and legs in the constellation. This visualization coincides with the view that the milky white autumnal cloud is a white elephant whose appearance in the sky indicates that the autumnal sky has conceived, an age-old view still prevalent among the Newars of the Kathmandu Valley. At the beginning of autumn, the Newars perform special pujas and rituals to honour the white elephant. Important shrines of the elephant are still extant in Kathmandu and Bhaktapur and the localities of these shrines are named after the divine animal as exemplified by Kilagal in Kathmandu. These shrines and the rituals associated with the divine animal await detailed study.

According to the legend of Buddha Sakyamuni, Queen Maya conceived Siddhartha Gautama miraculously as a white elephant descended from the atmosphere and entered her body in a dream. The earliest representation of this episode is found in the Bharhut stone medallion of the 2nd century BCE. An inscription just above the medallion

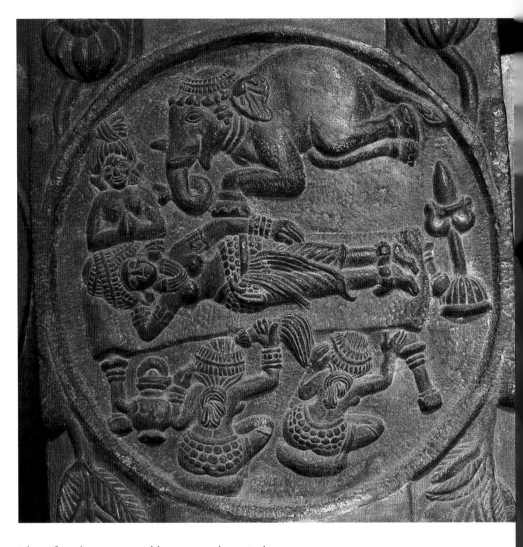

identifies the scene as *bhagavato ukranti*, the ascendance of the lord (figure 2). The key word *ukranti* (Sanskrit *utkranti*), meaning ascendance, soaring aloft, is used here to indicate the miraculous conception. Although in the yoga tradition *utkranti* implies "the rise of the soul", we know almost certainly that it originated from a pre-Buddhist concept associated with the evaporation of water and conception by the sky. The word derives from the Sanskrit verb *ut + kram*, "to soar aloft", and is regularly employed in a pre-Buddhist creation myth based on the annual phenomenon of cloud formation preceding the rainy season. A related passage from the *Atharvaveda* 8.10.18 can be translated as follows:

2
Maya's Dream, Bharhut, c. 2nd century BCE. Photograph courtesy Pratapaditya Pal.

She (female water visualized as a cow in the later part of the story) ascended (*udakramat*). She went to the lords of the forest (*vanaspati*s, the large forest trees). The trees pounded on her. Then, at the end of *samvatsara* she procreated. This is why at the end of *samvatsara* even a broken branch springs up.

A careful study of this riddle-like brief passage indicates that it is based on the following natural phenomena: the ascendance or evaporation of water, physical contact with the lords of the forest in the atmosphere, gestation, and the appearance of fresh and green branches with the arrival of the monsoon rain. Compare these phenomena with the concept of atmospheric gestation described in the *Ramayana* 4.27.3 and *Manusmriti* 9.305. According to these texts the technical term *garbha*, the foetus of the sky, is no other than the vapour drawn upwards by the rays of the sun during the summer – which is sent down again in the rainy season. Almost certainly, in the original story of the white elephant, before it was incorporated into the story of Maya's dream, the elephant, as a *garbha*, stood for the evaporation of water and the formation of the rain cloud. This seems to be the reason that the scene of Maya's dream is labelled in the Bharhut inscription as *ukranti*. As we will see shortly, this symbolism of atmospheric gestation, even after it became a part of the Buddhist story, remained intact in South Asian art of the later period, where the stylized cloud formation instead of the white elephant is shown entering Maya's womb (figures 3, 4).

Another autumnal rite in Newar is sky worship which involves the erection of a bamboo pole (Sanskrit *jarjara*) on a rooftop. The pole is equipped with a metal hook that holds an oil lamp or *palcha* placed inside a perforated earthen pot. This simple rite is observed on the full moon night of Ashvina (around the second week of October) and known to the Newars as Alammata Biyegu – "offering oil lamp to the sky". Either on this or the next full moon night, ancient India celebrated the Kaumudi-Mahotsava, the moonlight festival.[13] This particular evening was also a chosen time for the annual performance of Sanskrit dramas. In Nepal this ancient South Asian custom continued even in the late 1960s, when dance and drama, locally known as *dabu pyakham*, were performed in

3
(below)
Maya's Dream, fresco in Hemis Monastery, Ladakh, 17th century. From Madanjeet Singh, *Himalayan Art* (Unesco Art Books, Greenwich, Connecticut 1968).

4
Maya's Dream, Nepal, 19th century. Ink on paper; average folio size: 11.4 x 28 cm. Photograph: author.

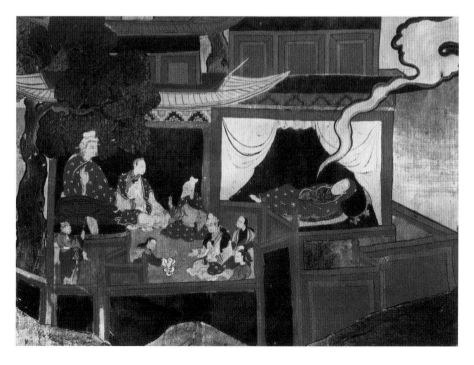

many parts of the Valley on and around this time. Such continuity helps us suggest that more than likely, the bamboo pole erected for the worship of the sky is no other than the *jarjara* of Bharata's *Natyashastra*, which was erected and worshipped during the *purvanga* ritual of Sanskrit drama performances. The ritual erection of a *jarjara* as a cosmic pillar symbolizes the separation of sky and earth, thus making a space for creation. In this context, the episodes of the drama represent the events of the cosmos, which unfold theatrically.

Although the *Natyashastra* does not refer to the oil lamp in association with the bamboo pole, apparently it is also significant in relation to the creation and procreation myth. According to Sanskrit literature the lighting of an oil lamp using the flame of a previously burning oil lamp is the same as the birth of the ideal offspring who does not differ from his begetter. This is a powerful symbolic expression in art and ritual. As we shall see shortly, in Gujarat the autumnal dance of gestation is performed around a lamp placed inside the womb of a large earthen pot. Moreover, a 7th-century oil lamp made of clay was found in recent excavations at Hadigaon, Kathmandu. This is indeed a *palcha*, the oil lamp designed for autumnal sky worship. The handle of the lamp is furnished with the image of a diminutive human figure lying on its back.[14] This posture was believed to be a characteristic of a healthy foetus growing in the womb; hence, in Sanskrit literature, the foetus is called *uttanashaya*, sleeping supine. But this foetus is a celestial being, which is suggested by the stylized lotus vine emerging from the navel of the baby as his umbilical cord. As we have explained elsewhere, a lotus vine is the main iconographic feature of the celestial child growing in the womb of the atmosphere.[15]

Perhaps the most undeniable evidence for the existence of the notion of the sky's autumnal conception in ancient India comes from the *Jaiminiyabrahmana* 3.106. The text clearly tells us that, just as a woman after menstruation, the atmosphere becomes clean and clear in the autumn after the monsoon rain, and ready to conceive:

At the end of the rainy season, the *Brahmana* (representing the cosmos) gave her the beauty of the female who is about to conceive when the *rajas* (rain/menstruation) is over. Verily, he gave her the beauty of the atmosphere (*antariksha*) devoid of *rajas* (rain/menstruation) at the end of the rainy season. He also gave the woman the beauty of the atmosphere, (that we see) at the commencement of a new year when not only the cloud but also the (autumnal) mist is gone.

This statement is in agreement with the ancient Indian belief that the perfect time for conception is immediately after menstruation. In Vedic literature when the word *ritu*, which has two meanings – a season or the menstrual period – is used alone, it signifies the rainy season (*Atharvaveda* 11.4.4). Logically, therefore, autumn is believed to be the time for atmospheric conception. More than likely, the Pleiades were named after the phenomena of rain, lightning, and thunder not because autumn is the time for heavy rain in India, but because they were identified with the celestial mothers who conceive in this season and give birth to the rain child with torrential rain, thunder, and lightning at the beginning of the monsoon.

The element of conception was not forgotten even in the further development of Krittika's story, when the seven stars of Pleiades became the wives of Saptarshi, the seven stars of Ursa Major representing the seven *rishi*s of Hindu myth. The wives of the *rishi*s conceived as they bathed in a lake whose water was imbued with the semen of Agni or Rudra.[16] These cloud mothers who turned into seven stars and the wives of seven *rishi*s are represented in Indian art anthropomorphically with swollen abdomens to indicate their pregnancy (figure 1).[17] Now the seven Pleiades are the mothers of the rain child, Kumara, and the child receives the appellation Kartikeya.

The story of Kumara/Kartikeya, however, does not stop here. In the classical period, it went through multiple layers of development and eventually the rain child became the son of Shiva and Parvati, a youthful warrior god reflecting the ideal prince of the classical period. This was the time when Kalidasa wrote the *Kumarasambhava,* in which the royal prince (*rajakumara*) like a youthful god is described as a great warrior. While in Vedic literature the word *kumara* is always used for a child, not for a young man, in classical Sanskrit it is used for both. As a result, the original significance of the rain child was almost completely forgotten. However, like the custom of frog worship, the concept of cloud mother and rain child is still traceable in the Newar culture of Kathmandu Valley.

We know from epigraphic evidence that not only in Kathmandu but also in Mathura, Mahanavami, the ninth day of Durga's worship was celebrated twice in a year – at the beginning of autumn and spring. The autumnal *navami* was known as *purva* (early)

5
Kuvera and Mother Goddesses, Mathura, c. 2nd century CE. Sandstone. Government Museum, Mathura. Photograph courtesy American Institute of Indian Studies, Gurgaon.

navami, whereas the vernal *navami* was *uttara* (later) *navami*. In Nepal these special days correspond to Dasai and Chait (Sanskrit Chaitra) respectively. The earliest epigraphic reference to *uttara navamika* is found in a Mathura inscription of the 2nd century CE which testifies that during the Kushan period both the autumnal and summer celebrations were in vogue.[18] The multiple examples of Matrika shrines belonging to the 1st and 2nd centuries CE found in the Mathura region also support this view (figure 5). The Mathura artists often depict the mother goddesses seated in child-delivering posture and adorned with a nimbus-like object.[19] Although this object is often identified as an arch, we have reason to believe that it is actually an iconographic element to indicate the association of the mother goddesses with celestial water. The *Vishnudharmottarapurana* 42.54 tells us that the god of the ocean, Samudra, should be depicted with waves in the place of the halo (*prabhasthane*). In Nepal the same iconographic element is employed to describe Bhagiratha who is famous for bringing down the celestial river/ocean Ganga to earth (figure 6). When we compare these textual and visual materials with the nimbus associated with the mother goddesses of Mathura, it becomes evident that the nimbus indicates celestial water. Evidently, association with water, pregnancy, and children are the main features of the mother goddesses.

Like Mathura, Kathmandu Valley is also dotted with ancient Matrika shrines (figure 7), which is not surprising because recent findings such as the Devakula, a royal portrait gallery, tell us that the people of the Valley were quite familiar with the culture of Mathura.[20] For various reasons, including Muslim invasions, the traditional culture was interrupted in

6
Bhagiratha, Mangal Bajar, Patan, c. 18th century. Photograph: author.

Mathura. But in the Valley some original aspects of the culture, particularly the concepts of the child god and mother goddess managed to survive side-by-side with the fully developed cult of the divine couple Shiva and Parvati. However, the continuity of pre-Vedic monsoon culture in the Valley is traceable not because some aspects of Mathura culture continued, but mainly because the concept of the rain child and atmospheric gestation is closely associated with the calendar of the agrarian society of the Valley. Just as in

7
Mother Goddesses, Kirtipur, c. 3rd century CE. Photograph: author.

ancient times, the farmers of the Valley are still deeply concerned with the arrival of monsoon rains, planting times, and successful harvests. This is the main reason why the concept of atmospheric gestation and the rain child has remained alive in their memory.

THE BIRTH OF THE RAIN CHILD AND CELEBRATIONS

The Newars of the Kathmandu Valley believe that the child god Kumara was born at the very first of the pre-monsoon rains, on the first day of the bright half of the month of Jyeshtha (see Appendix). This is the time of the year described in Vedic texts as the end of the gestation period (*samvatsare*). This concept, which continued in the classical period with some variation, is in harmony with the rain symbolism of the celebrations of Kumara's birth in the Valley. The newly born rain child is treated just like a Newar child, and vice versa. Following an ancient South Asian custom, the birth of a new baby is not celebrated on the day of delivery but on the sixth day after the birth when it is perceived that there is no longer life-threatening danger to the mother and child.[21] Thus, Kumara's birth is celebrated annually on the sixth day of the bright half of Jyeshtha, which is known to the Newars as Sithi (Sanskrit Shashthi) or Sithinakha, the festival of the Sixth Day. This particular day is deified as mother goddess Shashthi, who is sometimes identified with Vindhyavasini, at other times with Shitala, the goddess of smallpox. The Newars, however, believe that the presiding deity of the day is Kumara as well; hence, in the Valley the child god is called Sithidya, the god of Sithi. An unpretentious shrine in the northern section of a Newar town shelters a wooden image of Kumara riding a peacock and the

shrine is locally known as Sithidyaya Chem or Sithidya's house.[22] On the day of Sithinakha, Newars visit the shrine to celebrate his birth and offer the god many varieties of pancakes made of rice, lentils, mung bean, etc. The grains are considered to be the blessings of the child god. More importantly, the period of 18 days of planting rice seeds begins from this auspicious day and terminates on the eighth day of the dark half of Ashadha. The rice seeds grow into plants within two or three weeks and the baby plants are ready to be transplanted in a wider space when the real monsoon begins. When we quote Vedic and astrological and other Sanskrit texts in explaining the monsoon culture of South Asia it is important to note that the monsoon was crucial to the people not only for rice planting but for fresh vegetation for their cattle.

Epigraphic information about the agro-cultural rituals performed in the Valley immediately before Sithi also helps us to understand the symbolic significance of the child god. A 15th-century inscription on the wall of the Malla palace of Bhaktapur states that the people of the city should clean the roofs of temples and other buildings, the streets, and the water sources such as irrigational canals, fountains, wells, and tanks before Sithi. This medieval inscription also tells the people of Bhaktapur to repair the moats and gates surrounding the city before the day of Sithi.[23] Although there are no more moats and not many city gates left in the valley, Newars do repair buildings and clean water sources, including irrigation canals, even these days, in preparation for the monsoon and planting season. Almost certainly, this custom goes back much earlier than the medieval period. According to Banabhatta's

Kadambari (7th century), Kumara was worshipped in the royal palace of that time, together with the mother goddess Shashthi. As we know from a contemporaneous Lichchhavi-period edict, such a shrine was called Shashthidevakula, "sixth-day shrine". The edict, for taking care of an old palace, was issued on the day of Jyeshthashukla Shashthi, which is Sithi.[24]

The successful planting of rice seeds required plenty of water, and pre-monsoonal rains were expected around the time of Sithi. Both Vedic literature and astrological texts of the classical period tell us that throughout the early history of India the agrarian society of the subcontinent carefully observed the natural phenomena during this critical period of time which was known to them as *pravaris* or *pravarshana*.[25] As we know from Kautilya's *Arthashastra* 2.5.6, in conjunction with a short chapter called *Pravarshanadhyaya* in Varahamihira's *Brihatsamhita,* it was a custom of the Mauryan royal palace to keep a square water container known as *varshamana,* rain gauge, in front of the gate of the treasure house of the palace to collect the rain water of the pre-monsoon season so that the royal astrologers could predict the success of the upcoming planting and harvest. This custom is still in vogue in the Durbar Square in Kathmandu, but with a different Buddhist interpretation. Moreover, according to the *Sadhanamala* 214, 215, *varshamana* or *varshaghata,* the rain pot, is the main attribute of the rice goddess Vasudhara, her other important attribute being a rice plant. However, Vasudhara's rain pot is always round.

The Vedic rain child, Kumara, who was born in the season when frogs start croaking and even broken plants start growing cannot be different from the Kumara/Sithidya of the Newars. On a visit to Kathmandu Valley from late May to early June 2005, I had the opportunity to witness the sporadic pre-monsoon rain, the croaking of frogs, the sowing of rice seeds, and the preparations for the celebration of Kumara's birth.

We do find some traces of the cult of Kumara as a rain child in parts of India as well. In Gujarat, as we know from the local calendar, the sixth-day celebration of Kumara's birth, for instance, is still remembered as Skandashashthi, the sixth day of Skanda/Kumara. In Odisha (Orissa) the same day is designated as Shitalashashthi. In Tamil Nadu Vaikachi Vichakam is celebrated around late May or early June as the birthday of Subrahmanyam or Murugan, who is believed to be identical with Kumara. The celebration of the festival follows the Tamil calendar (Vaikachi being the name of the Tamil month and Vichakam one of the 27 *nakshatras*). It is true that this is not the exact day when Sithinakha is celebrated in Nepal. But rice seeds are sown in Tamil Nadu around this time. Unlike in other parts of south India, in Tamil Nadu pre-monsoon rains are later because the main winds blow diagonally from Kerala to Assam. However, just like in Nepal, Murugan's festival coincides here with the pre-monsoon rains.

It is also true that Skandashashthi is celebrated in some parts of India not toward the end of summer but in autumn (October–November). The Indian alternative practice of reckoning the birth of a child from the day of conception is exemplified by the ritual in the ancient Gurukula tradition mentioned in the *Vaikhanasagrihyasutra* 2.3, and the autumnal celebration of Kumara's birth is perhaps reminiscent of the initial day of atmospheric

conception of the rain child.[26] This may be the reason that this particular day is named after Skanda instead of Kumara because *skanda* means ejaculatory fluid, whereas *kumara* denotes a baby. In Tamil Nadu the Vaikachi Vichakam festival is considered the second birthday of Skanda/Subrahmanyam. As we will see shortly, this underlying significance of the important days correlates with the agrarian view recorded in the Vedas that a seed/baby is twice-born.

Although many scholars have studied the cult of Kumara/Murugan in detail, none, to my knowledge, seems to be familiar with the Kumara cult in Nepal. In a sense their study is incomplete, and this creates some problems. According to one scholar Skanda/Kumara is a solar divinity and his annual rituals indicate cosmic sunrise and sunset, a year being the micro version of the phenomena. He writes:

> Thus, Skanda-sasthi in October–November becomes the first festival to the god, and, in addition to all else that it represents, in the context of the solar year, represents his rising in the pre-dawn hours and subduing the forces of chaos and darkness. His overcoming of the *asura* thereby becomes a creative act, assuring the coming of a new cosmic "day" and a new created order.[27]

I believe that if the author of this statement were familiar with the textual evidence regarding the concept of atmospheric gestation, the birth of Kumara as a rain child, and its association with the Kumara cult in Nepal, he would have a totally different view on this subject. As we mentioned earlier, Kumara's career as a warrior is a secondary development; hence, his heroic fight with the *asura*s, demons, does not help us understand

the underlying original significance of the child god.

Although the legend of Kumara as the warrior god is popular in the Kathmandu Valley as well, the Newars clearly associate the birth of Kumara with the pre-monsoonal agricultural activity. His birth is also related to the last day of sowing rice seeds, which they call Bhal Bhal Ashtami, the eighth day called Bhal Bhal, when the very first torrential rain of the real monsoon is eagerly expected so that transplanting of the rice seedlings can begin.[28] In the well-known classical Newari text *Gopalarajavamshavali*, the same word is spelt *vala vala* (pronounced val val) and the torrential rain is described there as a mythical river or river goddess.[29] But it would be a big mistake to consider the nomenclature of the day peculiar to Newar society of the medieval period. In fact this is cognate to *bal* or *bal bal*, a pun used in Vedic literature for the birth of a child, both human and atmospheric.[30] The use of such a pun correlates with the Newar concept that pre-monsoonal rain means the birth of a rain child and the germination of seeds. This view is also found in Kautilya's *Arthashastra* 9.1.12 where the rice seed sown during the pre-monsoonal rain is designated *garbhadhānya*, foetus grain (*aprabhāvo garbhadhānyam avriṣṭir ivopahanti*: lack of might is almost like drought which destroys the rice seed/foetus grain). Likewise, in Vedic expressions the early monsoon rain that falls at the end of the atmospheric gestation (*samvatsare*) is a child who enters the womb of mother earth and takes second birth as fresh vegetation. Therefore, the rain child is described in the *Rigveda* 1.140.2 as twice-born (*dvijanman*). Such everlasting agrarian concepts seem to be deeply rooted in the Newar culture of the Valley.

The Shower of Babies

On the day of Bhal Bhal Ashthami, an interesting annual festival called Machatiya Jatra, "the festival of piercing the children", takes place in Deopatan, in a small city called Gvala, near Pashupatinath Temple in the Valley (figure 8).[31] This festival is indeed closely related with both the cult of Kumara and the Navadurga dance of Bhaktapur. Locally, this festival is known as *Khata Jatra*, the chariot festival, but *ratha*s or wheel-driven chariots are not used as would be expected. Instead, several cross-like structures are carried along the path of the procession.[32] Very likely, these structures represent cosmic poles because a similar structure, but much larger in scale, is annually erected on New Year's day in Bhaktapur as a cosmic pillar.[33]

Perhaps the most unusual feature of this festival is the participation of eight- or nine-year-old boys and girls, who are placed uncomfortably as well as dangerously on top of the vertical member of the structures. Figure 8 shows a scene in which a young boy is placed horizontally on the pole. His legs and back are carefully supported by two men so that he does not fall from the structure. The men stand on the horizontal beams. The entire structure including the child and his supporters is carried in procession on the shoulders of a huge group of people (figure 9).

Some people of the Valley, particularly the Nepali-speaking ethnic group, call this festival Trishul Jatra, "the procession of a trident". To my knowledge, however, no real trident is associated with this festival. On the contrary, it is mythically related to the Trishuli river (Newari Sihluti). This Himalayan river flows through the village of Nuwakot but does not enter the Kathmandu Valley. It is however interesting to note that the Newars of the Valley are fascinated by the story of the Trishuli and believe that the main source of water in the Valley is mystically connected to this celestial river. In an 18th-century copy of a much earlier Newar painting, the streams of the river are shown like a trident emerging from stylized clouds (figure 10). Commenting upon the inscription found on the painting, I have explained that the Trishuli river remained significant to the Newars because they originally migrated from Nuwakot, which is designated in ancient Tibetan literature as Bal-po rdzon or Newar village.[34] In my earlier work, I have shown that this river is also known to ancient Newars as the Bhal Bhal river.[35] Because *bhal bhal* or *bal bal* means both shower of rain and birth of a child, I am of the opinion that Newars of the Valley prefer to call the festival Machatiya Jatra, the festival of "piercing the children", associating the children with the trident-like triple

8
Preparing for a Machatiya Jatra. Photograph courtesy Linda Iltis.

9
Machatiya festival procession. Photograph courtesy Linda Iltis.

10
Nepal Pilgrimage from
Kathmandu Valley to
Gosainkund, detail showing
the Trishuli descending from
a rain cloud in three streams,
Nepal, probably Bhaktapur,
late 17th or early 18th century.
Colours on cloth; 83.8 x 435.6
cm. Philadelphia Museum of
Art: Purchased with the Stella
Kramrisch Fund, 2000.
Acc. no. 2000-7-3.

11
Child holding a pomegranate
twig during the Machatiya
Jatra. Photograph courtesy Axel
Michaels.

12
So-called *gana*s at the entrance
to a shrine of a goddess,
Bharhut, 2nd century BCE.
Photograph courtesy Digital
South Asia Library.

streams of the monsoon river descending from the atmosphere.

The symbolism of the boys and girls in the festival deserves special attention. When they are placed on the structure they hold a tiny branch of pomegranate around the area of their navel as if it is emerging from their body (figure 11). Such images immediately recall to us the depictions of so-called *gana*s (dwarf-attendants) with lotus vines emerging from their navels. In Indian art such baby-like figures are often depicted on either side of a temple entrance symbolizing the cloud gate of heaven (figure 12). In architectural texts the baby-like figures are designated as celestial children, *kumara* and *bala*. They are known in Pali literature as *dandamanavaka*s, the lotus babies. As mentioned in our earlier work, the lotus vines emerging from the navels of the babies represent their umbilical cords. Such lotus babies are depicted not only around the entrance of Indic temples and shrines but also in Ajanta ceiling painting, which symbolically represents atmospheric gestation (figure 13). Furthermore, the figures of the babies are often decorated with *meghapatra* (cloud foliage) motifs indicating their identity with the foetuses of cloud mothers.[36] In the light of this information, we believe that the children placed atop the poles, more than likely,

represent the rain-children descending from the wombs of the cloud rivers on the day of Bhal Bhal.

The custom of displaying children's vests during the procession of Machatiya Jatra further supports our view. People carry the vest hanging or stretched between two bamboo reeds. This is locally known as *bhoto kyanegu,* display of a vest.[37] Such display symbolizes a child's birth and well-being. A newborn Newar child does not wear a stitched cloth for five days. During this period the child is wrapped in a piece of cloth called *icha* provided by those maternal aunts who have never lost children, even in epidemics of diseases such as cholera and smallpox. On the sixth day after his or her birth, for the very first time the child ritually receives an auspicious *bhoto* provided by the maternal uncle. When the child wears the *bhoto* this symbolically suggests that the child has passed the most critical days of his life.

This Newar custom closely resembles the religious ritual called *dasha-samskara*, which is based on the belief that god is a child and vice versa. Kuladatta, the author of the celebrated Buddhist text, *Kriyasamgraha* (folios 113–14),[38] elaborately deals with the ritual in his work. According to the text, a newly established image of a Buddhist god is just like a newborn baby. Thus, the image is called *vatsa*, a baby. Perhaps even more interesting is the fact that before the birth of the divine "child", the *simantonnayana*, a ceremony observed by women during pregnancy, is also performed (folio 113). Just like a Newar child, the divine "child" does not receive a stitched cloth immediately after the consecration or birth. Only on the sixth day celebration of his birth, the newly consecrated image of the god receives the *kanchuka* or *kavacha* (Newari *bhoto*) made of yellow silk (folio 114). In the text such celebration is described as a part of the *jatakarma* or birth ritual of the divine "child".

This fascinating ritual is also associated with Bugma Avalokiteshvara or Bungadya, the most renowned Buddhist deity worshipped in the Valley as a rain god. At the end of Bungadya's chariot festival, the *bhoto* of the rain god is ceremonially displayed in an open

ground called Jawalakhya in Patan. This always takes place around the time when the sowing of the rice seeds begins because it is believed that the display of the vest brings pre-monsoonal showers. A similar *bhoto* or vest of child's size is preserved in the Los Angeles County Museum of Art (figure 14). This vest has nothing to do with the goddess of wealth Vasundhara or Vajrayogini as represented in a recent publication.[39]

The Buddhist priests of Kathmandu Valley are also familiar with the fact that all Buddhist newly installed images of deities are child gods (*vatsa*). According to the popular Buddhist chants, that one can hear in a Newar Buddhist monastery almost every day, each deity goes through the stage of embryo in the womb of Buddhist mother goddess, Mayadevi. The Sanskrit chants can be translated as follows:

13
Lotus Baby, ceiling painting, Ajanta Cave 1, 5th century CE. Photograph courtesy Archaeological Survey of India.

14
Vest of a Divine Child, Nepal, 15th century. Multicolour silk embroidery in brick and chain-stitch on yellow silk; 48.3 x 45.3 cm. Los Angeles County Museum of Art, purchased with funds provided by Mrs Harry Lenart. Photograph © 2009 Museum Associates/LACMA.

[O god] please stay in this image as you stayed in Mayadevi's womb.... All Tathagata Buddhas receive ritual bath immediately after their birth. In a similar manner, I will bathe you with this pure heavenly water.[40]

We find these *shloka*s in Kuladatta's *Kriyasamgraha* (folio 112) as well. He explains that after birth, the child gods should receive a bath (*snapana*) as a part of the *jatakarma* (after-birth) ritual. The Sanskrit word *snapana*, which simply means a bath, became *hnavam* in Newari. The word is, however, used in Newari only in a religious context for the annual bathing ritual of Buddhist and Hindu deities (including Bungadya and Janabadya) of the Valley. After the ritual bath, according to the text, the child god should wear a *bhoto* (*kanchuka* or *kavacha*) and go through other birth rituals such as the application of collyrium around the eyes. The Newars of the Valley still perform the rite of the very first application of collyrium for their newborn children on, or two or three days after, the important sixth-day ritual. But in the context of establishing an image of a Buddhist god this particular rite is described in the text as the eye-opening ceremony (*drishtidana*). Kuladatta also informs us that in the case of a painterly representation of a deity the eyes should be painted while looking at the reflection of the image in a mirror.[41]

Logically, the underlying concept of these birth rituals derives from the age-old cult of the rain child. In my earlier work I have reported the existence of a shrine of Kumara in the northern section of old Kathmandu.[42] In front of this shrine, on the day of Sithi, an elaborate Jatakarma ritual including Kumara's annual bathing or *hnavam* is performed. Such

after-birth rituals are meaningful when they are observed for the child god Kumara. The Buddhist Newars of Thimi, near Bhaktapur in Kathmandu Valley, however, believe that Bodhisattva Avalokiteshvara is not much different from Sithidya.[43] According to them (and indeed it is also a popular Buddhist belief in Nepal), after a period of gestation in Mayadevi's womb, the Bodhisattva is born on Jyeshtha Shukla Pratipada, the very first day of pre-monsoonal rain, which is also the birthday of Sithidya/Kumara. Immediately after the birth, the Buddhist child god of Thimi receives a ritual bath, *hnavam,* in the vicinity of the temple. Six days after the bath, on the day of Sithi, the newborn Bodhisattva is brought back to his original shrine and goes through other birth rituals, receiving the vest and ornaments. These similarities between the child god Kumara and Avalokiteshvara should not be considered Hindu influence over Buddhism or vice versa. In fact, both these religions inherited the concept and characteristics from the pre-Hindu and pre-Buddhist tradition of monsoon culture.

As I have explained elsewhere, the earliest reference to the concept of the rain child is found in Vedic literature. Just after birth, the child receives the very first bath of monsoon rain.[44] This concept survived and reappeared in the legend of the Buddha Sakyamuni's birth. According to the Buddhist texts, Prince Siddhartha was born in the Lumbini grove from the side of the queen mother Maya as she grasped a branch of a tree. Soon after this supernatural birth the newborn baby and mother received an atmospheric shower bath. In the *Nidanakatha* a peculiar phrase is used to describe the event, *utum gahapesum*: "[the gods] caused the baby and the mother to receive the monsoon rain (*ritu*)".[45] This

phrase helps us to connect the concept of the Buddhist nativity scene with the birth of the cosmic child who was also bathed by monsoon clouds.[46]

More support for our view comes from a significant sculpture from Nepal (figure 15). It depicts the scene almost exactly as described in the text. On the right, Maya is shown clutching the branch of a tree. On the left, immediately above baby Siddhartha,

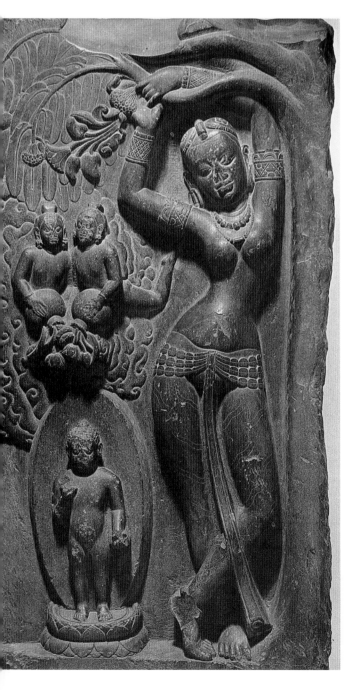

two cloud gods holding spherical water jars are depicted flying in the middle of the stylized cloud. Many years ago when Kramrisch published this image for the very first time, she correctly identified the cloud gods as *devaputra*s.[47] In early Buddhist texts such atmospheric deities are often described as *varshavalahaka devaputra*s – rain clouds, the sons of the gods (*Anguttaranikayatika* 2.2.37). In later Buddhist texts the cloud gods are identified as Nanda and Upananda – *devaputra*s or *naga*s, serpents. The lotus flowers flowing down from the jars held by the gods symbolize the shower.

In the light of such textual and visual evidence, if we give attention to the choice of the days for the procession of the Machatiya Jatra and a related puja, the symbolic significance of the children placed on top of the pole during the procession becomes even more transparent. The choice of day of Bhal Bhal for the procession is not accidental, because Bhal Bhal is the word for a shower of rain and also sounds like the word for the birth of a baby, but also because the children required for the procession are ritually selected on the day of Sithi and worshipped as Kumaras and Kumaris. The elaborate puja of this day is called Kumhapuja (Sanskrit Kumarapuja). These boys and girls are not, however, identical with Shaivite Kumara and the well-known virgin goddesses of the Valley. Instead, the ritual is based on the concept that the pre-monsoon raindrops signify the birth of rain children, so it makes sense that the concept of the rain child is expressed not only in its plurality but also in both genders. Thus, the ritual of the Kumhapuja and its close association with the time of planting rice and transplanting the seedlings strongly suggest that the Machatiya Jatra

15
Buddhist Nativity, Nepal, c. 9th century. National Museum, Kathmandu. From Madanjeet Singh, *Himalayan Art* (Unesco Art Books, Greenwich, Connecticut 1968).

is actually the enactment of the descent of celestial babies representing the early drops of monsoon rain and the germination of rice seeds, *garbhadhanya*. During the Jatra procession, the local people shout indecent words, a rain-making effort mentioned in early classical texts such as the *Gajayurveda*, a treatise on the life and well-being of elephants.

On the day of the Machatiya Jatra or Bhal Bhal, the dances of the Navadurga mother goddesses come to an end, understandably, because their annual responsibility of delivering rain children is over. During the rainy season, the mother goddesses remain dormant. It is this feature which clearly indicates that they cannot be identified with the earth mother, who remains most active during the rainy season. Compare the dormancy of the mother goddesses with the prolific activity of the earth goddess Shakambhari during the rainy season, when she constantly provides her devotees with seasonal vegetation growing on her body.[48]

THE FIRST DAY OF DURGA PUJA

We have spent a considerable amount of time discussing the cult of Kumara in the Kathmandu Valley. This should not be considered irrelevant because without understanding it properly we may not be able to detect the significance of the initial rite of Durga Puja on Ashvina Shukla Pratipada, (the first day of the bright half of Ashvina). In most parts of the Indian subcontinent, but mainly in north India, this important day is known as the day of Ghatasthapana, establishment of a water pot. Sometimes colourful mask-like faces of mother goddesses are painted on the swollen belly of the pot, thus associating the womb-like pot with the

mother goddesses. The faces of goddesses painted on a recently found water pot show close resemblance with the masks of the Navadurga goddesses of Bhaktapur (figure 16).

A careful observation of the legend and iconography of the autumnal star Agastya indicates that in ancient India such a water pot – *ghata* or *kumbha* – unambiguously symbolizes the autumnal womb of the atmosphere. For instance, the celebrated Sanskrit poet and dramatist Kalidasa, in his work *Raghuvamsha* 4.21 tells us that Agastya's rise in the southern sky indicates the end of the rainy season. This seasonal phenomenon is described in the legend as his ability to drink the entire ocean, the monsoon cloud, as if it is a single handful of water (*chulukitambhorashi*). Iconographically, he is presented emerging from a typical round water pot, designated in Sanskrit literature as *kumbha*, *ghata*, or *sthali* (figure 17). Such iconography is, however, based on the belief that Agastya was a *dimba* or foetus conceived in the atmospheric water pot. Thus, in Sanskrit literature he is called *kumbhadimba*, foetus in a pot. These stories of Agastya and his iconography are indeed based on the autumnal phenomena and the atmospheric gestation of the season. Thus, we have good reason to believe that the water pot of the autumnal ritual of the Ghatasthapana is also related to the seasonal phenomena.

On the day of the Ghatasthapana, in household shrines or in the temples of mother goddesses, usually a large earthen pot with a wide mouth is placed in an inverted position to cover the ritual planting of barley seeds on a circular altar. Although in the legend we have been told that the blades of the barley sprouts planted on this day turn into swords required for fighting demons, the ritual of the inverted water pot does not

seem to have any direct connection with Durga's victory over the buffalo-demon. On the other hand, the astrological tradition of India indicates that this is the day of atmospheric conception. There is however a controversy among authorities regarding the day of conception. Varahamihira, the author of the celebrated work *Brihatsamhita,* for instance, devotes a chapter of his book to atmospheric conception – *garbha-lakshana,* symptom of atmospheric gestation. At the very beginning of the chapter (*Brihatsamhita* 21.5), he informs us that according to his predecessors the atmospheric conception begins immediately after Kartika Shukla Purnima, known in classical Sanskrit

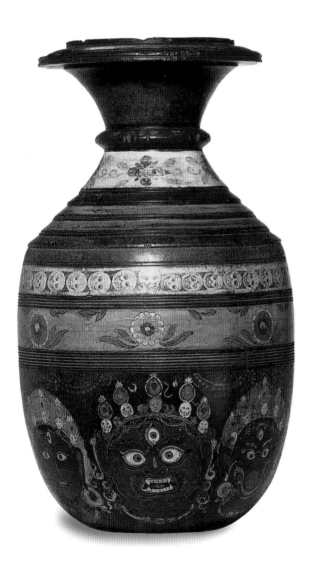

literature as Kaumudi-Mahotsava. As we have mentioned earlier, the Kaumudi festival is also celebrated one month earlier on the full moon night of Ashvina. But Varahamihira himself believes that the atmosphere conceives not on this day but several weeks later on Marga Shukla Pratipada, because the duration of pregnancy according to him is only six and a half months (*Brihatsamhita* 21.6). In his opinion, it is even possible that the clouds conceive in the morning and issue the child in the evening (*Brihatsamhita* 21.8).

The main significance of finding out the exact time and duration of pregnancy was an attempt to precisely predict the arrival of an early monsoon. But the monsoon is unpredictable; it arrives in different parts of the subcontinent at different times. Thus, it is understandable why there are different opinions about the date of conception. This may be the reason that, during the classical period, the duration of atmospheric gestation went through a modification. The gestation period was ten lunar months during Vedic times. In the *Ramayana* 4.27.3 the period of gestation is nine months, when the sun draws water from the earth. According to a more widespread notion, as we know from the *Manusmriti* 9.305, and also from the custom of rainy season retreat among Buddhist and Jain monks, the duration of the same phenomenon was considered to be only eight months. This post-Vedic version of the duration of atmospheric gestation helps us to understand the relation between Sithi and Ghatasthapana. Since the rain child is considered to be born on the first day of the bright half of Jyeshtha (six days before Sithi), in accordance with a post-Vedic belief, the cloud mothers must have conceived him eight months before on the day of the bright

17
Agastya, Nepal, c. 7th century. National Museum, Kathmandu. Photograph: author.

16
Wooden ritual water pot with paintings of mother goddesses, Nepal, 19th century. Pal Family Collection. Photograph: author.

half of Ashvina, which is exactly the day of Ghatasthapana.

In this context the Newari nomenclature for Ghatasthapana and the related ritual deserve attention. Just like in other parts of South Asia, the Newars plant corn or barley seeds in the soil and cover this with a large earthen pot. This ritual is known to them as Nala-svanegu, planting germs. The classical Newari word *nala* has double meaning – newborn baby and tender shoot or sprout.[49] The second word *svanegu* literally means inserting or placing inside. Thus the Newari compound word has a double meaning – "conception of a baby" or "sowing seeds". Thus the ritual of Nala-svanegu indicates that the seeds sown on the day of Ghatasthapana are babies growing in the womb of the inverted earthen pot. Furthermore, the pot has an interesting name in Newari, *vahla bhyaga* – womb bucket or basin. This ritual, however, cannot be interpreted as the conception of the earth mother because the time of Durga Puja is not a rice planting time but a season of harvest.

We mentioned earlier that some elements of the story of the Buddha Sakyamuni's conception derive from the concept of atmospheric gestation. In accordance with the Gujarati *panchanga,* Sakyamuni was born during the time of Navaratri. Going by the Indian custom of reckoning the birth from the day of conception, this is perhaps the day when Maya saw the white elephant in her dream, a story designed after atmospheric phenomena. For this reason it is not surprising that following the concept of a *garbha-lakshana*, symptom of atmospheric pregnancy, described in astrological texts such as *Brihatsamhita* chapter 21, Buddhist artists of the later period depict the scene of Maya's

dream replacing the white elephant either with a puff of cloud or with the *jaladharajala,* a cloud motif that resembles various creatures such as an elephant or the mythical *makara.* There are multiple examples of such treatments of the subject; the wall painting in Hemis Monastery, Ladakh (figure 3) is perhaps the best one, where a stylized cloud motif is shown. In a Nepali example the cloud motif appears like a *makara* and the motif is labelled as *megha* or cloud (figure 4). There is no reason to doubt that such cloud motifs stand for the same white elephant hovering in space depicted in the Bharhut stone medallion of the 2nd century BCE (figure 2).

In Gujarati tradition, the autumnal day of Ghatasthapana is much more transparently associated with the idea of "conception". Beginning from this day, for the ten days of the Durga festival, the men and women of Gujarat dance around an earthen pot which has an oil lamp inside. The dance is called Garbha-rasa, the circular dance around *garbha.* Since the word *garbha* has nothing to do here with human pregnancy, it reminds us of its association with the atmospheric gestation of autumn. Thus, if we compare the timing of dance with the *Jaiminiyabrahmana* statement and astrological theory that the sky conceives at the beginning of autumn, it becomes very clear that Garbha-rasa can not be other than the symbolic enactment of atmospheric conception.

The original meaning of the word *rasa* also deserves attention. Although in a later period the *rasa* or *rasaka* became associated with Krishna's dance with the *gopi*s, Indic theatrical tradition tells us that originally the word *rasa* and its synonym *pindi* were important technical terms in ancient Indian theatre. Bharata Muni, the author of the

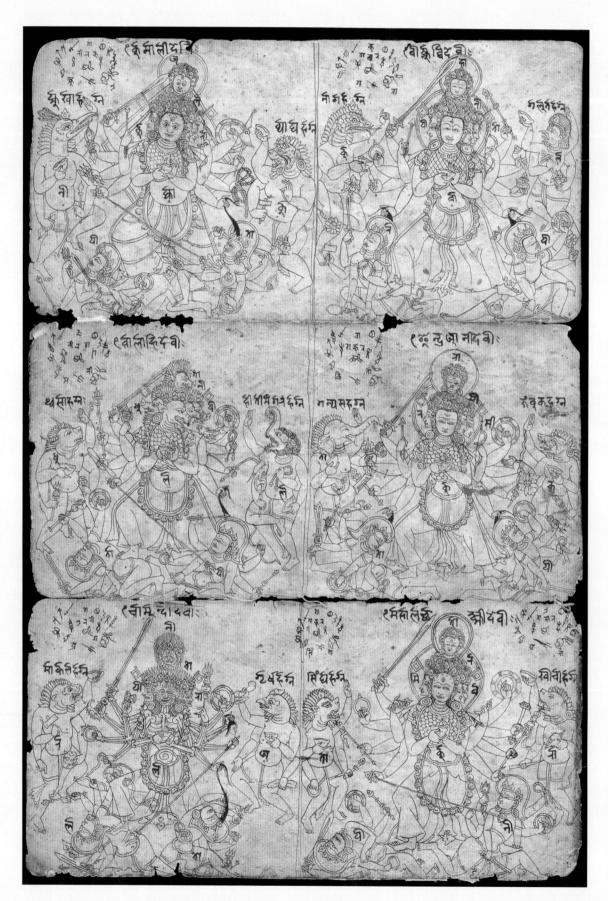

18
Kumari and Vaishnavi with
their personified attributes and
animal vehicles, from a Tantric
folio, Nepal, 18th century.
Ink on paper. Rubin Museum
of Art, New York. © Rubin
Museum of Art/Art Resource,
NY.

Natyashastra, clearly states that a *pindi* is a group dance, in which a divine protagonist participates together with the dancers representing his or her personified attributes and animal vehicles.[50] For instance, if an actor is acting as Vishnu in a theatre he will be dancing together with his personified attributes as well as his vehicle Garuda. As we know from the *Vishnudharmottarapurana* 20.55, 42.54, this is actually the origin of representing attributes in human form (*ayudhapurusha*) in the artistic tradition of South Asia. This subject, indeed, deserves to be treated in detail elsewhere. According to another important Sanskrit text *Bhavaprakasha*, the *rasa* dance is just like *pindi* and performed by a protagonist together with eight, twelve, or sixteen dancers.[51] Very likely, the Garbha-rasa of Gujarat was a version of the *pindi* and originally performed by a group of male and female dancers representing important divinities such as mother goddesses and their personified attributes and animal vehicles. This course of reasoning is also based on the fact that exactly on the same day as Ghatasthapana, the cycle of the ritual dance of Navadurgas, nine mother goddesses, begins in

19
Clay masks of the mother goddesses and their personified animal vehicles, Bhaktapur. Photograph courtesy Niels Gutschow.

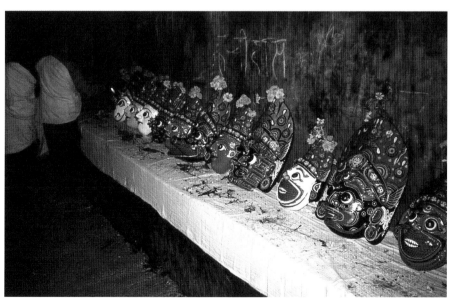

Bhaktapur. Unlike the Garbha-rasa of Gujarat, the Navadurga cycle is not, however, a ten-day event; it lasts for eight months. If we follow the terminology of the *Natyashastra*, the Navadurga dance is no other than a *pindi* or *rasa* type of performance because it is a group dance consisting of the mother goddesses and their animal vehicles – Simhi (lioness) and Vyaghri (tigress). A recently discovered 16th-century manuscript in the Rubin Art Museum, with valuable labels in Newari, represents various mother goddesses flanked by animal-headed dancers, for instance, Kumari with a peacock and tigress, Vaishnavi with a *naga* and Garuda (figure 18). All these animal-headed figures are shown dancing vigorously with flexed legs and raised hands. In the labels they are identified neither as attendants nor as *vahana*s or animal vehicles, but as *hagna*. Despite the fact that we do not know the exact etymology of this Newari word, undoubtedly it is synonymous with Sanskrit *pindi* because they are shown dancing with the main deities. Clearly, the concept and tradition of the *pindi* type of theatrical performance was alive in Nepal even in the 16th century.

In Bhaktapur the masks needed for mother goddesses and their animal vehicles are made of clay (figure 19).[52] Despite the fact that the colourfully painted clay masks are aesthetically pleasing, they are not simply works of art but also symbolize gestation and fertility. This becomes evident if we consider the association of clay with the ritual of making masks and the important role of gardeners in the performance of the dance.

The masked dance of the mother goddesses is performed by an ethnic group called Gathas, who specialize in the cultivation of flowers. In the Kathmandu dialect the

Gathas are known as Gathu and their performance of the dance of the mother goddesses is known in Kathmandu as Gathu Pyakhan. Thus the Navadurga dance is not peculiar to Bhaktapur as previous authors have stated. A miniature painting on a manuscript cover illustrates the figures of musicians, actors, and a director of a theatrical performance in the medieval period, in which an actor is labelled "Gathan".[53] Clearly for many centuries the Gathan or Gathas have practised two professions, theatrical performance and horticulture. The main reason for the involvement of these gardeners in the performance of religious dance is the symbolic significance of the masks made of fertile soil, knowledge of which is the speciality of the Gathas. Even these days the Newars of the Valley call fertile soils "Gathu-cha" or gardener's soil, and their theatrical performance Gathu Pyakhan or gardener's dance.

A 7th-century Nepali inscription tells us that stone sculptures of Matrikas replaced earlier clay figures of the same deities.[54] This information indicates that many more Matrika images of earlier times might have been made out of clay, not because the ancient sculptors were unfamiliar with stonework but because of the symbolism of fertility associated with clay. In other parts of South Asia people still fashion images of mother goddesses out of mud. Thus, the annual ritual of making clay masks of the Navadurga deserves special attention in order to understand the symbolism of both the rituals and the masks. An author describes the ritual of making masks in the following words:

> On the day of Gathamuga the gathas take some black clay from the field and erect a *linga* of Shiva. Some of this soil is left and preserved in order to be added to new masks. The gathas, i.e. mask-dancers, musicians and leader of the god-house go to Taleju with the new set of masks ritually made of special clay mixed with the ashes of the previous masks and of the black clay, the remains of the Shiva linga made on the day of Gathamuga Chare.[55]

In the light of earlier investigations conducted by Jehanne Teilhet, Robert Levy also records the ritual:

> On this day, according to some accounts, the Gathas take some black clay soil from the river bank and make a linga representing Siva from it. Some of this soil will later be added to the new Nine Durgas' masks to be made by the mask maker before the reappearance of the Nine Durgas during Mohani [Durga Puja].[56]

Gathamuga Chare, the 14th day of the dark half of Shravana, is the last formal day for transplanting rice seedlings into the paddy fields (see Appendix). On this day the Newars of the Valley erect at crossroads the straw figures of the three-legged ithyphallic demon Gathamuga, notorious for his sexual appetite. His name indicates his direct association with the fertile soil, *gathucha*. This demon is identified with Ghantakarna who is, however, not entirely a demon but also a fertility god.

We have good reason to believe that the Newars of the Valley are indeed conscious of such symbolism, not only because the mixing of the phallic clay with the clay of mother goddess masks suggests symbolic impregnation, but also because the Newars constantly relate the annual ritual Navadurga dance with the phenomena of autumnal and

monsoonal seasons – the official days for collecting mud, making masks, beginning and ending time of sowing rice seeds, transplanting the rice seedlings, etc. It is true that in the impregnation ritual, mud plays an important role. But this autumnal ritual is directly associated with the fertility not of the earth but of the atmosphere. Only because nothing can be planted in space, mud became the medium for the symbolic expression of atmospheric gestation – both in the mask-making ritual of Navadurga and in Ghatasthapana. Unarguably, however, the ultimate purpose of the ritual is indeed the fertility of the earth.

CONCLUSION

With these observations, we can safely conclude that the Matrika deities originally do not represent earth mothers but atmospheric phenomena. For this reason the mother goddesses are named after rain, thunder, and lightning. They conceive early in the autumn. This autumnal conception is celebrated in most parts of the Indian subcontinent as Ghatasthapana. The significance of the day is, however, more transparent in Nepal and Gujarat than elsewhere in India. After a period of gestation, the rain child Kumara is born at the beginning of pre-monsoon rains around the second week of June. Following the customs associated with human childbirth, the Newars of the Valley still celebrate the birth of the rain child on Sithi, the sixth day after the "birth". The last expected day for such atmospheric phenomena is believed to be Bhal Bhal Ashtami around the third week of July. This is also the day when the delivery of the babies representing pre-monsoonal rain (*Pravarshana*) is enacted in the festival of Machatiya Jatra. After the delivery, the

annual cycle of the mother goddesses comes to an end and they remain dormant during the rainy season for about three and a half months.

APPENDIX
Annual Events of the Agro-religious Calendar of the Kathmandu Valley
1. **The first day of the bright half of Ashvina (around October 12)**
Ghatasthapana; Newari: Nala-svanegu. The cycle of the masked dance of Navadurga begins on this day, which is also the initial day for atmospheric gestation.

2. **The first day of the bright half of Jyeshtha (around June 16)**
The birthday of the rain child Kumara. Following the birth rituals of a human child prevalent in ancient South Asia, his birth is celebrated not on the day of his birth but only six days later when the imminent danger to the child and the mother are over.

3. **The sixth day of the bright half of Jyeshtha (around June 21)**
The celebration of Kumara's birth (Newari: Sithinakha), when the sowing of rice seeds begins.

4. **The eighth day of the dark half of Ashadha (around July 7)**
Newari Bhal Bhal, a pre-Vedic word for rain, which sounds the same as the word for childbirth. Torrential monsoon rain is expected to begin from this day. This is also the last day for sowing rice seeds and the first day for transplanting rice seedlings. On this day the cycle of the masked dance of the mother goddesses comes to an end. They remain dormant during the rainy season.

5. The fourteenth day of the dark half of Shravana (around August 11).

Newari Gathamuga, when an ithyphallic image of the god/demon is erected. This is also the last day of transplanting rice seedlings. On this day the participants in the masked dance make a Shivalinga out of fertile soil, some of which is later mixed with the clay for making the masks of the mother goddesses.

NOTES

1 Gautama V. Vajracharya, "The Adaptation of Monsoonal Culture by Rigvedic Aryans: A Further Study of the Frog Hymn", *Electronic Journal of Vedic Studies*, 3(2), May 1997, http://ejvs.laurasianacademy.com/ejvs0302/ejvs0302.txt.

2 Robert Levy (with the collaboration of Kedar Raj Rajopadhyaya), *Mesocosm, Hinduism and the Organization of a Traditional Newar City in Nepal* (University of California Press, Berkeley 1984), pp. 514–17.

3 Our argument is primarily based on the related annual events of the agro-religious calendar of the Kathmandu Valley, given in the Appendix.

4 Vajracharya, "The Adaptation of Monsoonal Culture by Rigvedic Aryans".

5 The *Taittiriyasaṃhitā*, 5.6.1.

6 Compare the *Rigveda* verse 1.164.44: "(Agni) shaves the hair/vegetation (of the earth) at the end of *samvatsara*", with the *Atharvaveda* verse 8.10.18: "at the end of *samvatsara* even a broken branch springs up".

7 Katherine Anne Harper, *The Iconography of the Saptamātṛkās* (The Ewin Mellen Press, Lewiston 1989), pp. 21–26.

8 William Morris, ed., *The American Heritage Dictionary of the English Language* (Houghton Mifflin Company, Boston 1969), p. 786.

9 Haragovinda Das Sheth, ed., *Pāia-Sadda-Mahaṇṇavo* (Prakrit Text Society, Varanasi 1963), p. 686.

10 Vajracharya, "The Adaptation of Monsoonal Culture by Rigvedic Aryans".

11 The Vedic Aryans performed the Mahavrata ritual at the end of the rainy season, when the moon was full in conjunction with the Krittikas. See Asko Parpola, *Deciphering the Indus Script* (Cambridge University Press, Cambridge 1994), p. 205.

12 Compare the 7th-century CE classical Newari word *kicha* or *kichi* meaning elephant in the ancient name of the Newar village Kichaprichinga (modern

Kisipindi, "elephant village") in the Kathmandu Valley. For epigraphic evidence see Dhanavajra Vajracharya, *Licchavikālakā Abhilekha* (in Nepali), (The Institute of Nepal and Asian Studies, Tribhuvan University, Kirtipur 1973), p. 191.

13 M. Monier Williams, *Sanskrit–English Dictionary*, (Motilal Banarsidass, Delhi 1981), p. 316.

14 Giovanni Verardi, *Harigaon Satya Narayana, Kathmandu, A Report on the Excavations Carried out in 1984–1988* (IsMEO, Rome 1988), p. 88.

15 Gautama V. Vajracharya, "Atmospheric Gestation: Deciphering Ajanta Ceiling Paintings and Other Related Works", part 2, *Marg* 55(3), March 2004, p. 44.

16 For a detailed study on this subject see Sara L. Schastok, *The Samalaji Sculptures and 6th Century Art in Western India* (E.J. Brill, Leiden 1985), pp. 64–65.

17 Ibid.

18 Heinrich Luders, *Mathura Inscriptions: Unpublished Papers edited by Klaus L. Janert* (Vandenhoeck & Ruprecht, Gottingen 1961), pp. 208–09. The date of the inscription is the ninth day of the second month of summer, on which a temple of Devi was established. This day can be no other than Chaitra-navami, the vernal *puja* ceremony. Luders, however, thought that *navamika* was a location.

19 N.P. Joshi, *Mātṛkas: Mothers in Kuṣaṇa Art* (Kanak Publications, New Delhi 1986), figs. 23–25.

20 Gautama Vajracharya, "Threefold Intimacy: The Recent Discovery of an Outstanding Nepalese Portrait Painting", *Orientations*, Vol. 34, No. 4 (April 2003), pp. 44–45.

21 Monier-Williams, *Sanskrit–English Dictionary*, p. 1110.

22 Gautama Vajracharya, *Hanumāndhokā Rājadarabāra* (in Nepali) (The Institute of Nepal and Asian Studies, Tribhuvan University, Kirtipur 1976), pp. 157–63. The stylistic dating of the wooden sculpture needs to be reconsidered. It is difficult to study the work stylistically due to its being heavily painted.

23 Dhanavajra Vajracharya, "*Mallakalamā desharaksāko vyavasthā ra tyasaprati prajāko kartavya*" (in Nepali) (The Conduct of the Country's Defense in Malla Times and Citizens' Duty toward This), *Purnima*, 2(2), pp. 20–33.

24 Dhanavajra Vajracharya, *Licchavikālakā Abhilekha*, pp. 301–04.

25 The 14th-century Newari text *Gopālarājavaṃśāvali* records an event related to the planting time: "In N.S. 500 (A.D. 1379), on the third day of the dark half of Jyeṣṭha month, Bhaktapur observed Water Festival because planting the rice seeds (*puva*) became impossible (due to the lack of rains)." Dhanavajra Vajracharya and Kamal Prakash Malla, *The Gopālarājavaṃśāvali* (Franz Steiner Verlag, Wiesbaden 1985) pp. 67, 115, 161. This statement clearly shows

the anxiety of Newar farmers when rain water was not available to them during the time of the *pravarshana*.

26 W. Caland, ed., *The Domestic Rules of the Vaikhānasa School belonging to the Black Yajurveda* (Meharchand Lachhmandas Publications, New Delhi 1989), pp. 22–23.

27 Fred W. Clothey, *The Many Faces of Murukan: The History and Meaning of a South Indian God* (Mouton Publishers, New York 1978), p. 140.

28 In the Newar calendar of the Kathmandu Valley the day of Bhal Bhal Ashtami is also designated as Bhagashtami, a Sanskrit word which literally means "the eighth day of good fortune".

29 Vajracharya and Malla, *The Gopālarājavaṃshāvali*, pp. 32, 39, 58.

30 F.B.J. Kuiper, "The Genesis of a Linguistic Area", *Indo-Iranian Journal*, 10 (1967–68), p. 95. According to Kuiper the word *bal* has to be derived from pre-Vedic Indic language because in Vedic literature the word is used with *iti*, a technical element for quoting foreign words particularly those which sound the same. Since the word is used in the Kathmandu Valley as a symbolic expression for the torrential rain of the monsoon, Kuiper's linguistic study is in agreement with the fact that the annual celebration of the day called Bhal Bhal signifying monsoon rain is indeed another example of survival of pre-Vedic monsoonal culture in the Newar society of the Valley.

31 For a detailed study of the subject see Axel Michael, "The Trishulyatra in Deopatan and its Legends", in Niels Gutschow and Axel Michael, eds., *Heritage of the Kathmandu Valley, Proceedings of an International Conference in Lubeck, June 1985* (Wissenschaftsverlag, Sankt Augustin 1987), pp. 167–97. Despite the fact that I approach the subject in a quite different way, my study is highly inspired by Professor Michael's work.

32 For a detailed study of the festival with a different interpretation, see ibid.

33 Levy, *Mesocosm*, p. 477, fig. 26.

34 In my commentary on the inscription found on the painting, I have explained why the Trishuli river was so significant for Newars. See Pratapaditya Pal, *Himalayas, An Aesthetic Adventure* (The Art Institute of Chicago, Chicago 2003), p. 284.

35 Gautama Vajracharya, "The Creatures of the Rain Rivers, Cloud Lakes: Newars Saw Them, So Did Ancient India", asianart.com <http://www.asianart.com/articles/rainrivers/index.html#i19>.

36 Vajracharya, "Atmospheric Gestation: Deciphering Ajanta Ceiling Paintings and Other Related Works", part 2, pp. 48–50.

37 I am obliged to Dr Linda Iltis for providing me with the photographs of the Machatiya festival published here and also for showing me the videos of the festival that she took in 1984.

38 *Kriyā-Saṃgraha: A Sanskrit Manuscript from Nepal Containing a Collection of Tantric Ritual by Kuladatta* (Sharda Rani, New Delhi 1977).

39 John Huntington and Dina Bangdel, *The Circle of Bliss, Buddhist Meditational Art* (Serindia Publications, Chicago 2003), pp. 419–21. We leave detailed discussion of this subject for a further occasion.

40 "*māyādevyā yathā kukṣau tāvat tiṣṭhed ihākṛtau…yathā hi jātamātreṇa snāpitā sarvatathāgatāḥ / tathhām snāpayiṣyāmi suddham divyena vāriṇā//*."

41 "*tato hemashalākaya rupyamallikasthitaghṛtamad humṛkṣitayā // ajñānapatalam vatsa apanītam mayā tava // sālākikai vaidyarājais ca yathā lokasya timiram // aum cakṣur 2 samanta cakṣur vishodhane svāhā // kajjalāktena // iti paṭhan pratimāyās cakṣur udghāṭayet // iti dṛṣṭidānam.*" *Kriyāsaṃgraha*, folio 113.

42 Vajracharya, *Hanumāndhokā Rājadarabāra*, pp. 157–63.

43 Ratankaji Bajracharya, *Pulāngu, Hnugu Cacā Munā* (Sadakshari Mahavihara, Kathmandu 1999), p. 89.

44 Vajracharya, "The Adaptation of Monsoonal Culture by Rigvedic Aryans".

45 We mentioned earlier that in Vedic literature when the word *ritu* is used alone it means rainy season. This is also true in Pali literature although it is spelled there as *utu*.

46 Vajracharya, "The Adaptation of Monsoonal Culture by Rigvedic Aryans".

47 Stella Kramrisch, *The Art of Nepal* (The Asia Society, Vienna 1964), pp. 62, 130.

48 Gautama Vajracharya, "Pipal Tree, Tonsured Monks, and Ushnisha", in Pratapaditya Pal, ed. *Buddhist Art, Form and Meaning* (Marg Publications, Mumbai 2007), p. 17.

49 In Newari a newborn baby is called *nalihma,* "a new sprout".

50 Vajracharya, "Atmospheric Gestation: Deciphering Ajanta Ceiling Paintings and Other Related Works", p. 44.

51 Radhavallabh Tripathi, *Encyclopaedia of Nātyashāstra*, 4 vols. (Pratibha Prakashan, Delhi 1999), Vol. 2, p. 551.

52 See Appendix for the calendar of the Navadurga dance.

53 Pratapaditya Pal, *The Arts of Nepal*, two parts (E.J. Brill, Leiden 1978), Part 2, fig. 180.

54 Dhanavajra Vajracharya, *Licchavikālakā Abhilekha*, pp. 211–13.

55 http://www.nepa.com.np/culture/main.php?display=navdurga.

56 Levy, *Mesocosm*, p. 519.

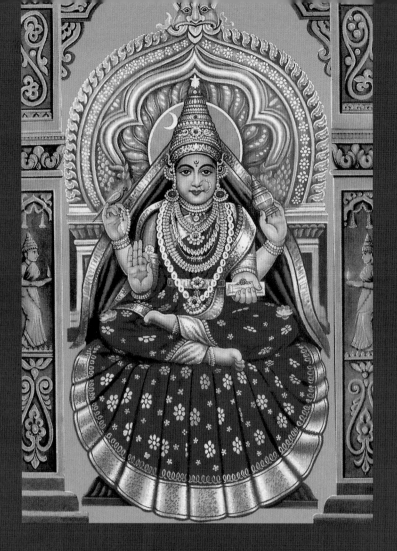

Constant Companion, Autonomous Spirit
Two Facets of the Feminine in Tamil Tradition

Rajeshwari Ghose

In this essay, I present vignettes from my recollections of the celebration of Durga Puja, or the worship of Shakti as the goddess Durga, in my family when I was a child. The purpose of this exercise is to see how ideas, particularly religious ideas, and in this specific case creating "Durga consciousness", were passed on to and interiorized by a child in the absence of temple-going and religious education.

Some three score and ten years ago I was born in a Tamil brahmin Shaiva-Shakta Smarta Aiyar family. I must first explain the cultural markers of this self-introduction as these determined to a great extent the worldview of my biological family and all other fellow followers of the Smarta interpretation of the school of thought called Shri Vidya. Understanding these markers is crucial to this essay, which deals with the refining of the autonomous, often fierce, goddesses and converting them into acceptably benign auspicious forms through a sophisticated process of metaphysical theories. Nonetheless, the autonomy of the goddess remained unchallenged.

The term Tamil denotes a language, a culture, and a people – and now a linguistically constituted state in India. The term brahmin has already been accepted as an English word.

In the hyphenated term Shaiva-Shakta, Shaivas are worshippers of Lord Shiva and Shaktas of the Goddess collectively designated as Shakti, often translated in English as Power, Energy, Kinesis, and so on. This does not necessarily denote female power and energy in particular, but all power and energy that is the attribute of the goddess. It comes from the Sanskrit root *shaknoti*, which means, "to be able". The capacity to do anything is Shakti. A medieval Sanskrit text explains this idea beautifully, after describing Shakti as the strength in all creation: "People say that a very weak man is devoid of Shakti, they don't say he is devoid of Shiva or of Vishnu."[1]

It is paramount to understand that Shakti is a collective term expressing several ideas and she is represented in a myriad forms. Durga is just one form of Shakti. To reiterate, there are those who are mainly Shiva worshippers and those who are predominantly the worshippers of one of the many forms of Shakti (figures 2–4). The hyphenated Shaiva-Shaktas are worshippers of Shiva and Shakti as an inseparable divine couple, although myths sometimes reveal tensions over their respective hierarchical status. The Shaiva-Shaktas worship Shiva and Shakti both separately and as two parts of a whole, as is represented iconically in the image of the Ardhanarishvara (figure 5). This approach to the divine played an important role in shaping the Tamil religious universe.[2]

Hinduism among the Tamils became systematized somewhere between the 7th and 9th centuries of the Common Era. It was during these 200-odd years that the devotional school called Bhakti came into existence. The saint-poets of this school composed their verses in Tamil, not Sanskrit, and expressed their passionate devotion to the deity of their choice. The Bhakti poets devoted exclusively to Vishnu were known as Alvars and those devoted to Shiva were known as Nayanmar (singular Nayanar).

The Nayanmar who were passionate and often sectarian devotees of Shiva nonetheless addressed all their hymns to Shiva with Shakti by his side. Expressions such as *Umaipankan, Umaipakan* (both meaning with Uma by his side), *mangaiorupankan* (with the woman as one of his sides – this refers to the hermaphrodite Ardhanarishvara form, figure 5), denote her constant presence in almost all the hymns. One of the saint-poets, Sundarar (figure 6) is deeply moved to see the Shiva icon alone at a temple in a place called Koti and he agitatedly and repeatedly asks Shiva why he is alone. The pain is evident in his anguished cry *"Yentay taniye iruntaye empirane"*, *"ettal taniye irunte empirane"* – Lord why are you alone, O my Lord what made you be alone? – he senses something wide of the mark in the divine pattern.[3]

This somewhat romantic idea is given a stronger doctrinal format by Adi Shankara (figure 7), the 8th-century monk, reformer, and reputed author of *Saundaryalahari*,[4] the great hymn to the goddess, written not in Tamil but in the pan-Indian ecclesiastic language Sanskrit. He begins: "If Shiva, the Auspicious One is united with Shakti, He is able to create. If He is not, He is not even capable of stirring." A popular ditty runs: "Without Shakti Shiva is *shava*" (a play on words for Shiva is the God and *shava* means a corpse). When stated thus, the Shiva-Shakti union becomes a symbol of many philosophical axioms, keeping of course the meaning of Shakti as energy, as life-force. Shiva and Shakti thus stand out as being paradigmatic of a worldview.

1
(opposite)
Sharada of Sringeri, Karnataka.
Contemporary oleograph.
Image courtesy *Tattvaloka*.

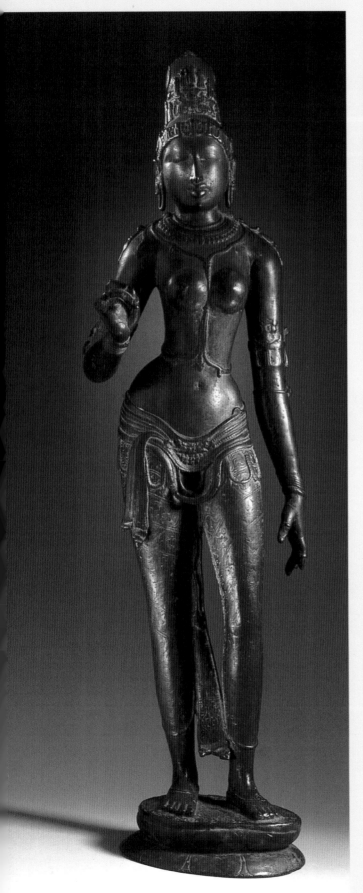

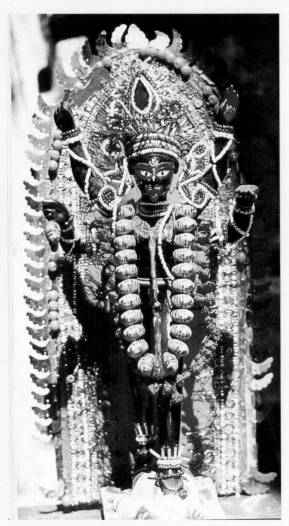

2
(extreme left)
Parvati, Tamil Nadu,
c. 975. Bronze; height
76.2 cm. The Norton Simon
Foundation, Pasadena. Acc. No.
F.1972.23.2.S.

3
(above)
Durga Mahishasuramardini,
Mahishasuramardini mandapa,
Mamallapuram, Tamil Nadu,
c. 7th century. Granite.
Photograph courtesy the
author.

4
Kali, Bengal. Stone; 1 m.
Photograph courtesy the
author.

5
(opposite)
Trident with Shiva as
Ardhanarishvara, c. 1050.
Cleveland Purchase from the
J.H. Wade Fund, Acc. No.
1969.117. Photograph courtesy
the author.

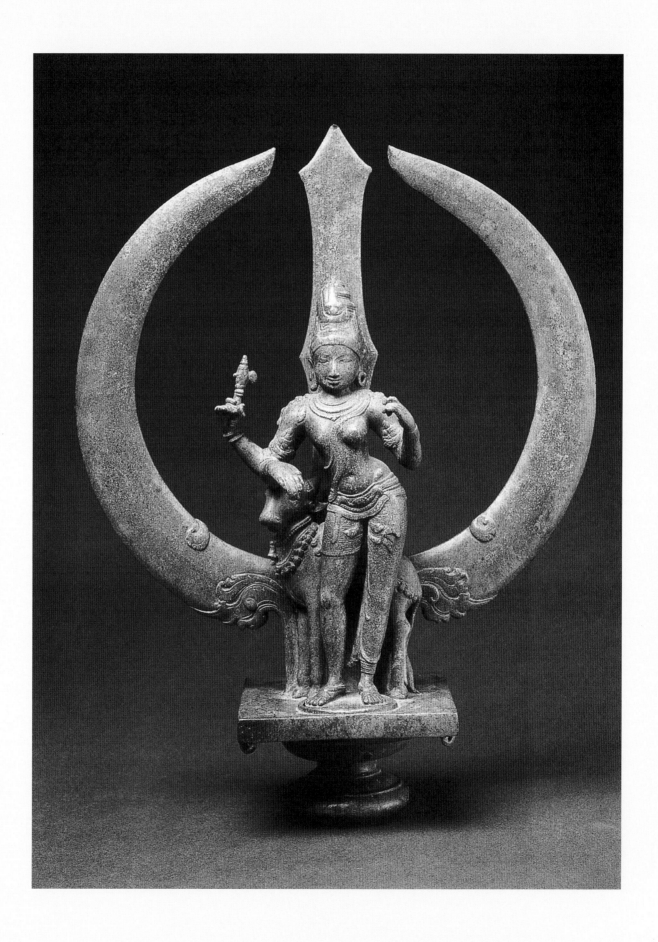

7
Adi Shankara, a bazaar painting hanging in the Kanchipuram *matha*. Photograph courtesy the author.

Adi Shankara is crucial to this work. It is to him primarily that we trace the origin of our being Smartas. In the accompanying photograph (figure 8), one can clearly see the *vibhuti* (ash) and the *kumkuma* (vermilion) on the Smarta priest's forehead, while the third identifying mark of the *chandana* (sandalwood paste) cannot be spotted. The white *vibhuti* stands for Shiva, the red *kumkuma* (the colour of blood) for the quality of dynamism or *rajas,* symbolizing the *shakti* of Devi, while the cooling unguent of yellow *chandana* is what is applied on Vishnu images. So just by comprehending the symbolism of the markings on a Smarta priest's forehead, one can surmise that the Smarta faith is a syncretistic one. Shankara not only established a syncretistic pan-sectarian faith but is also believed to have played an important role in the process of containing the fiercely autonomous Shaktis.

6
Shaiva Saint Sundarar, Tamil Nadu, 15th century. Bronze; 81.3 x 27.9 x 27.9 cm. The Norton Simon Foundation, Pasadena. Acc. No. F.1972.19.6.S.

To conclude, Smartas are brahmins in south India who describe themselves as believers in the *shadmatha (shad* = six and *matha* = opinions, beliefs, forms of beliefs) or six forms of worship as prescribed by the monist or Advaitin Vedantin Adi Shankara. This six-form worship consists of the worship of the Sun God Surya, of Vishnu and Shiva, of Shakti, as well as Ganapati and Kartikeya, the last two being sons of Shiva and Parvati. Often it is referred to as the *panchopasana* or the five modes of worship – excluding Kartikeya from the above six-fold category. Kartikeya was particularly popular in his form as Murugan in south India and it is most likely that the five-form worship was enlarged to six to accommodate this popular deity, who is often invoked as the essence of Tamil culture and identity.

The Smartas are followers ultimately of the Advaita, i.e. purely monist philosophy that says: "Brahman exists within me" – the Primeval Reality is Unity – and all the fragmentations that we see are caused by absence of knowledge or *avidya* in us. Once that saving knowledge is acquired and the *avidya* or ignorance is wiped clean, the Primeval Unity becomes the *only* reality and the illusion of multiplicity vanishes. Since the multiplicity of the phenomenal world is

8
A Smarta priest conducting *archanai*, prayers. Photograph courtesy the author.

the result of *maya* caused by non-knowledge, the relative truth of gods and goddesses could coexist as different stages of this *maya* till one reaches the goal of the Absolute Oneness. On reaching this stage of realizing the Transcendental, one no longer needs a visual form of the Divine to be one with the Divine. In the moment of the awakening of knowledge there will be but one indescribable entity, beyond word, beyond form. The phenomenal world, the monists believe, is like the reflection on a mirror (*darpana drishyamana nagari tulyam*), a metaphor very reminiscent of Plato and the reflections in the cave. Another imagery used by the monists is to relate the experience of the exterior world to the experience of seeing oneself as a person outside of the self, as in a dream. That person, though real for the dreamer while in the process of dreaming, vanishes when the dream is over. Thus, followers of Shankara seem to subscribe to several forms of immanent manifestations of the godhead, without any great sectarian animosity. Aiyars are at least in a ritual sense Sanskrit-literate, in a manner in which the other Tamil Shaivas, such as the Shaiva Siddhantins, Lingayats, etc. do not necessarily have to be. So what did Durga Puja mean to me, an Aiyar girl?

Durga Puja was a simple event filled with a lot of play and companionship. The chief aspect of Navaratri, as Durga Puja is called in Tamil Nadu, comprises little girls setting up what is called a *golu*.[5] Dolls are arranged on a platform made of five, seven, or nine steps (figure 9). The richer one's parents, the more elaborate the *golu*. What did we put in the *golu*? Just about anything of doll-like, toy-like appearance. I had silver miniature sets of telephones and gramophones and bicycles and inkpots. When I was young, an Anglophile

relative even brought me ceramic dolls of King George V and his Queen, much to my father's chagrin; these were additions in my generation. The original set of wooden dolls, hand-me-downs from my mother, always occupied the prime place in the exhibition and they were mainly of characters from the epics and the *purana*s and from everyday scenes of rich chubby Chettiyar merchants sitting with their wives chewing betel leaves – idyllic scenes of plenty and of harmony.

I am told that in my grandmother's time the *golu* included more figures re-creating mythic narratives – of wicked Kamsa being killed by Krishna, and so on. We, in my time, got dressed up to go and invite our little girl friends and their mothers to come to our house to see the *golu* dolls. It was common for us to go dressed as Lord Krishna with a yellow silk dhoti, peacock feathers stuck in our hair, and little flutes on which we endlessly blew to the attrition of all around. It was years later that I got to know of the Hina Matsuri, the dolls festival of Japan. Except for the fact that girls and dolls are involved, there is nothing, at first sight, common between these two festivals. In Japan it was a tableau of the Heian (c. 8th–12th centuries CE) hierarchy of emperor and court. In Tamil Nadu, it was simply creativity as play, as fun, though

a religious explanation was provided by our elders. We were told that when Devi in the form of Durga engaged the buffalo-demon Mahishasura in battle, she had to absorb the *shakti* or energies of the various gods and goddesses, who willingly lent her their strength and stood like silent dolls as they witnessed in awe the mighty cosmic battle. People re-enacted this divine tableau through the annual doll festival.

While the connection between royalty and the doll festival is more obvious in the Hina Matsuri, the connection between royalty and Durga Puja was also very strong in the days of Hindu monarchs. Even in recent times, during Dassera in Mysore, the platform of dolls was arranged to resemble the Wodeyar royal court. Manuscripts and inscriptions hint of such a practice going back to the early days of the Vijayanagara empire, as early as the 13th century. Then there are the Nillu Gowri dolls of goddesses (figure 10), and the Pattada Bombe – those clothed in the silks of royalty.

9
A modern *golu* display in Tamil Nadu. Photograph courtesy the author.

10
A Nillu Gowri display. Bronze; c. 60 cm. Private collection. Photograph courtesy the author.

The connection with royalty, the pomp and theatricality of power, was reproduced, albeit in miniature form, in the *golu*s of past ages.[6] There was a strong connection between royal power and the worship of the goddess as Shakti – Power, Energy, and Dynamism.

The feeling of participating in a domestic *golu* celebration in Tamil Nadu is very different from seeing Durga Puja celebrated, say, in Bengal, where it is communally organized, where men play an important role in the organization of the festival, and a sense of what Victor Turner calls *communitas* is created by the intense fervour of the crowd, which is deeply focused. However, both the Tamil and the Bengali festival and variants in other regions of the country are all very much a part of a living pan-Hindu tradition.

To return to my personal experience, as a child, of the nine-night or ten-day festival: On the tenth morning five-year-old children were made to sit in front of the image of Goddess Sarasvati, and write the first letter of the Tamil alphabet on a black slate with white chalk. A piece of bread (*idli*) dipped in honey was used to inscribe the letter on the child's tongue, so that they might enjoy the sweetness of learning. Thus the tenth day was reserved for the gentle form of Shakti as the goddess of learning, Sarasvati.

Every evening young girls and their mothers would gather at someone's house and sing songs. I do remember they were always asked to sing the compositions of the late-18th–early-19th-century musician Muthuswami Dikshitar,[7] particularly his *navavarna* compositions. Those were appropriate songs for the Navaratri for they dealt with the worship of the Goddess as the Primeval Power – the Adi Shakti. Depending upon the specific composition the goddess

could assume different names and different forms but she still remained the Great Primeval Energy Force. In these songs one sees the blending of myth/philosophy and straightforward iconographic description. What is interesting is to note the process by which a fierce form of Devi was transformed into an abstruse symbol to express a philosophical axiom, all through classical Carnatic music. The lyrics expound an esoteric doctrine, the secret of the school called Shri Vidya. The goddess is the embodiment of vibrant life and Ultimate Truth. She becomes superior to all the gods and is a part of the mystical yoga system called Kundalini yoga. This form of visualization, worship of the goddess as the supreme yogini and expressing the ideas through esoteric symbols is what essentially constitutes the Tantric form of worship. The *nava* or nine songs symbolically represented the nine angles or the nine *avarana*s (veils) of the mystico-

बिन्दु-त्रिकोण वसुकोण दशारयुग्ममन्वश्र नागदलसंयुत षोडशारम् ।
वृत्तत्रयं च धरणीसदनत्रयंच श्रीचक्रमेतदुदितं परदेवताया: ॥

The point, the triangle, the eight-cornered figure, the two ten-edged figures, the fourteen-cornered figure, eight petals, six petals, the three circles and the three squares - this is called the Sri Chakra of the Supreme Deity.

11
Shri Chakra. Contemporary oleograph. Image courtesy *Tattvaloka*.

magical diagram called the Shri Chakra (figure 11). Each angle is like a veil. By lifting one veil, we reach the next stage and so on till we reach the centre – the *bindu* and that is Brahman. Each *avarana* thus becomes a step in the spiritual ladder as we ascend, and hence each *avarana* is worthy of worship. Thus this diagram is both mystical and magical. It symbolizes the Divine Shakti and Shiva as one. It is described as the abstract form of Shakti. It also has the magical quality of subduing the fierce aspect of Devi and making her into the sublimely peaceful goddess, as we shall presently see.

One of the nine songs, which is addressed to Goddess Kamalambika of Tiruvarur[8] (figure 12) begins: *Kamalambike ashritakalpatilake chandike* – "O Kamalambike, you are the wish-fulfilling tree to those who seek refuge in you. You are Chandika, the fierce one wearing beautiful red silk and with a parrot in your hand, protect me." Chandika is one of the

fierce emanations of Goddess Durga when she sets out to fight Mahishasura. Interestingly, this Kamalambike *kirtanam* or song in praise of Kamalambika, was the quintessence of what I was later to learn as Shri Vidya belief systems. It was thus, through a play-acting arrangement of dolls, the singing of songs, the recounting of myths, and the drawing of patterns on the floor, which symbolically represented esoteric sacred geometry, that the young were acculturated into a particular worldview.

So who was being worshipped, and what is the Devi concept? I was dressed up as Krishna, my grandmother had images of Krishna and Kamsa, of Rama and Sita and Hanuman, on the *golu* stands, and the children were seated before the image of Sarasvati. Yet, the piece de resistance was Vijaya Dashami (the tenth day of victory), literally the day when Goddess Durga finally destroyed the evil buffalo-headed demon and emerged victorious. They are all however connected in an intricate labyrinth of myths. It was Durga who took birth as a baby girl and traded places with Krishna. She was, therefore, both the sister and the saviour of Krishna. The wicked uncle Kamsa had threatened to kill all his nephews for it was forecast that he would be slain by his sister's son, and Durga deceived him by taking the place of Krishna. Kamsa dashed her against the stones, but the goddess re-emerged from the form of the baby, laughing at the futile rage of the king, and took her abode in the Vindhya mountains where to this day she is worshipped as Vindhyavasini Durga.

Whatever the myth being enacted, whatever the form the worship takes, the underlying substructure of what is called the festival of Navaratri or Nine Nights,

12
Kamalambika of Tiruvarur.
Contemporary oleograph.
Image courtesy *Tattvaloka*.

Dassera or Ten Days, or Durga Puja has as its substructure the worship of Durga. It was Durga who helped Rama to vanquish Ravana. The victory took place on the tenth day and in north India on this day the wicked hosts of Ravana, Kumbhakarna, and others are burnt in their effigies and the crowning of Rama (*pattabhisheka*) is celebrated. In the Mahabharata war it was Durga who revealed the hidden weapons that helped the Pandavas defeat the Kauravas. It was she whom the Pandavas asked for protection during the critical final year of their long exile. Krishna asked Arjuna to worship Durga before entering the final battle and she promised him victory. Despite this underlying refrain, the forms of worship do take very different tones.

I am simply going to take up two aspects of Devi for discussion. The first is that, for a person like me raised as an Aiyar, much of our tradition was traced to the dictum of Adi Shankara, the codifier of the Advaita system. He is believed to have lived around the 8th century, was born in Kaladi in Kerala, became an ascetic, and travelled around India establishing several monasteries all over the country. He was the pioneer of the Hindu monastic tradition. To the best of my knowledge there were no monks in Hinduism before his time. To Adi Shankara is attributed the famous liturgical psalm the *Saundaryalahari,* which is the "Bible" of the Shri Vidya School.

As far as Tamil Nadu is concerned the Kanchipuram monastery claims to have been instituted by Adi Shankara. Sringeri in Karnataka is another claimant for being the authentic Shankaramatha of south India, and there are ongoing and unresolved issues between these two monastic establishments as to who is the rightful inheritor of the

mantle of the 8th-century philosopher.[9] This controversy, however, does not impinge on the present essay, as it is focused on Adi Shankara.

The present south Indian monasteries at Kanchi and Sringeri have their own temples dedicated to the goddesses called, respectively, Kamakshi "lady with eyes of love" (figure 13), and Sharada, a name of Durga and of Sarasvati, meaning young, fresh, bashful (figure 1). The heads of the *matha*s, called Shankaracharyas, had (and still have) great influence on several temples as administrators. Thus, one can see that the monks and monasteries, by their close relationship to court-sponsored temples, linked several socio-religious nodal points. This court–temple nexus was a symbiotic relationship providing patronage for the latter and legitimacy for the former.

What is interesting and most relevant for the subject matter of this paper is that

13
Kamakshi of Kanchipuram.
Contemporary oleograph.
Image courtesy *Tattvaloka*.

most of these shrines have a temple myth. We are told that the absolutely autonomous or quasi-independent goddess of the temple was a ferocious deity causing destruction in the vicinity of the temple, and it was Shankara, the ascetic, the *sannyasin*, the world renouncer, who tamed the goddess and controlled her destructive aspects, bringing forth her gentler or *saumya* aspects. This story is told in many temples in Tamil Nadu and forms the leitmotif of their pilgrim literature, called *sthalapuranas*. Similar myths dealing with Shankara's subduing of the fierce goddess also occur in the various hagiographies of Shankara.

The source for these legends is late, for the earliest written hagiography of Shankara is datable only to the 13th century, a full 500 years after the death of Shankara, though one must take into consideration that the written text is often very late in the Hindu tradition, which relied for most part on oral recitations and auditory memories. There are about 34 hagiographies of Shankara available, of which only seven are in printed form, the others in the form of manuscripts, but they all carry this leitmotif. Obviously an oral tradition must have preceded the written ones. What is of significance here is not whether Shankara really did or did not tame the goddess, but that it is through such myths that the modus operandi of converting the fierce goddess to a gentler form is made acceptable to temple-goers in general as well as to worshippers of the fierce forms of goddesses. It is thus not the historicity of the myth but the tutored memory of the process of reconciliation that is of interest to us here.

The archetypical myth is from Kanchipuram. It is believed that Kamakshi, the goddess of Kanchi, was originally an *ugra svarupini* (of fierce disposition), and Adi

Shankara, by embossing the mystical diagram called the Shri Chakra, pacified her, after which she assumed the *shanta svarupa* or the peaceful form of herself. The word *sva* in *svarupa* or *svarupini* means inherent in one's self, primordial, and so she is believed to have reverted as it were to her pristine form of the peaceful one. Tradition has it that during the days of Adi Shankara, the destructive presence of the *ugra svarupini* or the Destructive Ferocious Self was felt in the neighbouring villages, and so Shankara had requested her not to leave the temple complex without his permission, and she had agreed. Symbolic of this pact, the bronze portable festival image of Kamakshi, to this day, stops before Shankara's shrine in the inner *prakaram*, before she begins her procession through the city. One can see in the myth several layers of ideas. More on this later. Suffice it to say at this point that the Shri Chakra, the magico-mystical diagram that quietened the wild one is believed to be the transcendental form of the Devi in the Shri Vidya system. It is her cosmic self, expressed through a formless diagram – formless in the sense of not having an anthropomorphic form, but ideas expressed through sacred geometry. The Primeval Energy or Shakti has three aspects – her gross form is the image; her subtle form is the specific mantra by which she is invoked; and her absolute form, equivalent to the Formless Brahman of the monist Shankara, is the Shri Chakra.

The Devi Kamakshi in her anthropomorphic form or the *sthula rupa* is seated in majestic cross-legged *padmasana*, showering grace, peace, and plenty on those who come to her for darshan. In the *garbhagriha* or innermost sanctum she is installed as a stone image, seated in the cross-legged *padmasana* or *yogasana* pose,

four-armed, holding *ankusha* (elephant goad) and *pasha* (noose) in the rear arms and lotus and sugarcane bow in the front arms. The bow has a quiver of five floral arrows, which she holds in her lower arms. These show her as the sensuous goddess – the sugarcane bow and the five arrows (signifying the five senses) are the weapons of the God of Love, Kama or Manmatha, the Cupid of Hindu mythology. Her name means Lady with Eyes of Love, *kama* being sensual love and *akshi* meaning eye. She is closely connected in all the myths to the God of Love.

This uncomfortable idea of *kama* or sensuality is connected rather awkwardly with an episode in the life of the ascetic Shankara. He defeats all his rivals by the versatility of his genius. Then he encounters a woman protagonist and she poses very difficult questions to him on the art of making love. The celibate ascetic is confused but, not to be outwitted, he magically enters into the corporeal form of a king and vicariously, at least in a spiritual sense, partakes of the pleasures of the regal experiences with a plethora of women in the royal harem. Thus, this terribly disturbing force of worldly love, an essential aspect of dynamic energy, of Shakti, had to be accommodated even within Shankara's world of ascetic monasticism. In a similar manner the dynamism that gives birth also deals the death blow and so cannot be separated from violence.

Kamakshi is addressed as Rajarajeshvari (the empress of emperors), and an embodiment of universal power – Para Shakti. As she encompasses all divinity in the universe within herself, there is no separate Amba or Shakti shrine in Shiva temples within the limits of Kanchipuram. She is all-pervasive and so does not have to appear

as the domesticated spouse standing or seated demurely with her husband, as a Hindu wife is expected to do. In Tamil Kamakshi is called Kamakottamudaiyal, the owner of the ritual, psychosomatic, and sacred space called *kamakottam* – the house of *Kamakalavidya* (knowledge of the art of love). In front of her image in the middle of the sanctum of the Kanchipuram temple is installed a *pitha* or a seat, suggesting that the goddess takes a seat in this case as the presiding mistress of Kanchipuram. The *pitha* is in the form of *yoni pitha* (a sacred seat in the form of the female generative organ). The word *pitha* also refers to the base of the linga, the female part of the male linga, going back to the divine hermaphrodite concept. According to a canonical statement the sky itself is the shaft and the *pitha* is the earth. Thus the imagery is not a simple one of the phallus and the female generative organ. It is a complex metaphor – the linga is fire, it is the axis mundi, and the base is the *pitha*.

A Shri Chakra Meru[10] is at the centre of this *pitha* on top of which is a *bindu* (the quintessential centre spot of the macro- and the microcosmos, the spot where all becomes one). The daily *abhisheka* or ritual anointing is performed for this *pitha*. This is the focal point of worship while the sculpture at the back called Kamakshi and Lalita is regarded as the personification of the Shri Chakra or *chakraraja*. Shankara, it is believed, had installed and consecrated a Shri Chakra in front of the deity and the daily worship is offered to this Chakra – known as the Kamakoti *pitha*. The goddess is said to reside as Bala Tripurasundari or the child goddess in a *bila* (niche) situated below the shrine.

During the Navaratri festival the Shankaracharyas worship a girl child who is

two years old. As in Nepal, this rite is called Kumaripuja but, to the best of my knowledge, it is not an ongoing institution like in Nepal, in the sense that the two-year-old of one year is left to lead a normal life and another two-year-old takes her place the following year for that one day. The front mandapa of the Kamakshi Temple is called the Gayatri mandapa. This suggests the connection with the Gayatri mantra, the most sacred mantra offered to the sun, and is also evocative of Gayatri, the wife of Brahma. The town of Kanchi has a Shiva temple, with the local

form of the god known as Ekambareshvara. The temple complex, thus, has a *kamakottam* of Shiva's wife Devi as well as a *kumarakottam* or house of their son Kumara. Thus the father, mother, and son have constituted realms for themselves in Kanchi and this is evocative of the concept of Somaskanda (figure 14), which is unique to Tamil Nadu and symbolizes domestic bliss. So within this sacred precinct we have the ferocious and autonomous goddess, the goddess of love, and the domesticated wife and mother – but by virtue of the fact that she does not share

14
Somaskanda, Shivapuram, Tamil Nadu, 950–975. Bronze; 58.4 cm. The Norton Simon Foundation, F.1972.23.I.S.

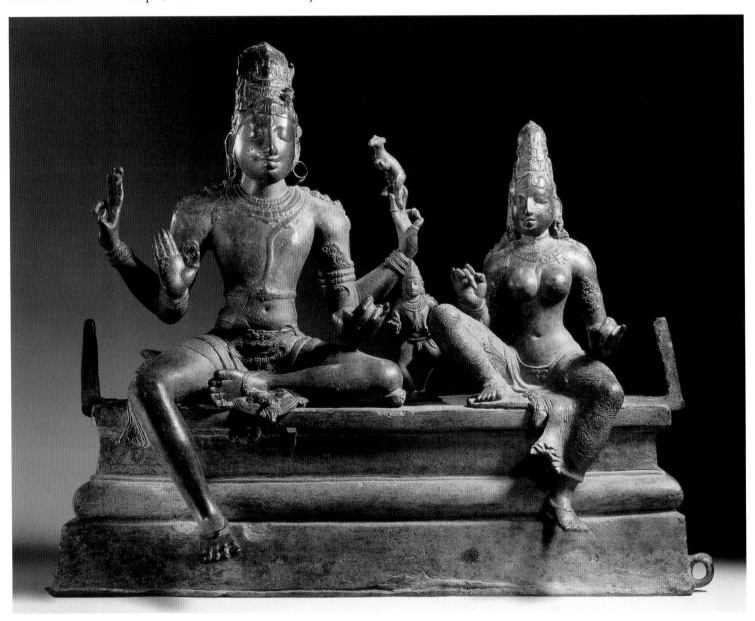

15
Meenakshi of Madurai.
Contemporary oleograph.
Image courtesy *Tattvaloka*.

the domestic space of the god's shrine as an adjunct image, the memory of her autonomy is clearly preserved. She has her own commanding space and is the original goddess of this site.

As mentioned above, the Kamakshi tradition appears in different forms with different narrative structures and varying iconography in other temples, but the leitmotif is the conversion of the wild goddess into a tame one – and by the intercession of a man, or god, or a devotee so close to god that he is treated like god, like the ascetic Shankara. Kamakshi in the form of her iconic manifestation looks different from Kamalambika or Meenakshi of Madurai (figure 15) or any of the other locotheistic goddess forms.

To give one more example, in the case of Akhilandeshvari at Tiruvanaikkaval, too, the ferocity of the goddess is believed to have

been pacified by Shankara by adorning her with two earrings (*tatanka*) on which were embossed the Shri Chakra or Shri Yantra. The earrings were a reminder for her to revert to her pristine form of quietitude and peace. To further calm the goddess, images of her sons Ganapati and Kartikeya were established, making her into the benign, caring, nourishing mother. I could provide endless examples. In Tiruvorriyur, a suburb of modern Chennai, Shankaracharya is believed to have pacified the wild goddess Vattaparaiyamman, before whom sacrifices were offered (with the last human sacrifice recorded in the 1930s), by covering her with a flat slab. The belief is that the slab was embossed with a Shri Yantra (Shri Chakra).

The Agamas (canonical texts) devoted to the worship of Devi or Shakti classify her names according to her age – if she is one year old she is called Sandhya; if two, Sarasvati; if nine, Durga; if sixteen, Lalita; and so on and so forth. In the *Devimahatmya*, Devi tells her devotees of how she will assume different forms for different functions at times of major crises and how each of these manifestations will be known by a different name. When she bestows food on a famished horde she becomes Shakambhari; when she kills fierce demons she becomes the bloody Chamunda or Rakta Chamunda (figure 16) as she gruesomely chews the body of the demons with blood in her mouth and dripping from her body. So the fierce element is retained within the larger framework of the Devi concept. Thus Lalita is contrasted with Kali and Durga, the former being gentle, the latter dynamic and ferocious. The benign Lalita has been compared to quasi-independent devis such as Durga. In the *Lalitasahasranama* invocation number 190

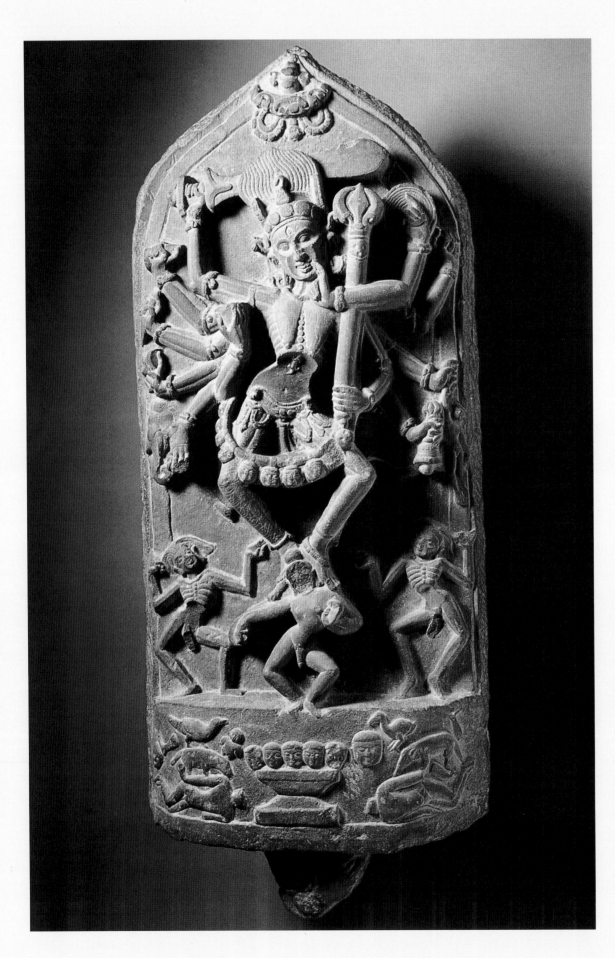

16
Dancing Chamunda, West
Bengal, 11th century. Black
stone; 60.9 x 27.31 x 8.9 cm.
Museum Acquisition Fund and
the Indian Art Special Fund.
M.90.166. Los Angeles County
Museum of Art. Photograph
© 2009 Museum Associates/
LACMA, licensed by Art
Resource, NY.

calls her Durga, number 210 Mahalakshmi, and number 246 Parvati. Her "Shri" or her auspiciousness is not derived primarily from her position as a spouse but on her own. She is Rajarajeshvari etc. but she is also the ideal Indian woman conforming to Hindu norms. She wears her sacred marriage thread – *tali* (a purely non-Sanskritic south Indian custom), as mentioned in the *Lalitasahasranama*. She is a *saubhagyavati* (blessed with auspiciousness). However, since she is identified with every form of goddess, she is also described as being terrifying despite being inherently *saumya* or peaceful. These manifestations are not mutually exclusive but encompassing and dynamic. In this goddess theology the goddesses appear under particular names of village, city, forest, and mountain but are seen as aspects of the Great Goddess – Mahadevi. In the texts we get a long list of names, often placed together for purposes of metre and rhyme.

Shri Vidya or Auspicious Wisdom, as Renfrew Brooks translates it,[11] is a pan-Indian goddess centred on the Shakta cult, whose roots are traceable to the 6th century or even earlier. This centres on the *saumya* aspect of the goddess and though practised today amongst different castes of men and women all over India, historically it was accessible only to those literate in Sanskrit, at least in a ritual sense. There is a distinct south Indian form of this pan-Indian cult, which is promulgated by the Smarta brahmins. To reiterate, the word Smarta etymologically means one who believes both in the revelation (*shruti*) of the Vedas and in the canonical literature authored by mortals called *smriti*. The *tantra*s are historically classified as *smriti*s. The *Tirumantiram* of the poet mystic Tirumular (7th century) is the

first Tamil text to refer to Shri Chakra and the Shri Vidya mantra,[12] and in that sense the first known Tamil text which recognizes Tantric concepts.

What is ironic is that when one asks Shri Vidya worshippers in Tamil Nadu if they are Tantrika, they would vehemently deny this and assert that they are Vaidika or Vedic followers. Though many of their beliefs, liturgies, and rituals are Tantric, the appellation "Tantric" has earned disapprobation especially amongst the conservative Smarta brahmins. The term therefore is a very problematic one for most practising Hindus. To understand this we have to remember that Shri Vidya was created, elaborated, and perpetuated by Sanskrit-literate Hindus, who were familiar with that most sophisticated form of Brahmanic culture, i.e. Smarta Brahmanism, the upholders of which were male Smarta brahmins.

Though one cannot really describe the manner in which Tantric ideas have permeated through temple and icon worship in Tamil Nadu, their presence is palpable. Today there are several practitioners and canonical texts available for the study of Shri Vidya in Tamil Nadu, whether they call themselves Tantrikas or not. In contrast, texts are available in Kashmir, the other major home of Shri Vidya, but practitioners are few. This practising continuity in south India is to a great extent owing to the efforts of the 18th-century Bhaskararaya Makhin from Bhaga (now in Maharashtra) who settled in Tamil Nadu during the time of the Maratha ruler of Thanjavur, Sarfoji. He was one of the greatest exegetes of Shri Vidya a la Smarta mode.

By claiming itself to be Tantric and Vedic, Shri Vidya creates an opportunity to study a relationship of what Renfrew Brooks terms

"proximate otherness", that rather problematic situation that occurs when two distinct, competing, and sometimes irreconcilable phenomena negotiate coexistence. And what better place could there be to negotiate this coexistence than in the sacred space of a Hindu temple, with its vast experience of dealing with conflict and accommodation of ideas and the people who uphold them, and who are essential as worshippers and benefactors for the institution to survive.

The Shri Vidya proponents also worship other gods and are upholders of Vedic rites, and they co-opt many deities and practices into their system. Exchanges between the Shri Vidya writers are marked by varying degrees of tolerance towards (and metaphoric acceptance of) Tantric rituals like *panchamakara* (in which wine or *madya* and flesh or *mamsa* are consumed, and esoteric *mudra*s or gestures and abstract geometrical

patterns as well as sexual yoga are practised) and *kamakaladhyana* (meditation on the aspect of desire, the worship of the primeval female generative organ or *yoni*).

Apart from religious and literary references, little iconographic details show that the independent goddess had a status at par with the male gods, if not higher. Only Durga and other autonomous forms of Shakti are portrayed with a lion-headed clasp to hold their girdles in place (this lion clasp is otherwise the prerogative of male gods, goddesses have a *makara* clasp). The

17, 18
Kali and Shiva Dancing the Urdhvatandava, Shiva Temple, in Tiruvalankatu. Bronze. Photographs: Bharath Ramamrutham.

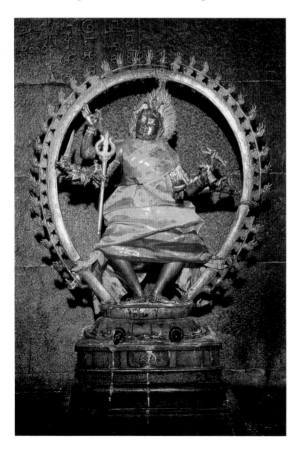

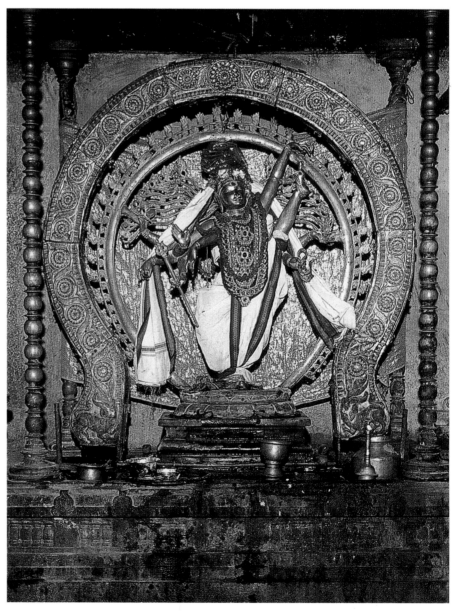

autonomous goddess is portrayed seated cross-legged in the *yogasana* and even in *vajrasana* while the docile wife is seated demurely with one leg folded on the seat and the other pendant. Only independent goddesses have separate gateways (*gopura*s) leading to their shrines. There are many other small iconographic clues which reveal the ancient substratum of the autonomous goddesses to a discerning observer.

The myth of the conversion from fierce to peaceful goddess includes several narratives in which Shiva, the deity himself, subdues the ferocious Kali. To give just one example, in Tiruvalankatu, the fierce Kali was subdued by Lord Shiva who challenged her to a dance and tricked her by lifting his leg well above his head – the *urdhvatandava*, which Devi, as a woman, was too modest to perform in the company of the sages and other gods (figures 17, 18). She was then sent off to a temple of her own, outside the inner courtyard. This is a phenomenon of conflict and accommodation that one sees taking place, whether the myths make Shiva himself or his human incarnation (as his followers believe) the Adi Shankara of the 8th century responsible for this act of pacification. The temple thereby provides sacred space to accommodate two otherwise irreconcilable philosophies and practices.

To now pause and ruminate for a while on the distant Tamil traditions, pre-dating our monist renouncer Shankara by at least 400 to 500 years, we come across the ancient concept of the warring goddess, familiar in the earliest literature of the Tamils, the Sangam literature, which is dated from c. 200 BCE to about the 5th century CE. In the works of this period she is known as Korravai, the goddess of war. The Cheras, Cholas, and Pandyas were regarded as the original rulers of the southern regions of India. They were collectively called the Three Kingdoms or *muvendavelar*s in Sangam literature. These three original royal families of the south all worshipped Durga, as we can glean from Sangam literature. Thus, for example, the Chola goddess was Champapati, the goddess of Pumpuhar, and the goddesses of all the three kingdoms were equated with the great goddess of war and victory, Korravai. She was portrayed with a lance and glowing flame as her attributes. Kings worshipped Korravai before embarking on wars, according to the ancient treatise on Tamil grammar *Tolkappiyam*. She was also worshipped by hunters, and the cemetery was her abode. *Tirumurukarrupadai*, another Sangam work, albeit a later one, identifies her as the mother of Murugan. She is described as surrounded by demonesses, who draw out burning corpses and eat the flesh and dance in the battlefields with dead bodies on their heads.[13] Here there is no sense of minimalism – it is gruesome as gruesome can be. The *Silappadikaram,* again a Sangam work and dated to somewhere around the 3rd–4th centuries CE also describes Korravai as the goddess of victory standing on the defeated buffalo-demon's neck. We can see in this the Sanskritization of the Tamil Korravai, as it is of course the picture of Durga as the slayer of Mahishasura so graphically described in the *Markandeyapurana*, chapters 81–93 and called the *Devimahatmyam* or the Story of the Greatness of Devi. These chapters extolling the Devi are also called *Durgasaptashati* or *Chandimahatmya.*

The earliest image in south India of Durga standing on a buffalo head which acts as her pedestal, is found in Karur, which was a seaport where ancient Roman artefacts were

discovered. On paleographic and stylistic grounds it has been dated to the 2nd century CE. In the Adivaraha Cave in Mamallapuram we have the 7th-century image of Durga with her accompanying devotees portrayed in acts of self-immolation. In another image from Singavaram we see a devotee drawing blood from his hand and offering it to the goddess. Images with devotees in the act of self-decapitation before Durga are found in the Draupadi Ratha at Mamallapuram and in the Lower Cave at Tiruchirapalli. Inscriptions refer to one's offering one's own flesh to Bhattari Durga. While textual references to such grisly rites occur in several places all over India, to the best of my knowledge it is only in Tamil Nadu and Karnataka that we find iconic forms portraying such rites. Thus Korravai, the goddess of the Tamil tradition, was easily blended with Durga and Kali.

In medieval Tamil literature a genre of composition dealing with the gruesome details of battlefields and gory deeds, called the *parani*,[14] became popular. Of special interest are two *parani*s, written during the reign of the Cholas. One was *Kalingattupparani* by Jayakontan, written under the patronage of Kulottunga I in the 11th century. The second *parani* called the *Takkayagapparani* was written by Ottakuttar, the court poet under three successive rulers – Vikramachola, Kulottunga II, and Rajaraja II in the 12th century. In both these *parani*s the battlefield is described and the *Kalingattupparani* describes the building of a temple to the goddess Korravai, of skulls and bones, using flesh and blood as binding materials. Several scholars believe that the *Kalingattupparani* was actually a dance drama and meant to be acted in the court or the temple in the presence of the king. The *Takkayagapparani* describes the

raging battle between Shiva and his father-in-law Daksha, who did not invite Shiva to the sacrifice he performed. Here too the macabre is emphasized as being an aspect of Korravai, and several Tantric rites are mentioned. Thus, gruesome rites in the worship of the ferocious form of Devi were well known in Tamil Nadu of the 11th and 12th centuries. The effort at keeping the sense of power, independence, and grandeur of the goddess, while somehow censoring the unacceptable and taming her, was no mean feat and this was accomplished by the Shri Vidya School in Tamil Nadu, sponsored and nourished by the Advaitin Shankaracharyas and patronized by the kings and court.

These *parani*s were written 400 years after the initial effort of Shankara to tame the goddesses. So the process we are talking about has to be understood in time zones of history, not of individual lives. Adi Shankara was probably the pioneer and under his name this process of bringing the wild goddesses into the temple courtyards was a slow, ongoing one. This led to the strange arrangement whereby the temple system in Tamil Nadu was provided with two goddesses. One was a very subdued one, described as the golden spouse, who occupied a space in the same temple *prakaram* or courtyard as the god, and to whose bedroom the bronze processional *murti* of the god was taken every night, so that divine conjugal bliss might ensure the peace, prosperity, and fecundity of the soil and of mankind. This consort, in the case of the Tiruvarur temple for example, was named Nilotpalambal, "the lady blue lotus" (figure 19), also called Alliyankothai, and she was the mild, gentle, fair-complexioned goddess with two hands. The other, an independent or at times semi-independent, powerful or at times

19
Nilotpalambal of Tiruvarur,
c. 15th century. Bronze;
c. 68 cm. Photograph courtesy
the author.

outright ferocious, divine female form was enshrined in another outer courtyard of the Tiruvarur temple – in the northwest corner of the third courtyard. She was enshrined on her own, and the god was never brought to her chamber at night. In the case of Kamalambika (lotus lady, not to be confused with the blue lotus lady mentioned above) of Tiruvarur, who was the object of the songs sung on Navaratri days which I have described above, this goddess was the autonomous one. She was seated alone, in the powerful pose of a yogi; her right leg crossed over her left, a pose not conventional for the female spouse. She was four-armed, not two-armed as the gentle spouse. She was not the spouse of Tyagaraja, the deity of the temple. In the *puranam* related to the temple we are told that she is Para Shakti, the Supreme Power, and she performs yogic *tapas* (meditation) throughout the ages in Tiruvarur so that all creatures may be happy (Tiruvarur, 16.2: *katavulvalttu* – Praise be to God). She is powerful but peaceful – the strength of the yogini.

The independent shrines to the goddesses were called *kamakottam*. The name is interesting because what it is trying to tell us is that in spirit they are all similar to the shrine of Kamakshi, the goddess of Kanchi, as it is in connection with Kanchi that for the first time we get the term *kamakottam*. The present Shankara *matha* of Kanchi is called Kamakoti Shankara Matham, giving unrivalled predominance to the goddess figure.

Debating whether Shankara did or did not pacify the wild goddesses is not as important as recognizing that there were certain tensions within the Hindu faith. Temples, myths, and rituals in which temple icons were used helped in glossing over the differences and provided a bridge. Thus the

Smarta brahmins connect Shankara's Advaita with Shakta. Between the 9th and 10th centuries a reformism seems to have taken place.

In order to distinguish Shri Vidya from the morally suspect Kaula-Shakta, i.e. those forms of goddess worship which involved the use of the five *m*s (*matsya, mamsa, mada, mithuna, mudra* – fish, meat, wine, sex, cereal), Shakta non-dualism is construed as being compatible with Advaita monism, the glaring points of difference being simply glossed over. Philosophically creation is regarded as a real transformation (*parinama*) of the Absolute in Shaktism. It thus has a reality. The body and the physical world are real, while the theory of *maya* and cognitive error (*vivarta*) form the essential principles of Advaita Vedanta.[15] There almost seems to be something politically correct and, even more than that, politically necessary about acquiring royal and court patronage, about this glossing over differences and asserting compatibility. Shri Vidya is made acceptable to even the most conservative Hindus as it makes no mention of the five *makara*s or other objectionable practices. This is made at the expense of distinctive Kaula Tantric marks common to most Shri Vidya literature. The *Kamakalavilasa* of Punyanada, a text popular in Shri Vidya circles, is so intellectualized – especially in the commentaries – that it is acceptable even to the conservative Smarta.

To conclude, the worship of Durga as pointed out by Coburn[16] has three strands in the *Devimahatmyam*. The first is that she is the Grand Illusion. She envelops Vishnu, who is unable to rise from his cosmic sleep and defeat the evil demons Madhu and Kaitabha. The gods request her to withdraw and she passively leaves Vishnu alone. Durga, it must

be remembered, is the sister of Vishnu and one of her descriptions is Vishnu Maya – she is the *maya* that veils us. It is this Vaishnava connection that makes Durga a goddess both for the Shaivas and the Vaishnavas in Tamil Nadu. In fact hymns of the saint poet Andal are sung in the weddings of Shri Vaishnava girls. In these Andal describes her mystic wedding to her beloved Lord Krishna. She talks of how her would-be sister-in-law Durga helps her don her sari and helps adjust her garland (these are the prescribed ritual duties of a Tamil sister-in-law in the wedding ceremony). So Part 1 of the *Devimahatmyam* attributes a very passive role to Devi.

In Durga's second role she is asked to defeat the buffalo-headed demon, who is causing untoward harm and whom the gods are powerless to defeat. Then comes the dynamic story of Mahishasuramardini. Last of all there is the destruction of Shumbha and Nishumbha. The many forms that help her, Devi claims, are all created by her. When Shumbha taunts her and says that it is the help of all the gods and all the Matrikas etc. that make her win, she says that they are all her emanations and she can withdraw them all into herself, which she does. So we have the cosmic Durga – the only force. And according to the *Saundaryalahari*, attributed to Shankara, "She fills the three worlds with her splendour, bending low the earth with her stride, scratching the sky with her diadem, shaking the netherworlds with her bowstring, standing there filling the ten directions of space with her one thousand arms."

It is this Cosmic Power, this strength and energy, that are still retained by the Shri Vidya goddess, albeit adorned with the auspicious chord of marriage. This chord enforces domestic order, gentleness, and the nurturing

mother image that was subtly combined in the Shri Vidya School. It is fascinating to see the way sacred space, liturgy, and ritual along with narrative and myth were used to accomplish this transformation without obliterating the two aspects of the continuum: Devi the Protective and Devi the Destructive. Believers insist that the visual is not necessarily the real, for to the believing devotee something appears in the icon that is beyond representation and this something permeates the icon. Thus the whole icon goes beyond representation – the Form transgresses into the Formless, the Finite into the Infinite.

NOTES
1 *Devibhagavata Purana*, III.6, 18b–19.
2 Here it must be remembered that many of the ideas presented in this article in terms of the Hindu religion as practised by the Tamil people had parallels in other regions of India. Representing the great vanquisher and warrior goddess as a loving daughter returning to her maternal home is a common theme in the Durga Puja in Bengal. This aspect of the daughter's return to her natal home does not form a part of the Tamil repertoire. The songs and rites focus on this domestic sentiment in Bengal. The domestic *golu* tradition is unknown in Bengal. The particular aspects were different and my specific concern is with the worship of Durga in the Smarta Tamil context. The Aiyangars or Vaishnavas also had the *golu* festival and their celebratory songs but they would concentrate on Vaishnava themes, and the Shri Vidya songs etc. would not be a part of their repertoire.
3 *Tirumurai*, VII, 32.
4 *Saundaryalahari* translates as "waves of beauty", and consists of two parts: the first 41 verses are known as *Anandalahari*, or "waves of bliss", and the remaining verses are known as *Saundaryalahari*. These 100 verses contain the essence of the subtlest of Shri Vidya Tantra. In the first verse of the *Anandalahari* we are told that it is the union of Shiva and Shakti that makes creation possible and that without Shakti Shiva cannot even vibrate. "*Shivah shaktya yukto yadi bhavati shaktah prabhavitum// Na chedevam devo na khalu kusalah spanditumapi.*"
5 While *golus* are arranged by non-Smarta brahmins like Aiyangars, who are Vaishnavas and by other non-brahmin caste groups, the specific choice of themes, the songs, and the myths of fierce goddesses are distinctive

of the Smarta faith.

6 The close connections between the Vijayanagara court and the goddess Chamundi, a form of Durga, are well recorded in the accounts of Abdul Razzak (1442–43) and Domingo Paes in the 1520s. The traditions were kept intact by the Wodeyars of Mysore till the princes' privy purses were abolished in 1971. The king had a string tied to his wrist showing his bond to Devi Chamundeshvari, which he untied only on the tenth day, to be used again in the following year. The royal throne and the royal sword were worshipped and a huge pumpkin was slit open in place of the ancient ritual animal sacrifice. The Mahanavami Dibba in Hampi bears mute witness to the elaborate celebration of Dassera in Vijayanagara.

7 Though Oothukadu Venkata Kavi lived nearly a century before Dikshitar and was the first one to compose *navavarna kriti*s, his beautiful *Kamakshi navavarna* was unknown to the music world until recently. Great composers like Oothukadu Venkata Kavi and Muthuswami Dikshitar who were initiated into Shri Vidya while they were young, have composed *navavarna kriti*s on Devi, which contain the essence of Mantra and Tantra Shastras. Svati Tirunal has also composed *navavarna kriti*s to be sung over the nine days of Navaratri.

8 The *navavarna kriti*s consist of 11 *kriti*s in praise of Kamalambika. In each *kriti* the composer describes and names one of the enclosures of the Shri Chakra and invokes the goddess in all known cases in Sanskrit grammar namely the nominative, the accusative, instrumental, dative, etc.

9 Tradition has it that Adi Shankara established four *matha*s, which became centres of Smarta authority in India in the four quarters of the subcontinent. These were: Govardhana *matha* in Puri, Jyoti *matha* near Badrinath, Sharada *matha* in Dwarka and Sringeri *matha* in Karnataka. The other *matha* in Tamil Nadu is the Kanchi *matha* and there has been an ongoing controversy between the Sringeri and Kanchi *matha*s over legitimacy, authenticity, and antiquity. It is argued that the heads of a *matha* in Kumbakonam acquired control of the Kamakshi Temple in Kanchipuram and moved their establishment to that city between the years 1842 and 1863, and that it is to this late period that we must trace the origin of the Kanchi *matha*. See Mattison Mines and Vijayalakshmi Gourishankar, "Leadership and Individuality in South Asia: The Case of the South Indian Big-Man", *Journal of Asian Studies* 49(4), 1990, pp. 761–86. Under the leadership of its late centenarian head, Chandrasekharendra Saraswati, the Kanchi *matha* had become very popular and the tendency is to regard it as the authentic *matha* founded by Shankara in south India. See the preface in T.M.P. Mahadevan, *The Sage of Kanchi* (Kanchi Mahaswami Ninetieth Birthday Celebration Committee, Secunderabad 1983), pp. i–iii. An important lineage text of the Kanchi *matha*, called

Sushama, claims authenticity for this *matha*. This *matha*'s origins and history remain highly controversial, and contested most vigorously by followers of the Sringeri *matha*. See R. Krishnaswamy Aiyar and K.R. Venkataraman, *The Truth About the Kumbhakonam Mutt* (Sri Ramakrishna Press, Madurai 1973), and Raj Gopal Sharma, *Kanchi Kamakoti Math – A Myth* (Ganga-Tunga Prakashan, Varanasi 1987). See also William Cenkner, *A Tradition of Teachers – Shankara and the Jagadgurus Today* (Motilal Banarsidass, Delhi 1983), pp. 109–10.

10 The Shri Chakra Meru is the three-dimensional version of the Shri Chakra, which is a two-dimensional diagram. The word Meru refers to the cosmic mountain, the centre of the universe. If we project the Meru on to the two-dimensional Shri Chakra, and imagine that the *bindu* or spot in its centre is the peak of a mountain, which is built up in tiers, each tier being one of the circles around each of the triangles that constitute the Shri Chakra, then the outermost square represents the ground level of the mountain. Now, if we imagine a vertical spine down the centre of the mountain, then at each point that the spine and a tier intersect, there is a *chakra*. The peak represents Mount Meru, the centre of the cosmos and the abode of the universal spirit.

11 Douglas Renfrew Brooks, *Auspicious Wisdom: The texts and traditions of Srividya Sakta Tantrism in South India* (State University of New York, Albany 1992).

12 *Tirumantiram* 1307, the first verse of the 12th chapter entitled *puvanapatichakkaram (bhuvanapati-chakram)* is an explicit reference to the Shri Vidya mantra in its 15-syllable configuration beginning with the syllable *ka*.

13 George Hart, *The Poems of Ancient Tamil, Their Milieu and Their Sanskrit Counterparts* (University of California Press, Berkeley 1975), pp. 31–41.

14 The word *parani* has been traced to the Sanskrit *bharani*, a star in the constellation said to be dear to Korravai-Kali-Durga, propitiated by kings and warriors for victory on the battlefield. This practice also finds mention in the *Durgasaptashati* where we are told that kings offered special worship to Durga before embarking on battles and a great sacrifice was made for her and her attendants.

15 For an excellent analysis of the philosophical differences between Advaita and Shakta see Brooks 1992.

16 Thomas B. Coburn, *Encountering the Goddess: A Translation of Devi Mahatmya and a Study of its Interpretation* (State University of New York, Albany 1992).

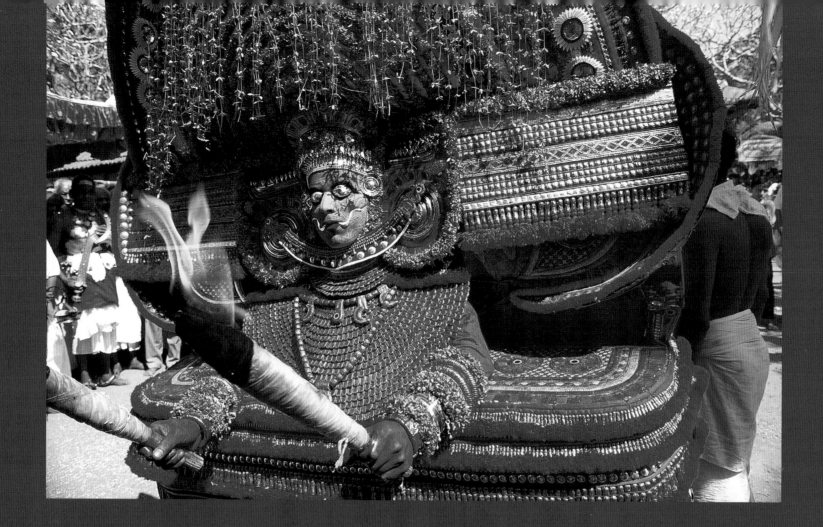

The Muchilottu Bhagavathi Cult in Kerala

Pepita Seth

1

Kerala's Malabar region is the home of Theyyam, a 2000-year-old ritual of worship in which empowered men are transformed into deities. This is achieved by the face of the *kolakaran*, the "image man", being intricately made up, his body being fantastically costumed, and an internal process obliterating his human characteristics. These initial preparations end with the defining moment of the *kolakaran* donning his headdress and gazing into a small hand-mirror to see the deity, the Theyyam, he has now become. While all Theyyams perform specific rituals and dances, the last stage of their manifestation involves interaction with their devotees as they bless, heal, exorcise, answer questions, and maintain the link between man and the divine.

The deities worshipped include gods and goddesses, warrior heroes, wronged women, ghosts, spirits, tigers, and divine serpents. The range of headdresses and costumes and the intricacies of makeup are vast but, regardless of their physical appearance, all Theyyams emit an aura of power and almost inconceivable beauty. While some are feared, others are openly loved. The most important of the latter type is a deified woman, a beautiful goddess called Muchilottu Bhagavathi.

Her story began centuries ago in the ancestral home of the Rayaramangalam Namboodiri Brahmin family where she was the only child of the house and where she would have remained until marriage but for the extraordinary events that transformed her life.

Despite the chasm of time one can still sense that this nameless girl really existed, that she lived an orthodox life, was intelligent, devout, and beautiful; noble and desirable qualities yet ones which upset her elders and aroused their jealousy. Matters came to a head in her twelfth year when, as plans for arranging her marriage began, she insisted that her husband should be someone whose knowledge of the *shastra*s and *purana*s was greater than hers. To find such a husband an assembly was arranged, consisting of not only the girl, her family and gurus, but the Chirakkal and Kasargode Rajas and, of course, prospective bridegrooms – men whose questions, if answered incorrectly, required her to accept the winner in marriage. Yet, though many were reputed scholars, her knowledge was superior to them all. As a result, injured male pride caused the thrust of their questions to change, intentions to warp, and minds to twist as her interrogators sought not to marry her but to bring her down.

Which, one of them cunningly asked, is the most important *rasa?* Even now, aware that the truth would trap her, her poignant smile can be imagined. *Kama,* she declared, seeing their satisfaction, knowing they could now ignore her innate knowledge and *choose* to doubt her innocence and virginity. Then came the second question: What is the greatest pain? Childbirth, she said, sealing her fate.

This extraordinary young girl then told her family that she was leaving them and venturing out into a world she had never seen. Her father's concern was such that he set land aside as her sole property, appointing an overseer to manage it. Yet, though she refused his gift and began her self-appointed exile by praying to Shiva in the Echikulangara temple, food and clothing were sent to her every day. On the fortieth day Shiva appeared before her, acknowledging her innocence but saying she must prove her virginity by making a fire and accepting *danam,* an offering given with a full heart, from anyone who approached. "Leave your body," he told her.

The next morning she rose early, bathed, prayed to Shiva, and left the temple, travelling south until she reached Karivellur. Here she halted and, having gathered enough firewood to make a pyre, used her power to ignite it. After again praying to Shiva, she circled the fire three times, removed one of her heavy anklets, and entered the flames. However her purity was such that the fire refused to consume her. Finally a Vaniyan, an oil presser carrying oil for Rayaramangalam temple, came by and was so moved by the girl and her aura that he cried out "My Mother is going to die" and immediately poured his oil on the fire, thinking it was water. As the flames blazed up the girl opened her eyes and looked at him, just once. And vanished. Suddenly, driven by an unknown fear, the Vaniyan began desperately kicking the fire, trying to find her. But his efforts were in vain and, almost overwhelmed by sadness, he picked up his empty pot and set out for home. On arrival, though, he was surprised to find the pot miraculously full of oil, and when it began moving he immediately knew the identity of the presence it contained and exclaimed "Oh, my Mother!"

Meanwhile Shiva had begun his great *tandava,* dancing in a blur of motion as he looked in every direction and saw, faraway in the south, the fire in which the girl had perished. Shiva then

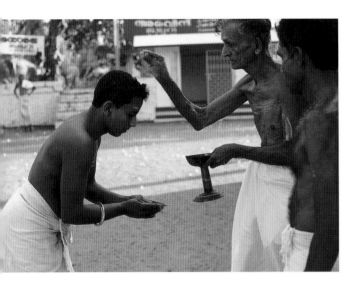

opened his third eye and gave such a beautiful shape to the girl's soul that she too started dancing, finally stopping when she was tired. Shiva then blessed her, gave her the name Bhuvaneshvari and said she must now not only bless the entire universe but be the cause of its blessing.

Though full of respect she questioned Shiva: "Why have you given me this shape and this name?" His reply was a lengthy one, explaining that every goddess was an aspect of Parvathy, created by him to destroy specific asuras, conquer evil, and overcome ignorance and that, like her, they were all his Shaktis. He then related how, long ago, two men, one a vaishya "from the north", journeyed to consult a rishi and were advised to pray to Bhuvaneshvari. The goddess listened to their prayers and, after giving them *moksha* and blessings, told them that in Kali Yuga brahmins would be full of pride and that to destroy this trait she would take birth as a *kannya,* a virgin, adding that the vaishya would also be reborn and able to worship her. Though the new Bhuvaneshvari had forgotten her earlier manifestation, Shiva gently reminded her before instructing her to return to her land and look after the punished. "But

they rejected me. If I go back how can I fulfil their needs?" she asked.

"With your Maya they will know you and know why you have come and worship you", Shiva answered as he began giving the goddess all her symbols of power: her great headdress, her ornaments, her sword and small shield, a winnowing tray, a *trishul,* and her canine teeth. Lastly he gave her false eyes of silver, explaining that the power of her eyes was so great that anything she looked at would be consumed by their fire. The new goddess then wondered how she would find her way and asked Shiva to give her two of his 1,008 *pandam*s, his great fire-torches "because," she declared with practicality, "I need to see."

Lastly she stated that she wanted to cure leprosy and disease and though Shiva gave her crushed gold and diamond powder to distribute as *prasadam* she immediately

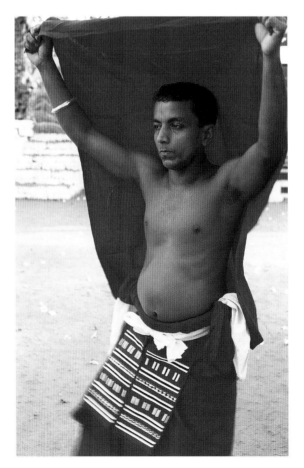

2
When the *kolakaran* and his family arrive at the shrine they are formally welcomed and blessed by the authorities. The *kolakaran* is Lakshmanan Peruvannan. Whilst his family act as assistants to the Bhagavathi's Theyyam some of them will be the *kolakaran*s of the other deities honoured at the shrine. The exception is the Theyyam of Vishnumurthy whose *kolakaran* must be a member of the Malayan community.

3
The *kolakaran* making one of his daytime entries into the shrine to perform the *tottam,* the long song detailing the story of the goddess and her relationship with the particular shrine. Sung in an atmosphere of intense solemnity, it takes three days of morning and evening sessions to complete the *tottam.*

4
One of the most ritually crucial moments occurs on the first night when one of the Vaniyan priests hands the *kolakaran* a plantain leaf containing burning wicks. These wicks, which have been lit from the lamps burning inside the sanctum, signify that the presence of the deity is being conceptually transferred to the *kolakaran*. His red costume has now been tied around his head in recognition of the Bhagavathi's virginity.

5
Throughout Kerala goddesses are often represented by *komarams*, individuals who act as mediums and who, when possessed by the divine, are deemed capable of healing, blessing, and interpreting the deity's moods. In Theyyam's universe their presence is often ritually essential and the festivals honouring Muchilottu Bhagavathi require not only a *komaram* to honour and represent the Bhagavathi but others who perform the same role for the three goddesses who play their part in her complex story. Their elaborate gold ornaments belong to the shrine.

asked how she would manage when it was finished. "After reaching your place you must plant turmeric bushes and when they have grown, you should wash the tubers and, *without* boiling them, dry and pound them to a powder." He then pointed out that as it was too difficult for her to walk from Kailasam to her place he was going to send her in a palanquin. She made three rounds of Shiva, seated herself in the palanquin and, within moments found herself landing at the Taliparamba Shiva temple. The first thing she did was take a bath and change into the clothes she had carried with her in a bundle. Then, dressed as a very poor brahmin *kannya*, she began walking, eventually arriving at a house in Karivellur which a passer-by told her belonged to Muchilodan Pada Nair. She decided to stay there and though at first she

rested in the gatehouse, she eventually felt thirsty and went to hide inside the well and drink water.

Soon Muchilodan Pada Nair's wife came to the well and, on looking down to draw water, saw the goddess in her full form, smelt the gold and diamond powder, and heard the rattling of an *aramani,* a belt of bells. Frightened by this strange vision, she ran to her husband's bedroom, calling for him to bring an oil lamp and look in the well. But he saw nothing out of the ordinary for by then the goddess had hidden herself in the large *pala* tree in front of his bedroom. The next morning when Muchilodan woke and looked out of the window he was surprised to see that the tree's leaves were dry and withered. Though this puzzled him he was finally more concerned by the conviction that the twelve new bows he needed for Muchilottu Fort must be made from this tree. Carpenters were

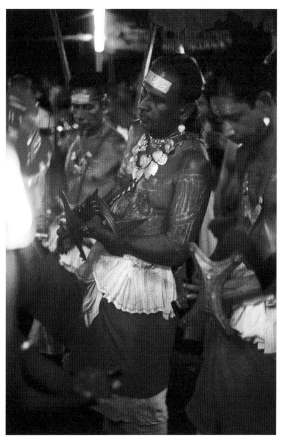

immediately summoned but as soon as they started cutting the tree a voice called out: "Don't touch this tree!"

Muchilodan then decided to cut it himself and the twelve bows were made without incident, eleven of them being sent to his fort. The only problem was that the twelfth one could not be lifted; even an elephant failed to move it. An astrologer was summoned and almost immediately declared that Shiva's daughter was present. Muchilodan then respectfully said: "If you are here please come with me to my fort." To everyone's amazement, the bow then flew like a bird, reaching the fort before he finished talking. That night Muchilodan had a dream in which a disembodied voice said: "You cut down my

tree and now I have nowhere to sit so you must make a place for me in your *puja* room." And so it was that the goddess Bhuvaneshvari came inside Muchilodan's fort and was placed on a silver *peedham*, worshipped every day, and known as Muchilottu Bhagavathi.

Then one evening, during worship, the goddess entered the body of Muchilodan's nephew and, through him, asked for a fire in which to dance. She also pointed at a jack-fruit tree, saying she wanted it cut down and turned into forty bundles of wood stacked as *meleri,* a way of stacking that ensures even burning. This was done and when the goddess began to dance in the fire, three goddesses – one of whom was Rayaramangalam Bhagavathi – arrived and were very pleased with what they saw.

6
Every stage is accompanied by complex rituals. For instance, the *tottam* cannot begin until the *kolakaran* has performed a preliminary puja which includes conceptually blocking all bodily orifices. At this stage his detachment and the increasing "other-worldliness" of his persona can be clearly seen.

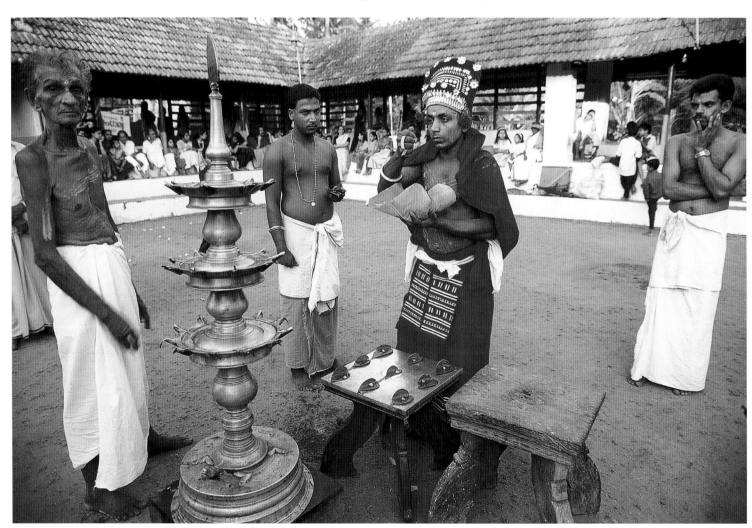

7
The elaborate preparations for the Bhagavathi's Theyyam are completed behind a shielding cloth where every visible part of the *kolakaran*'s body is either painted or clothed. Surrounded by the expectant tension of vast crowds waiting for the first glimpse of the Bhagavathi, the physical facade of an extraordinary divinity gradually emerges as each piece of the costume is tied onto the body whilst the assistants quietly sing the *tottam* to maintain the atmosphere's sanctity.

the root of the problem: her domain consisted of three small fields and one very large one. Though the small ones were cultivated their yield was insufficient for her needs while the large field, though very fertile, was full of wild animals and the haunt of the dangerous forest goddesses. It was also the land given to the brahmin girl just before she left home. After some thought, the two Bhagavathis decided that the best solution was to seek the help of Nharambil Bhagavathi, the most terrifying goddess.

The *bhutagana* sent to bring Nharambil Bhagavathi found her enveloped by fire and in a terrible rage. This was because one of her devotees had gone to give thanks to the goddess for the birth of her daughter and returned late to prepare her husband's meal. Angered by this the husband knocked his wife to the ground and killed her, instantly alerting and enraging the omniscient goddess who, with fire spontaneously coming from her body, rushed to her devotee's house to destroy her killer. It was at this moment that the *bhutagana* arrived.

The goddess agreed to go with him, but on seeing the two Bhagavathis she stamped her foot and shouted, making Rayaramangalam Bhagavathi so frightened that she ran inside her house and hid. Nharambil Bhagavathi then demanded to know what they wanted. Once more Muchilottu Bhagavathi's practical side emerged as she said: "Go and wash your face and then we will eat. After that we will talk."

Later they all sat together and after hearing about the land Nharambil Bhagavathi agreed to act as its protector. Muchilottu Bhagavathi told her: "Whenever I receive food, a portion will always be given to you. In addition you may continue to eat flesh and

Afterwards Muchilottu Bhagavathi felt she should have a place of her own and went to Rayaramangalam to see what the Bhagavathi could suggest. However the goddess informed her that "the situation here is not good. I should give to everyone who comes but for the past twelve years it has been impossible. There is no one to look after things or do the accounts." Then she brightened and said, "I will give *you* the box with the property deeds, the keys, the measuring pots, and the accounts to look after." Lastly she explained

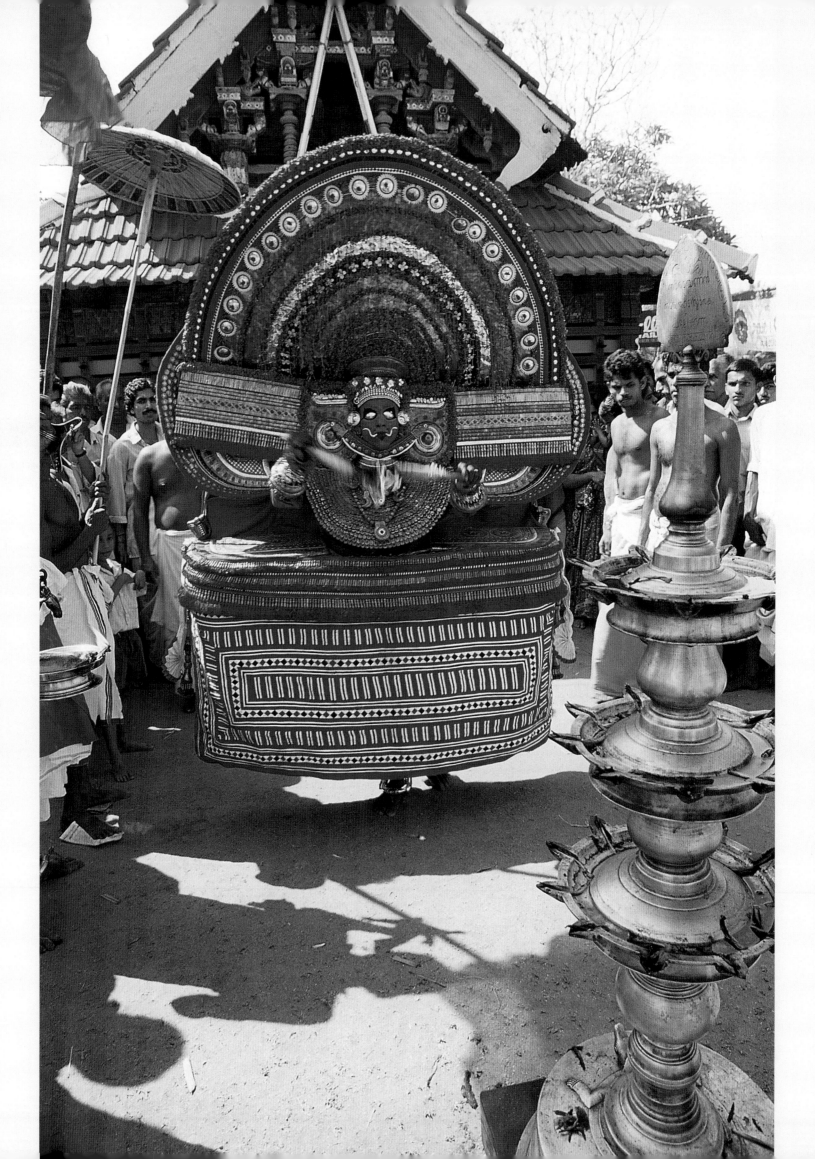

8
(opposite)
The Theyyam of Muchilottu Bhagavathi blesses her devotees. At this stage her eyes are concealed behind silver masks and she holds two fire-torches.

9
(below)
The eye-masks are removed when the Bhagavathi conceptually descends into the shrine's well, an echo of the time when she hid in Muchilodan Pada Nair's well. They are respectfully removed by the *kolakaran*'s father (Krishnan Peruvannan) supported by his brother (Dinesan Peruvannan).

10
(right)
The Bhagavathi blesses a devotee who, though a member of the *kolakaran*'s family, is prostrating to his goddess.

blood, it will even be provided for you – but outside." From then on, the field was free of problems. Nharambil Bhagavathi kept her word and Muchilottu Bhagavathi oversaw its cultivation, including the growing of turmeric bushes, while Rayaramangalam Bhagavathi was happy since all her needs were met. Muchilottu Bhagavathi also gave her, in a mere 2½ *nazhika*s of time (about an hour), all the accounts of the previous twelve years. She was very efficient.

Rayaramangalam Bhagavathi now decided that Muchilottu Bhagavathi should be married. Although apparently agreeable she explained: "I have been sent from Kailasam to perform certain duties. At the moment I have no separate identity. I need a place outside, of my own." Rayaramangalam Bhagavathi was not against this but asked how she would leave and who would take her. Muchilottu Bhagavathi had, of course, worked that out. Every day Muchilodan Pada Nair came to Rayaramangalam for worship. The next day

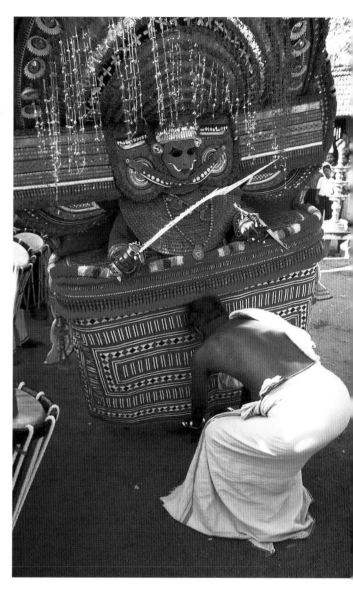

she simply sat on the crown of his palm-leaf umbrella and travelled to his house. When the umbrella was put down it immediately started jumping. An astrologer was summoned and, having divined that Muchilottu Bhagavathi was present, a shrine was made for her – paid for by Rayaramangalam Bhagavathi.

Then the subject of marriage re-surfaced and, as people started arriving from all over the country, the cooking of the food needed to feed them began. Although this was deemed to be Muchilottu Bhagavathi's responsibility, Rayaramangalam Bhagavathi provided everything else, sending lamps, salt,

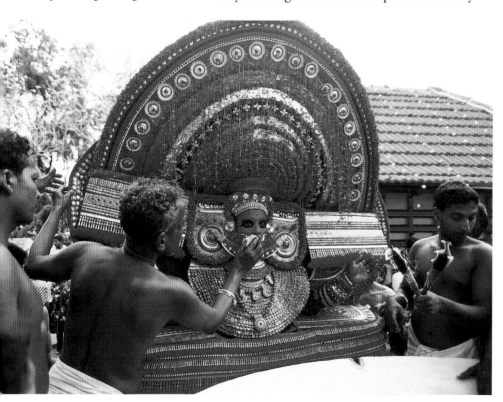

masalas, vegetables, sets of stones to support the cooking vessels and even water from her well.

2

When Muchilottu Bhagavathi is honoured as a Theyyam, the festival is, in essence, to celebrate her marriage, conceptually taking place in Kailasam where the unnamed groom is assumed to be Shiva. For this reason vast amounts of food are cooked since all those who attend are regarded as her guests. Yet every year and at every festival she sidesteps actually being married, evading the issue by

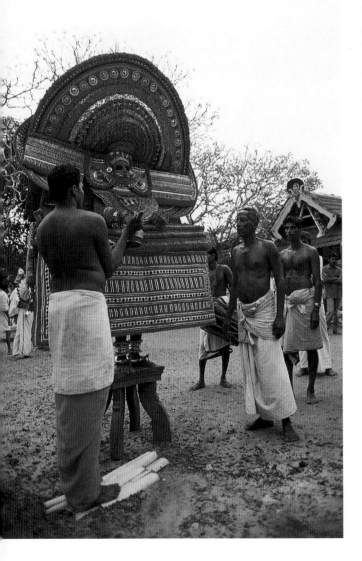

saying that the shrine's lamp-lighter is in a polluted state.

In this highly structured universe Muchilottu Bhagavathi's *kolakaran* must belong to the Vannan community, hold the title of Peruvannan and, more pertinently, possess enormous stamina since the rituals last for four days and nights.[1] Though her devotees come from all communities her shrines are always owned by Vaniyans, in recognition of the man who poured the oil on her pyre.

The rituals begin on the first evening with the Bhagavathi's *kolakaran,* dressed in a simple red costume, entering the shrine's compound and, in a state of almost liquid grace, making one round, holding a cloth over his head to shield the virgin goddess. Finally as he stands before the shrine a small red *mudi* is placed on his head and he begins singing part of the long *tottam* detailing Muchilottu Bhagavathi's story, accompanying himself on the *chenda.* It is a song of aching sadness and though the *kolakaran*'s face is devoid of expression no one can doubt the emotion within him or that a transformation has begun.

Meanwhile four red-clothed, gold-bedecked men approach, the *komarams,* the shaman-like representatives of Muchilottu Bhagavathi, and three other Theyyams who, as the *tottam* ends, face the *kolakaran* and begin moving backwards before him, making three rounds of the shrine whilst always maintaining their spatial relationship. The *kolakaran,* supported by attendants, holds his head to one side, a stance heightened by his serene face and the dance's beautiful swaying movements. Though surrounded by shrine authorities, drummers, and lamp-holders they are preceded by a man carrying a pot of water – symbolizing the Vaniyan who had poured the oil.

11
The long ritual performance of Muchilottu Bhagavathi taking a bath. She stands on a *peedham*, a wooden stool commonly used in Kerala's rituals.

12
The Theyyam of the frightening Nharambil Bhagavathi, the goddess who guards the land belonging to Muchilottu Bhagavathi. Her headdress and costume are rimmed with fire.

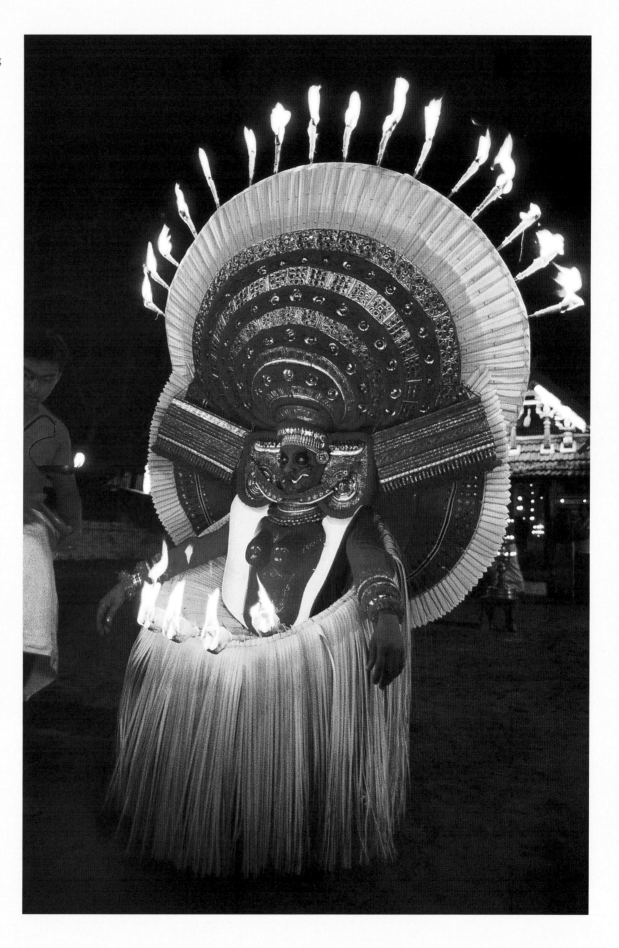

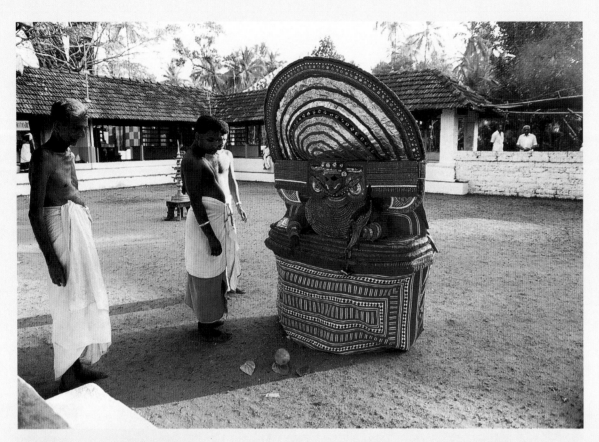

13
The Theyyam of Kannangattu
Bhagavathi, a deity who became
associated with Muchilottu
Bhagavathi *after* she was
deified. Though her myth has
been transformed to give her
story a Malabar locale she is in
fact Yoga Maya, the goddess
born as Yashoda's daughter and
substituted for Krishna but
who flew from Kamsa's hands
when he tried to kill her.

14
The Theyyam of Puliyoor
Kali who, though seen as
the sole female among the
six divine tiger cubs born
to Shiva and Parvathy when
they transformed themselves
into tigers, is worshipped as
a manifestation of Parvathy.
She bestows her blessings on
the Bhagavathi just before she
"rises" as a Theyyam.

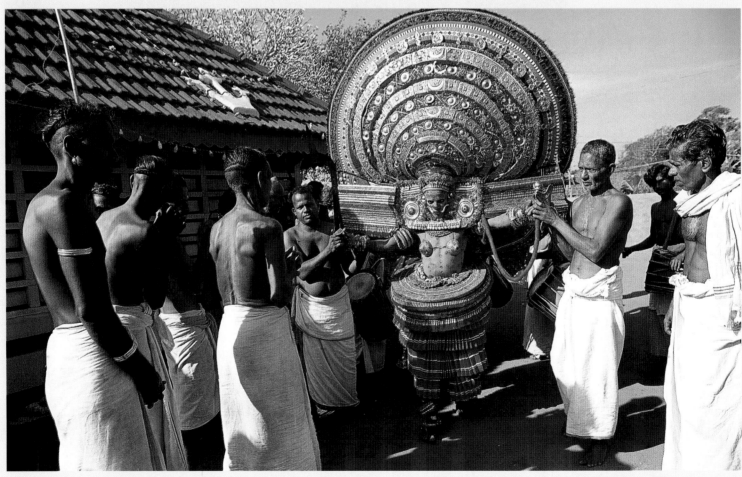

Over the next two days this pattern is repeated, morning and evening, the *tottam* always advancing Muchilottu Bhagavathi's story. In between other Theyyams enter the shrine's precincts to manifest their own presence and power. On the last evening the *kolakaran* retires to a temporary shelter, spending the night meditating and making decorations for the Bhagavathi's headdress, finishing in the early morning in time for his elaborate makeup to begin.

Afterwards, ringed by attendants the transformed *kolakaran* is taken, holding a special mirror containing the Bhagavathi's presence, to finish dressing behind a cloth held to preserve the deity's modesty. The assistants sing the *tottam* to maintain the sense of a divine presence, ending when the Theyyam of Puliyoor Kali, a manifestation of Parvathy as a tiger goddess, comes to shower the goddess with *prasadam* declaring: "As Parasurama gave all his strength and ability to Sreerama so I give all mine to you."

During this time there is an elaborate interaction between the shrine authorities and the *komaram*s. Finally, just after a senior Peruvannan has placed the *mudi* and the false eyes on the goddess, the lamp-lighter gives him two *pandam*s and, as Shiva, he hands them to the goddess. The cloth is removed and, very slowly, the magnificent and otherworldly figure of Muchilottu Bhagavathi "rises" like a brahmin girl, her head modestly lowered.

Accompanied by her attendants she makes nine rounds of the shrine, with nine different steps, every action and all accompanying music echoing a different aspect of her story. After the last round she goes to the shrine's well to conceptually drink and douse the fire within her. The false eyes are removed and,

after dancing with a golden winnowing tray, she is lifted onto a *peedham* where to the beat of a *chenda* she mimes taking a bath – even gasping at getting water in her eyes.

After more dancing she seats herself to bless, give *prasadam*, and reassure her thousands of devotees. Finally, long after nightfall, when all have been blessed she circumambulates the shrine thrice and, after making her personal requests to Rayaramangalam Bhagavathi, stands on a *peedham* to fix the date of her marriage for the following year. When she gets down, the *thirumudi,* the sacred headdress, is removed.

NOTE
1 Six other Theyyams are honoured, all connected with Muchilottu Bhagavathi's myth: Nharambil Bhagavathi, Kannangattu Bhagavathi, Puliyoor Kali, Puliyoor Kannan, Vishnumurthy, and the Vaishya.

FIGURE ACKNOWLEDGEMENTS
The photographs reproduced here were taken by the author at the Kunnavu Sree Muchilottu Bhagavathi Temple near Chirakkal.

The Fifty-one Shakta Pithas

Pratapaditya Pal

dehasthāḥ sarvavidyāśca dehasthāḥ sarvadevatāḥ /
dehasthāḥ sarvatīrthāni guruvākyena labhyate //
All knowledge resides in the body;
All deities reside in the body;
All pilgrimages are located in the body;
And none can be achieved without the guru's instructions.

PROLOGUE

That the traditional number of Shakta Pithas (*pitha* variously meaning seat, altar, shrine, or pilgrimage centre) is 51 is well-known and has been mentioned by all scholars who have written on the subject.[1] However, none of these scholars seems to have given any thought as to why the number came to be fixed at 51. The number 51 or 50 (as in the *Jnanarnava Tantra*) is mentioned, among other texts, in the *Devibhagavatapurana*, the *Shivacharita*, the *Tantrasara*, *Pithanirnaya*, and the *Pranatoshini Tantra*.[2]

Among the Tantric texts we can be reasonably certain of the date of the *Tantrasara* of Krishnananda Agamavagisha who probably lived in the second half of the 16th century.[3] Since he quotes the *Jnanarnava* list of 50 *pitha*s, we can further assume that by the 15th century the concept of 50 *pitha*s had become current.[4] The *Devibhagavata* (V, 29–30), which was certainly compiled at about this time or earlier, connects the 51 *pitha*s with the body of Sati, Shiva's first wife, who died or killed herself, unable to bear the insults hurled against her husband by her father, Daksha. This story is mentioned invariably by all those who have written on the subject, and the most elaborate discussion is to be found in Sircar's book. However, neither he nor anyone else has sought to explain why the number is 51 and not 64, 84, or 108, which are all sacred numbers in Indian religious symbology. Moreover, if the idea of *pitha* was conceived simply to legitimatize shrines and temples dedicated to the various tribal, aboriginal, rural, and non-Aryan goddesses, then it seems strange that the number of pieces into which Sati's body was chopped up was limited to 51, when clearly the shrines are literally legion. Furthermore, the practice of legitimatizing or Sanskritizing such shrines had already begun as early as the *Mahabharata,* and the *purana*s contain lengthy and monotonous chapters incorporating innumerable shrines not only of the Goddess but also of all other deities. Therefore, why should Tantric theologians suddenly declare their preferences for the number 51 (or 50) around the 16th century or a little earlier? In this chapter we attempt to answer this question, and will begin by briefly reviewing the relevant material in the *Tantrasara* which appears to be the first Tantric text in Bengal to mention the number 51.

1

The *Tantrasara* is an encyclopaedic digest of Tantric religious ideas and traditions that was compiled by Krishnananda Agamavagisha, an eminent Bengali brahmin who lived in the town of Navadvip in West Bengal. Among the various rites and rituals described in this text, one of the most important is that known as *nyasa*, which is basic to the Tantric mode of worship. There are various kinds of *nyasa*s, such as *shodanyasa, matrikanyasa,* etc., included in the text, but we will concentrate in this paper on *pithanyasa*. The word *pitha* literally means a seat or altar, but we will have more to say about this presently. Let us first begin by defining *nyasa*, which is the term used to describe the rite.

Mircea Eliade[5] defines the word *nyasa* as follows:

In connection with tantric iconography, mention must be made of *nyasa*, the "ritual projection" of divinities into various parts of the body, a practice of considerable antiquity but one that tantrism revalorized and enriched. The disciple "projects" the divinities, at the same time touching various areas of his body; in other words, he homologizes his body with the tantric pantheon, in order to awaken the sacred forces asleep in the flesh itself. Several kinds of *nyasa*s are distinguished according to their degree of interiorization, for in some cases the divinities and their symbols are "put" into the various organs of the body by a pure act of meditation.

Agehananda Bharati[6] gives us two definitions of the term *nyasa:*

1. Literally, *nyasa* is the process of charging a part of the body with a specified power through touch...

2. *Nyasa* (lit. placing down, depositing) is the process of placing one meditational entity into another, and applies both to actual, physical, and to imagined entities....

According to the *Kularnava Tantra,* "nyāsa is so called because therein riches that are acquired in a righteous way are deposited or placed with persons whereby all-round protection is got".[7] S. Shankaranarayana[8] further elaborates upon this when he writes:

nyāsa means a pledge or a deposit that is entrusted to one's care. One must begin to identify oneself with the Mantra one worships and this is done by completely surrendering the individuality, the sense of "I"ness and "my"ness in all parts of one's being and entrusting it to the Mantra which is the sound-body of the Deity.

Notwithstanding the different styles of verbalization by the various scholars, it is evident that the term *nyasa* generally means the process whereby the adept homologizes his body with the divinity, and, once this is done, he not only holds his body in trust, so to speak, for the Divine, but the body itself is transformed into a sacred area, devoid of all profanity. This, of course, is an important point to bear in mind, for the true *sadhaka* thereafter is one with the Divinity, and all his subsequent ritual acts must not be interpreted by ordinary standards of morality. In any event, we must remember this meaning of *nyasa* in order to understand not only the *pitha* concept but also the number 51 which seems to have been generally misunderstood by modern scholars.

2

The *Tantrasara* mentions the word *pitha* in several different places but always in the context of *nyasa.* In connection with the worship of Bhuvaneshvari, we are told that one should invoke the goddesses Jaya, Vijaya, Ajita, Aparajita, Nitya, Vilasini, Doghdhri, Aghora, and Mangala who are the nine *pithashaktis.*[9] In this instance, the number of *pitha*s is nine, although no geographical places are named. The association of the *nyasa* rite and four geographical *pitha*s is made in the *pithatattvanyasa* related to the goddess Srividya or Mahatripurasundari and is quoted from the *Navaratneshvara.*[10] The four *pitha*s are Kamagiri/Kamarupa, Jalandhara, Purnagiri, and Uddiyana. The details of this *nyasa* are provided in Table 1. There can be little doubt that here we are witnessing the homologization of the *yogin*'s body, the *pitha*s, different deities, and letters of the alphabet. Rather curious are the facts that Uddishanatha

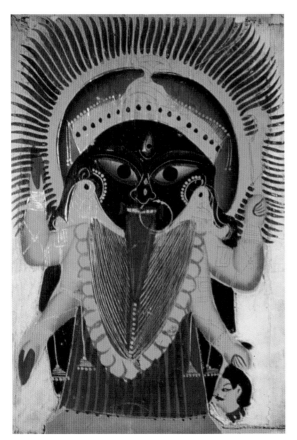

2
Kali of Kalighat, Kalighat School, c. 1875. Opaque watercolour on paper. Pal Family Collection.

3
(opposite)
Durga, Punjab plains, 19th century. Opaque and transparent pigments on paper; 75 x 59.7 cm. Pal Family Collection.

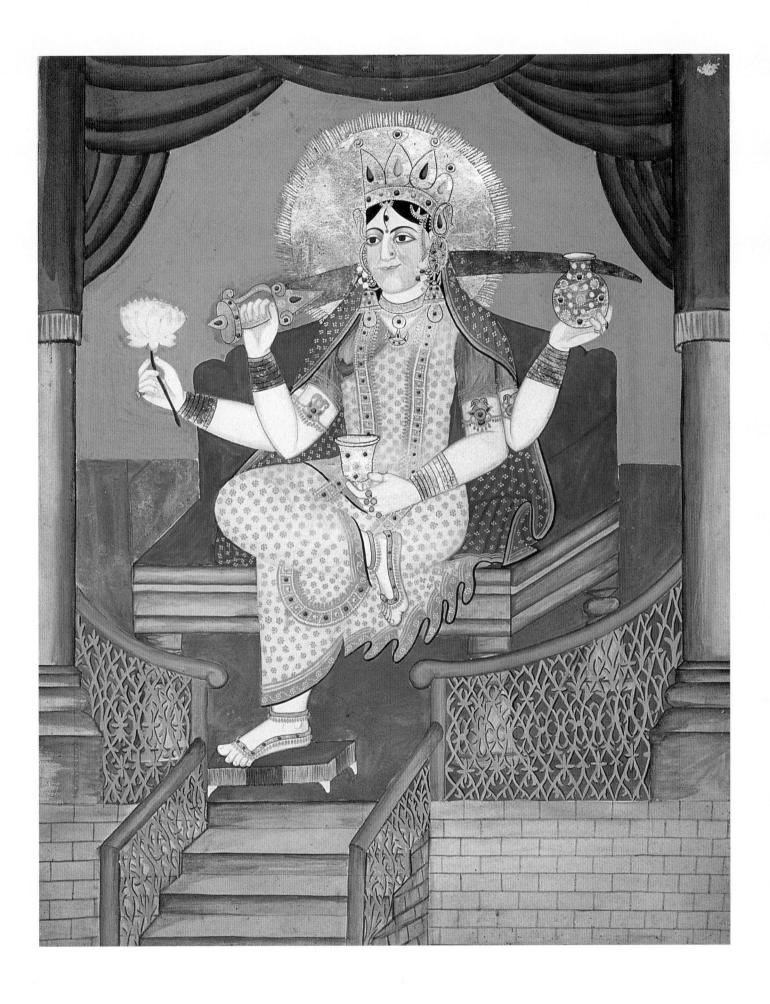

TABLE 1

Pitha	*Chakra*	Bhairava	Bhairavi	Part of the Body	Letters
1. Kamagiri	Agni	Mitrishanatha	Kameshvari = Rudratmashakti	*muladhara* (base of the spinal column)	ka, e, ī, la, hrī
2. Jalandhara	Surya	Shashthinatha	Vajreshvari = Vishnvatmashakti	*hridaya* (heart)	sa, ha, ka, ba, la, hrī
3. Purnagiri	Soma	Uddishanatha	Bhagamalinidevi = Brahmatmashakti	*lalata* (forehead)	sa, ka la, hrī
4. Uddiyana	Parambrahma	Shricharyanatha	Mahatripurasundari = Brahmatmashakti	*brahmarandhra* (cranium)	ka, e, ī, la, hrī, sa, ha, ka, ha, la, hrīṃ, sa, ka, la, hrī

is not the Bhairava of Uddiyana, and both Bhagamalini and Mahatripurasundari are characterized as Brahmatmashakti. The *Tantrasara* also quotes several verses from the *Kulamrita* to further explain the meaning of this *nyasa*.

In the worship of Tara a more elaborate *nyasa* is quoted from the *Rudrayamala*.[11] The *nyasa* is to be performed on ten different parts of the body, as set out in Table 2.

That there was some consistency in such lists is evident from the fact that the four most important *pitha*s are homologized with the same four parts of the body in both. The number of letters however varies from one *pitha* to another, and two of them, viz.

Ayodhya and Kanchi, do not appear to be associated with any letters at all. This is strange since all the letters of the alphabet have not been used in this *nyasa*. It is also interesting that these ten *pitha*s are regarded as the most important (*dashaitāni pradhānāni piṭhāni...*).

There is yet a third *pithanyasa*[12] quoted in the text which involves 51 different parts of the body and is associated with 51 letters of the alphabet and 51 goddesses known as *matrika*, or mother goddesses (Table 3).

It may be pointed out that the word *matrika* also denotes the letters of the alphabet. The names of the *pitha*s given in this list are the same as those which occur in the

TABLE 2

Pitha	Part of the Body	Letters
Kamarupa	*muladhara* (base of spinal column)	hrī, strī, hū, aṃ, āṃ, kaṃ
Jalandhara	*hridaya* (heart)	iṃ, īṃ, caṃ
Purnagiri	*lalata* (forehead)	uṃ, ūṃ, ṭaṃ
Uddiyana	*brahmarandhra* (cranium)	riṃ, ririṃ, taṃ
Varanasi	*bhruvormadhye* (between the eyebrows)	liṃ, liliṃ, paṃ
Jvalanti	*lochantraye* (in the three eyes)	eṃ, aiṃ, yaṃ, raṃ, laṃ
Mayavati	*mukhavritte* (face)	oṃ, auṃ, śaṃ, shaṃ, saṃ, ham
Madhupuri	*kanthe* (neck)	aṃ, aḥ, laṃ, kshaṃ
Ayodhya	*nabhideshe* (navel)	none
Kanchi	*katya* (hip)	none

TABLE 3

Names of Mothers with Corresponding *Pitha*s, Letters, and Parts of the Body

Letter	*Pitha*	Mother	Part of the Body
a	Kamarupa	Tripura	head
ā	Varanasi	Malini	face
i	Nepala	Madana	right eye
ī	Paundravardhana	Unmadini	left eye
u	Kashmira	Dravini	right ear
ū	Kanyakubja	Khechari	left ear
ṛ	Purasthita	Jhatika	right nostril
ṝ	Charasthita	Kalavati	left nostril
ḷ	Purnashaila	Kledini	right neck
ḹ	Arbuda	Shivaduti	left neck
e	Amratakeshvara	Subhaga	upper lip
ai	Ekamra	Bhagavaha	lower lip
o	Trisrotah	Vidyeshvari	upper teeth
ou	Kamakotta	Mahalakshmi	lower teeth
ṃ	Kailasa	Koulini	throat
ḥ	Bhrigu	Kaleshvari	mouth
ka	Kedara	Kulamalini	right armpit

kha	Chandrapura	Vyapini	right elbow
ga	Shripitha	Bhaga	right wrist
gha	Omkara	Vagishvari	right finger base
ṅg	Jalandhara	Kalika	right fingertip
ca	Manava	Pingala	right finger
cha	Kupantaka	Bhagasarpini	right finger
ja	Devikotta	Sundari	right finger
jha	Gokarna	Nilapataka	right thumb
ń	Maruteshvara	Siddheshvari	left armpit
ṭa	Attahasa	Mahasiddheshvari	base of right foot
ṭha	Vijaya	Aghora	right knee
ḍa	Rajagriha	Ratnamala	right heel
ḍha	Kolvagiri	Mangala	base of right toe
ṇa	Elapura	Bhagamalini	tip of right toe
ta	Kameshvara	Raudri	base of left foot
tha	Jayanti	Yogeshvari	left knee
da	Ujjayini	Ambika	left heel
dha	Kshirika	Attahasa	base of left toe
na	Hastinapura	Vyomarupini	tip of left toe
pa	Uddisha	Vajreshvari	right side

pha	Prayaga	Kshobhini	left side
ba	Vindhya	Shakambhari	back
bha	Mayapura	Ananga	navel
ma	Jaleshvara	Lokeshvari	stomach
ya	Malaya	Rakta	heart
ra	Shrishaila	Sustha	right shoulder
la	Meru	Shukra	hump on back
va	Giri	Aparajita	left shoulder
sa	Mahendra	Samvarta	right hand
śa	Vamana	Vimala	left hand
sha	Hiranyapura	Aghora	right foot
ha	Mahalakshmipura	Bhairavi	left foot
la	Uddiyana	Amogha	belly
ksha	Chayachatrapura	Sarvakarshini	mouth

Jnanarnava.[13] However, while the *Jnanarnava's* list is of 50 letters, the *Tantrasara* has 51. Table 3 correlates the names of the *pitha*s with different parts of the body, the letters of the alphabet, and the various goddesses.

3

We thus see that the *Tantrasara* itself knows of at least three different traditions regarding the number of *pitha*s: 4, 10, and 51. Although it seems that there was a tradition of three *pitha*s, as enumerated in the *Matasara*,[14] generally the early Tantric tradition knows

4
An image from the exterior of Kamakhya Temple, seat of the menstruating goddess in Guwahati, Assam. Women flock here to pray for fertility. Photograph: Sundari Johansen Hurwitt.

of a group of four. The Buddhist *tantra*s are quite consistent about the *pitha*s being four and the earliest text to mention them is the *Hevajra Tantra*.[15] The *Sadhanamala* was compiled at least as early as the 11th century, and there too only four *pitha*s are mentioned. The Buddhists also composed a text called *Chatushpitha Tantra*,[16] the earliest manuscript of which is dated to 1145 CE.

According to the *Chatushpitha Tantra* the four *pitha*s are *atmapitha, parapitha, yogapitha,* and *guhyapitha* or in other words the *pitha* of the self, the supreme *pitha*, the *pitha* of yoga, and the secret *pitha*. Thus, there is nothing geographical about the four *pitha*s in this text. In the earlier *Hevajra* too the *pitha*s do not appear to have any topographical significance as is clear from the commentaries.[17] In answer to Vajragarbha's question, "What O Lord, are these places of meetings?" the Lord enumerates 12 different places which are called *pitha, upapitha, kshetra, upakshetra,* etc. He then clearly states that "these correspond with the twelve stages of a Bodhisattva".[18] These 12 stages are obviously the 12 *bhumis,* as the commentators tell us. Vajragarbha then continues to ask: "What are these *pitha*s and the rest?" In reply, the Lord enumerates several places including the four principal *pitha*s: Jalandhara, Uddiyana, Purnagiri, and Kamarupa.

As Snellgrove[19] has discussed, there is considerable confusion among the commentators regarding the exact number of places and the number of veins and "limbs" in the body. However, there is no ambiguity about the meaning of these *pitha*s, *upapitha*s, etc. According to Naropa's commentary, "the places, Jalandhara and so on, are mentioned for the benefit of simple fools who wander about the country." Snellgrove adds: "They

are therefore interpreted as symbols for the places within the body, that is to say, they are the external equivalent of that which exists within." The confusion of the commentators was resolved by Tucci,[20] who appears to be a pioneer in discussing the correspondence between the *pitha*s, in the Buddhist context, and the *yogin*'s body.

Of the four principal *pitha*s named by the *Hevajra Tantra,* there is no doubt regarding the identification of Kamarupa and Jalandhara. By common consensus Uddiyana is identified with the Swat Valley in Pakistan, although some have questioned this identification.[21] There is also some uncertainty about the identification of Purnagiri. It may be pointed out that while Jalandhara is consistently characterized as a great centre for the worship of the Goddess, it is not especially associated with Buddhism. Kamarupa too was not as important as Bengal, Odisha (Orissa), or Nepal for the

history of Buddhism, although the temple of Kamakhya in Assam may once have been associated with the faith.[22] Only the Swat Valley has had important connections with Buddhism which in fact is an argument for its identification with Uddiyana. If the four *pitha*s were originally intended to be four external places of pilgrimage, it is rather curious that the Buddhists did not choose four better known centres of Tantric Buddhism. On the other hand, it is possible that these four places were simply important for the Tantric tradition in general, and were incorporated in both Buddhist and Hindu religious literature. Swat today bears no traces of Hindu Tantra, or of the Shakta tradition, but its neighbour Kashmir has been an important centre of Tantrism from early times. Kalhana makes no particular mention of the Swat Valley or Uddiyana as important *pitha*s, but does allude to the shrine of Sharada in Kashmir. Indeed, the temple of Sharada was

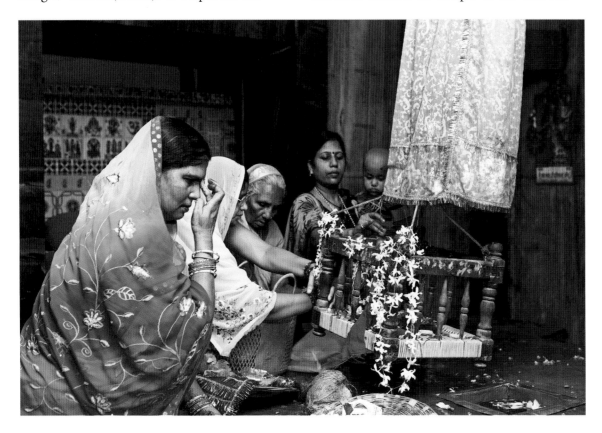

5
Alopi Devi Temple, Allahabad, Uttar Pradesh where a finger of the Devi is fabled to have fallen. Photograph: Rajesh Vora.

6
Kamakshi Amman Temple, Kanchipuram, Tamil Nadu. The Devi's hip is said to be here. Photograph: V. Muthuraman.

so important that it became associated with the hagiography of Shankaracharya, while Abul Fazl substituted it for Uddiyana in his discussion about the *pitha*s.[23]

We may never know why these four particular places were chosen by the Buddhist *tantra*s. Certainly, when the early Buddhists first selected the eight places of pilgrimage, at least four were directly associated with the principal events in the life of the Buddha – Lumbini, Gaya, Sarnath, and Kasia. The selection of the other four, as is well-known, may have been dictated by geo-political considerations. Eliade has suggested that "since each pitha represented the actual presence of the Great Goddess, the quaternary symbolism expresses the victory of the cult of Sakti in all India".[24] While this interpretation may be applicable to the Shakta Pithas, it is doubtful if the Buddhists had selected the number four for the same reason. It is difficult to connect the four *pitha*s with the

four cardinal directions, as has already been pointed out by Bharati. However, the number four may reflect quaternary symbolism in an abstract manner, and this would explain why the number of great miracles of the Buddha's life too was settled at eight, perhaps to symbolize the eight directions, although they are not actually situated in these directions. The number of *pitha*s too was increased to eight, as we encounter in the *Jnanarnava,* as well as to ten in the *Rudrayamala.* Elsewhere in the *Tantrasara* the number of *dikpala*s is increased from eight to ten with the addition of Brahma and Ananta to the conventional eight.[25] Thus four, eight, and ten may all symbolize the universe with four, eight, or ten directions (including the zenith and the nadir), and in the *nyasa* ceremony, by either the four or the ten *pitha*s, the adept's body or the microcosm is homologized with the macrocosm. In my opinion, therefore, it is fruitless to try and identify the *pitha*s with

exact geographical locations, for these *pithas* exist only in the mind and the body of the Tantric.

4

This is also clearly evident from the choice of the number 51 though here we do not have a directional symbolism. However, there are other numbers of *pithas* such as 15 *(Brahmayamala),* 18 *(Kularnava* and *Ashtadashapitha),* and 42 *(Kubjika Tantra),* but these are not necessarily associated with the *nyasa* rites. Nevertheless, all these numbers do have symbolic significance. Eighteen of course is a very important number in Indian numerology, while 42 is closely associated with alphabet mysticism, as for example, the *Bhuta-lipi* which consists of 42 letters and plays an important role in astrological calculations.[26] Similarly, it seems unnecessary to discuss the grouping of 108 *pithas,* for it obviously follows the standard Indian practice of enumerating 108 names of deities. Moreover, in Tantric *sadhana,* the *mulamantra* is to be recited 108 times.[27]

It is significant to note that the first part of the *Lalitasahasranama,* traditionally ascribed to Shankaracharya (8th century or earlier), consists of 51 verses obviously corresponding to the 51 letters of the alphabet.[28] If indeed the *Sahasranama* was composed by the philosopher-saint, then this would be one of the earliest applications, though indirect, of the *varnasadhana* or *akshara-vada,* consisting of the 51 letters of the alphabet. Among the other texts, which we have mentioned above, the earliest is the *Jnanarnava* which names 50 *pithas.* By splitting one of these 50 names, Krishnananda Agamavagisha arrived at the number 51 which was accepted by his followers. Unable to understand the significance of this number, Sircar has written:[29]

> Curiously enough the *Tantrasara,* in spite of its clear recognition of the number of Pithas to be fifty-one in accordance with the *Jnanarnava Tantra,* actually makes fifty-one Pithas out of the fifty enumerated above. This has been done *strangely* [italic ours] by splitting the name of one of the fifty Pithas, viz. Merugiri (No. 44) into two names, viz. Meru Pitha and Giri Pitha, in the formal *nyasa* associating certain limbs with the Pithas. The *anomaly* [italic ours] was probably the result of a modification of the text of the *Tantrasara* by later hands. What is, however, more interesting is that the *Pithanirnaya* or *Mahapithanirupana,* which has been quoted in the *Pranatosani Tantra* by Ramatosana Vidyalankara...adheres exactly to this modified number of the Pithas, viz. 51, although the list itself is independent of the earlier lists of Pithas.

It is obvious from the above statement that Sircar has not appreciated the significance of the number 51 which is basic to the enumeration of the *pithas.* He has laid much too much emphasis on the interpretation of the *pithas* as pilgrimage centres that have a "geographical" reality. This is understandable in a scholar who is a leading authority on ancient Indian geography. The same emphasis on the *pitha* as a verifiable and identifiable geographical site is also evident in Chattopadhyay's discussion of Shakta Pithas.[30] He begins his essay disagreeing with Sircar's theory about the origin of the *pithas* – that they "are

nothing but the transformation of the early *yoni-kundas*", – and plunges immediately into a discussion of certain names that occur in the *Tirtha-yatra* section of the *Mahabharata*. Obviously, he too identifies the words *pitha* and *tirtha* and seeks a topographical resolution of the *pitha* concept. Based on the geographical locations of some of the *pithas*, he even discovers that "the *pithas* developed in India at the initial stage under foreign influence".[31]

5

The *Tantrasara* quotes the entire *pithanyasa* from the *Jnanarnava* in connection with the worship of Mahatripurasundari. It is therefore a further elaboration of the simpler *pithanyasa* with four *pithas* we have already discussed. Instead of using four groups of letters, however, in the more elaborate *nyasa*, one letter is associated with one *pitha*, and then homologized with a limb in the body of the *sadhaka*. Thus, the basis of this *nyasa* appears to be the entire alphabet of the Sanskrit language which consists of 50 or 51 letters from *a* to *ksha*. A glance at Table 3 clearly demonstrates how the *pithas*, the letters, and different parts of the body are homologized. Indeed, that the letters are the key to this symbology is evident not only from the fact that many of the names of the *pithas* such as Meru Pitha and Giri Pitha are contrived but also from the nomenclature of the different parts of the body, some of which had to be repeated to conform to the number of letters. The number of letters is considered to be 50 or 51 according to whether or not one counts the letter *ksha*.

The importance of the concept of letters, which constitute *shabda* (word) and *dhvani* (sound), in the Tantric tradition has been

discussed by Woodroffe.[32] However, there is much more to be said about the subject. The *Sanatkumariya Tantra,* as quoted in the *Tantrasara,* as well as other *tantras*, explicitly states that the 50 letters from *a* to *ha* constitute the garland of letters and *ksha* is their Meru, presumably the cosmic axis (*kramotkramāgatairmālā matṛikārṇaiḥ kshamerukaiḥ/*). We are further told that it is forbidden to cross the Meru during *japa* or recitation (*caramaranam merurūpaṃ langhanaaṃ naiva kārayet/*). According to the *Malinivijaya Tantra* the thread of the garland of letters is the sleeping Kundalini power.[33] The *tantras* therefore advocate two theories, one of 50 and the other of 51 letters, which constitute what is known as *varnasadhana*.

The profound significance of the number 51, symbolizing all the letters of the alphabet and hence all words and sounds, is also evident from other iconographic information given in the *Tantrasara*. Among other deities, Ganesh, Kama, Shiva, and Vishnu, each have 51 forms and 51 Shaktis.[34] The text divides the names of Shiva and Vishnu, along with their Shaktis, into two groups: 16 vowel images (*svaravarnamurti*) and 35 consonant images (*vyanjanavarnamurti* or *halamurti*). What is also curious is that in the cases of both Ganesh and Kama the names have been repeated in order to reach the required number, just as the 51 *pithas* include both real and imaginary names of "pilgrimage" centres. The *akshamala* or the rosary, also known as *japamala*, plays an important role in the Tantric tradition and here too the number of beads, we are told, should be 51. The central bead should be larger than the others for it represents the letter *ksha* or Meru, which is the axis mundi. It is interesting to note that the rosary or garland is called *aksha* because it

is made up of the 51 letters from *a* to *ksha* (= *aksha*).

It is clear from the above discussion that the number 51 was not an arbitrary or a *strange* choice as Sircar thinks but was deliberate and reflects the primary importance of both *shabdasadhana* and *atmasadhana* in the Tantric mode of worship. The doctrine of Shabdabrahman is expounded at length in his *Sharadatilaka* by Lakshmana Deshikendra (10th century). "Shabdabrahman is the Consciousness in all beings" (*caitanyaṃ sarva-bhūtānāṃ śabda-brahmeti me natiḥ*). As Woodroffe has commented, "This is the Śabdabrahman or the Brahman as the cause of manifested Śabda and Artha and therefore Mantra."[35] And *mantra* of course is constituted with letters which are used to form words and sentences. The relation between *mantra*s, the adept's body, and Shabdabrahman has been very lucidly explained by Woodroffe:

> All Mantras are in the body as forms of consciousness (Vijñānarūpa). When the Mantra is fully practiced, it enlivens the Saṃskāra and the Artha appears in the mind. Mantras are thus a form of the Saṃskāras of Jīvas – the Artha of which appears to the consciousness which is pure. The essence of all this is – concentrate and vitalise thought and will power. But for such a purpose a method is necessary, namely, languages and determined varieties of practice according to the end sought.... Mantra-vidyā is the science of thought and of its expression in language as evolved from the Logos or Śabda-brahman Itself. It is in this sense that the universe is said to be composed of the Letters.[36]

The concept of Shabdabrahman and the symbolic significance of the letters of the alphabet play an important role in Pancharatra theology. Among others, the *Ahirbudhnya Samhita* devotes several chapters to the subject, although there is no specific mention of the 50 or 51 letters.[37] We are told, however, that from *nada* develops *bindu* and from the latter proceeds two kinds of sounds: vowels and consonants. The vowels are then integrated with Shakti or specifically Kundalini Shakti, and the consonants with Vishnu who is the Kutastha Purusha. These ideas are developed further in the later *Lakshmi Tantra*[38] where also several chapters are devoted to the origin of letters and their symbolic role in Pancharatra theology. In keeping with the central idea of the Supremacy of the Goddess, Lakshmi declares: "I then automatically evolve out of the great God into Śabdabrahman."[39] An entire chapter is dedicated to the description of the Goddess as *matrika*, which of course means both the Mother and the letters of the alphabet.[40] She is called the mother of *mantra*s and her body, constituted with the letters, is said to be Shabdabrahman. Indeed, this hypostasization of the letters finally results in the creation of a goddess called Varneshvari or the Mistress of Letters in the *Tantrasara*.

The importance and antiquity of alphabet mysticism is evident in the doctrine of sound or *sphota* in the Yoga tradition.[41] The *sphota* theory of Patanjali's *Mahabhashya* is concerned with words and their significance. Naturally the letters (*varna*), and their sounds (*dhvani*), and the modifications of sounds known as *nada* are important elements in the doctrine. The Yoga view holds that all letters have infinite potentialities of manifesting endless meanings, and the *Hatha-Yoga-*

Pradipika (IV, 101–02) tells us that "whatever is heard in the form of sound is Śakti". In Kundaliniyoga, Maha-kundalini, of endless potentialities like the letters, remains coiled normally, but when aroused, according to the *Shaktisangama Tantra,* she manifests herself into 51 forms obviously corresponding to the total number of letters of the alphabet.[42] She creates the universe and all it contains in the form of the letters and then returns to rest in the *muladhara* of all living creatures. As the *Shiva Samhita* (V, 58) says, Kundalini is self-luminous and is the Goddess of Speech, Vagdevi. We are repeatedly told in Tantric texts that the body of the deity is constituted with *mantra*s which are composed of letters, and hence, they are of such paramount importance.[43]

7
Mahalakshmi Temple,
Kolhapur, Maharashtra.
Photograph: Satish Parasher/
Dinodia Images.

6

To return to the subject of our discussion, the 51 letters of the alphabet are equated with 51 *pitha*s not because these *pitha*s are places of pilgrimage recommended to the devotee but because they represent the universe. That is why it would make no sense to try and find historical truth in these *pitha*s as to their exact geographical location or to discuss whether or not they existed at all. Collectively, they symbolize the macrocosm which is not only homologized with the microcosm of the adept's body through the *pithanyasa*, but is also interiorized, as has been suggested by Tucci and others. The process of interiorization is basic to both Yoga and Tantra, as is clearly stated in the following verse from the *Kularnava Tantra* (5, 106):

liṅgatrayaviśeṣajñaḥ
shaḍādhāravibhedakaḥ/
pīṭhasthānāni cāgatya
mahāpadmavanaṃ vrajet//

The *sadhaka* who knows the three lingas and can distinguish between the six *chakras* wakes Kundalini and with her travels through the *pitha*s and reaches the greater lotus forest which is located in the cranium. Indeed, it is well known that each of the six *chakras*, which are within the adept's body, is considered to be a *pitha*.

The fundamental importance of the process of interiorization was recognized by the Tantrics long before the theory of 51 *pitha*s was thought of. It is interesting that one of the *stotra*s composed by Abhinavagupta is called *Dehasthadevatachakrastotra*.[44] In it Abhinavagupta has homologized the eight *matrika*s with the eight *chakra*s of the body and in the Tantric tradition the *matrika*s are always eight in number. It may be pointed out that generally the letters of the alphabet are divided into eight groups in Tantric philosophy which may explain the importance of the group of eight *matrika*s rather than the traditional seven. Furthermore, Abhinavagupta addresses the Mothers as seated on eight petals of the lotus within the body; thus here the body is also seen as a *mandala,* which, as we know, is a microcosmic symbol of the universe. At the centre of the universe or the *mandala* is Shiva and on the eight petals are the eight Mothers symbolizing the energy radiating from that centre. As Silburn has commented:

> Furthermore, *shaktichakra* designated the group of energies, these rays that allow the devotee to enter in the light of the Conscience, free and without duality.[45]

7

Neither the idea of the *dehasthadevata* of Abhinavagupta nor that of *nyasa* originated with the *tantra*s, but as Eliade[46] with his characteristic erudition and insight has shown, both are of considerable antiquity which "tantrism revalorized and enriched". The seminal idea of *nyasa* is reflected in the *Rigvidhana* and the process of interiorization can also be traced back to the homology between Vedic sacrifice and *atmayajna,* as was brilliantly demonstrated in an essay by Coomaraswamy many years ago.[47] I can only remind the reader of the following verses from the *Katha Upanishad* which is the most lucid and eloquent statement of Yogic (or Tantric?) interiorization that I have come across:

> A hundred and one are the channels
> of the heart;
> One of them leads to the crown of
> the head.
> By this channel, proceeding upward,
> one goes to immortality.
> The rest serve for movement in
> various directions.
> The Person of a thumb's size, the
> *atman* within,
> ever dwells in the heart of beings.
> One should draw him out of one's
> body with care —
> just as an inner stem is drawn from
> its sheath.
> Him you should know, the Pure, the
> Immortal;
> Him you should know, the Pure, the
> Immortal.[48]

In this connection it is worthwhile to discuss Chapter 104 of the *Vayupurana* which contains interesting material both about the symbology of interiorization and the *pitha*s.[49] Apart from closely associating Parabrahma and

Shakti, we are told that Krishna is none other than Brahma.[50] Neither in the Nigamas nor in the Agamas is anything said to be beyond him. And yet Vedavyasa is puzzled by the fact that according to the Nigama he is beyond the letters, while in the Shruti he is said to be *paratastvaksharat*.[51] Thus mystified, Vyasa goes to Mount Meru and begins to meditate upon the four Vedas who appear before him as personified beings. Interestingly, their bodies are constituted of the letters of the alphabet in the following manner: faces with the vowels and their middle with *pranava* or *om;* arms and hands with the letters beginning with *ka* and *cha*; right leg with *ta-varga;* left with *cha-varga*; etc., etc. It then continues to homologize the four Vedas with various pilgrimage centres, rivers, the sacrifices, fires, religions, and *mantra*s. The shortlist of pilgrimage centres begins with Mathura and significantly the word *pitha* is used to characterize Nepala, Purnagiri, Mathuri, Kanchi, Jalandhara, and Bhrigu.[52] Uddiyana is conspicuously omitted from this list. In any

8
Kalighat Temple, Kolkata.
Photograph: Debasish Banerjee/
Dinodia Images.

event, Vyasa then reveals his doubt before the four Vedas who commend him for his many-faceted qualities and declare that he is none other than Vishnu (*sādhu sādhu mahā prajna viṣṇurātmā śarīriṇām*). However, they are unable to dispel his doubt about existence of a being or principle beyond the Supreme Being and tell him that *akshara* is *parama brahma*. Further, just as the flower has beauty and fragrance, so also *atma* has its own essence, which is a great mystery unknown even to the Vedas.[53]

Thus, the homology between the *pitha*s and the *yogin*'s body is without question an ancient concept which receives new and added emphasis in the *tantra*s, whether Buddhist, Hindu, or Jain. We have already discussed the evidence of the *Hevajra Tantra;* and the *Chatushpitha Tantra* categorically mentions *atmapitha*. Fascinating information about *pitha*s and alphabet mysticism is contained in the *Dakarnava Tantra* which seems to have been altogether ignored by most scholars interested in the *pitha* concept.[54] There we have a division of four *chakra*s within the body located at the navel, heart, throat, and the head, and these are equated with the letters of the alphabet. This may also explain why the Buddhist tradition generally recognizes a group of four *pitha*s only. However, the number is increased to 24 in the Buddhist *tantra*s corresponding to 24 places in the body, as has been thoroughly discussed by Tucci.[55]

9
The Guhyeshvari Temple, Nepal. As in all Shakta Pithas, worship here is aniconic. Photograph: Yogesh Budhathoki/Nepal Research Centre.

The Hindu *tantra*s repeatedly emphasize that the human body itself is the seat of Brahma. According to the *Shiva Samhita*:[56]

This temple of suffering and enjoyment (human body), made up of flesh, bones, marrow, blood, and intersected with blood vessels, etc., is only for the sake of suffering or sorrow.

This body, the abode of Brahma, and composed of five elements and known as Brahmānda (the egg of Brahma or microcosm) has been made for the enjoyment of pleasure or suffering of pain.

The *Kularnava* (5, 80a) asserts that Brahma is the ultimate bliss and resides in the body *(ānandaṃ brahmano rūpaṃ tacca dehe vyāvasthitam/)*. In the *Jnansankalini* we are told that all knowledge, deities, and pilgrimages exist in the body.[57] Quoting from the *Tantrantara*, the *Tantrasara* informs us that if one bathes in the pure Pushkara *tirtha* located in the heart one is never reborn. This body is the *tirtha* of Shiva through which flows the two rivers of gnosis known as Ida and Sushumna. If one bathes constantly in these waters of gnosis, then why should one bathe at *tirtha*s?[58]

The idea that the *pitha*s – whether seats, altars, or pilgrimage centres – lie within the body of the *sadhaka* has also been repeatedly emphasized by the *mahasiddha*s in their *sahaja sadhana*. In the *Kalachakra Tantra* the Buddha himself explains how everything in the universe with all objects and localities, and how time with all its divisions and subdivisions, are contained within the body.[59] At the same time, however, they have characteristically questioned the efficacy of all external rituals. In his *Dohakosha*, Saraha-pada unambiguously states:[60]

What will one do with lamps, offerings, Mantras and services – what is the good of going to holy places or to the hermitages? – can liberation be attained only by bathing in holy waters?

An even more trenchant criticism of pilgrimage is offered by the Jain Muni Rama Simha (c. 1000 CE) in his *Pahuda-doha*:[61]

Prevent this elephant of the mind from going to the mountain of Vindhya, for it will trample under feet the forest of Shila (i.e., good conduct/discipline).... Of no avail is travelling from one sacred place to another; for the body may be cleansed, but what of the mind?

The *Kumari Tantra* (7, 14–19) tells us that one can visit the various *pitha*s such as Kamarupa, Purnashaila, Vindhyaparvata, Uddiyana, Varanasi, Louhitya, Karatoya, Aryavarta, Prayaga or Brahmavarta, but better than a *pitha* is the burning ground. And as Ramprosad Sen sings in a hymn to Kali: "Because you love the burning ground, mother, I have converted my heart into one."

EPILOGUE

To sum up, although the majority of the names of the *pitha*s in Tantric literature are those of real pilgrimage centres, the act of pilgrimage or *tirthayatra* had nothing to do with the *pitha* concept. Rarely does a Tantric text recommend a visit to a *pitha* to be as effective spiritually as the *purana*s do with the *tirtha*s. Rather, the *pitha*s are repeatedly said to be located within the *sadhaka*'s body and in general they symbolize the entire universe. The earliest number of *pitha*s found in Buddhist texts is generally restricted to four, which may symbolize the four directions and hence

the universe. The number four may also have
been inspired by the earlier Buddhist tradition
of four primary pilgrimage spots associated
with the life of the Buddha. Although the
four places are not actually located in the
four cardinal directions, one cannot overlook
their directional symbolism. It is equally
possible that the four *pitha*s symbolize the
four *chakra*s in the adept's body as stated by
Buddhist *tantra*s, or represent the four kinds
of *shunya* enumerated in *Hathayoga-pradipika*:
shunya, *ati-shunya*, *maha-shunya*, and *sahaja-*
or *sarva-shunya*. We may also recall that there
are four types of Yoga – *mantra*, *laya*, *hatha*,
and *raja* – and Yoga is fundamental to Tantra.
Similarly, the three *pitha*s of *Matasara* and
other texts may symbolize the three aims
(*trilakshya*) concept of the Yoga tradition. That
the *pitha*s are internal rather than external in
the Hindu Tantric tradition is evident from
Abhinavagupta's *stotra* discussed above where
the internal *chakra*s are homologized with the
eight directions, and hence with the universe.
Finally, because there are 51 letters in the
alphabet, Sati's body was divided into 51 parts
and the homology established among the parts
of the deity, the *sadhaka*, and the letters, as is
clear from the *Pithanirnaya*.

It is quite clear from the above discussion
that neither the doctrine of Shabdabrahman
nor that of alphabet mysticism is as late as
one might think because of the generally
prevailing views that Tantric literature is
not very old. Apart from the fact that some
of these ideas are clearly discussed and
delineated in the Upanishadic texts and the
concept of *nyasa* may be traced back to the
Rigvidhana, the early Pancharatra texts where
alphabet mysticism plays an important role
are generally believed to have been compiled
by the Gupta period (300–600 CE). Most

scholars are also agreed that the *Vayupurana* is
one of the earliest *purana*s and in its present
form was compiled probably before the 7th
century.[62]

En passant, one may introduce here the
doctrine of alphabet mysticism that is an
essential element of both Manichaeism (4th
century CE) and Mazdakism (6th century). In
discussing the alphabet mysticism of Mazdak,

10
Detail from Shiva and Shakti,
see figure 1 and back cover.

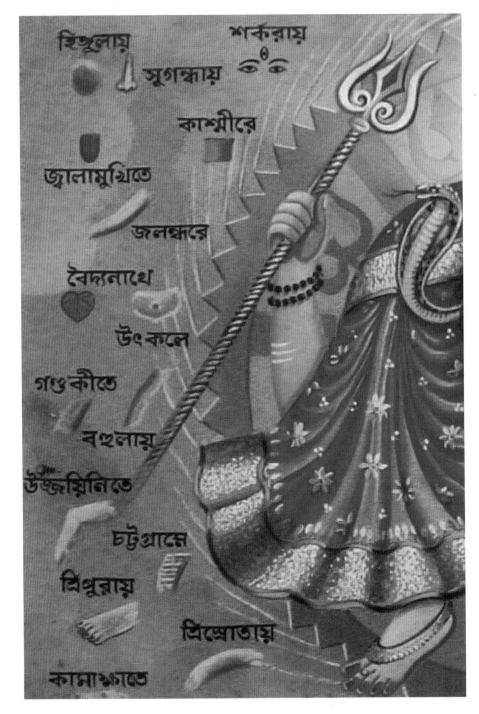

Altheim and Stiel traced the origin of the doctrine to Greek influence, but as Müller has shown Mazdak very likely borrowed the idea from Manichaeism.[63] According to Mazdak, "the king of the upper world rules by means of the letters of the alphabet whose sum yields the highest name".[64] As Müller has suggested, the idea must derive from Mani's ABC classification in his *The Great Gospel from Aleph to Tau*. It is not our purpose to discuss the relationship between Mani's and Mazdak's ideas and the doctrines of alphabet mysticism in India. However, is it a pure coincidence that alphabet mysticism should play a significant role both in Iran and in the Pancharatra system in India at about the same time?

In any event, certainly between the 5th and the 11th centuries (Abhinavagupta, Lakshmana Deshikendra, as well as the *Rudrayamala)*, the homology between the universe (symbolized by 4, 8, or 10 *pitha*s or directions), the *yogin*'s body, and the letters of the alphabet became a familiar concept. The homology was ritualistically enacted through the rite known as *nyasa*. Sometime during the 11th to 16th century, there developed a *nyasa* called *pithanyasa* involving the entire alphabet. Depending on the number of letters (50 or 51) the concept of 51 *pitha*s was evolved. The Buddhists do not appear to have accepted the idea of the 51 *pitha*s, but certainly the Hindus did. The mythological justification of the number was contrived by chopping up Sati's body into 51 parts. It should be remembered that the Dakshayajna story is *not* the origin of the *pitha* concept, as Sircar and his followers seem to imply. The function of the myth was rather to legitimatize a new concept and establish a "linkage" with an ancient creation myth. While attending Daksha's sacrifice,

Sati in a sense sacrifices herself (*atmayajna* or self-sacrifice), and since each of us has *pitha*s within us, she may be said to be the cosmic creator like the Purusha who creates through primal sacrifice. By interiorizing and homologizing the *pitha*s and the letters with his body in the *nyasa* rite, the *yogin* is essentially transmuted into the divine and ceases to be a mortal.

Thus, these 51 *pitha*s have nothing to do with the geographical reality of pilgrimage centres that an adept must visit.

Rather, they should be mentally visited by the *yogin* for they exist within his/her own body. Finally the Sahajyas even rejected this homologization when Muni Rama Simha said:

What can one do with the letters which will shortly die with the times?
That is, O Fool, called Moksa by which a man becomes changeless (*anakkharan*).[65]

NOTES

This article was published earlier in *Orientalia Josephi Tucci Memoriae Dicata*, edited by G. Gnoli and L. Lanciotti (Instituto Italiano per il Medio ed Estremo Oriente, Rome 1988), and since that volume is not easily available to Indian scholars, the article is being reproduced here, as well as for the relevance of the topic to this book.

1 M. Eliade, *Yoga* (New York 1958), pp. 346–48; D.C. Sircar, *The Śākta Pithas* (Delhi, Varanasi, and Patna 1973); A. Bharati, *The Tantric Tradition* (New York 1975), pp. 85ff.; S. Chattopadhyay, *Reflections on the Tantras* (Delhi, Varanasi, and Patna 1978). Bharati (1975, p. 90) suggests that Eliade was the first scholar to formulate the relationship between centres of pilgrimage and the mystical body of the Tantric. This is not altogether true for Tucci had already discussed both the homology and the hypostasis doctrines as related to the *pitha* concept over 40 years ago (see below, note 20). It is surprising, however, that neither Sircar nor Chattopadhyay were aware of the discussions about the homology between the *pitha*s and the adept's body by the three Western authors.

2 See Sircar 1973, where all the textual references are cited.

3 Although some scholars would like to make him a contemporary of Chaitanya, and thereby place him in the first half of the 16th century, Sircar (1973, pp. 74–80) argues for a 17th century date. In my *Hindu Religion and Iconology according to the Tantrasara* (Los Angeles 1982), I have demonstrated that Krishnananda very likely lived during the second half of the 16th century.

4 The dates of Tantric texts are difficult to establish. However, since the *Jnanarnava* is quoted authoritatively by Krishnananda, it must have been well known by the 16th century. Moreover, the *Jnanarnava* is also mentioned by the *Mundamalini*, a text quoted extensively in the *Tantrasara*. Thus, at a conservative estimate, the *Jnanarnava* was an established work by the 15th century and is probably a much earlier text.

5 Eliade 1958, pp. 210–11.

6 Bharati 1975, pp. 91, 273.

7 P.V. Kane, *History of Dharmasastra*, V, 2 (Poona 1977), p. 1123. The entire Chapter XXVII is devoted to the various kinds of *nyasa*.

8 S. Shankaranarayana, *The Glory of the Divine Mother* (Madras 1973), p. 113.

9 All references are to the Basumati edition entitled *Bṛhat-Tantrasāraḥ* (10th edn. Calcutta n.d.) edited by Upandranath Mukhopadhyay and Satishchandra Mukhopadhyay: *tathā ca nibandhe – tataḥ sampūjayet pīṭhaṃ navaśaktisamanvitam/ Jayākhyā vijayā paścāt ajītā cāparājītā/ nityāvilāsinī joghdhrā taghorā maṅgalā pī ca//*

10 Ibid., p. 270.

11 Ibid., p. 339.

12 Ibid., pp. 275–76.

13 Sircar 1973, pp. 20–21.

14 Chattopadhyay 1978, p. 3. The concept of only three *pitha*s is also known to the *Tantrasara* and the *Anandarnava,* where they are associated with the *chakra* of the lowest level. See Sircar 1973, p. 17 and Chattopadhyay 1978, p. 33.

15 D. Snellgrove, *The Hevajra Tantra*, 2 parts (London 1959). Part I, p. 70. Snellgrove has shown that the Tantra must have existed in its present form by the 8th century (p. 14).

16 Sircar 1973, p. 11.

17 Snellgrove 1959, I, pp. 69–70, n. 2.

18 Ibid., p. 68.

19 See note 17.

20 G. Tucci, *Indo-Tibetica*, III, 2 (1936) pp. 38–45, also cited by Snellgrove 1959.

21 One of the more recent scholars to revive the identification of Uddiyana with Odra or Odisha (Orissa) is Professor Bijan Bihari De of Guwahati University who has discussed the subject in a thesis for Calcutta University. I have not had the opportunity to examine this thesis however. That there was some confusion between Odra and Uddiyana is also evident from the *Kalikapurana.* Lokesh Chandra, "Oddiyana: a new interpretation" in M. Aris and A.S. Suu Kyi, eds., *Tibetan Studies in Honour of Hugh Richardson* (Warminster 1980), pp. 73–78, has proposed the identification of Uddiyana with Kanchipuram in south India.

22 Apparently there are many Buddhist sculptures scattered around the hill on which this temple is situated. Professor Bijan De has also informed me that the Tibetans and Bhutanese come down to the temple annually by the hundreds to worship the goddess on the birthday (*vaisakhi purnima*) of the Buddha.

23 For Shankaracharya's association with Sharada, see Madhava-Vidyaranya, *Sankara-Dig-Vijaya,* tr. by Swami Tapasyananda (Madras 1978), pp. 198ff. Abul Fazl was the court historian of the Mughal emperor Akbar (1556–1605). See Sircar 1973, p. 14.

24 Eliade 1958, p. 346.

25 *Bṛhat-Tantrasāraḥ*, p. 387. (*indrādidaśadevatāḥ saṃpūjya*).

26 Ibid., p. 43.
pañcahrasvāḥ sandhivarṇā vyomerāgnijalandharāḥ/ antyamādyaṃ// dvitīyanca caturthaṃ madhyamaṃ// kramāt//
pañcavargākṣarāni ṣyurvāntaśvetendubhiḥ saha/ eṣā bhūtalipiḥ proktā dvicatvārimśadakṣaraiḥ//

27 Similarly, the number of *asana*s in Tantra is 84 as is stated in the *Kulārnava* (*padmādi caturaśitinānāsana vicakshanaḥ/* 13, 89a). The *Gheraṇḍasaṃhitā* (2, i) tells us that the number of *asana*s are innumerable, but 84 are the most important. In the *Skandapurana* the lingas of Shiva are described in 84 chapters, and perhaps these are some of the reasons why the number of *mahasiddha*s was also settled at 84.

28 R. Ananthakrishna Sastry, *Lalita-Sahasranaman* (Madras 1951), p. 6.

29 Sircar 1973, p. 19.

30 Chattopadhyay 1978, p. 30ff.

31 Ibid., p. 34.

32 John Woodroffe, *The Garland of Letters,* 7th ed. (Madras 1979).

33 *Bṛhat-Tantrasāraḥ*, p. 28.
antarvidrumabhāsamāna-bhujagiṃ suptotthavarṇojjvalām/ āroha-pratirohataḥśatmayiṃ vargāṣṭashṭottarām//

34 See P. Pal, *Vaisnava Iconology in Nepal* (Calcutta 1970), Appendix F. See also Pal 1982 (note 3).

35 Woodroffe 1979, p. 43.

36 Ibid., pp. 224–25.

37 F.O. Schrader, *Introduction to the Pāñcarātra and the Ahirbudhnya Samhitā* (Madras 1916), pp. 118–20. Chapters 16 and 17 of the *Ahirbudhnya* are devoted entirely to an exposition of Shabdabrahma and the doctrine of the letters. Similar discussions also occur in the other principal Pancharatra *samhita*s.

38 S. Gupta, *Laksmi Tantra* (Leiden 1972),

pp. 104–26; chapters XIX–XXIII.

39 Ibid., p. 109.

40 Ibid., p. 125.

41 S.N. Dasgupta, *Yoga as Philosophy and Religion* (Delhi, Varanasi, and Patna 1978), pp. 179–87.

42 Woodroffe 1979, p. 225. It is also interesting that the number of heads that form the garland of the goddess Kali is 51.

43 In passing it may be pointed out that the two categories of *bhava,* as given in the *Sāṃkhyakārikā,* are eight and 50, which seems a very abrupt jump from the first number. The number eight here is consistent with the eightfold subtle body, eight forms of supra-animal existence, eight manifestations of *buddhi,* eight *yoganga*s, and eight Shaktis, as enumerated in the early Pancharatra texts (Schrader 1916, pp. 55, 62, 70, 72, 122, 124, 171). Scholars have rightly been puzzled by the abrupt increase of these numbers to 50. While Keith considered the passages as later interpolations, Frauwallner was of the opinion that the doctrine of 50 *bhava*s is in fact older. G. Larson, *Classical Samkhya* (Varanasi, Delhi, and Patna 1979), pp. 191–94, agrees with Keith although he does give an alternate explanation. Can we suggest that the number 50 reflects the influence of alphabet mysticism and that the verses indeed are an interpolation in the *Samkhyakarika*?

44 L. Silburn, *Hymns de Abhinavagupta* (Paris 1970), pp. 85–86. Compare also the Kutastha Purusha of the early Pancharatra *samhita*s.

45 Ibid., p. 90 (here translated from the French).

46 Eliade 1958, pp. 210–11.

47 A.K. Coomaraswamy, "*Ātmayajña*" in R. Lipsey, ed., *Coomaraswamy* (Princeton 1977), Vol. 2, pp. 107ff.

48 R. Panikkar, *The Vedic Experience* (Berkeley and Los Angeles 1977), p. 568.

49 Sircar 1973, p. 128, has alluded to this chapter but has not fully discussed its import.

50 *rādhāvilāsarasikaṃ krishṇākhyaṃ purushaṃ param/* 104, 52a.

51 *nātaḥ parataraṃ kiñcīnnigamāgamayorapī/ sathāpi nigamo vakti hyaksharāt parataḥ paraḥ// golokavāsī bhagavānaksharāt para ucyate/ tasmādapī paraḥ ko'sau gīyate śrutibhiḥ sadā uddhishṭairvaidavacanairviśesho jñāyate katham/ śrutervārtho'nyathā bodhyaḥ paratastvaksharāditi//* 104, 53–56.

52 104, 71–85.

53 *aksharaṃ brahma paramaṃ sarvakāraṇakāraṇam// tasyātmano'pyātmabhāvatayā pushpasya gandhavat/ rasavadvā sthitaṃ rūpamavehī paramaṃ hi tat// arubhūtaṃ tadasmābhirjāte prākritike laya/ aksharātparatastasmādyatparam kevalo rasaḥ/ na ca tatra vayaṃ śaktāḥ śabdātite tadātmakāḥ//* 104, 108–10.

54 H.P. Sastri, *A Descriptive Catalogue of Sanskrit Manuscripts in the Government Collection,* I (Calcutta 1917), pp. 92–100. A detailed discussion of this material must be postponed for another occasion.

55 See note 20.

56 S.C. Basu, ed. and tr., *The Siva Samhita* (New Delhi 1979), p. 14.

57 S. Chattaraj, ed. and tr., *Jñānasankalinī-tantram* (Calcutta 1980), p. 2. The verse is quoted as the epigraph to this article.

58 *snāyācca vimale tirthe pushkare hṛdayāśrite/ vindutīrthe'thavā snātvā punarjanma na vidyate// iḍāsushumne śivatīrthake'smin jñānambupūrṇe vahataḥ śarire/ brahmāmbubhiḥ snāti tayoḥ sada yaḥ kintasya gāṅgairapi pushkarairvā//* Bṛhat-Tantrasāraḥ, p. 640.

59 S.B. Dasgupta, *Obscure Religious Cults,* 2nd edn. (Calcutta 1962), p. 25.

60 Ibid., p. 56.

61 Ibid., p. 59.

62 Chapter 104 does not occur in all the manuscripts but is included in the Vangavasi edition. It is very likely that the chapter is an interpolation, especially as it mentions Radha and includes Nepal as a *pitha.*

63 Werner Müller, "Mazdak and the Alphabet Mysticism of the East", *History of Religions* 3(1), Summer 1963, pp. 72–82.

64 Ibid., p. 77.

65 See note 61.

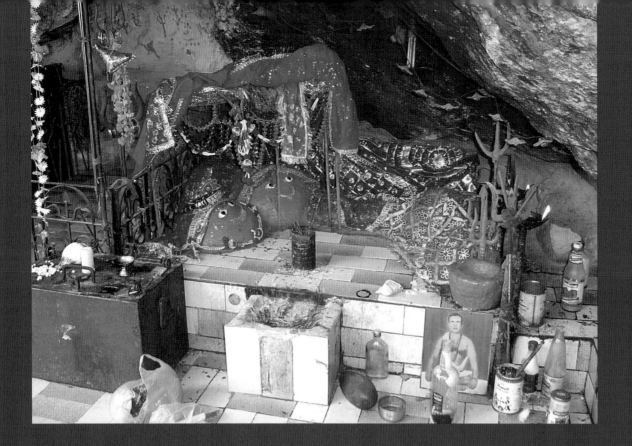

The Hinglaj Shrine, Baluchistan

Ibrahim Shah

The celebrated Hindu pilgrimage site of Hinglaj[1] is located on the right bank of the river Hingol at a total distance of about 240 km from Karachi (figure 2). Our visit to Hinglaj proved to be an adventurous and arduous journey, guided by Chandu Lal of Karachi who frequently leads religious caravans to Hinglaj. Makin Khan, Superintendent-in-Charge of the National Museum Karachi kindly arranged for my stay at the museum, and for a photographer, Fayyaz Ahmad. We started our journey at 8 am on February 8, 2007, following the Regional Co-operation for Development Highway (N25) leading to Quetta (figure 3). After covering a distance of 105 km, we reached Zero Point where the recently constructed Makran Coastal Road branches off to the left terminating at Gwadar, 532 km away from this point. Pilgrims bound for Hinglaj have to follow this road. It passes through barren plains and sandy deserts along the rugged mountain ranges on the right and the coastal belt of the Arabian Sea on the left. After a drive of 120 km from Zero Point, we reached Aghore check-post of the Pakistan Coast Guards at the juncture where an unmetalled road bifurcates to the right along the left bank of the river Hingol. We did not cross the Malir Hingol Bridge beside the check-post. The bumpy *kachcha* road crossed the Hingol after a distance of about 15 km. Here the water level in the dry season permits the come and go of pedestrians and even vehicles. We happened to meet a caravan of Hindu pilgrims coming back from Hinglaj with shaven heads, bearing signs of inner happiness on their faces. According to Chandu Lal, it is from the point of crossing the Hingol that the pilgrims begin their rituals that continue throughout their visit to various *asthana*s (small shrines) at the site. The actual Hinglaj shrine lies on the right bank of the river. The journey takes about five or six hours from Karachi by vehicle.[2]

Hinglaj (25° 30′N, 65° 31′E) is located at the foot of the peak of the same name within the jurisdiction of tehsil Liyari, district Lasbela (figure 4).[3] Lasbela remained, for a greater part of its history, under the Hindu rulers of Sindh.[4] The shrine is known to the general masses as Nani Mandir, which name can be seen here and there on the signboards along the road. The actual spot lies in a narrow picturesque gorge hidden by high mountains on all sides. The place, away from the noise and disturbance of civic life, is best suited to calm and serene meditation on one's personal deity and the smooth performance of rituals and ceremonies. In spite of the absence of an artificial cave or any structural building of antiquity, Hindus from all over the Indian subcontinent hold this natural cave in great reverence (figure 5). It demarcates the westernmost limit of the Hindu shrines (or sanctuaries) of Jambudvipa[5] and is generally considered as one of the 50, 51, or 52 Shakta Pithas where the bodily relics (or *sharira*) of Sati (consort of Bhava or Shiva in her previous existence) are said to have fallen. The local Hindus believe that Hinglaj marks the shrine of Sati's abdomen, basing their argument on the U-shaped narrow subterranean passage now concealed under the masonry platform of the actual sanctuary.[6] The mud structure of the shrine, once recorded by early sources on the site,[7] has now been renovated in cement blocks, and the floor flagged with ceramic glazed tiles (figure 1).

Hindu mythology relates that after the death of Sati (the daughter of Daksha), Shiva was inconsolable and wandered about the world carrying her corpse. To bring this to an end, the gods reduced her corpse to pieces; another version of the tradition holds Vishnu responsible for dividing it with his *chakra*.[8] The Tantric texts give 51 places as the Shakta Pithas, where parts of Sati's dead body fell.[9]

"In modern times," to quote J.N. Banerjea, "the most important objects of worship in many of these shrines are usually stone blocks covered over with red cloth, which are described as this or that limb of the goddess."[10] He further adds that after dispersal of the *sharira* of Sati, Shiva assumed the many forms of Bhairava and stationed himself in the proximity of each sacred spot to safeguard it.[11] That is why every Shakta Pitha has a Bhairava (Shiva) *asthana* close by (figures 6, 7). The site of Hinglaj is not the site where Sati's head fell, as misunderstood by Khurshid Hasan[12] and others,[13] which *asthana* is believed to lie in the Shingh Bhavani Mata at Makli near Thatta (about 100 km east of Karachi).[14]

Hinglaj is venerated by Hindus and Muslims alike. The caretaking has been in the hands of Muslims for several generations. The Muslims take it to be the shrine of Bibi Nani,[15] while the Hindus believe it to be the shrine of Kali Mata, Hinglaj Mata, or Durga (figure 8).[16] The shrine of Bibi Nani's brother, dubbed as Pir Gha'ib (or the hidden saint) and buried at Khajuri (about 10 km from Aab-i Gum railway station on the main Quetta–Sibi section) is believed to be a Mahadeva shrine by the Hindus of the Kachchi area of Baluchistan.[17] The syncretic character of the shrine is further strengthened by the fact that, in addition to Hinglaj, the shrines of Shah Bilawal and Lahut Lamakan are also visited by Muslims and Hindus alike.[18] Hindus are said to perform the head-shaving rites for their sons, before investing them with the sacred thread, at the shrine of Shah Bilawal, the custodians being Muslims.[19]

1

(opposite)
The original mud shrine at Hinglaj has now been lined with glazed tiles.

Some legends associated with Hinglaj, are heard from local Hindus. Lord Rama, accompanied by Lakshmana, Sita, Hanuman, and Valmiki, is said to have visited it after slaying Ravana. With him is related another story saying that at nearby Chaurasi mountain, Lakshmana begged for water to quench his thirst. Rama procured this by hurling an arrow at the rock so forcefully that a spring issued from it. The religious potential of the shrine is further ratified by adherents to the extent that they include Gurus Gorakhnath and Matsyendranath[20] among those who had visited it. They have secured asthanas at the Chaurasi mountain where pilgrims visit and perform ritualistic ceremonies to complement their yatra to Hinglaj Mata.[21]

Despite its being visited all year round with great religious fervour, for five days in April Shaktas from distant parts of Pakistan and India throng the site to attend the annual ceremonial fair (or mela) held there.[22] In pre-Partition days, kings and princes from Rajasthan and Gujarat used to visit Hinglaj Mata. To facilitate the board and lodging of pilgrims, different Hindu communities of Sindh and Baluchistan have recently built a number of halls, rooms, kitchens, bathrooms, etc. The pilgrims on their way back home visit the shrine of Shingh Bhavani Mata just opposite the historical graveyard of Makli near Thatta. As mentioned above, the local Hindus believe that this site marks the asthana of Sati's head. We can now safely enumerate at least three[23] Shakta Pithas in Pakistan.[24] The third one, referred to by Xuanzang[25] as Bhimasthana with the temple of Ishvaradeva (i.e. Shiva) at Bhimadeviparvata close by, was formerly located in the Karamar range near

2
The Hinglaj shrine, also known as Nani Mandir, lies in a picturesque gorge in Baluchistan, Pakistan.

3
The Makran coastal highway leading to Gwadar takes pilgrims to Hinglaj.

4
The pilgrimage site of Hinglaj is located at the foot of the peak of the same name.

5
The goddess is worshipped in this natural cave at Hinglaj.

6
The Bhairava shrine at Hinglaj.

7
A trishul of Shiva at the entrance to the Bhairava shrine at Hinglaj.

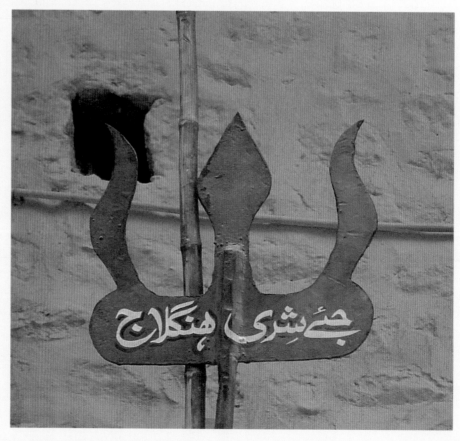

village Shiva in district Swabi (this writer's native town).[26] Harry Falk[27] and others[28] now locate it at Kashmir Smast in district Mardan in the light of seals depicting Lajja Gauri, and other associated antiquities.

Returning to Hinglaj, the eastern ridge of the narrow and naturally protected gorge contains two clefts a little apart which consecrate the main shrines of Kali Mata and Hinglaj Mata. Pilgrims begin their worship by attending the Ganesh *asthana* that comes first (figure 9), sheltered by a natural boulder accommodated in a fanciful way that gives the impression of its being disgorged from the mouth of a *makara*-like creature. This is followed by the twin shrines of Ashapura and Hanuman (figures 10, 11). Among other subsidiary *asthana*s at the

complex, we hesitate to identify one as that of Shitala, the goddess of small-pox, though she is represented with her donkey mount, as otherwise the attributes she holds in and the *mudra*s she displays with four of her six hands are not in conformity with Shitaladevi (figure 12).[29] Moving on, we find on our left the first of the two clefts in the eastern ridge of the mountain, that accommodates the Kali Mata shrine. It houses a semicircular raised platform clad in glazed ceramic tiles of black and white, recently built, bearing the consecrated image of Kali laden with all sorts of ornaments and exhibiting essential attributes (figure 14). Beside the image of the goddess there is a wide open crater with which are related some mythical stories regarding sacrificial ceremonies. The local

8
The shrine of Bibi Nani as Muslims call her, or Durga as she is known to Hindus, at Hinglaj.

Hindus believe that a faction of Hindu pilgrims offer the sacrifice of goat or ram that they slaughter on this platform before the image of the Devi. The blood collected in a bowl placed on the platform is consecrated to Kali Mata by pouring it into this hole. The blood, signs of which are still visible, was taken as having been drunk by her as it did not flow back to the platform. Actually this is a result of a geological formation, as the underlying sedimentary rock has loosely packed particles that make its surface porous and a good absorbant of liquid. Believers associate this phenomenon with the acceptance of the blood sacrifice offered to propitiate Kali. After completing the puja and offering sacrifices at the *asthana* of Kali Mata, the pilgrims move forward to the main shrine

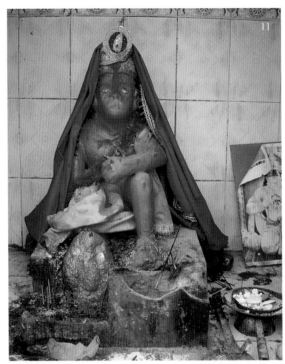

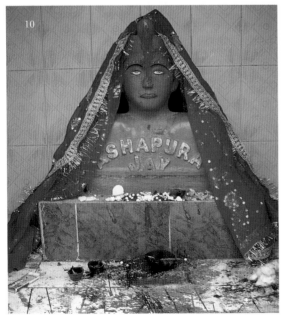

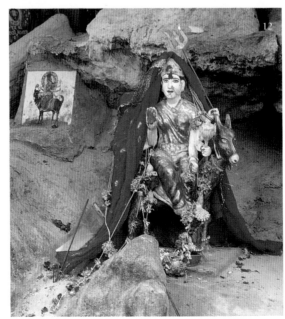

9–12
The circuit at Hinglaj begins with worship of Ganesh, followed by obeisance to Ashapura and Hanuman in the next set of subsidiary shrines, and then Shitaladevi(?) on her donkey mount.

of Hinglaj Mata that gives the entire complex its present name.

Most of the structures at the site are of the recent past and there seems nothing of antiquity except for the two shrines and ponds in front of each of them,[30] which have now dwindled in size and depth by the accretion of natural deposit through the ages. The Hinglaj shrine stands on a raised platform within an enclosure wall accessible by a flight of steps. Apparently all the masonry work can be placed in the past few decades, which is also verifiable from a few inscribed stelae. The site accommodates the Hinglaj Mata *asthana,* while in the lower area we find the Shiva *asthana* in the northwestern corner of the enclosure consisting of a seated figure of Shiva fronted by a *sarpa* (or cobra) and two lingas – one with a *pitha* (figure 6). Pilgrims make offerings to the Devi in the form of sweets, coconuts, *sindhur* (vermilion), incense burning, and red shawls (or dupattas). The presence of the Hinglaj Mata is made sure by two stones placed close together and painted with *sindhur.* Each is likened to a

maiden's face with essential facial features and ornaments.[31] The two stones might represent the *dvimukha* (two-faced) form of the goddess who is usually covered with red or orange (figure 1).

Natural formation and subsequent dressing of the rock underneath the masonry platform built recently allows a narrow and dark U-shaped passage. This has been reinforced with stones laid in cement mortar and part of its ceiling supported by wooden beams and strips (figure 5). The pilgrims enter the dark channel through a small opening in the rock and circumambulate the shrine thus performing the Rakhibandi rite, crawling on all fours in clockwise direction and emerging from the second opening adjacent to the first.[32] This rite is performed in the spring[33] by male or female members of different families to indicate "a sort of brotherly or sisterly adoption".[34] There is a brass image of eight-armed Durga seated on a lion, her right hands holding *gada* (mace), *chakra* (disc), *khadga* (sword), and displaying *abhaya* (reassurance); while the left ones wield *trishul* (trident), *dhanush* (bow), *shankh* (conch), and *padma*

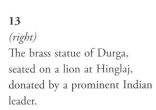

13
(right)
The brass statue of Durga, seated on a lion at Hinglaj, donated by a prominent Indian leader.

14
This platform consecrating Kali at Hinglaj is of recent origin.

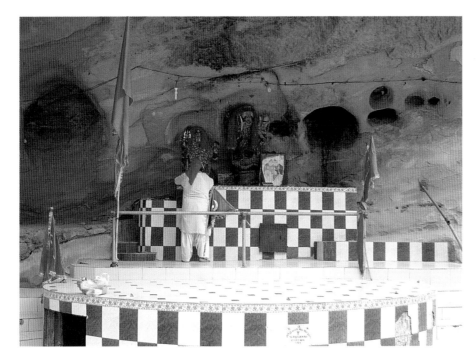

(lotus) (figure 13). These various attributes are found in different forms of Durga.[35] This beautiful image, we are told, was donated by a prominent Indian leader.[36]

In front of the Hinglaj Mata shrine is a big boulder (now supported on smaller stones) which is considered sacred (figure 15). Elderly pilgrims, who are unable to climb the Chaurasi mountain for the discharge of ceremonial rites, are required to complete seven circumambulations of this boulder for the perfection of their yatra. Murlidhar Dawani[37] records a local legend that there is access from the Hinglaj shrine all the way to another cave temple of Kali Mata some distance away at Aror (modern Rohri), the capital city of Raja Dahar.

The shrine at Hinglaj (figure 16) attracts both tourists and pilgrims, quenching the spiritual thirst of adherents from different parts of the South Asian subcontinent. If the site is properly taken care of, the *kachcha* road metalled, and a bridge constructed at the crossing point on the Hingol, this would facilitate the movement of pilgrims to this most sacred and frequented Hindu shrine in Baluchistan. This site would also grow into a fascinating tourist point and hopefully earn revenue for the country.

NOTES

1 I. Shah, "*Saktipithas* in Pakistan", in G.J.R. Mevissen, ed., *Indo-Asiatische Zeitschrift*, Vol. 12 (Berlin 2008), pp. 25–32.
2 For the route, see *The Gazetteer of Baluchistan: Lasbela* (Quetta 1986; 1st edn. 1906), p. 221. On p. 36, the same source records that the journey to and from Hinglaj could be covered in about 24 days.
3 The term "Las" stands for "plain". *The Encyclopaedia of Islam,* ed. C.E. Bosworth, et al. (Leiden 1986), Vol. V, p. 684; see also M.S.K. Baluch, *History of Baluch Race and Baluchistan* (Quetta 1958), p. 215; *Lasbela Gazetteer,* p. 3.
4 Baluch 1958, pp. 215–16.
5 S.K. Hasan, *Architectural Heritage of Pakistan: Ancient Hindu Temples and Shrines* (National Institute for Historical and Cultural Research, Islamabad 2009), Appendix A, p. 108; A. Stein, "On Alexander's Route into Gedrosia: An Archaeological Tour in Las Bela", *The Geographical Journal*, 102(5, 6), November–December 1943, Blackwell Publishing (http://www.jstor.org. stable/1789131).
6 *Lasbela Gazetteer*, p. 35.
7 Ibid.
8 M. and J. Stutley, *A Dictionary of Hinduism: Its Mythology, Folklore and Development 1500* BC – AD *1500* (London 1977), p. 226.
9 J. Dowson, *A Classical Dictionary of Hindu Mythology and Religion, Geography, History, and Literature* (London 1979), pp. 235, 287 for Sati.
10 J.N. Banerjea, *The Development of Hindu Iconography* (Calcutta 1956), p. 83.
11 Ibid, p. 495, fn.1.
12 Hasan 2009, Appendix A, p. 108.

15
The sacred boulder at the entrance of the Hinglaj cave.

16
The Hinglaj complex.

13 http://www.flickr.com/photos/
mbukhari/2642820083/

14 The author, accompanied by Chandu Lal, also
visited this Shakta Pitha on February 9, 2007. The
present name of Makli, I speculate, might have been
derived from Maha Kali, keeping in view her legendary
association with the spot.

15 Perhaps an apellation of the Bactrian Nana,
Nanaia, Nanay, or Nanaya of the Kushan or even earlier
age, who was later assimilated with Uma or Parvati, the
consort of the Kushan Wesho identified with the Indian
Shiva. See M. Ghose, "Nana: The Original Goddess on
the Lion", *Journal of Inner Asian Art and Archaeology* 1
(London 2006), pp. 97–112; see also M. Ghose, "The
Origins and Early Development of Anthropomorphic
Indian Iconography", 2 vols., unpublished PhD
dissertation (School of Oriental and African Studies,
University of London, 2002), pp. 147ff; J. Cribb, et
al. "A New Bactrian Inscription of Kaniska the Great",
Silk Road Art and Archaeology 4 (Kamakura 1995/6),
pp. 75–142; G. Azarpay, "Nana, the Sumero-Akkadian
Goddess of Transoxiana", *Journal of the American
Oriental Society* 96 (1976), pp. 536–42; Stein 1943, pp.
202–03.

16 *Imperial Gazetteer of India, Provincial Series:
Baluchistan* (reprint Lahore 1991), pp. 192–93; *Lasbela
Gazetteer*, pp. 35–36.

17 I.H. Kausar, *Tazkirah-i Sufiya-i Baluchistan* (Urdu)
(Lahore 1986; 1st edn. 1976), p. 52, fn. 2, p. 195.

18 *Encyclopedia of Islam*, Vol. V (1986), p. 684.

19 *Lasbela Gazetteer*, p. 38; *Baluchistan through
the Ages: Selection from Government Records*, 2 vols, I:
Geography and History, II: Tribes (Quetta 1979; 1st
edn. 1906), Vol. I, p. 470.

20 The first incarnate teacher of the Naths, see Stutley
1977, pp. 101–02.

21 *Lasbela Gazetteer*, p. 37.

22 Personal communication from Chandu Lal,
February 8, 2007; Hasan 2009, p. 108 gives four days.

23 For the total 52 or 51 all over the Indian
subcontinent, see www.hinduofuniverse.com/hinglaj-
yatra.html.

24 Of them, 49 or 48 Shakta Pithas are counted in
India, see http://forum.atimes.com/topic.asp?TOPIC_
ID=5697.

25 S. Beal, *Si-Yu-Ki: Buddhist Records of the Western
World*, 2 vols., English translation (Motilal Banarsidass,
Delhi, Varanasi, and Patna 1981), Vol. I, pp. 113–15.

26 J.N. Banerjea, "The Identification of Some Ancient
Indian Place-Names: *Deva Sabhā-Dewas*", *The Indian
Historical Quarterly* XIV (1985/1938), pp. 747–56;
Banerjea 1956, p. 83, 135; A. Foucher, *Ancient
Geography of Gandhara*, English translation by
H. Hargreaves (repr. Lahore n.d.), pp. 46–50; A.H.
Dani, *Shahbazgarhi* (Peshawar 1964), pp. 18–19.

27 H. Falk, "A Copper Plate Donation Record and
Some Seals from the Kashmir Smast", *Beitrage zur
Allgenmeinen und Vergleichenden Archaologie*, Vol. 23
(Mainz 2003), pp. 1–19.

28 M. Nasim Khan, "Lajja Gauri Seals and Related
Antiquities from Kashmir Smast", *South Asian Studies*,
18 (London 2002), pp. 83–90.

29 Or Mariyamma in south India, see Banerjea 1956,
p. 383; cf. H.K. Sastri, *South-Indian Images of Gods and
Goddesses* (Madras 1916), pp. 213, 224.

30 Originally meant for ritual bathing (or *snan*) and
named after the two shrines respectively – Kali *kund*
and Hinglaj *kund*.

31 Cf. Banerjea 1956, p. 495, fn. 1, p. 84.

32 *Lasbela Gazetteer*, p. 35.

33 More precisely, in April on the occasion of the
grand festival.

34 J.A. Garrett, *Classical Dictionary of India Illustrative
of the Mythology, Philosophy, Literature, Antiquities, Arts,
Manners, Customs &c. of the Hindus* (Delhi 1987; 1st
edn. 1871), p. 498; Hasan 2009, pp. 108–09.

35 T.A.G. Rao, *Elements of Hindu Iconography*, 2 vols.
in 4 parts (Madras 1914, 1916), Vol. I, Part 2, pp.
343–44.

36 Personal communication from Chandu Lal,
February 8, 2007.

37 M. Dawani, "Hindu Temple Architecture and
the Temples of Sindh", in K.K. Mumtaz, et al., eds.,
Temples of Koh-e-Jud & Thar (Lahore 1989), pp. 15–20
(see especially p. 19).

ACKNOWLEDGEMENTS

I am grateful to Makin Khan (now retired), Fayyaz
Ahmad Shah (photographer), both of the National
Museum Karachi, and Chandu Lal (brother of Ram Lal
of the National Museum) for their help and facilitation
during my archaeological tour to the Hinglaj shrine in
February 2007.

All photographs are courtesy of the author.

Index

Page numbers in bold indicate captions

Abhinavagupta 33, 180, 184, 185
Adi Shankara 20, 131, 134, **134**, 135, 139, 140, 147, 148
Adivaraha Cave, Mamallapuram 148
Afghanistan 13, **15**, 87
Agamas 43, 83, 143, 181
Ain-i-Akbari 93, 175
Alsdorf Collection, Chicago 90, **90**
Anahita 83, 84
Ananda Bazar Patrika 67, 69
Anandavardhana 33
Aphrodite 23
Ardoksho 83, 84
Arthashastra 114, 115
Ashapura 193, **194**
Ashtamatrika 102–04
Asian Paints 52, 58
Assam **173**, 174
Athena 23
Ayodhya 97, 168, 169

Bactria 13, 15, 87
Baluchistan 20, 189, 190, **190**, 196
Bankura, West Bengal 42, 72
Basu, Gautam 67–69, **67**
Bengal 39, 42, 43, 50–53, 55, 60, **60**, **61**, 65, 67, 70, 71, 74, 94, 96, 137, 165
Bhabananda 50
Bhadrakali **10**, 12, 17, 74, 85, 87, **87**, 89, 94, 102
Bhagavadgita 24
Bhagavati/Bhavani **9**, 97, 99
Bhairava temple, Hinglaj 189, **192**
Bhaktapur/Bhatgaon 97, 98, **101**, 102, 103, **103–05**, 106, 108, 113, 116, **117**, 119, 121, 125, **125**, 126
Bhakti 24, 131
Bharhut, Madhya Pradesh **23**, 108, **108**, 109, **117**, 123
Bhaskararaya Makhin 145
Bhedadevi 17
Bhimadevi 19
Bhuvaneshvari 154, 156, 166
Bijbehara, Kashmir 83
Brahma 18, **25**, 26, **32**, 34, 39, 43, 85, 142, 175, 181, 183
Brahmilakshmi 84
Brihatsamhita 114, 122, 123
British Museum, London 84
Buddhism/ist 13, 17, 20, 24, 28, 43, 83, 84, 93, 96, 102, 104, 118–20, **120**, 122, 123, 173–75, 182–85

Cambodia 13, **13**
Champapati, Pumpuhar 147
Chamunda/Rakta Chamunda 19, **27**, 85, 103, 143, **144**
Chandi Borobudur, Java 17
Chandi/Chandika 17, 27, 138
Chandrapal, Rakhal 74, **77**
Chatushpitha Tantra 173, 182
Cholas 147, 148
Cybele 13, **15**, 87

Dasai/Mohani 10, 96–105, 112, 126
Dassera 9, 136, 139
Deb, Nabakrishna 50, 51
Demeter 23
Dengapura 13
Deopatan 116
Devibhagavatapurana 28, 164
Devipurana 9, 87, 93
Duimaju 97, 99, 102
Durga Puja 9, **10**, 13, 38, 39, 42, 50–52, 54–81, 94, 96, 106–30, 135–37, 139
Durgasaptashati/Chandimahatmya/Devimahatmya 12, 13, 17–19, 25, **25–27**, 27, 28, **33**, 37, 39, 42, 82, 84, 85, 93, 97, 143, 147, 149, 150
Dutt, Akrur **40**, 51
Dutt, Gurusaday 67
Dutt, Rajinder 51

Faridpur 52
Fo Guang temple, Mt Wutai, China 43

Gajalakshmi **84**, 93
Gajayurveda 121
Ganapati/Ganesh 36–39, 43–45, 49, 52, 55, 74, 81, 103, 135, 143, 177, 193, **194**
Gandhara 13, 83
Ganga/Hooghly 9, 112
Gauri 85, 193
Golu 135–38, **136**
Government College of Art and Crafts, Kolkata 68
Guhyeshvari **182**
Guptas 83, 90, 184
Guruvayur temple, Trichur **9**

Hadigaon 97, 110
Hajra, Syamapada 43, 44
Harisimha Deva 97
Hariti 83
Hemis Monastery, Ladakh **109**, 123
Hevajra Tantra 173, 174, 182
Himalayas 13, 19, 87
Hinglaj, Lasbela 20, 188–97, **189–93**, **195**, **196**
Hutum Penchar Naksha 52

Indrani 24, **88**
Indus Civilization 24
Ishtar 23
Isis 23

Jaiminiyabrahmana 110, 123
Jain 24, 28, 122, 182, 183
Jalandhara 166, 168, 169, 171, 173, 174, 181
Janamejaya 82
Japan 43, 136
Jhelum/Vitasta 82
Jitawarpur 63

Kadambari 114
Kailash, Mount 38, 39
Kalhana 19, 83, 174

Kali **6**, 9, 12, 17, 19, 27, **27**, 28, **29**, **31**, **32**, 34, 36, 37, 51, 85, 94, **132**, 143, **146**, 147, 148, 154, **162**, 163, 166, 183, 187, 189, 193, 194, **195**, 196
Kali Mata, Aror 196
Kalidasa 111, 121
Kalighat, Kolkata 34, 74, **76**, 166, **181**
Kalingattupparani 148
Kamagiri 166, 168
Kamakalavilasa 149
Kamarupa 166, 169, 170, 173, 174, 183
Kamakhya 17, **173**, 174
Kamakoti Shankara Matham 149
Kamakshi/Rajarajeshvari 139, **139**, 140–43, 149, **175**
Kamalambika, Tiruvarur 138, **138**, 143, 149
Kanchipuram **134**, 139–41, **139**, 175
Kangra, Himachal Pradesh **31**, 34
Karachi 20, 188, 189
Karnatakas, Nepal 97
Kartikeya/Kumara/Murugan/Skanda 36–39, 43–45, 49, 51, 52, 55, 58, 68, 74, 106–29, 135, 142, 143, 147
Kashmir 13, **15**, 17, 19, 20, 33, 43, 82–95, **84**, **87**, **88**, **90–92**, 145, 174, 193
Kashmira 84, 170
Kashyapa 82
Kashyapashilpa 43
Kathmandu 10, 96–105, **99**, **101**, **103**, 106–08, 110–16, **117**, 118, 119, **120**, 121, 122, 125–27
Kerala **9**, 12, 17, 19, 20, 65, **65**, 72, 114, 139, 152–63, **155**, **160**
Kolkata **10**, 39, **39**, **40**, 54–81, **57**, **78**, **181**
 Babubagan 65, **66**, 67
 Badamtala Aashar Sangha **6**
 Bakulbagan, Bhowanipur 59, **60**, 69
 Barisha Shrishti 50, **62**, 63, **63**, 64, 67, 72, **72**
 Behala 55, **60**, 62–65, **62**, **63**, 72, **72**, 80
 Bosepukur **39**, 61
 College Square **55**, 58
 Hatibagan 69–71, **70**
 Hindusthan Park 67–69, **67**, **68**, 74, **76**
 Jodhpur Park 17, 57, 58, 68
 Lake Temple Road 68
 New Alipore Suruchi Sangha **6**, 65, **65**
 Salt Lake 56
 Sahajatri Club 64
 Sreebhumi Suruchi Sangha 58
 Ultadanga **6**, 74, **77**, 80
Korravai 147, 148
Krishnachandra Roy 50
Kriyasamgraha 118, 119
Kularnava Tantra 166, 176, 179, 183
Kumarasambhava 111
Kumari 97, **97**, 102, **124**, 125
Kumartuli 49–51, 59, 60, 69, 74, **77**, 78, 80
Kushan 20, 83, 84, 87

Lahut Lamakan, Baluchistan 189
Lajja Gauri 193
Lakshmi/Shri 24, 28, 38, 39, 43–45, **46**, 49, 50, 52, 55, 58, 74, 83–85, 89, 90, 178
Lalita 141, 143

Lalitasahasranama 143, 145, 176
Laxmikanta of Barisha 50
Lichchhavis 97, 114

Machatiya Jatra 116, **116**, 117, **117**, 120, 121, 127
Mahabharata 24, 83, 139, 165, 177
Mahadevi/Ambika 32, 145, 171
Mahakali 32, 34, 39
Mahalakshmi 32, 39, 84, 97, 103, 145, 170, **179**
Mahapratyangira 13
Maharashtra 81, 145, **179**
Mahasahasrapramardani 13
Mahishasura **15**, 19, 26, **26**, 38, 52, **78**, 83, **87**, **88**, 90, **90**, 96, 136, 138, 147
Mahishasuramardini 13, 34, 44, 55, 90, **132**, 150
Makli, Thatta 189, 190
Makran 188, **191**
Malabar, Kerala 152, **162**
Malla/s 97–99, **99**, **101**, 102, 113
Mamallapuram **10**, **132**, 148
Manadeva I 97
Maneshvari 97
Manusmriti 109, 122
Mardan, Pakistan 193
Mariamma 17
Markandeyapurana 25, 147
Mathura 83, 111, **111**, 112, 181
Maya/Maia 107, 108, 119, 120, 123, 135, 149, 150, 154, **162**
Meenakshi 17, 143, **143**
Mitra, Gobindram 50
Muchilottu Bhagavathi/Bhuvaneshvari **6**, 12, 152–63, **161**, 166, **153**, **155**, **159–62**
Murshidabad 50
Mysore 136

Nadia 42, 50, **60**
Nagaswami Temple, Manampadi **11**
Nana 13, 20, 83, 84, 90
Nanyadeva 102
Narayana 12, 13, **25**
Narayani 13
Narayanistuti 13
Nataraja/Nasadyah 104
National Museum, Bangkok 71
Natyashastra 110, 125
Navadurga 96, 97, 102–04, **103**, **104**, 106, 116, 121, 125–27
Navaratri 12, 96, 123, 135, 137, 138, 141, 149
Nepal 10, 13, 20, 96–105, 109, **109**, 112, 114, 115, **117**, **118**, 119, 120, **120**, **122**, **124**, 125, 127, 142, 174, **182**
Newars 97, 103, 108, 109, 113–16, 119, 123, 126, 127
Nharambil Bhagavathi **6**, **161**
Nigamas 181
Nilamatapurana 19, 82–84, 93, 94
Nilotpalambal **148**

Orissa (Odisha) 17, 70, 74, **75**, 114, 174

Pahari 19, **25**, **31**, **32**, 87
 Basohli **32**, 34
 Guler **25**, **33**, 34
 Kangra **31**, 34

Pal, Gopeshwara 52
Pal, Jagadish 52
Pal, Kalachaudi 50
Pal, Sunil **68**, 69
Pal, Sushanta 71
Pallavas 13
Pancharaksha 13
Para Shakti 141, 149
Parnashavari 13
Parvati/Parvathy/Uma 13, 24, 25, 27, 34, **34**, 36, 43, 82, 84, 87, 89, 111, 112, 131, **132**, 135, 145, 154, **162**, 163
Patan 97, **97**, 98, **98**, 102, 104, **112**, 118
Patanjali/*Mahabhashya* 178
Paul, Nemai Chandra 43–45, **44**, **46**, **48**
Persephone 23
Poddar, Gopal 74, **76**
Prajnaparamita/*Prajnaparamita* 28, 93
Puliyoor Kali **162**, 163
Punjab 13, 17, 87, **166**
Purnagiri 166, 168, 169, 173, 174, 181

Rajasthan 13, **16**, 17, 34, **34**, 56, 94, 190
Rajatarangini 19, 83, 93
Rajmahal 50
Ramayana 24, 55, 109, 122
Ray, Ramnarayan 64, 67
Ray, Subodh 64, 65, **65**, **66**, 67–69, 72, 79
Rayaramangalam Bhagavathi 156, 157, 159, 163
Rudrapal, Mohanbanshi 74, **77**
Rudrapal, Pradip 74, 76, **78**, 80
Rudrapal, Sanatan 74, **77**, 79, 80

Sachika/Sachiyamata 13, **16**, 17
Sakyamuni 108, 123
Samkhya Yoga 12
Samkhya-karika 18
Samurtarchanadhikarana 43
Sarasvati 24, 38, 39, 43–45, **48**, 49–52, 55, 58, 74, 93, 137–39, 143
Sarkar, Amar **62**, 64, 67
Saundaryalahari 20, 28, 131, 139, 150
Shahs, Nepal 98, 102
Shah Bilawal, Baluchistan 189
Shah Hamdan Mosque, Srinagar 82
Shakambhari 19, 42, 121, 143, 172
Shakta Pitha 12, 19, 164–87, **181**, **182**, 189, 190
Shankaracharya 20, 143, 175, 176
Sharada Pitha 82
Sharadamahatmya 93
Sharadatilaka 178
Sharika 17
Shashthi 9, 42, 113, 114
Shashthitala, Krishnanagar 43
Shatakshi 19
Shatapathabrahmana 107
Shitaladevi, Hinglaj 193, **194**
Shiva 9, 19, **20**, 21, 24–27, **32**, 34, **34**, 39, **42**, 43, 55, 70, 83, 85, 89, 103, 104, 111, 112, 126, 131, **132**, 134, 135, 138, 141, 142, **146**, 147, 148, 153–55, **162**, 163, **165**, 177, 180, 183, **184**, 189, 190, **192**, 193, 195
Shiva Samhita 179, 183

Shri Vidya 130, 137–39, 140, 145, 146, 148–50
Shyama 94
Sindh 13, 20, 189, 190
Sita 25, 28, 138, 190
Smarta 12, 130, 134, **135**, 145, 149
Somaskanda 142, **142**
Spiti 43
Sri Lanka 36
Srinagar, Kashmir 82, **88**
Sringeri 131, 139
Sundarar 131, **134**
Sureshvari, Kashmir 19
Suri, Birbhum 49
Sutar, Bhabatosh **63**, 64, 68, 69, 72, 74
Swat 174

Tagore, Rabindranath 9, 74
Takkayagapparani 148
Taleju/Tulaja 10, 17, 97–99, **99**, 101–04, 126
Tamil Nadu **10**, **11**, 12, 37, 114, 115, 130–51, **132**, **134**, **136**, **142**, **175**
Tantrasara 164–66, 168, 173, 175–78, 183
Tantric 18, 28, 70, 83, 94, 97, 104, **124**, 137, 145, 146, 148, 149, 165, 173, 174, 176–80, 183, 184, 189
Tara 17, 168
Tarapitha, West Bengal 19
Thanesar **34**, **107**
Theda/Thid, Kashmir 19
Theyyam/s **6**, 12, 74, 152, 154, **157**, **159**, 160, **161**, **162**, 163
Tibet/an 13, 116
Timmamtiram 145
Tiruchirapalli 148
Tirumurukarrupadai 147
Tiruvalankatu **6**, **146**
Titumeer 65–67
Tripurasundari/Bala Tripurasundari 102, **103**, 141
Trishuli 116, **117**
Tughlaq, Ghiyas-ud din 97
Turner, Victor 32, 137

Uddiyana 166, 168, 169, 172–75, 181, 183
Utpala 89

Vaikachi Vichakam 114, 115
Vaikhanasagrihyasutra 114
Vaishampayana 82
Vajrayana 13, 17
Varahamihira 122
Varneshvari 178
Vasudhara 114
Vedas 20, 24, 107, 108, 110, 115, 145, 181, 182
Vimanarchanakalpa 43
Vindhyas 13
Vindhyavasini 30, 113, 138
Vishnu 12, 17, 19, 21, 24–26, **32**, 34, 39, 43, 83, 84, 90, 125, 131, 134, 135, 139, 150, 177, 178, 182, 189
Vishnu Maya 150
Vishnudharmottarapurana/VDP 83–85, 87, 94, 112, 125

Wodeyars 136

Xuanzang 19

Contributors

Pratapaditya Pal is the General Editor of Marg Publications. He has been associated as curator with leading American museums that have South Asian collections and has taught at several universities. Recognized as an authority on the arts and cultures of the Indian subcontinent, particularly the Himalayas, and Southeast Asia, he is a prolific writer with over 60 publications. Dr Pal was awarded a Padma Shri by the President of India in 2009.

Gerald James Larson is Professor Emeritus, Religious Studies, University of California, Santa Barbara, and Tagore Professor Emeritus of Indian Cultures and Civilization, Indiana University, Bloomington. He has authored/edited some 12 books and well over 100 scholarly articles on cross-cultural philosophy of religion, history of religion, classical Sanskrit, and South Asian history and culture. His recent books include *India's Agony Over Religion* (1995, 1997), *Changing Myths and Images* (2000), and *Religion and Personal Law in Secular India* (2002). His most recent publication is Volume XII of *Encyclopedia of Indian Philosophies*, co-edited with the late Dr Ram Shankar Bhattacharya, entitled *Yoga: India's Philosophy of Meditation* (2008). A collection of essays has been published in his honour, *Theory and Practice of Yoga* (2005, 2008).

Susan S. Bean is Curator, Department of South Asian and Korean Art and Culture at the Peabody Essex Museum, Salem, Massachusetts. She curated the exhibition *Timeless Visions* (1999) on the Chester and Davida Herwitz collection of contemporary Indian art, a substantial part of which was gifted to the Peabody Essex Museum in 2000.

Tapati Guha-Thakurta is a Professor in History at the Centre for Studies in Social Sciences, Kolkata. She is the author of *The Making of a New "Indian" Art: Artists, Aesthetics and Nationalism in Bengal* (1992) and *Monuments, Objects, Histories: Institutions of Art in Colonial and Postcolonial India* (2004). She is currently completing a book-length study on Durga Puja in contemporary Kolkata.

Anne Vergati, an anthropologist and historian, is Directeur de Recherche at the Centre national de la recherche scientifique (CNRS), Paris. She has done intensive field work in Nepal, on Newar culture and religion in Kathmandu Valley, and later in western Rajasthan in India. Her main publications are on the anthropology of art, the relation between art and society (*Art and Society in Kathmandu Valley*, 2005), image and ritual, and the social religious organizations of towns of the Kathmandu Valley (*Gods, Men and Territory*, 1995).

Gautama V. Vajracharya is a Sanskritist with a deep interest in South Asian art and culture. In his youth, he went to a gurukula Sanskrit school. He received a prestigious Rockefeller grant to work as a trainee at the Los Angeles County Museum of Art, and later earned a Masters degree in art history from the Claremont Graduate School, California, and a PhD on South Asian language and culture from the University of Wisconsin, Madison.

Rajeshwari Ghose has for many years been teaching and researching the history of Hinduism and Buddhism and Hindu-Buddhist sacred art in South, Central and Southeast Asia. She has authored, contributed to, and edited several books and articles, the most recent being the Marg volume *Kizil on the Silk Road* (edited, 2008). Her other works include *Tyagaraja Cult in Tamilnadu: A Study in Conflict and Accommodation* (1996), *In the Footsteps of the Buddha: An Iconic Journey from India to China* (edited, 1998), and several entries in *Magische Gotterwelten: Worke aus Dem Museum für Indische Kunst Berlin*, with Marianne Yaldiz and others (2000). She has taught in several universities and retired from the Department of Fine Arts, University of Hong Kong. Since then she has been living in Toronto, Canada.

Pepita Seth was born and brought up in England. In 1970 the discovery of her soldier great-grandfather's 1857 diary brought her to India to retrace his journey. All subsequent trips focused on Kerala and in 2000 she settled in Thrissur. Driven by respect and passion for the region's culture and traditions, she has devoted herself to writing about and photographing Kerala's rituals. She has lectured extensively and had exhibitions of her photographs in India, the UK, and the USA. She recently published *Heaven on Earth: The Universe of Kerala's Guruvayur Temple* and is now working on a book on Theyyam.

Ibrahim Shah is Chairman, Department of Archaeology, Hazara University, Mansehra, North-West Frontier Province. Till recently he taught ancient Indian history, art, and architecture in Peshawar University. He did a PhD on Hindu sculpture in Pakistani museums, and also studied Mughal art and architecture at the MPhil level. He has to his credit more than 50 research papers published in various national and international journals, and has participated in numerous conferences in Pakistan and abroad. He has been a Charles Wallace Fellow.

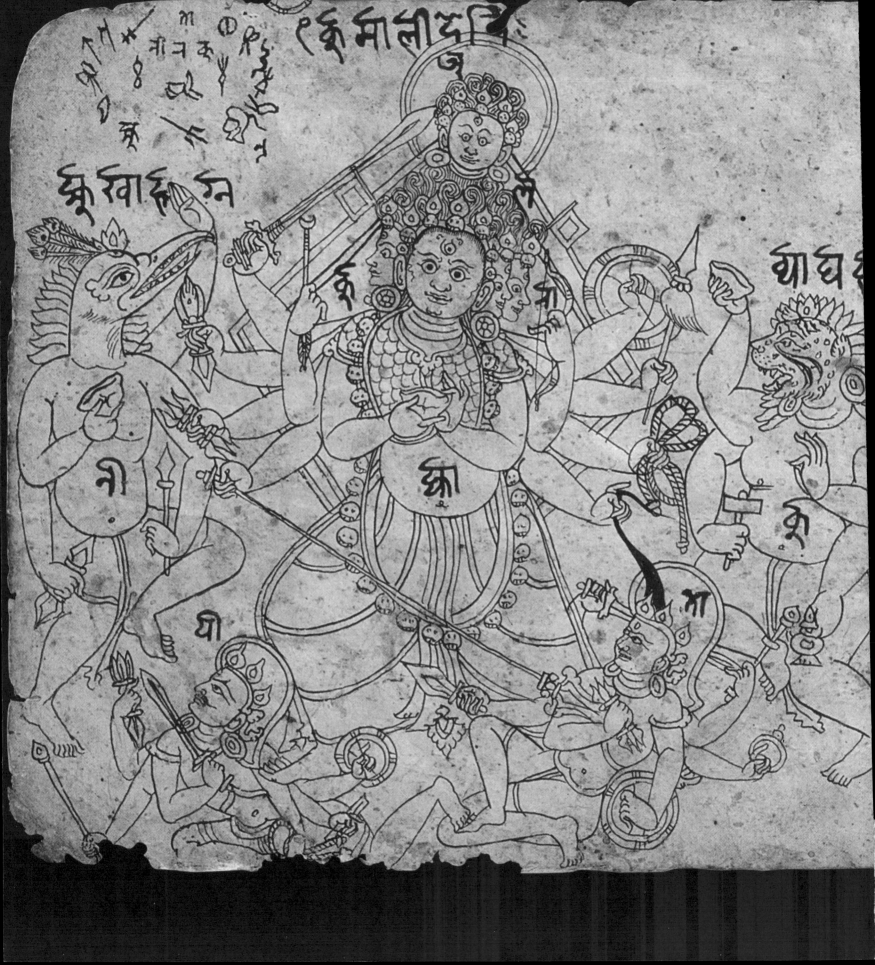